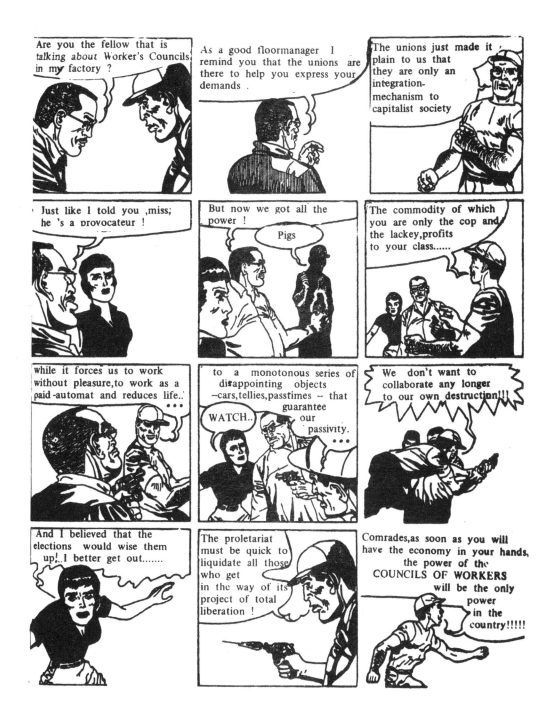

Councillist Comix issued in Toulouse (France) June 1968

To the reader:

The posters produced by the Atelier Populaire are weapons in the service of the struggle and are an inseparable part of it.

Their rightful place is in the centres of conflict, that is to say in the streets and on the walls of the factories.

To use them for decorative purposes, to display them in bourgeois places of culture or to consider them as objects of aesthetic interest is to impair both their function and their effect. This is why the Atelier Populaire has always refused to put them on sale.

Even to keep them as historical evidence of a certain stage in the struggle is a betrayal, for the struggle itself is of such primary importance that the position of an "outside" observer is a fiction which inevitably plays into the hands of the ruling class.

That is why this book should not be taken as the final outcome of an experience, but as an inducement for finding, through contact with the masses, new levels of action both on the cultural and the political plane.

*This text appeared as the frontispiece of the 1969 Atelier Populaire book* Posters From The Revolution *documenting the posters and the circumstances of their making.*

# BEAUTY IS IN THE STREET

# A VISUAL RECORD OF THE MAY '68 PARIS UPRISING

Edited by Johan Kugelberg
with Philippe Vermès

Four Corners Books

Published in 2011 by Four Corners Books
56 Artillery Lane, London E1 7LS, United Kingdom
www.fourcornersbooks.co.uk

Back cover image and p. 73 courtesy Jacques Carelman / ADAGP

Thank you:
Philippe Vermès, Nancy Vermès, Ralph Rugoff and the Southbank
staff, Jeff Boardman, Steve Lazarides, Ralph Taylor, Bob Stanley,
Didier Lecointre, Dominique Drouet, Kevin Repp, Nancy Kuhl,
Michael Laird, Taylor Brigode, Edward Lasala, Katherine Reagan,
David Strettell/Dashwood Books, Madison Brigode, Siena Fleming,
Majida Mugharbel, M+S+S, DawkinsColour, Walter Lewino,
Jo Schnapp, Jacques Carelman

Edited by Johan Kugelberg

Co-Editor: Philippe Vermès
Co-Editor: Nancy Vermès
Co-Editor: Gabriel Mckee

Associate Editor: Michael Daley
Associate Editor: Will Cameron

Designed by Pierre Le Hors
Cover design: John Morgan

Printed in Hong Kong by Imago
Print Production: Martin Lee

ISBN 978-0-9561928-3-7

MAI 68
DEBUT
D'UNE LUTTE
PROLONGEE

ATELIER POPULAIRE

# CONTENTS

## THE LATE SIXTIES

*Philippe Vermès, co-founder of the Atelier Populaire*

Born in a small village in Calvados, an agricultural region in France, I come from a farming family of Normans, longtime descendants of Vikings who have that peculiar historical particularity of being high-spirited adventurers and skilled sailors. As a young boy, I thrived on the peaceful seashores and hilly wooded landscapes; national politics changed all that as the draft threatened to wrench me from my studies and send me to Algeria to fight in a French colonial war. Enrolled in a fine arts school in Caen, I redoubled my efforts to keep my student status. I obtained a military deferral when I was admitted to the Ecole National Supérieure des Beaux Arts in Paris where my life morphed from fine arts student to political activist.

An old French saying, "Au mois de mai, fais ce qu'il te plaît" (In the month of May, do whatever you like), captures the fun and frolic of that time of year but "May '68," as it was branded, broke like a maverick from those carefree clichés. The 60s were serious, emblematic times for many of us who strolled into them in our mid-20s. Economic issues and political strife plunged everybody —university students and factory workers, office employees and company executives, truck drivers and garbage collectors, teachers, social workers—willingly or not into the volcanic magma of social upheaval.

I hadn't been especially involved in a specific political movement; I tended to shy away from organized groups and most of the "ists" (Maoists, Communists, Situationists, Trotskyists, etc.). If anything, I was kind of a loner caught up in my painting but associated and active in le Salon de la Jeune Peinture—a loosely formed collective of politically committed artists (les artistes engagés). The climate of the times was colored by social unrest, thirst for independence, and the war in Vietnam. This proved a volatile mix, wreaking havoc throughout the planet and especially in Paris.

Curiosity led me to the first student gatherings in the amphitheater of Censier University, in the 5th arrondissement, a short walk from the Latin Quarter and the venerable Sorbonne. I wanted to join in, be a part of a growing student movement launched by protesting student unions led by Dany Cohn-Bendit, Le mouvement du 22 mars. It was at those noisy turbulent meetings that I got a sense of the extent of the student unrest, and it was there, too, that I met fellow painters from La Jeune Peinture who, like myself, wanted to participate. But how? We decided with the Comité des grèves des Beaux Arts to occupy the painting and lithography ateliers. On May 14, we printed in the lithography room the first poster of "May '68," "Usines, Universités, Union" ("Factories, Universities, Union,") to express in a nutshell the determination to connect students and workers. This was followed by another lithograph entitled "L'art au service du peuple" ("Art at the service of the people.") Factories, too, were occupied at that point, and the production of posters was an obvious choice to express the power of protest of our collective union. The lithography process that used stone took too long, though. We needed another method of multiple printing. Guy de Rougement and Eric Seydoux,

two artists and silkscreeners volunteered their know-how and equipment to us—young artists, high school and university students and workers—so the second floor of the Beaux Arts was transformed into a silkscreening workshop. They showed us how to use photography within the process as well. The change in technique made a huge difference as we could dramatically increase the number of posters printed in one night. We could do 2,000 at a stretch, and we learned quickly how to use the scraper on the framed silk screen, how to clean it, and use it again for another poster. We learned stencilling as well. We worked day and night in shifts. People brought in food, hot coffee and helped whenever they could. Anybody and everyone—students, factory workers, office employees, transporters, media people, mailmen, fishermen—could bring ideas and work on the actual silkscreening. There were general assemblies daily, and discussions could be tumultuous among the groups represented who vied for votes for their poster choice. Everyone respected the general principle of anonymity concerning the poster's designer and writer. The idea was to keep the effort collective to avoid bourgeois values. We no longer called ourselves Ecole des Beaux Arts; we signed our posters Atelier Populaire des Beaux Arts or simply Atelier Populaire and stuck one up on the atelier door that read Atelier Populaire: oui, Atelier Bourgeois: non.

Striking newspapers and printing shops contributed paper and paint and specialized silkscreen stores provided materials at low cost. I remember clearly, driving my tomato-red Citroën 2CV from les Beaux Arts in the 6th arrondissement, crossing Le Pont du Carousel and racing to the rues Réaumur and Quatre-Septembre to get more paper from striking dailies. I would rush back with my precious supply of the throwaway leftovers of long rolls of newsprint paper. We'd set up a stand to unroll the paper in the director's garden on the ground floor, and hoist the paper up through the second floor window where it was stretched under the framed silkscreen, printed, and then pulled back into the garden to dry outdoors.

The posting took place under the cover of night. Parisians would wake up the following morning and see the issues at hand. The posters, as common as popcorn, were everywhere for everyone. The posters were also picked up by strikers at the Atelier and distributed to their fellow workers. It was a dangerous business. Loud demonstrations had been severely repressed by nervous CRS squads. We feared a police bust at the Atelier Populaire, and they did finally come on June 27 and shut down the Atelier. There was no resistance; we took our paper, our paint, and our press with us and walked out. The police had expected to seize a big printing press; they didn't realize that we had carried out our tools for poster making with us! The poster entitled "La Police s'affiche aux Beaux Arts, Les Beaux Arts affichent dans la rue" ("The police post

themselves at the School of Fine Arts—the Fine Arts students poster the streets") was the immediate riposte of the Atelier Populaire and represented its continuing resistance. Activity continued for a while in and out of Paris. One of the posters from that period was done in my Paris atelier, and was entitled "La France Enbastillée" created especially for Bastille Day on July 14.

In an effort to promote the idea and creation of further ateliers populaires, we formed a non-profit association called UUU (Usine Université Union). It aimed to complete the publication of a collection of the posters from '68 in a book entitled *Mai 68: début d'une lutte prolongée* by an English publisher, Dobson Books, in 1969. Another smaller book of posters was edited by UUU and entitled *Atelier Populaire presenté par lui même: 87 affiches de mai-juin '68*. It was designed to be an inexpensive handbook for people to create their own atelier populaire. The entire collection inherited from the Atelier Populaire was donated to the Bibliothèque Nationale at rue Richelieu.

The Atelier Populaire had been a working space for ordinary people whose popular voice could be heard loud and clear, graphically, visually throughout the streets of Paris and around the occupied factories. Simple, direct, striking. The posters were created to capture popular imagination and awareness. It'd be different now if we ran the same scenario through current times. Twitter and Facebook and cell phones didn't exist in May '68.

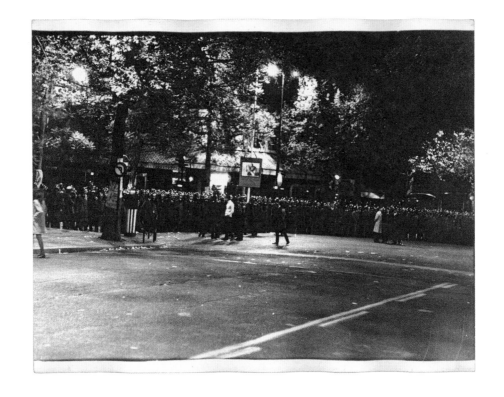

Student demonstrations on the Left Bank, May 1968. *Photographer unknown.*

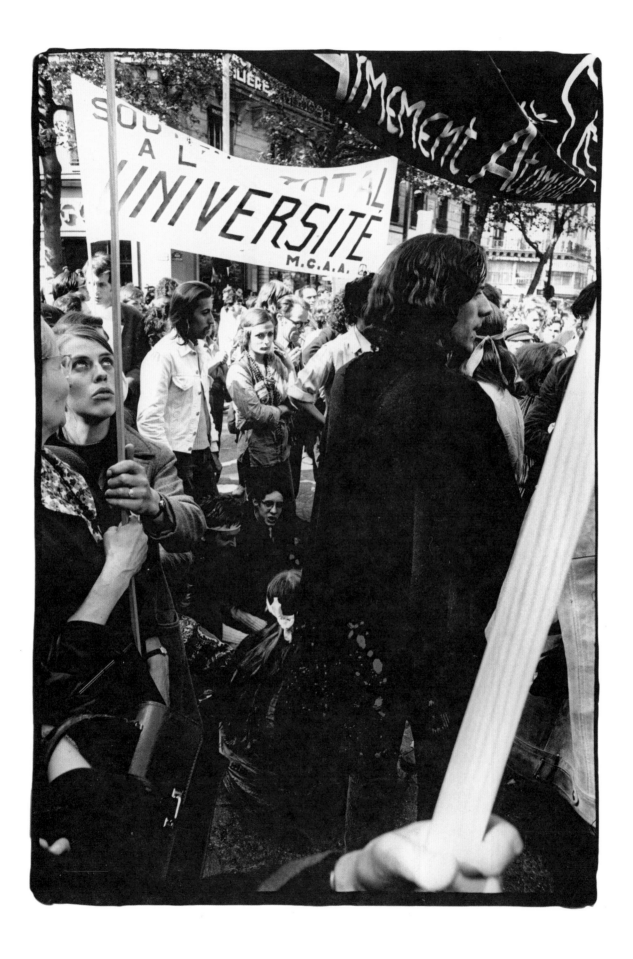

↑ Student demonstrations on the Left Bank May 1968 *Photographer unknown*

## A JUMBLE OF REALIA

*Johan Kugelberg*

This jumble of realia conjures up a past time, when a grassroots reaction against complacency almost came to tumble a regime that showed serious totalitarian streaks. An unprecedented wave of strikes, walkouts and demonstrations by students, followed by a general workers' strike, paralyzed the French capital. These events that came close to shutting down France, and almost drove President Charles de Gaulle out of office, were not pre-meditated by left-wing intellectuals; they weren't planned by trade unions or by the communist party. They can rather be described as the greatest wildcat strike in history. Everyday people witnessed how the Parisian students were treated by the cops, and reacted. At its peak, millions of Frenchmen were on strike.

The slogans on the posters and the walls are superb, they are invigorating and happy-making. These posters and the wall graffiti comprise some of the most brilliant graphic works ever to have been associated with a movement for social and political change. Produced anonymously, these bold graphic messages appeared on the barricades, were carried in demonstrations and were plastered on walls across France. The posters were the main carriers and propagators of the students' and workers' messages, as the media, left to right, was tainted with the grinding will of the propaganda of the eversame.

The political activism of French students had been increasing gradually in the mid 60s, following the relative inactivity of the period immediately after the Algerian War. The Chinese Cultural Revolution,

the iconic Che Guevara, Castro and above all the anti-Vietnam war movement inspired and influenced student activism globally. Left-wing groups flourished, with radical bookstores, pamphleteers and community activism increasingly becoming a part of the everyday fabric of student life. Street protests became common throughout 1966 and 1967.

In 1968, in Germany, students protested against their university system and the right-wing monopoly of the popular print media; in Spain street demonstrations were held against Franco and for freedom of the press; in Italy students demanded reform of the university system; in Poland and Czechoslovakia demands for freedom of expression from the students were brutally repressed.

Nanterre University, in a western suburb of Paris, was an overcrowded extension of the Sorbonne. From its inception, it had a reputation as a centre of left-wing activism. Campus activism increased in strength consistently throughout the 60s. The anti-war movement was strong at Nanterre, and the students were also tired of the mass of rigid rules of conduct on campus, applied to the mostly post-graduate students who were treated like teenagers with curfews and fraternizing between the sexes forbidden. On March 22, 1968, approximately 150 students staged a sit-in to protest, and the campus authorities called the cops, who came out in force. Several hundred CRS (Compagnies Républicaines de Sécurité, the French riot police) sealed off the building where the sit-in was held, escalating the situation, and

bringing about solidarity from hundreds of students. The mass arrests and the brutality were shocking. Word spread to other campuses, and the students of the Sorbonne staged a protest.

Nanterre University had been closed on May 2 by the authorities after clashes between Vietnam War protestors and right-wingers. Approximately 300 students had gathered that day, some of them armed with truncheons in anticipation of a confrontation with right-wing extremists from the organization Occident who were rumored to be showing up. Again, the campus authorities called the cops, the cops showed up in brute force and the students were arrested and manhandled by the CRS. Across town, the word spread quickly through the Sorbonne that something nasty was going on. The cops called for tear gas. As the police attempted to move the black vans out with their cargo of arrested students, the crowd, at this point very angry, surged in the way of the vehicles. The shock of the tear gas only seemed to agitate the crowd further. The cops and the CRS were apparently shocked at the level of resistance they encountered.

Marc Rohan writes in his superb book *Paris '68*:
"There was no organization behind the students' reaction, there were no agitators, no leaders (those who could have played those roles had all been inside the Sorbonne and were now in the police vans), there had been no directive, no leaflet to tell people what to do. The vast majority of those who stepped into the street to fight back on that day were not closely involved in any political organizations, nor did they share the political beliefs of those arrested, or even know much about what had led to the arrests. Their reaction was simply an angry outburst of 'we've had enough!'"

The battle raged for several hours up and down the boulevard Saint-Michel. Paving stones were shattering police van windows, tear gas was everywhere, people on both sides were getting hurt. By the end of the day, 600 students had been arrested, 72 police officers and an unknown number of students had been injured. The right-wing newspapers the next day blamed agitators; the left-wing newspapers were baffled by the anger of the students. Over the weekend of the fourth and fifth of May, students all over Paris were forming committees, preparing for demonstrations on Monday May 6 to demand the release of the students arrested on Friday and the re-opening of the Sorbonne. The May 6 demonstration started peacefully. Approximately 20,000 people marched, snaking from the left bank to the right bank and then back. When the demonstration reached the immediate vicinity of Sorbonne University, the police charged. Tear gas was used. The crowd, however, wouldn't give in. Paving stones were hurled at the cops, and for sixteen hours the unrest continued.

The following day, twice as many people had showed up for the demonstration. Workers and teachers were now lined up alongside the students. The demonstration was peaceful, staying on the right bank, and culminating under the Arc de Triomphe. On Wednesday May 8 and Thursday May 9, negotiations for the release of the students and the reopening of the Sorbonne commenced. It was announced on French radio that the university was to reopen on the Thursday, but the Minister of Education pulled the plug at the last minute, arguing that the students would occupy the buildings.

Friday May 10 was to be violent. A demonstration of approximately 30,000 people found itself more or less blocked in on the boulevard Saint-Michel, the police controlling the bridges to the right bank and several of the main arteries leading out of the Latin Quarter. Hundreds of people started building barricades. This was spontaneous: there was no urban guerilla masterplan, no strategy. The stand-off continued until 2 a.m., when the police charged the barricades. The battle lasted for four hours. The police had tear gas and nightsticks, the demonstrators threw paving stones and hastily assembled Molotov cocktails. Hundreds of people were wounded, but there were no deaths, which was miraculous. France and the world followed the events on radio and on television. The horrific scenes had ordinary working men and women appalled by their government's violence and uncompromising aggression. The government had gone too far: The lion's share of French trade unions announced a one-day general strike in tandem with a mass demonstration on Monday May 13. The announcement that the Sorbonne University was to be re-opened on the Monday morning, and that the arrested students were to be released without charge, came as too little too late. One million people marched calling for the resignation of Charles de Gaulle. As the police had left the Sorbonne on the morning of the thirteenth, the premises were occupied by protestors during the day. Posters and graffitied political slogans covered the façade of the Sorbonne, and the Atelier Populaire was formed to print posters, handbills and leaflets, and distribute them.

In the following days, it was reported that wildcat strikes and the occupation of factories were happening all over France. By May 16, over 50 factories were occupied, and by May 17, over 250,000 people had gone on a wildcat strike. On May 18, the trade unions opportunistically called for a general strike for wage increases, particularly ironic as up until that day they had mostly criticized the events as the work of troublemakers and provocateurs. By the evening of that day, the number of people on strike had risen to two million. By Wednesday May 23, nine million people were on strike and France had been brought to an absolute standstill.

It is difficult to maintain a detached tone about the days that followed. When one reads first-person accounts of the camaraderie that spanned economical, social and racial lines during these days, it is a moving experience. Students, workers, academics and burghers connected in egalitarian brotherhood and sisterhood. People talked. They communicated: the television and the radio were switched off, and any locale became a place for dialogue and discourse. People changed. Ideas and inspirations, with the potency to last a lifetime and to change it forevermore, were everywhere. A revolt against the spectacle, protesting against the dehumanized life, a protest of real individuals against their separation from a community that would fulfill their true human and social nature and transcend the spectacle. A revolution of everyday life.

On May 24 there was a televised speech by Charles de Gaulle, which offered a referendum in one month's time. It was not well received. During the same day, Daniel Cohn-Bendit, a charismatic student at Nanterre who had become one of the main spokespeople for the rebellion, was blocked from entering France. This resulted in another night of fighting on the barricades in the Latin Quarter, much more severe than the night of May 10. One person was killed, struck by shrapnel. The Paris stock exchange was looted and torched. From May 25 to May 29 frantic talks were held among committees, unions, students, left-wing politicians to further this unrest into a full revolution with an alternative system of government. A large demonstration was held on May 29. Afterwards, government officials admitted that, on that day, they thought they weren't going to be able to remain in power for more than an additional 48 hours. Charles de Gaulle left the country that morning, and flew by helicopter to West Germany to meet with the general and commander-in-chief in charge of the French troops stationed in Germany in order to get his support if there was an attempted coup from the French left. On Thursday May 30, de Gaulle spoke to the nation. The speech was short, and stated that he wouldn't resign, that the French parliament was to be dissolved and that new elections were to take place. If people wouldn't return to work and order wasn't reinstated, he would declare a state of emergency. Later the same day, approximately 800,000 people marched from the Place de la Concorde to the Arc de Triomphe in support of Charles de Gaulle's government.

Some changes and improvements were implemented to appease the workers and the trade unions. Work started again, and if it didn't, the police were there to rid a factory of the people who were trying to prolong its occupation. Order was restored by increasingly brutal methods. At the Renault factory in Flins, the battle between workers and students on one side and the cops and CRS on the other lasted for four days. One more life was lost in this skirmish, that of a seventeen-year-old student. The fury of the local population over this death forced the CRS to withdraw from the area.

On June 11, after extremely violent clashes between workers and police at the Peugeot car factory in Sochaux, the police opened fire and two workers were killed. On June 12, the French government banned a wide variety of student organizations and left-wing groups. On June 16, the Sorbonne University was stormed by the police. On June 27, the Atelier Populaire was shut down. Imagination was no longer in power.

The reason all this is important after all these years is that the events of May 1968 have frequently been perceived as a failure by people of an idealistic inclination in France and elsewhere. This just isn't true: A wildcat strike of this magnitude, commenced without agitators or demagogues or strike-leaders or the supervision of left-wing political party brass or union leaders, is nothing short of miraculous. The publication of a newspaper (*Action*) without a central editorial committee, the editorializing, manufacturing and distribution of thousands of fly-posters, pamphlets and handbills on a daily basis all showcases the wondrous ability and solidarity inherent in people when societal push becomes societal shove. The regime of Charles de Gaulle, with its totalitarian and fascistoid streaks, was within a hair of being brought down.

The subsequent events where the unions and the left-wing political parties sold their own brothers and sisters down the river, requesting bigger cages and longer chains instead of seizing power, is ultimately the grand cop-out of the May 1968 heritage, and a lesson that should be known by youth in any time and age. The ideas behind this uprising, and its spontaneous and rebellious outpouring in graphic art, should and could be utilized by us all and furthermore remind us that instant online communication might not lead to change. Dare one whisper that the spectacle has found another great means of pacifying subversives: if the powers that be are upsetting to you, you can always write something scathing about them on your blog.

Hey: if one feels righteously pissed off about the ways of the world in 2011, one can turn to these uplifting posters and activities as a tonic, and realize that the potency of grassroots activism, and how it can boost the righteous indignation of everyday people, almost brought down the de Gaulle government.

*New York City 8/2010*

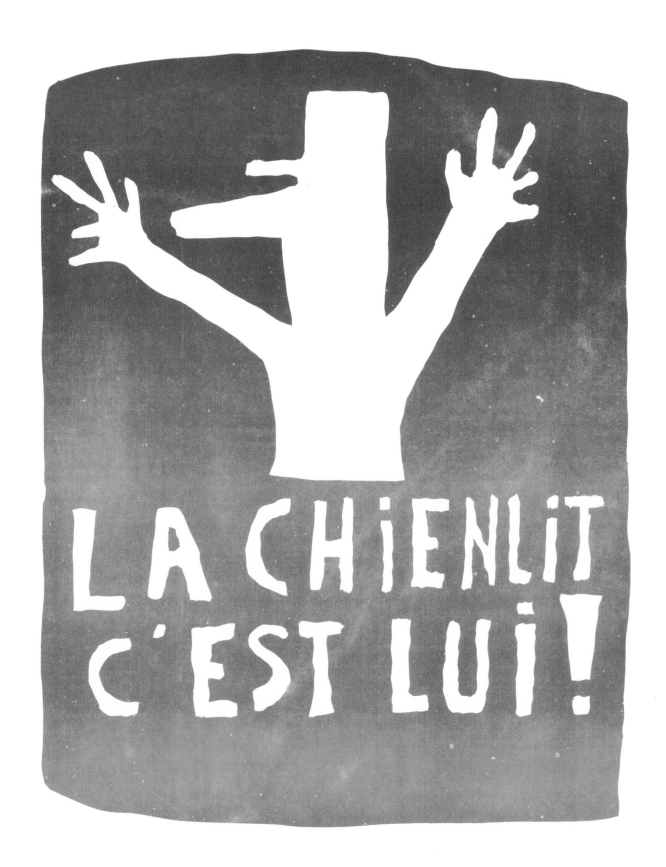

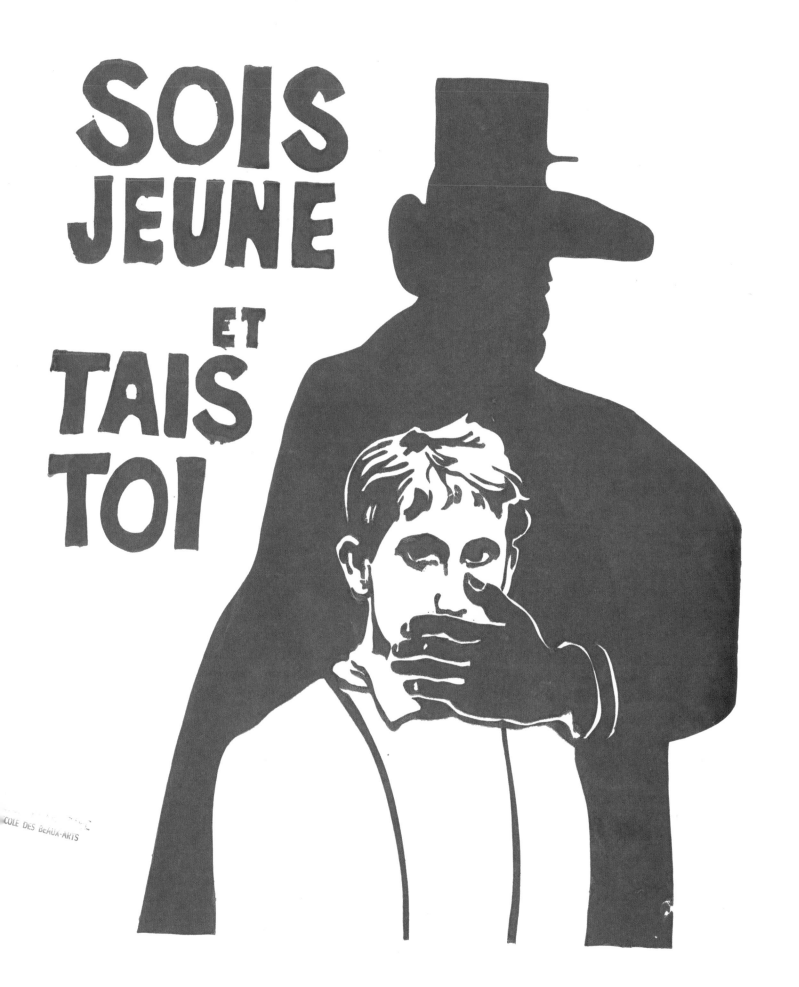

SOIS JEUNE
ET
TAIS
TOI

17

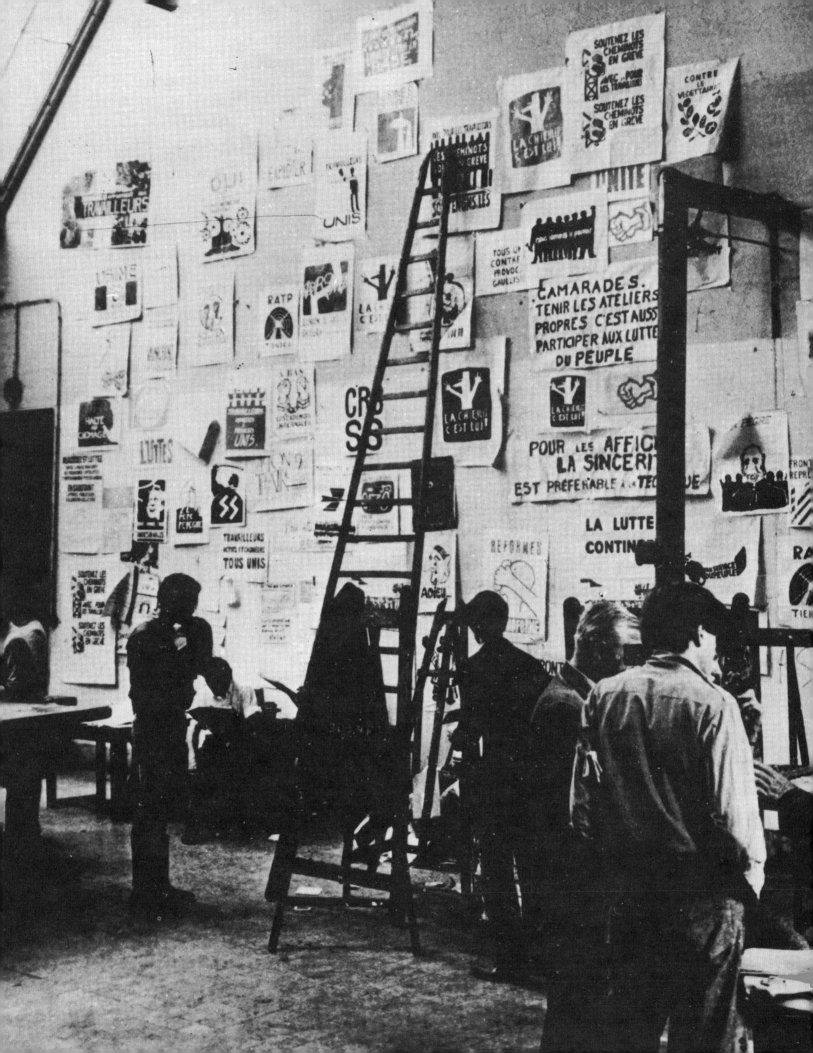

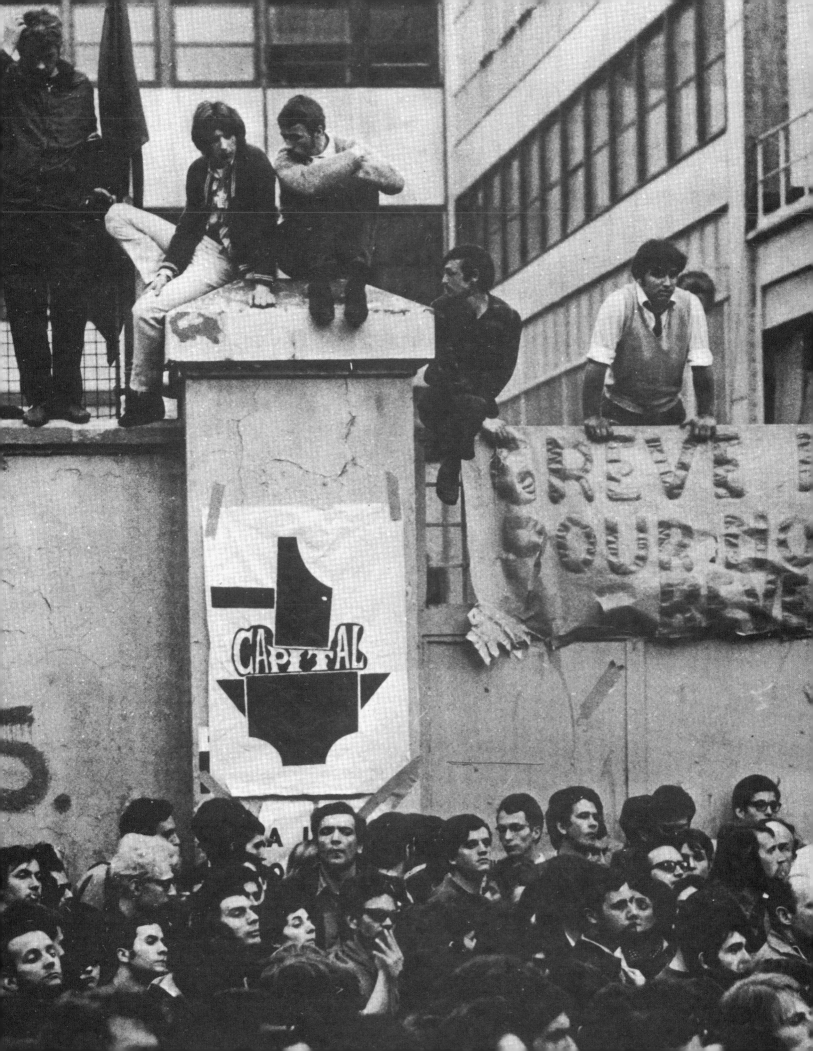

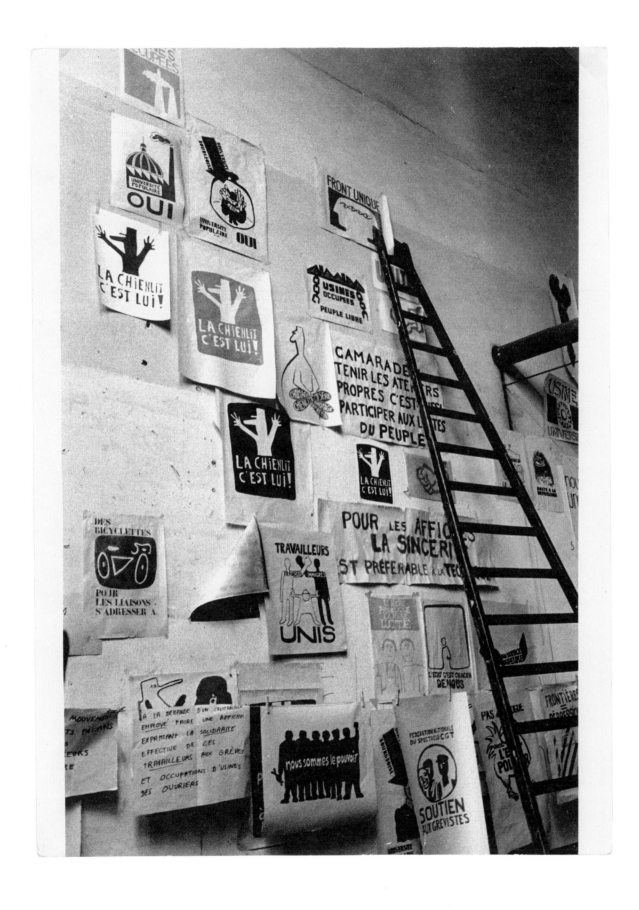

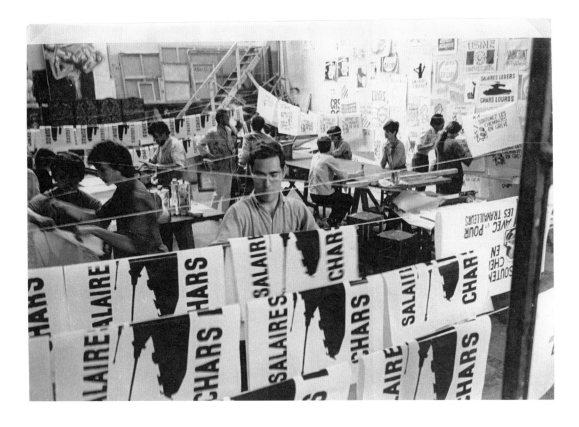

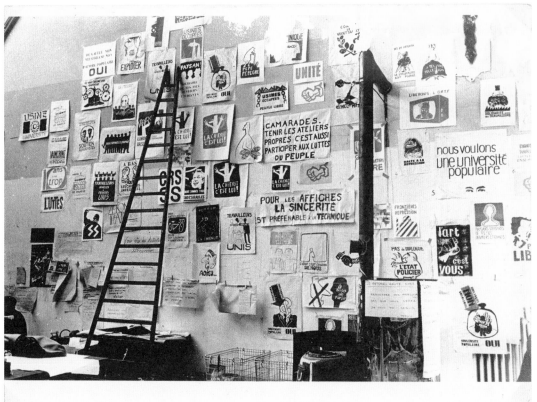

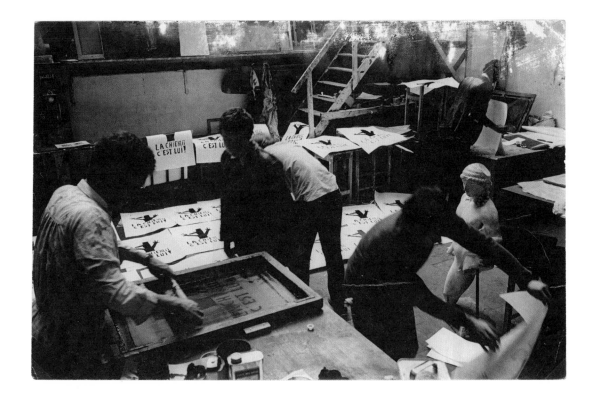

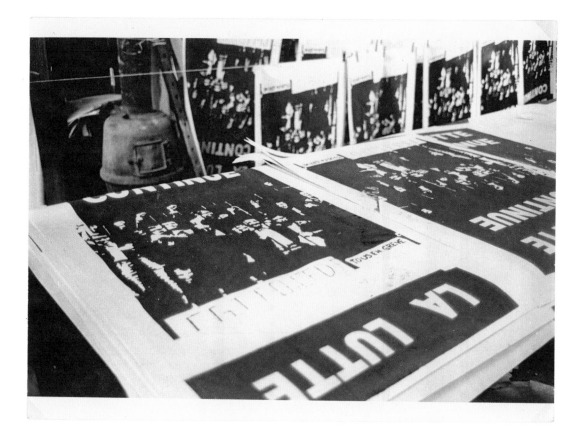

↑↑ The poster printing process at the Atelier Populaire, May 1968. *Photographs by Philippe Vermès.*

LA LUTTE CONTINUE

TOUS EN GREVE

# SALAIRES

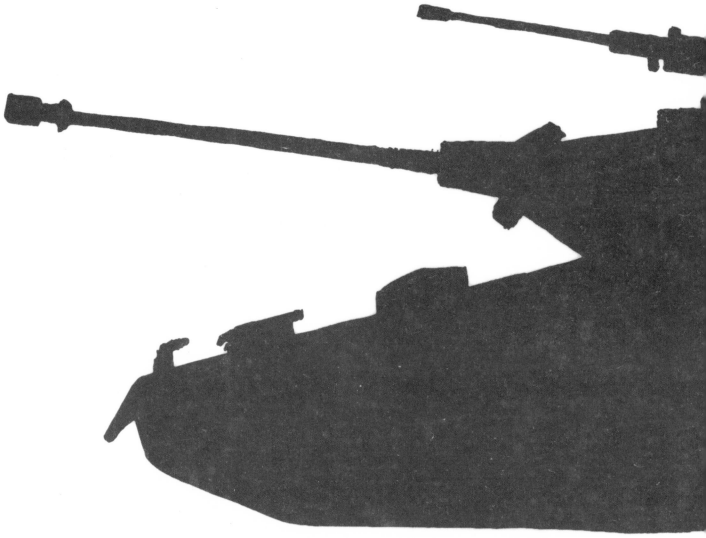

# CHARS

# LEGERS

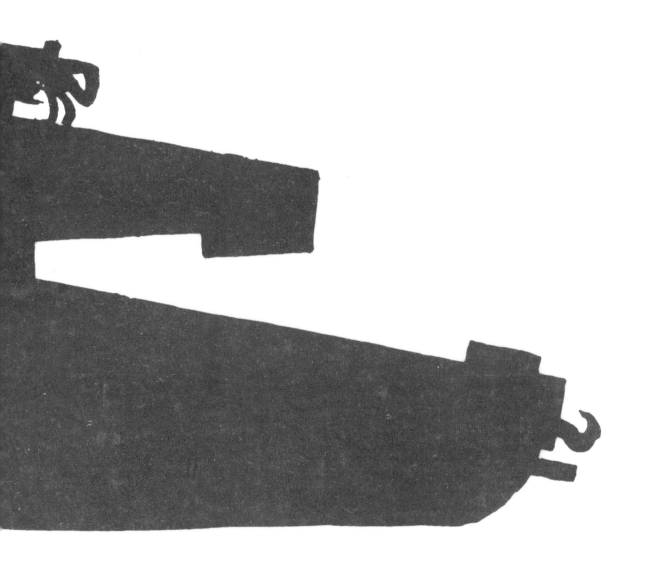

# LOURDS

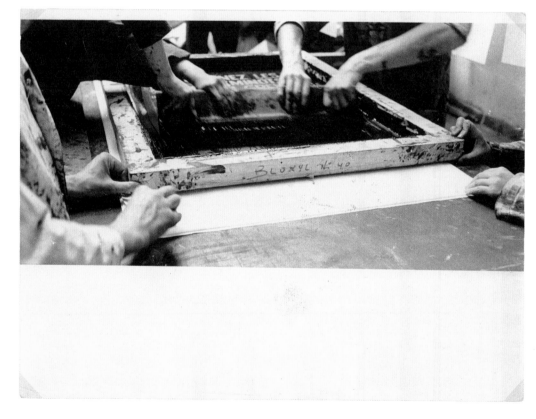

Poster design and printing at the Atelier Populaire, May 1968. Photos: Left: Philippe Vermès

MEMBRE DU CONSEIL
D'UNITE

C.I.U.

ATTENTION !
de ne pas tomber dans la
BUREAUCRATIE

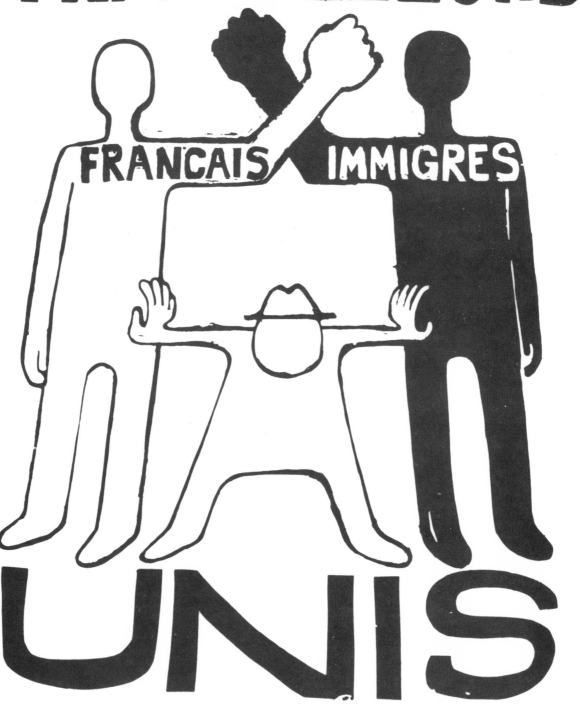

# TRAVAILLEURS

FRANCAIS IMMIGRES

# UNIS

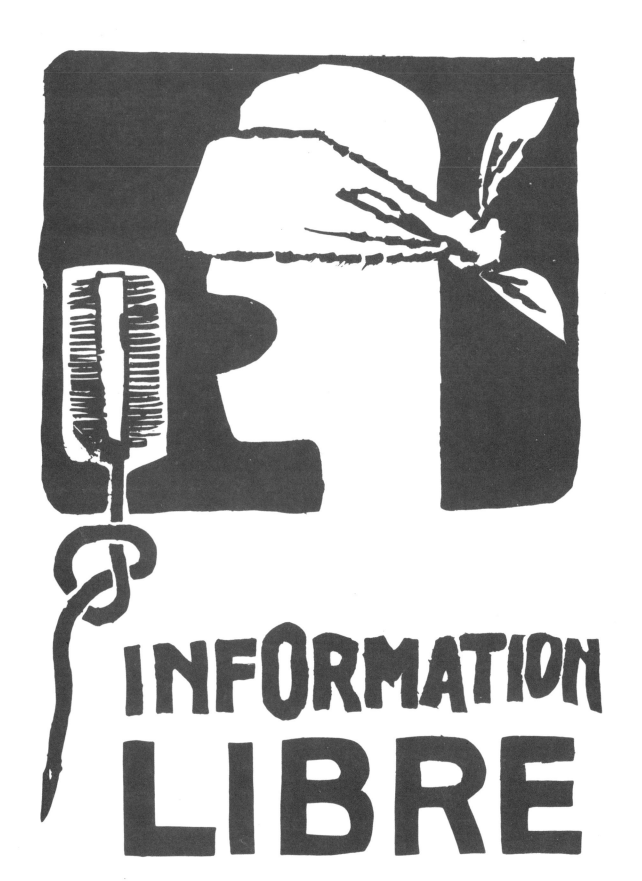

INFORMATION LIBRE

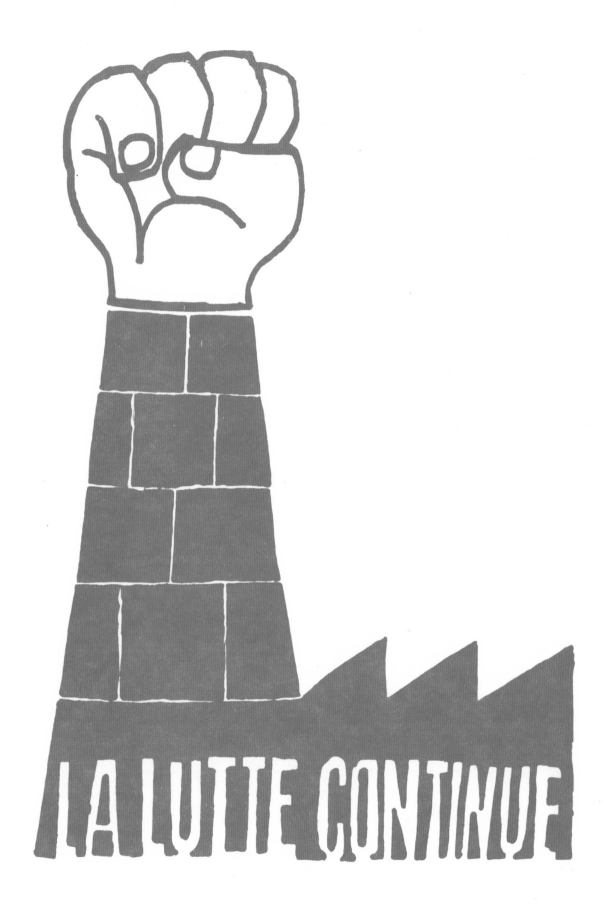

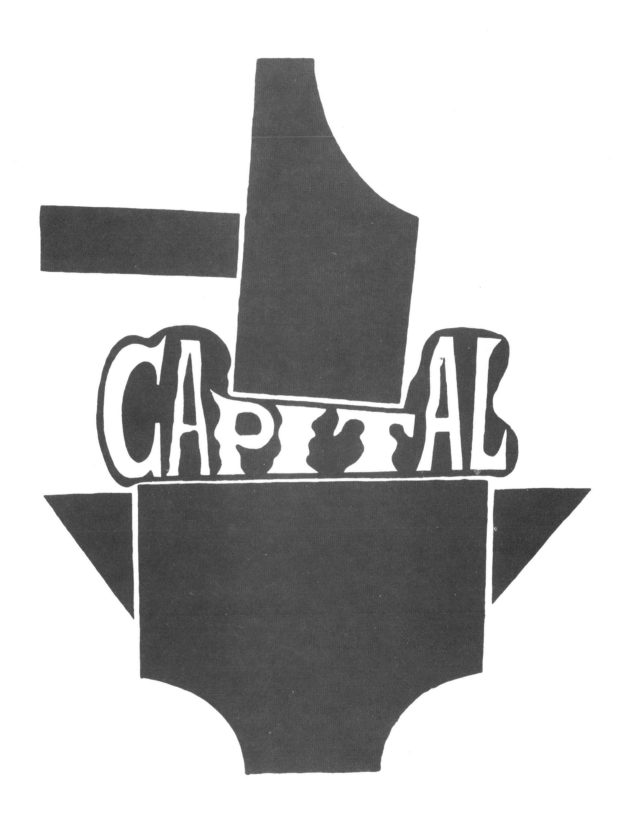

31

Usines Universites Union

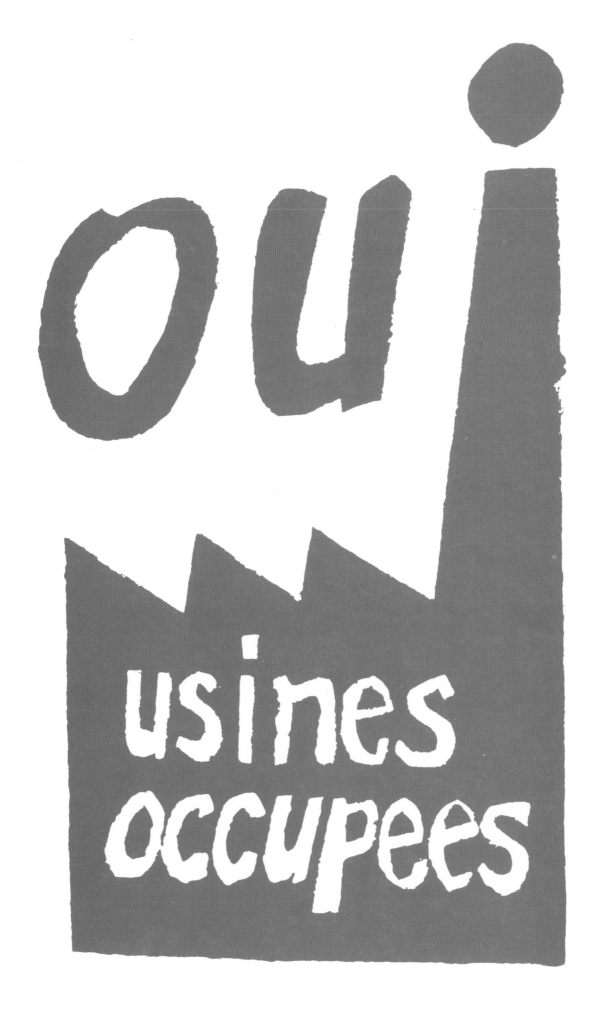

## GENERAL ASSEMBLY OF THE STRIKERS IN THE ÉCOLE DES BEAUX ARTS

*These texts have been taken from the 1969 Atelier Populaire book* Posters From the Revolution, Paris, May 1968.

*As early as May 14 several students met together spontaneously in the lithographic workshop and, deciding on direct action, produced the first poster:*

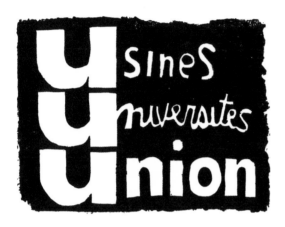

*On May 16, during the meeting of a Reform Committee set up that morning, a certain number of those taking part, both pupils and painters from outside, decided to occupy the studios in order to put into action directly and practically the programme of struggle drawn up on May 15. At the entrance to the studios they wrote: ATELIER POPULAIRE OUI ATELIER BOURGEOIS NON.*

We set to work in accordance with this principle. We are beginning to produce posters and at the same time we define our position in opposition to the Reform Committee in the following statement (distributed as a leaflet several days later, May 21):

ATELIER POPULAIRE OUI ATELIER BOURGEOIS NON
If we try to be precise about the words we have written at the entrance to the studios and to comprehend what they mean, they will dictate to us the main lines of our future action. The words indicate that it is not in any way a question of reforming, that is to say of bettering what already exists. "Improvement" implies that basic principles are not to change, hence that they are already the right ones. We are against the established order of today. What is this established order? Bourgeois art and bourgeois culture. What is bourgeois culture? The means by which the forces of oppression of the ruling class isolate and set apart the artists from the rest of the

workers by giving them a privileged status. Privilege locks the artist in an invisible prison. The fundamental concepts which underlie this act of isolation which culture brings about are:
— the idea that art has "gained its autonomy" (Malraux—see the speech made at the time of the Grenoble Olympic Games).
— the defence of "creative freedom": culture makes the artist live in the illusion of freedom.

1. He does what he wants to do, he believes that everything is possible, he is accountable only to himself or to Art.
2. He is a "creator" which means that out of all things he invents something that is unique, whose value will be permanent and beyond historical reality. He is not a worker at grips with historical reality. The idea of creation gives his work an unreal quality.

In giving him this privileged status, culture puts the artist in a position where he can do no harm and in which he functions as a safety-valve in the mechanism of bourgeois society. This is the situation of every one of us. We are all bourgeois artists. How could it be otherwise? This is why when we write Atelier Populaire it cannot be a question of improvement, but of a *radical change of direction*. It means that we are determined to transform what we are in society. Let us make it clear that it is not the establishment of better contacts between artists and modern techniques that will bind them closer to all the other categories of workers, but opening their eyes to the problems of other workers, that is to say of the historical reality of the world in which we live. No teacher could help us to become more familiar with that reality. We must all teach ourselves. This does not mean that there does not exist objective, therefore admissible, knowledge, nor that older artists and teachers cannot be very useful. But this is on condition that they themselves have decided to transform what they are in society and to take part in this work of self-education. The bourgeoisie's educative power thus challenged, the way will be open to the educative power of the people. There will then be ten million strikers in France. Those who worked in the Atelier Populaire go out to the occupied factories, to the workshops and the building sites, to learn from the workers on strike how to constitute the rearguard of the struggle of which they are the vanguard. It is not a job for specialists. Those who come to take part enthusiastically in the production of posters are

now numerous. They are workers and students, both French and foreign. Workers come with suggestions for slogans and to debate with the artists and students, to criticize the posters already made, or to distribute them outside. At the entrance to the studios is the notice: *To work in the Atelier Populaire is to give concrete support to the great movement of the workers on strike who are occupying their factories in defiance of the Gaullist government which works against the people. By placing all his skills at the service of the workers' struggle, each member of this workshop is also working for himself, in that he is coming into contact through his practical work with the educative power of the people.* The radical students and artists re-examine their points of view by allying with the workers. They strive by action, criticism and self-criticism to eliminate the practices of individualistic bourgeois creation which come persistently to the fore, whether consciously or not. How is the work carried out? Projects for posters worked out in common after a political analysis of the day's events or after discussions at the factory gates are democratically proposed in General Assembly at the end of the day. The criteria for judgment are:

— Is the political idea sound?

— Does the poster put over this idea well?

Today, the struggle continues for us: the movement of May is not dead. The mass strike movement of over ten million workers is not crushed. Far from being finished, it is only just beginning. Everything points to this: methods of carrying on the struggle have been revived (unlimited strikes, occupation of factories, building sites, depots and offices); the strikers are aware of their strength—there is solidarity between the strikers and other working sections of the community, especially a section of the rural working class. And finally thousands of young workers' cadres are being organized today. These gains are irreversible. After the Gaullist success, blackmail and demagogy paid off. The party of fear pulled in all of its votes. But thousands of voters have abstained. They would not vote for left-wing politicians who, after having made them capitulate, dragged them on to a battleground which was not their own—that of the legislative elections. We have entered a phase of prolonged struggle. After the elections the fight will continue in workplaces—the new battlegrounds. Today, as when the move-ment of May was at its height, the challenge which remains to be answered is that of the PEOPLE'S POWER. The Atelier Populaire must not fall into the parliamentary trap. We have chosen the workers' battlegrounds as our own. Our task is therefore:

— To show up capitalist oppression in all the forms it has assumed today under Gaullism (repression by employers and police).

— To support the workers in their determination to prolong the struggle.

Through our work we will help to bring them victory, in factories, on building sites, in depots, in offices. It will be the victory of the cause of class war over that of class collaboration, the path chosen by the PCF (French Communist Party) and the federal leadership of the CGT (General Confederation of Workers) who regard parliamentary struggle as being central to the conquest of power. In our choice of posters we will support struggles of a revolutionary nature. These are the struggles which will give power to the people and lead to socialism by the overthrow of the parliamentary regime which is the instrument forged by the bourgeoisie to protect its own interests. We will support the unity of all the forces of the working people grouped around the militant workers fighting against the bourgeoisie. Culture is a direct manifestation of the class struggle. This is why the Atelier Populaire intends to continue its work through artistic activity. (Today posters and the puppet theatre, tomorrow painting, sculpture, films, songs, etc…)

We aim to denounce the bourgeois culture which was created by and which serves that class. The system of values which it defends and propagates appears to be established in absolute terms. But in reality, just because it assumes this mask of universality, this system of values is the best means of defending and reinforcing the capitalist structures of society. Bourgeois culture is an integral part of the system of oppression which the ruling class has erected against the interests of the people. All attempts to carry on the struggle on the level of culture alone are, in their different ways, equally deceptive. The belief that it is possible to deny a society that one does not accept by placing oneself beyond its reach, is a retreat into an attitude of passivity, thence tacit acceptance. To challenge the cultural system from the inside rapidly leads from challenging art to the art of challenge, another form of bourgeois art as cut off as the others from the people and of no use to the people's struggle. These different attitudes in the long run provide an alibi for the system of bourgeois culture and keep people's minds away from the real fight. A cultural challenge if it is to become really effective must become political and place itself at the service of the workers. We have already stated that the people will not gain power through the parliamentary system. In the same way we insist that we will not help a people's culture to develop by allowing the diffusion of bourgeois culture. We therefore cannot but denounce the system of cultural "participation" proposed by Malraux and the Maisons de la Culture, as a sort of "cultural fascism". We should work towards the development of a truly popular culture, that is to say of the people at the service of the people, we must drive for the creation of more ateliers populaires, in opposition to the oppression of bourgeois culture.

More and more posters are indeed being produced. Our principal task is not, however, to flood the country from one central point. We must encourage the creation of new ateliers populaires wherever the workers are fighting, so that the work of political analysis which provides the inspiration for the posters we produce and their distribution, will remain linked to the people's struggle.

## ORGANIZATION AND METHOD

What we have to say is of less importance than the use of your own initiative; invent many new forms of action. The Atelier Populaire consists of a workshop where the posters are conceived, and several workshops where they are produced (printing by the silk-screen process, lithography, stencilling, dark-room and so on). All the militants—workers, students, artists, etc.—from the Atelier Populaire meet daily in a General Assembly. The work of this assembly is not merely to choose between the designs and slogans suggested for posters, but also to discuss all current political problems. It is mainly during the course of these debates that the political policy of the Atelier Populaire is developed and defined. It is essential that as many workers as possible should take part. The procedure that is adopted when voting in the General Assembly is the one that you will discover for yourselves through daily experience of direct democracy. Each person submits to criticism from everyone; he takes it into account and modifies his work accordingly. Experience has taught us that there are certain dangers to be avoided:
— Time lost in futile debate owing to poor organization of the day's work
— Slogans which are vague and too numerous
— Voting on projects that have been too hastily conceived

The end result is a dissipation of effort and has a demobilizing effect. We found that the most effective solution was the creation of a provisional committee whose work was to propose a series of themes and precise slogans to the General Assembly, and to get several work groups moving. This avoids wasting effort on too many and useless projects. It is obvious that this does not prevent new comrades from working with slogans that have not been previously selected. All authority is provisional and changes as necessary or as willed by the participants. The choice of subject matter for the posters and slogans and discussion around these help the Atelier Populaire to evolve its political standpoint. This work is the mainspring of our activity. How do the slogans arise? Where do they come from? Their inspiration is the struggle of the workers, whether they are on strike or not. We must never lose consciousness of their real needs and of the reality of their struggle. In this way slogans will emerge which strike home with

solid impact; in this way we shall be able to produce posters which will support the people's struggle in an effective way. When posters are requested from outside, we consider the suggestions in so far as their particular area of the struggle is relevant to the interests of the struggle as a whole. Experience has taught us the danger of ambiguity, and the necessity of incorporating slogans as an integral part of design. Sincerity, fantasy and imagination are only effective when they interpret and reinforce the attack made by the slogan.

## THE SILKSCREEN PROCESS FOR PRINTING POSTERS

It will be appreciated that this is only a brief summary of the silk-screen process, a process enabling many thousands of posters to be speedily printed and with relatively simple materials.

1. A wooden frame and silk for the silkscreen (special nylon). For the sake of economy, we stretch the special nylon covering ourselves.
2. The text is drawn to the required scale on paper. This drawing is then traced onto the surface of the screen with a soft pencil.
3. The characters are filled in with liquid drawing gum, which when dry forms a plastic skin. Dry well.
4. A fine coating of filling varnish is spread over the entire surface of the screen by means of a scraper. Dry well.
5. The parts covered with drawing gum are scraped with an eraser or simply a cork. The plastic coating forms into a ball and peels off.

There now remain two types of surface on the screen:
— the base where the screen is coated with varnish
— the text where the surface of the screen was freed on removal of the plastic coating. All that now remains is to stick a band of adhesive paper 1/3" in width around the mounted frame in order to prevent ink from running into the cracks.

6. Printing can begin. The printer's ink must be of a fluid consistency for rapid drying. This should be done by diluting with white spirit and special oil, never with acetone which dissolves the varnish on the screen. When printing is completely finished the screen should be carefully rubbed down with acetone. It can then be used for another design. If printing is stopped for even half an hour the frame should be cleaned with white spirit so that the ink does not clog the screen.

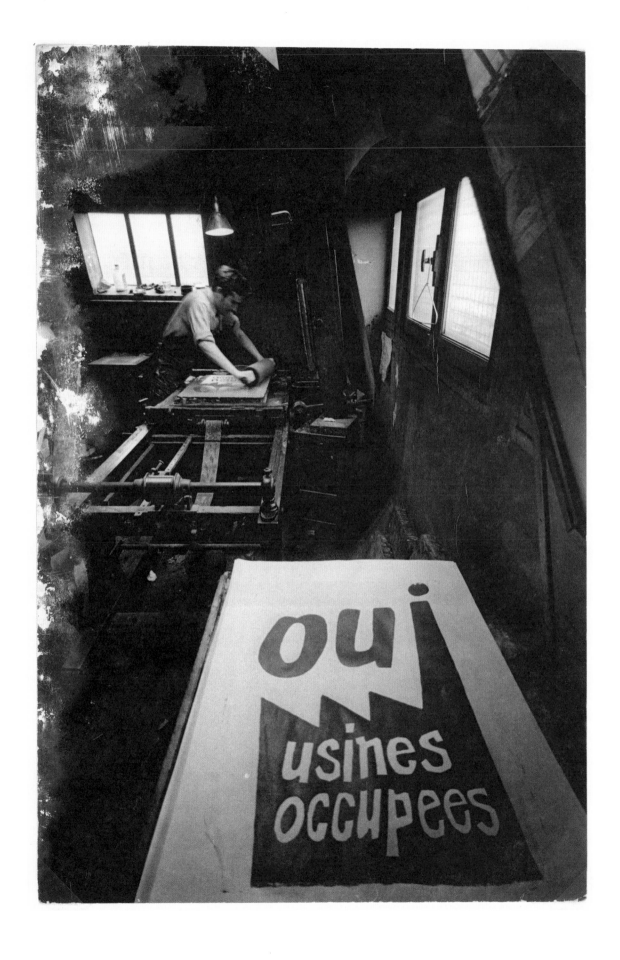

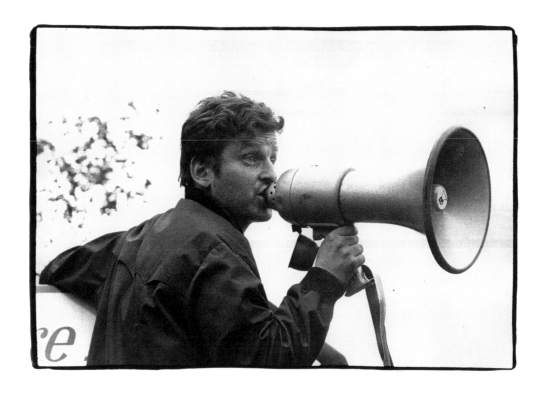

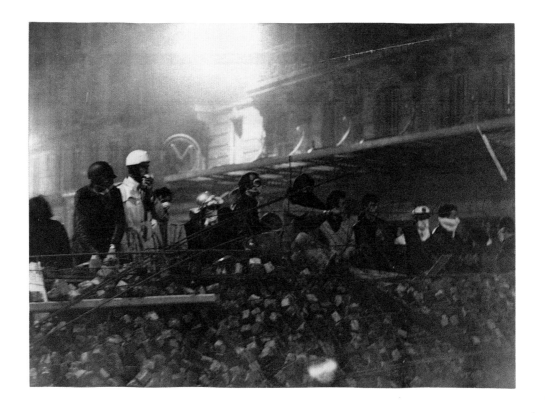

Odéon CASERNE

Sorbonne CASERNE

Beaux-Arts CASERNE

Fac. Sciences CASERNE

Médecine CASERNE

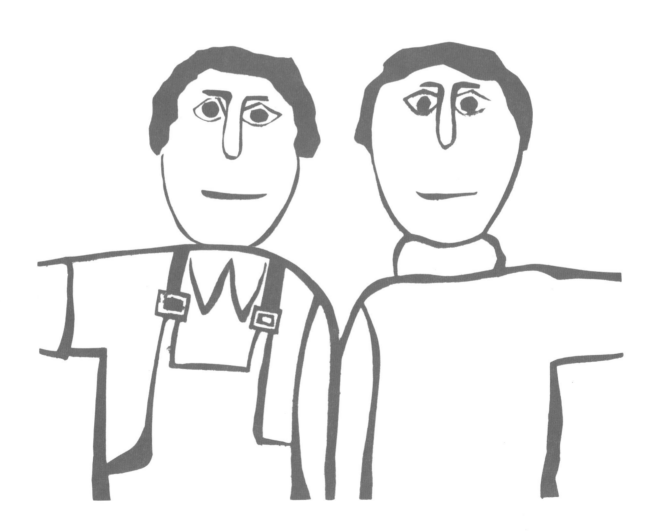

41

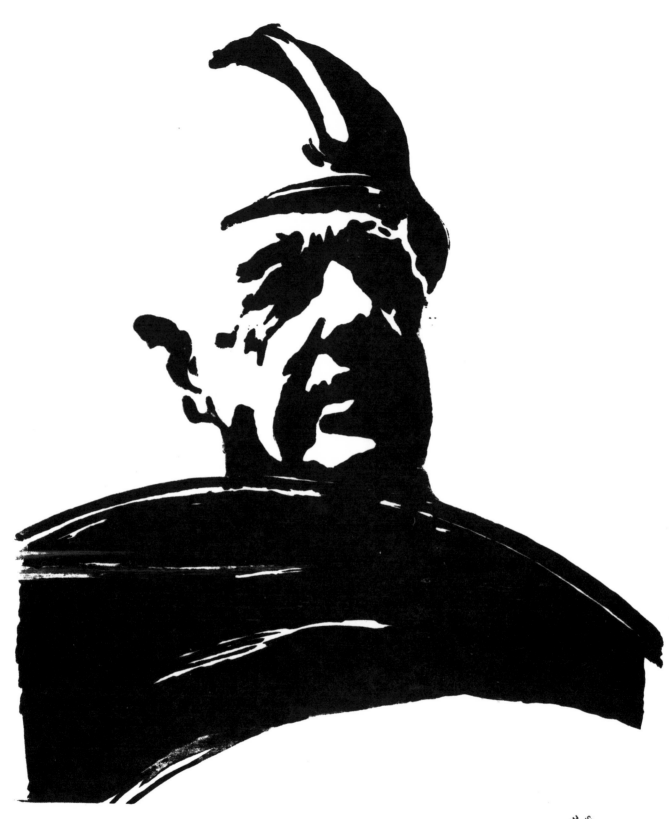

42

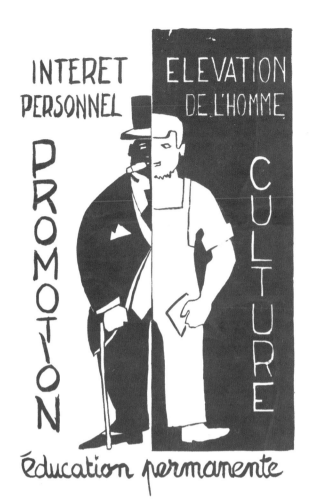

INTERET PERSONNEL — ELEVATION DE L'HOMME

PROMOTION — CULTURE

Éducation permanente

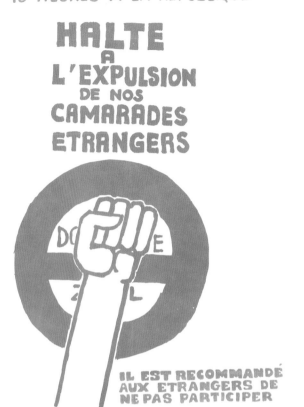

TOUS MERCREDI 12 JUIN 18 HEURES A LA REPUBLIQUE

HALTE A L'EXPULSION DE NOS CAMARADES ETRANGERS

IL EST RECOMMANDÉ AUX ETRANGERS DE NE PAS PARTICIPER

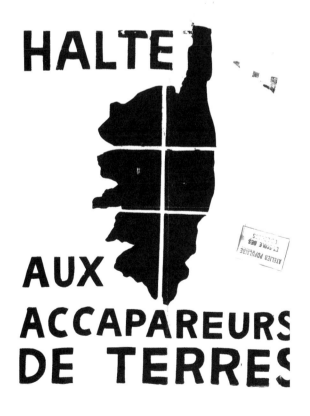

HALTE AUX ACCAPAREURS DE TERRES

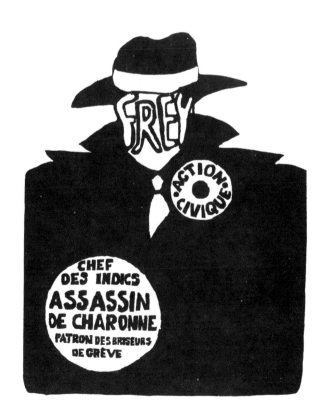

FREY ACTION CIVIQUE

CHEF DES INDICS ASSASSIN DE CHARONNE PATRON DES BRISEURS DE GREVE

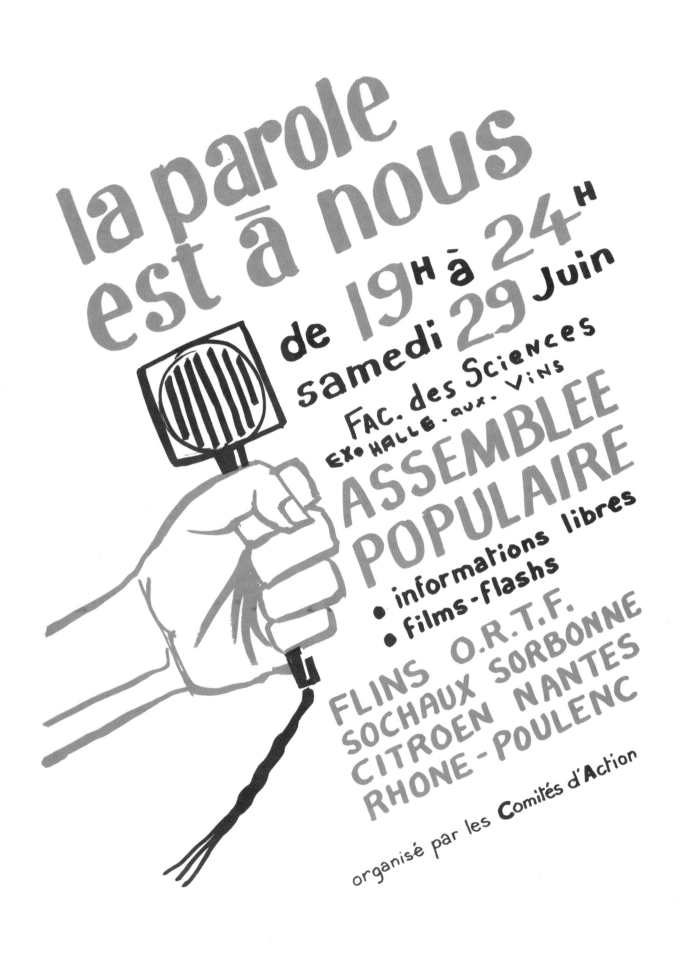

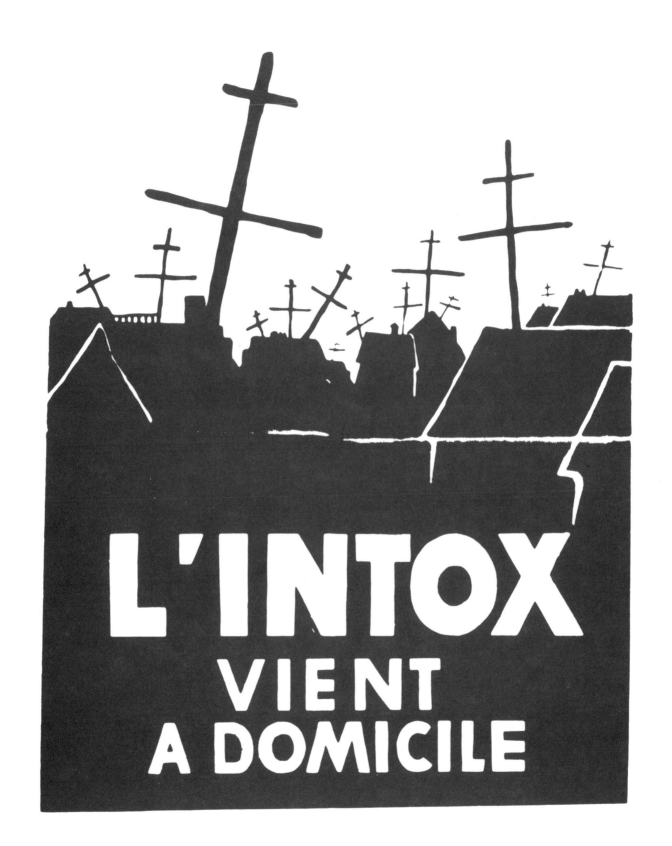

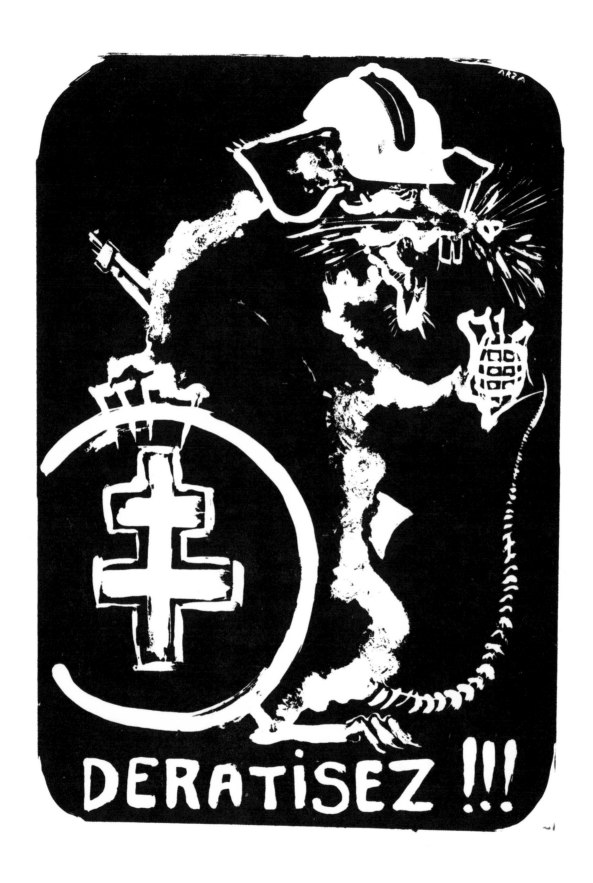

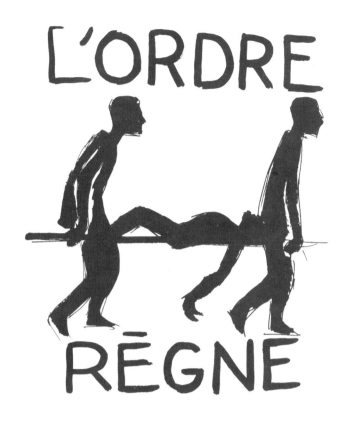

L'ORDRE RÈGNE

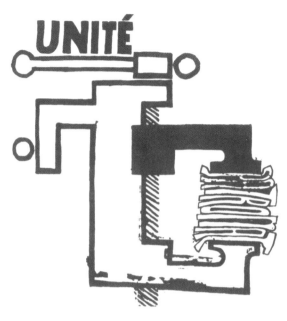

UNITÉ

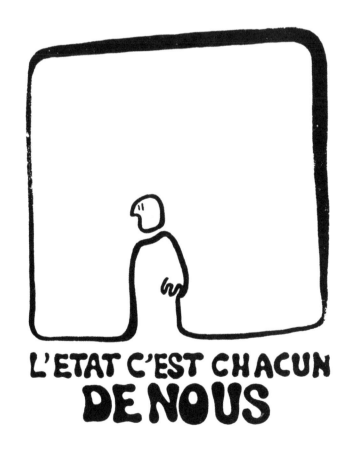

L'ETAT C'EST CHACUN DE NOUS

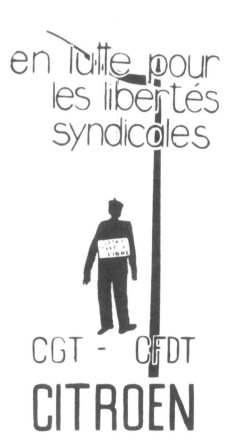

en lutte pour les libertés syndicales

CGT - CFDT

CITROEN

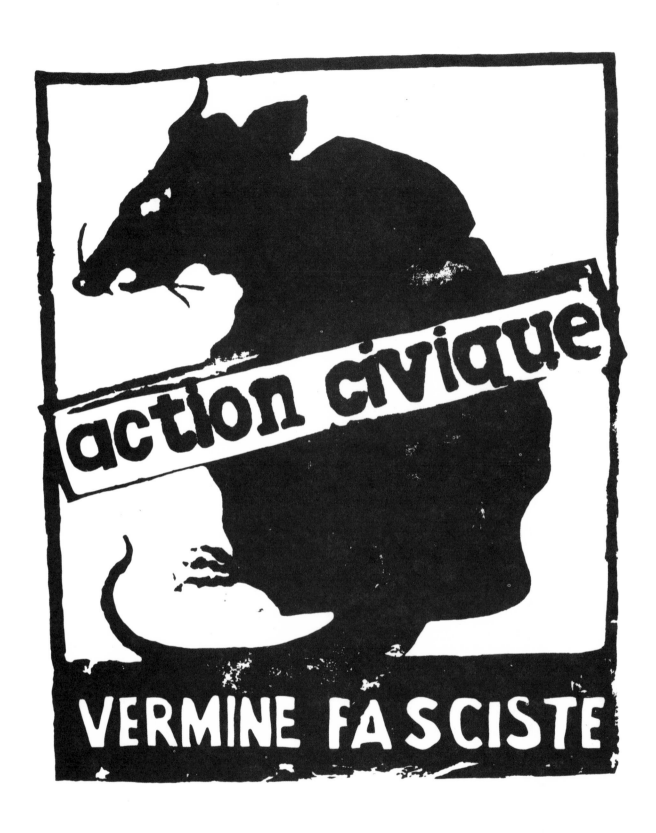

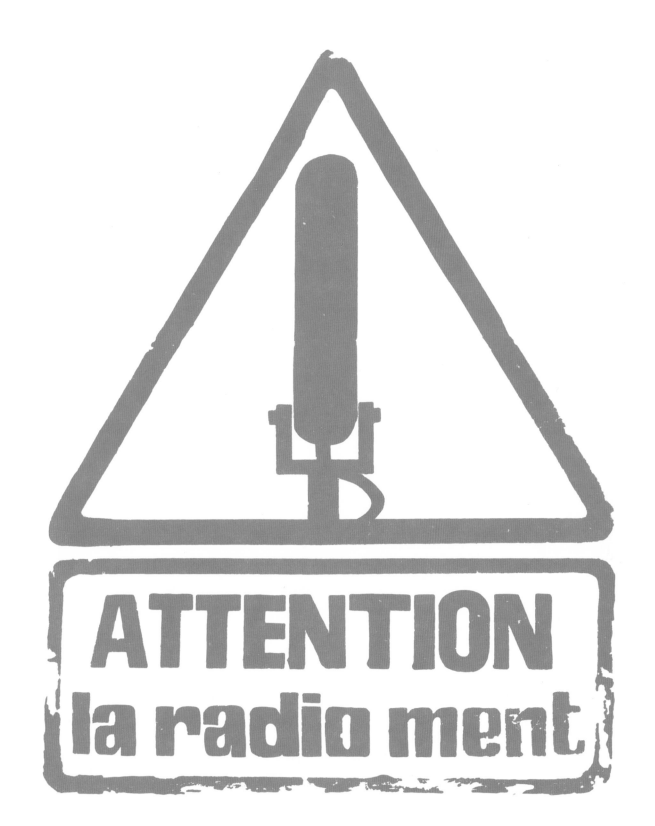

# SERA·T·

CH

18 Juin : Boulogne.Billancourt
à la reprise du travail
les ouvriers scandaient :
## ce n'est q'un debut
## continuonsle combat

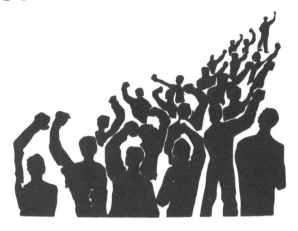

# ET APRES ?

EN SYNDICALISME
LA PROMOTION OUVRIERE EST
COLLECTIVE

TE RECONNAIS TU ?

PIQUE
ASSIETTE
NE SOIS PAS
CELUI LA

CELUI QUI TIRE BENEFICE
D'UNE VICTOIRE EN AYANT
REFUSE LE COMBAT
N'EST PLUS DIGNE
D'ETRE APPELE UN
## HOMME

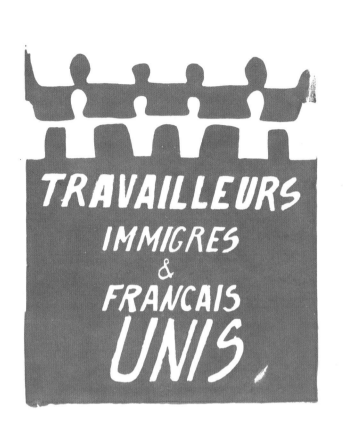

TRAVAILLEURS IMMIGRES & FRANCAIS UNIS

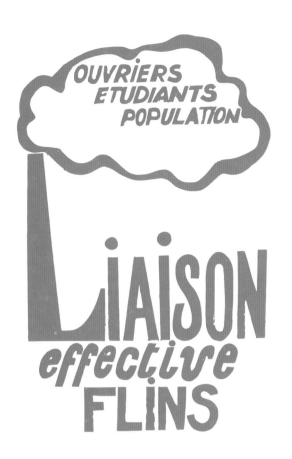

OUVRIERS ETUDIANTS POPULATION

LIAISON effective FLINS

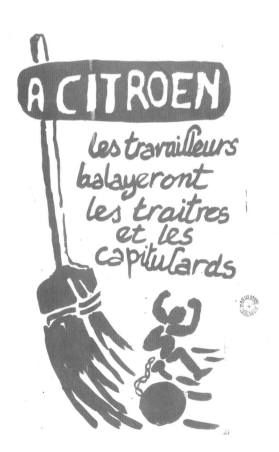

À CITROEN les travailleurs balayeront les traitres et les capitulards

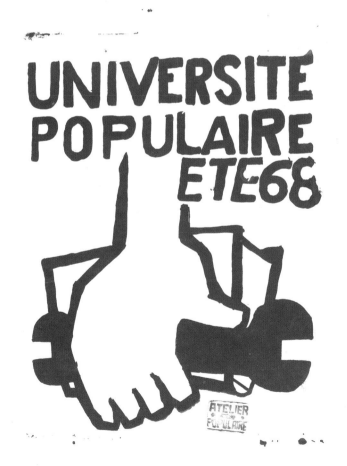

UNIVERSITE POPULAIRE ETE68

ATELIER POPULAIRE

53

# TROP TARD CRS

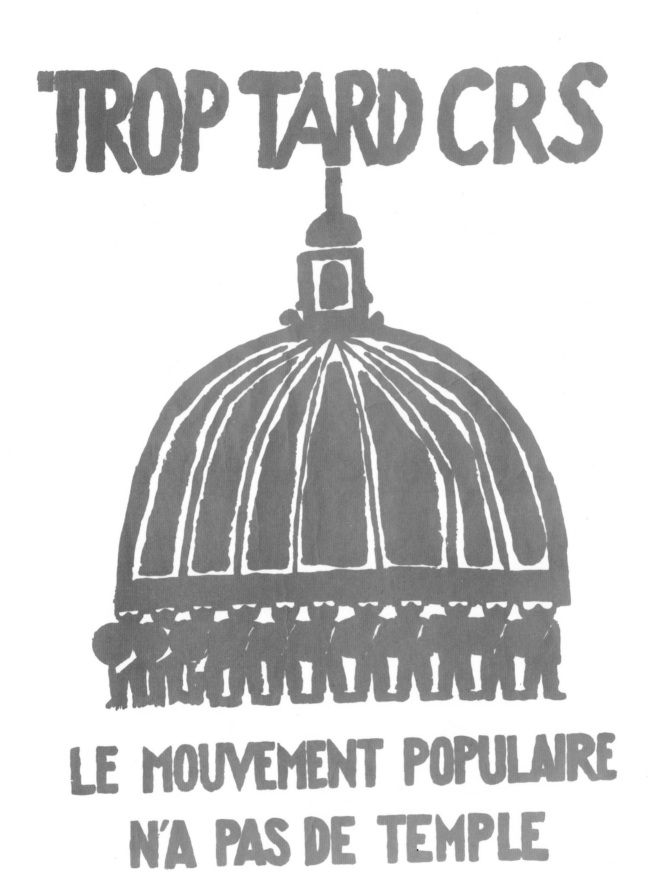

# LE MOUVEMENT POPULAIRE N'A PAS DE TEMPLE

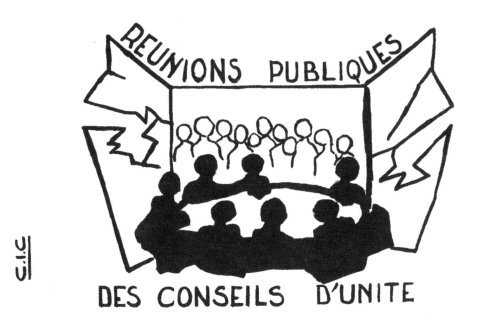

RÉUNIONS PUBLIQUES DES CONSEILS D'UNITÉ

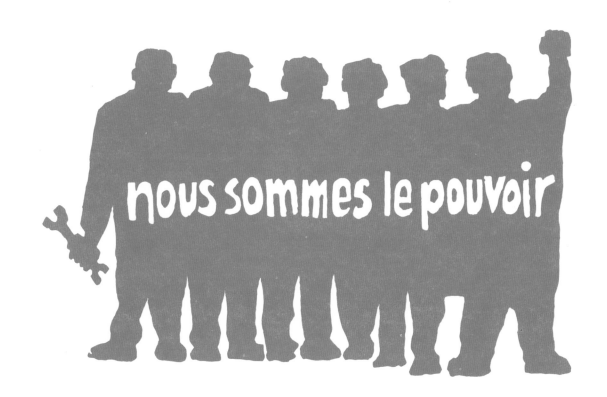

nous sommes le pouvoir

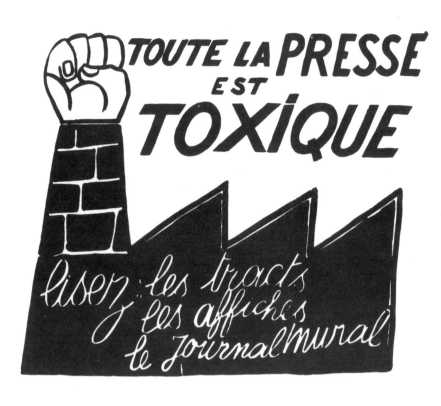

TOUTE LA PRESSE EST TOXIQUE

lisez les tracts les affiches le journal mural

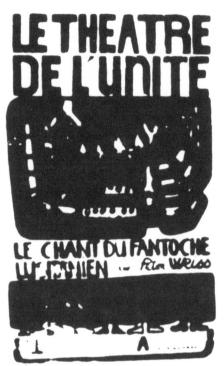

LE THEATRE DE L'UNITE

LE CHANT DU FANTOCHE

## RENAULT FLINS
### NOUVELLE ETAPE

VENDREDI, FLINS 5000 CRS BLOQUENT L'USINE
5 heures FACE AUX FLICS 9000 OUVRIERS S'UNISSENT
POUR CONTINUER LA GREVE
10 heures LES FLICS ATTAQUENT A LA GRENADE
OFFENSIVE LE RASSEMBLEMENT OUVRIER
LES C.R.S. SONT LES SEULS PROVOCATEURS
LE POUVOIR ET LA RADIO PRETENDENT QUE C
SONT LES ETUDIANTS QUI SE BATTENT
DE 10 heures AU LENDEMAIN LES OUVRIERS
ORGANISENT ET DIRIGENT LA RIPOSTE
POUR TOUT LE MOUVEMENT GREVISTE
DES SECTEURS REPRENNENT LA GREVE
PAR SOLIDARITE LES TRIS POSTAUX FURENT LES
PREMIERS

SOLIDAIRES AVEC FLINS ...
MOBILISONS NOUS SAMEDI DIMANCHE
LUNDI POUR CONTRIBUER AU RENFORCEMENT
DU MOUVEMENT DE GREVE

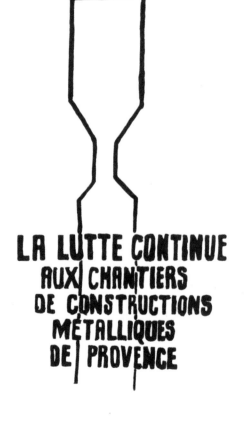

LA LUTTE CONTINUE AUX CHANTIERS DE CONSTRUCTIONS METALLIQUES DE PROVENCE

# PARTICIPATION GAULLISTE

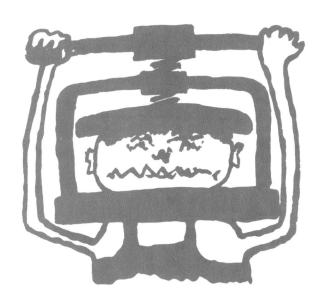

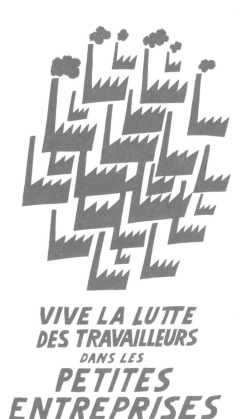

VIVE LA LUTTE
DES TRAVAILLEURS
DANS LES
PETITES
ENTREPRISES

# LES CONQUETES NOYEES

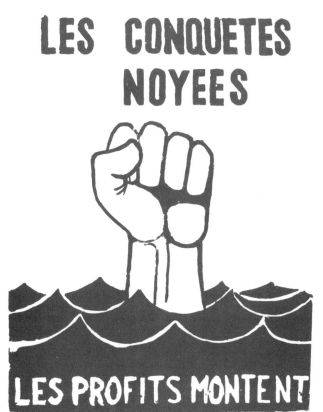

LES PROFITS MONTENT

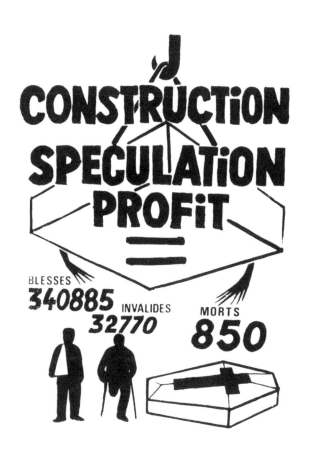

CONSTRUCTION
SPECULATION
PROFIT
=

BLESSES
340885  INVALIDES  MORTS
32770   850

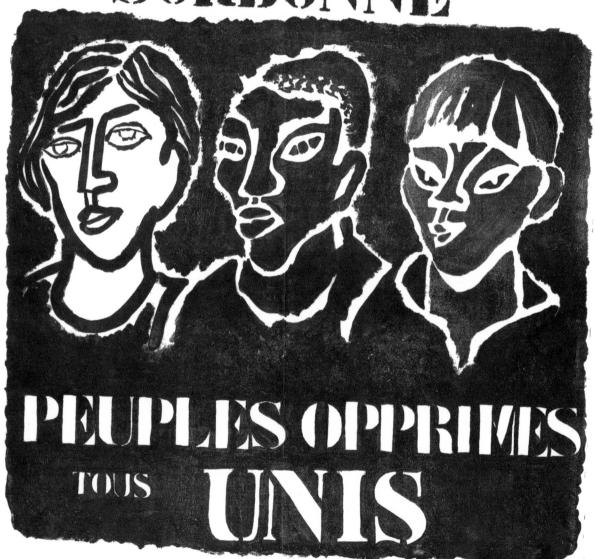

TRICONTINENTALE
SORBONNE
PEUPLES OPPRIMES TOUS UNIS

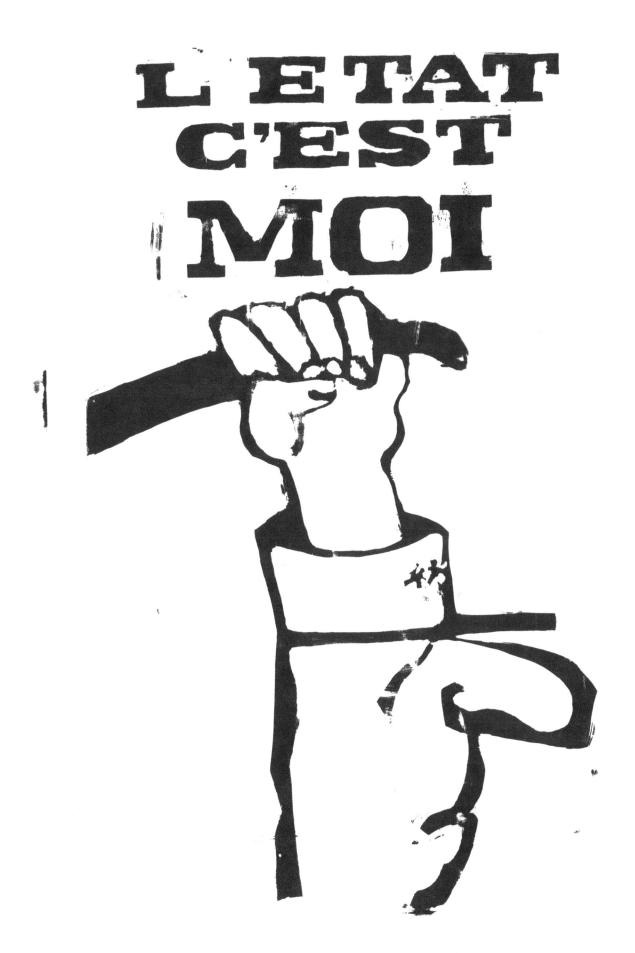

SOUTIEN
POPULAIRE
DE LA
GREVE
DE
L'EDF

le vote en chambre noire
a éclairé le patronat

CONTRE OFFENSIVE
LA GREVE CONTINUE

Kodak

FLINS
PAS
FLICS

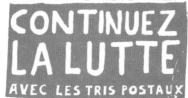

TRAVAILLEURS
DES P.T.T
L'ETAT PATRON
VOUS A TROMPE

VOS BUREAUCRATIES
SYNDICALES VOUS ONT DECU

CONTINUEZ
LA LUTTE

AVEC LES TRIS POSTAUX

LE VOTE À BULLETIN
SECRET EST UNE
MÉTHODE DU PATRON
POUR BRISER L'UNITÉ
OUVRIÈRE.

UN OUVRIER QUI N'OSE
PAS DIRE SON OPINION
DEVANT SES CAMARADES
NE MÉRITE PAS LE NOM
D'HOMME.

NOUS NE SERONS PAS DUPES
JUIN 36  LES CONQUETES OUVRIERES SONT
REPRISES EN MOINS DE 2 ANS
PAR LA BOURGEOISIE.
GREVE DES MINEURS DE 63
LE PATRONAT REGAGNE EN 2 MOIS
CE QU'IL A LACHE

COMMENT ?
PAR · LA HAUSSE DES PRIX
· L'INFLATION
· LE CHOMAGE ORGANISE
· LE VIOL DES LIBERTES
SYNDICALES SITOT RECONNUES

SOUS PEINE DE SUICIDE
LE SYSTEME
CAPITALISTE EST CONTRAINT DE
REPRENDRE TOUT CE QU'IL A LACHE
SEULS LES TRAVAILLEURS AU
POUVOIR POURRONT GARANTIR LA
SATISFACTION DE NOS REVENDICATIONS

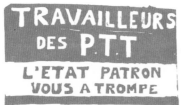

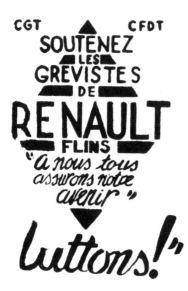

CGT        CFDT
SOUTENEZ
LES
GREVISTES
DE
RENAULT
FLINS
"A nous tous
assurons notre
avenir"

luttons!"

CAMARADES OUVRIERS !
CONTRE LES PROVOCATIONS
PATRONALES ET POLICIERES
CONTRE LE DEFAITISME ET
LA CAPITULATION
POUR LA SATISFACTION DE
TOUTES LES REVENDICATIONS
REJOIGNONS NOTRE POSTE
DE COMBAT CONTRE LE CAPITAL
L'USINE OCCUPEE !
ORGANISONS L'AUTODEFENSE !
NOUS VAINCRONS !

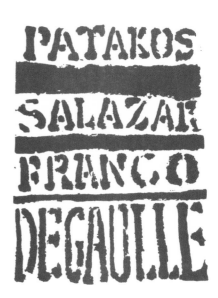

PATAKOS
SALAZAR
FRANCO
DEGAULLE

C'EST EN ARRETANT
NOS MACHINES
DANS L'UNITÉ QUE
NOUS LEUR DEMONTRONS
LEUR FAIBLESSE

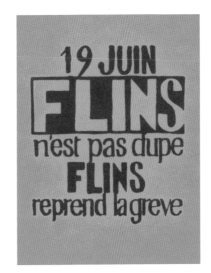

19 JUIN
FLINS
n'est pas dupe
FLINS
reprend la greve

Journée Populaire
Dimanche 9 Juin
de 9h à minuit
quartier Mouffetard
Contrescarpe
•
Spectacle dans la rue
Atelier d'affiches populaire
Débats:
l'information à l'O.R.T.F.
les luttes ouvrières
Pot populaire

Comité d'action du 5e

TRAVAILLEURS
FRANCAIS IMMIGRES
TOUS UNIS

A TRAVAIL EGAL SALAIRE EGAL.
A LAVORO UGUALE SALARIO UGUALE
A TRABAJO IGUAL SALARIO IGUAL
ΙΔΙΑ ΔΟΥΛΕΙΑ ΙΔΙΑ ΠΛΗΡΩΜΗ
A TRABALHO IGUAL SALARIO IGUAL
KAKAV UČINAK TAKVA ZARADA
لأعمال مساوية أرباح مساوية

RENAULT
FLINS
PILIER
DE GREVE
TIENT

CRS
SS

LE POUVOIR
EST TRANQUILLE

SA MACHINE
ELECTORALE
IL L A CONSTRUITE
LUI-MEME

BATTONS NOUS

SUR NOTRE
TERRAIN
L'OCCUPATION
DES USINES

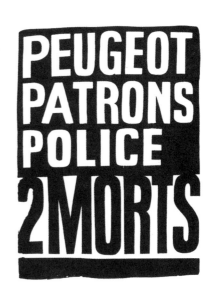

PEUGEOT
PATRONS
POLICE
2 MORTS

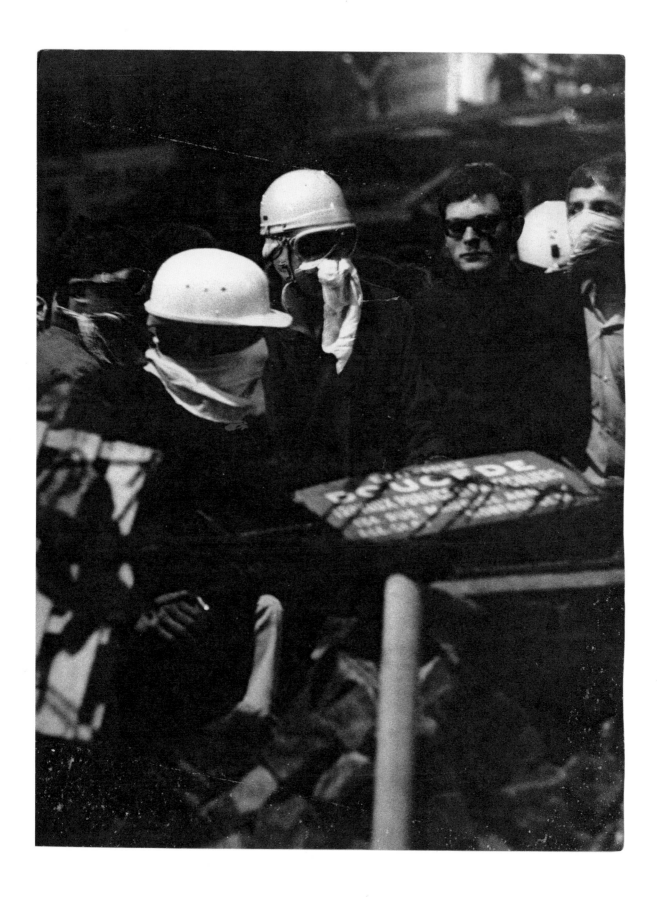

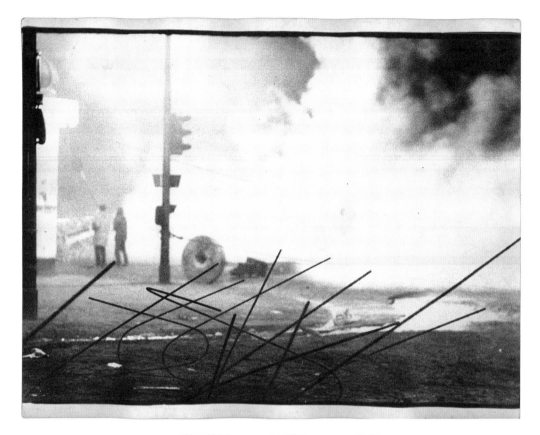

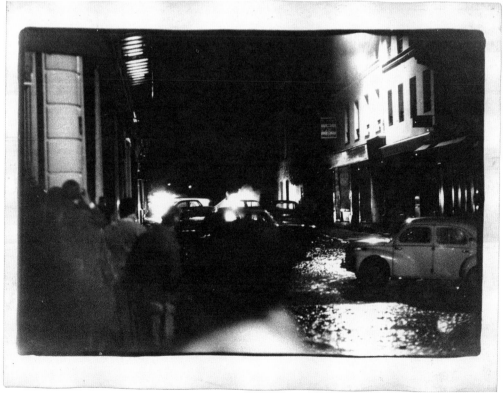

The barricades in St. Germain, May 1968. Photographer unknown.

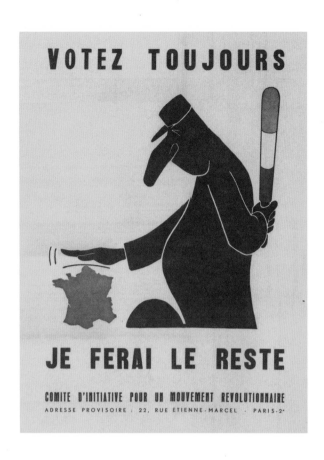

VOTEZ TOUJOURS

JE FERAI LE RESTE

COMITE D'INITIATIVE POUR UN MOUVEMENT REVOLUTIONNAIRE
ADRESSE PROVISOIRE : 22, RUE ETIENNE-MARCEL · PARIS-2ᵉ

marionnettes populaires

LA LUTTE
CONTINUE
SOUTENONS
LA GREVE
DES BATELIERS

LA VOIX
DE SON
MAITRE

non !

LA LUTTE
CONTINUE

OU FOUCHET PASSE
LA PEGRE POUSSE...

USINES
OCCUPEES

FREY

RETOUR
A LA NORMALE...

une jeunesse que l'avenir inquiète trop souvent

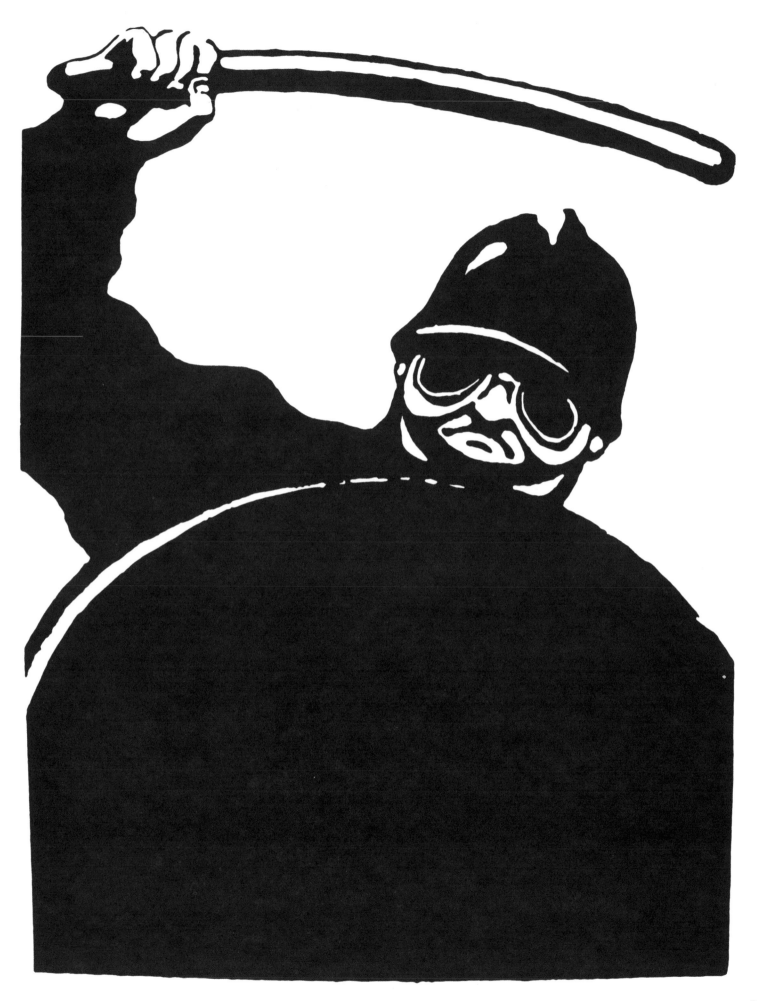

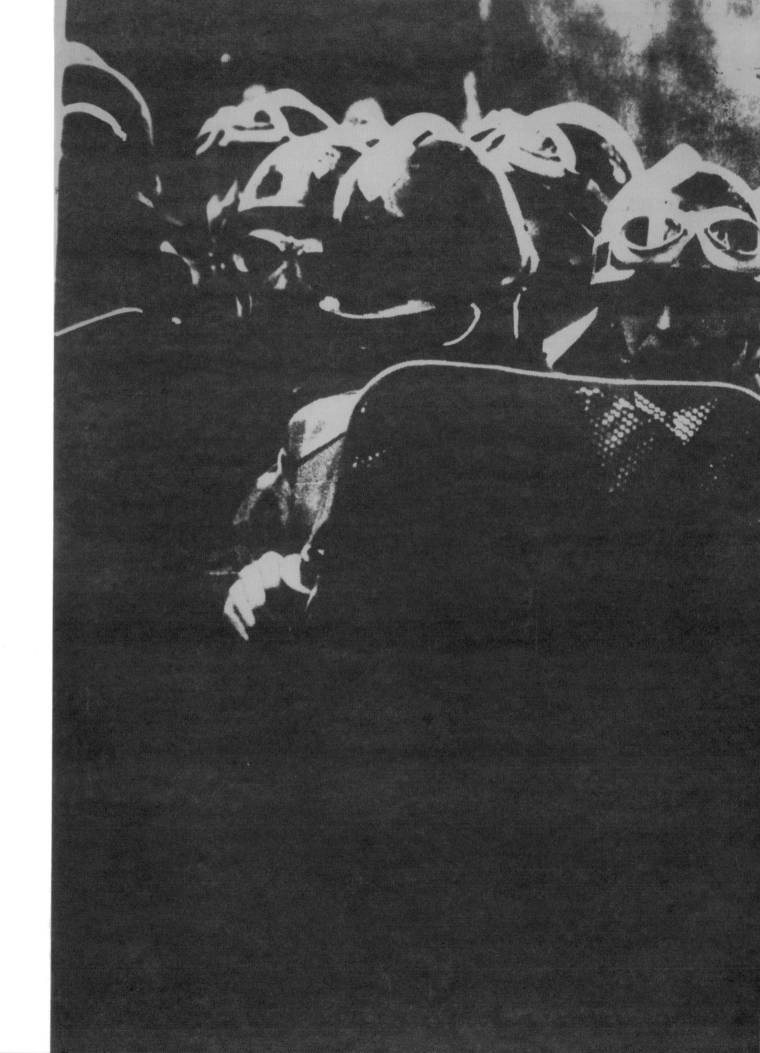

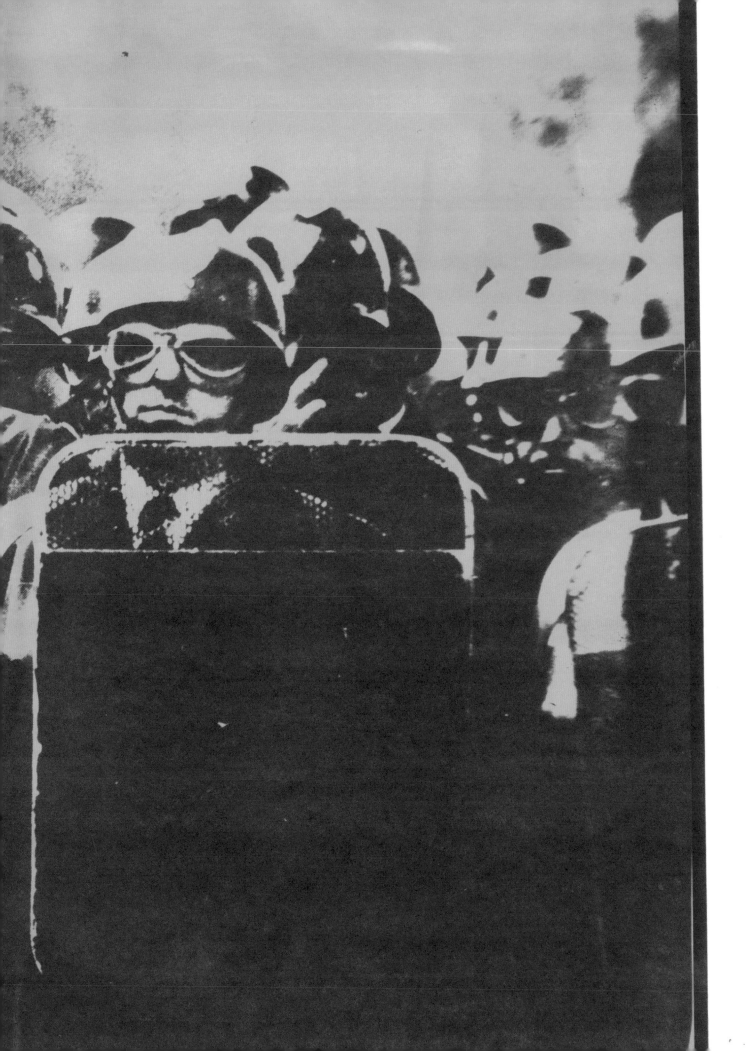

↑ The CRS. *Photographer unknown.*

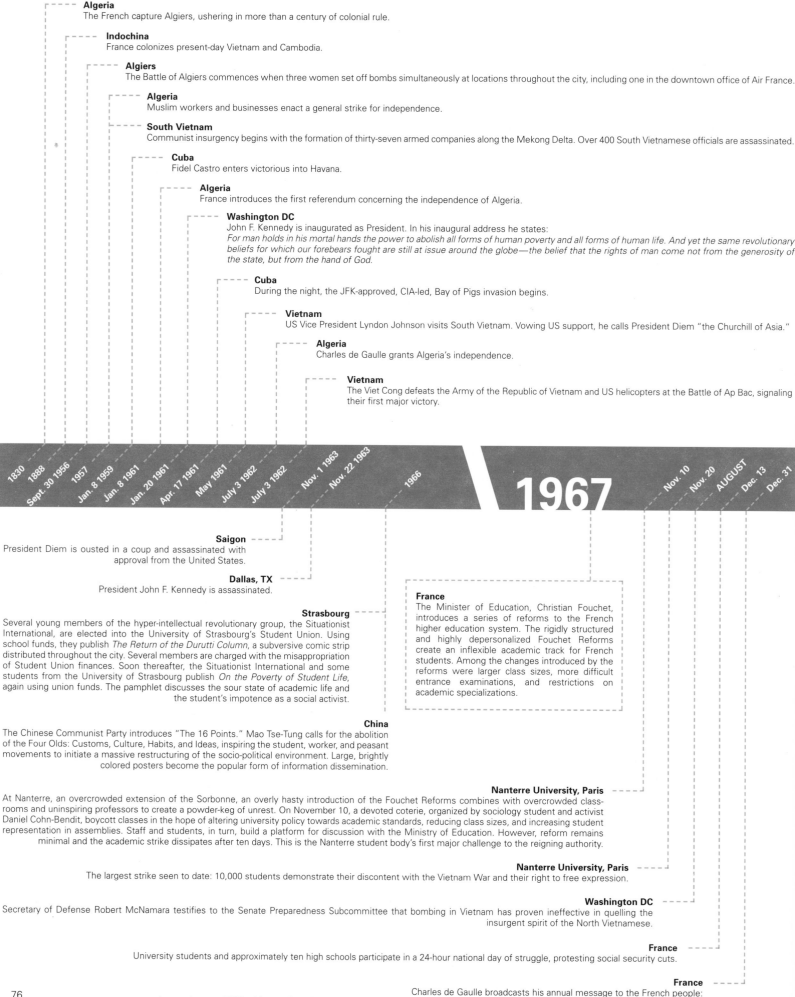

**Algeria**
The French capture Algiers, ushering in more than a century of colonial rule.

**Indochina**
France colonizes present-day Vietnam and Cambodia.

**Algiers**
The Battle of Algiers commences when three women set off bombs simultaneously at locations throughout the city, including one in the downtown office of Air France.

**Algeria**
Muslim workers and businesses enact a general strike for independence.

**South Vietnam**
Communist insurgency begins with the formation of thirty-seven armed companies along the Mekong Delta. Over 400 South Vietnamese officials are assassinated.

**Cuba**
Fidel Castro enters victorious into Havana.

**Algeria**
France introduces the first referendum concerning the independence of Algeria.

**Washington DC**
John F. Kennedy is inaugurated as President. In his inaugural address he states:
*For man holds in his mortal hands the power to abolish all forms of human poverty and all forms of human life. And yet the same revolutionary beliefs for which our forebears fought are still at issue around the globe—the belief that the rights of man come not from the generosity of the state, but from the hand of God.*

**Cuba**
During the night, the JFK-approved, CIA-led, Bay of Pigs invasion begins.

**Vietnam**
US Vice President Lyndon Johnson visits South Vietnam. Vowing US support, he calls President Diem "the Churchill of Asia."

**Algeria**
Charles de Gaulle grants Algeria's independence.

**Vietnam**
The Viet Cong defeats the Army of the Republic of Vietnam and US helicopters at the Battle of Ap Bac, signaling their first major victory.

1830  1888  Sept. 30 1956  1957  Jan. 8 1959  Jan. 8 1961  Jan. 20 1961  Apr. 17 1961  May 1961  July 3 1962  July 3 1962  Nov. 1 1963  Nov. 22 1963  1966  **1967**  Nov. 10  Nov. 20  AUGUST  Dec. 13  Dec. 31

**Saigon**
President Diem is ousted in a coup and assassinated with approval from the United States.

**Dallas, TX**
President John F. Kennedy is assassinated.

**Strasbourg**
Several young members of the hyper-intellectual revolutionary group, the Situationist International, are elected into the University of Strasbourg's Student Union. Using school funds, they publish *The Return of the Durutti Column*, a subversive comic strip distributed throughout the city. Several members are charged with the misappropriation of Student Union finances. Soon thereafter, the Situationist International and some students from the University of Strasbourg publish *On the Poverty of Student Life*, again using union funds. The pamphlet discusses the sour state of academic life and the student's impotence as a social activist.

**France**
The Minister of Education, Christian Fouchet, introduces a series of reforms to the French higher education system. The rigidly structured and highly depersonalized Fouchet Reforms create an inflexible academic track for French students. Among the changes introduced by the reforms were larger class sizes, more difficult entrance examinations, and restrictions on academic specializations.

**China**
The Chinese Communist Party introduces "The 16 Points." Mao Tse-Tung calls for the abolition of the Four Olds: Customs, Culture, Habits, and Ideas, inspiring the student, worker, and peasant movements to initiate a massive restructuring of the socio-political environment. Large, brightly colored posters become the popular form of information dissemination.

At Nanterre, an overcrowded extension of the Sorbonne, an overly hasty introduction of the Fouchet Reforms combines with overcrowded classrooms and uninspiring professors to create a powder-keg of unrest. On November 10, a devoted coterie, organized by sociology student and activist Daniel Cohn-Bendit, boycott classes in the hope of altering university policy towards academic standards, reducing class sizes, and increasing student representation in assemblies. Staff and students, in turn, build a platform for discussion with the Ministry of Education. However, reform remains minimal and the academic strike dissipates after ten days. This is the Nanterre student body's first major challenge to the reigning authority.

**Nanterre University, Paris**

**Nanterre University, Paris**
The largest strike seen to date: 10,000 students demonstrate their discontent with the Vietnam War and their right to free expression.

**Washington DC**
Secretary of Defense Robert McNamara testifies to the Senate Preparedness Subcommittee that bombing in Vietnam has proven ineffective in quelling the insurgent spirit of the North Vietnamese.

**France**
University students and approximately ten high schools participate in a 24-hour national day of struggle, protesting social security cuts.

**France**
Charles de Gaulle broadcasts his annual message to the French people:
*I greet the year 1968 with serenity… It is impossible to see how France today could be paralyzed by crisis as she has been in the past.*

**Germany, 1968**
Students protest against restrictive universities and the right-wing monopoly of print media.

**Spain, 1968**
Anti-Franco street demonstrations take place in favour of a free press.

**Italy, 1968**
Students fight for university reform.

**Poland, 1968**
Students fighting for free speech are viciously repressed.

**Paris, 1968**
The student population has grown by 224% since 1958. However, resources to accommodate the dramatic rise are left unrealized.

Tumultuous recent history combined with de Gaulle's conservative domestic rule inspires the booming French student movement to work towards social change. Bookstore meetings, pamphlet dissemination, and street protests make up the fabric of student life.

**Paris**
Pierre Viansson-Ponte writes in *Le Monde*, "la France s'ennuie." ("France is bored.")

**Paris**
Protesting the Vietnam War, left-wing radicals attack the American Express building. A student at Nanterre University, Xavier Langlade, is arrested with five others.

**Nanterre University, Paris**
Protesting the rigid rules of conduct on a mostly post-graduate campus—including curfews, the right of the administrative officers to intrude on a student's room at any hour, and the forbidding of fraternization between the sexes—approximately 150 Nanterre students, including Daniel Cohn-Bendit, stage a sit-in starting the "March 22 Movement."

French Riot Police (CRS), created in 1947 to combat striking communist workers, seal off the building where the sit-in is taking place, escalating the tension and, in turn, student solidarity. Mass arrests and police brutality follow, inspiring the students of the Sorbonne to protest. Courses at Nanterre are suspended until April 1.

# 1968

JANUARY · Feb. 14 · March 15 · March 21 · March 22 · April 11 · April 13 · April 27

**Nanterre University, Paris**
Rumors quickly spread across campus that undercover policemen are compiling a black book of subversive students. This prompts demonstrators, including anarchists, militant leftists, and the small insurrectionary group, "Les Enragés," named for their bombastic outbursts, to protest against the presence of plain-clothed police on campus. The protest is suppressed with the arrival of sixty gendarmes at the university. Resistance against the armed officers raises awareness and inspires revolutionary spirits.

**Berlin**
Charismatic student leader, Rudi Dutschke, is shot three times and critically wounded by disgruntled house painter Josef Bachmann. Bachmann is found to have posters of Adolf Hitler and Napoleon hanging in his bedroom. The brutal attack on Dutschke reverberates in France, sparking student demonstrations in defense of his ideas.

**Paris**
A French National Student Union (UNEF) meeting is broken up by neo-fascists.

**Caen**
Poor pay and a dehumanizing company structure leads the SAVIEM truck factory workers to execute a massive strike. A violent skirmish ensues between workers and police wherein 200 are injured.

**Nanterre University, Paris**
Daniel Cohn-Bendit is arrested for battery following a scuffle with a right-wing student.

**France**
Student demonstrations rage across France.

**Paris**
Workers are granted government permission to parade on May Day for the first time in fourteen years.

**Nanterre University, Paris**
Approximately 300 students gather to protest the Vietnam War. Some of the protesters are armed with truncheons, anticipating a confrontation with Occident, the right-wing extremist student organization. Nanterre University calls the CRS, who brutally suppress the students. The savagery causes more protesters to pour in, charging the black vans holding the arrested students. Following no order, the protesters respond to the fervor surrounding them. Tear gas is deployed, only aggravating the resistance further. Paving stones shatter the windows of police vans amidst a fog of tear gas. After several hours of conflict the fight subsides with 600 students arrested. Seventy-two policemen and an unknown number of students are injured. Nanterre University's campus is closed.

**Sorbonne, Paris**
Students protest the closure of Nanterre at the Sorbonne. Ferocious clashes with the CRS continue. 500 demonstrators are arrested by a grossly disproportionate police response. UNEF calls for a strike. 3,000 go on general strike.

**Sorbonne, Paris**
Courses at the Sorbonne are suspended. Right-wing newspapers blame agitators, left-wing newspapers are befuddled by the students' intense anger. New student unions form and call for unlimited strikes. An amalgam of UNEF, faculty, and fledgling revolt groups march in protest of the previous day's arrests sparking a riot.

**Sorbonne, Paris**
More revolutionary committees form in preparation for demonstrations on the following day, where a massive protest is planned for the release of arrested students and the re-opening of the Sorbonne.

**Sorbonne, Paris**
What begins as a peaceful protest march, parading from left bank to right bank and back again, turns into a savage confrontation as the demonstrators reach Sorbonne University. Upon the arrival of crowds, estimated between 15,000 to 20,000, the police charge and implement tear gas as the protesters throw paving stones. The Latin Quarter melee dies out after an exhausting sixteen hours.

**Paris**
The number of demonstrators double as workers, teachers, and high school students join the ranks of protesters. Limited to the right bank, the demonstrations are peaceful, culminating under the Arc de Triomphe. Students refuse to negotiate until the May 3 prisoners are released.

40,000 are now on general strike.

# MAY
# 1968

Wed. 1 · Thur. 2 · Fri. 3 · Sat. 4 · Sun. 5 · Mon. 6 · Tue. 7 · Wed. 8 · Thur. 9 · Fri. 10 · Sat. 11 · Mon. 13 · Tue. 14 · Wed.

**Paris**
Negotiations for the reopening of the Sorbonne and the release of arrested students begin. L'Ecole des Beaux Arts goes on strike.

**Sorbonne, Paris**
After a public radio announcement declaring the reopening of the Sorbonne, the Minister of Education cancels the order at the last minute, fearing the students will reoccupy the buildings. The Sorbonne remains closed. High schools begin to strike.

**Sorbonne, Paris**
The morning of May 10 begins with insurrectionary spirits enlivening the medical students of the Sorbonne. By nightfall a revolutionary fervor spreads. Known as the First Night of the Barricades, 30,000 demonstrators blockade the Boulevard Saint-Michel as police bar exits via bridges and other main arteries leading out of the Latin Quarter, thus creating a pressure cooker of opposing ideologies. What follows is a brutal stand-off that lasts through the night as the police wield nightsticks and teargas and protesters rain down paving stones and Molotov Cocktails. The local middle class population acts in solidarity with the students amidst torched cars and wrecked homes. No deaths occur. The French public, workers, and union members experience the sights and sounds of the savage clash via media: the radio and TV coverage brings about solidarity with the protestors. Two cars from Radio Europe 1 are present, the only station not controlled by de Gaulle. The free radio provides news of the struggle along with student discussion and opinions.

**Sorbonne, Paris**
Catalyzed by the atrocity, the lion's share of French trade unions—including its two biggest, CGT and CFDT—announce a one day general strike in tandem with a mass demonstration to take place on Monday, May 13. Students re-occupy Sorbonne under the title of the "Autonomous Peoples' University." Moved by the preceding evening's brutality, the PCF (French Communist Party) assumes support for workers and ultra-left groups. These very same groups the PCF had formerly denounced as "False revolutionaries... objectively they serve the interests of the Gaullist power and large capitalist monopolies."

**Sorbonne, Paris**
The workers' strike commences. This is the biggest demonstration Paris has ever seen. High school students all over Paris begin to occupy their schools. They take to the streets, inspiring the Monoprix Supermarket walkout. Groups of high school students approach small businesses and workers encouraging them to join the demonstrations. The Sorbonne re-opens and arrested students are released without charge. Despite the state's appeasement, French trade unions see out their planned one-day general strike concurrent with a march nearly 1,000,000 strong. The workers and students storm the streets, calling for the resignation of Charles de Gaulle and the dismantling of the repressive Gaullist government that no longer represents its people. Trailing behind the student/worker-led march are leftist politicians and CGT leaders. Here resentments begin to fester between union leaders who resent the student initiated revolution and students who consider the Communist party and unions untrustworthy and often antithetical to the revolt. Political posters and graffiti slogans blanket the façade of an occupied Sorbonne. Committees form to print posters, handbills, and leaflets. Other assemblies form to disseminate the agitprop.

**Ecole des Beaux Arts, Paris**
Spontaneously, students converge at the prestigious art school, designing and printing the first of an onslaught of political posters. The first poster produced reads: "Usines Universités Union" (Factories, Universities, Union). Several hundred metalworkers strike at the Sud-Aviation aircraft factory near Nantes. Despite the trade unions' declaration of a finite, one-day strike, workers' boycotts and protests expand. Attempting to spread democracy in the Eastern Bloc, Charles de Gaulle leaves France on a state visit to Romania.

**Paris**
2,500 students occupy the treasured Odéon national theatre. Workers occupy the Renault factory at Cléon.
The Strike Committee of the Ecole Nationale Superieure des Beaux Arts issues what is to become the mission statement of the Atelier Populaire. [See page 205.]

**France**

After the strike at the Renault plant in Cléon, there are actions at Flins, Le Mans, and the 30,000-strong Renault-Boulogne-Billancourt factory.

Wildcat strikes and occupations occur across France, including those by metalworkers, airplane manufacturers, and other automobile factories. A total of fifty factories are occupied. Revolutionary students and faculty at the Ecole des Beaux Arts form the Atelier Populaire (People's Workshop). Scrawled across the entrance are the words: ATELIER POPULAIRE OUI—ATELIER BOURGEOIS NON. What follows this initial occupation is an oeuvre spanning hundreds of silkscreen posters, created in bold colors with white backgrounds and provocative slogans. Created without an artist's signature, only the stamp of the Atelier Populaire, the posters display an extraordinary outpouring of political graphic art. In a statement, the Atelier Populaire declared the posters:

*...weapons in the service of the struggle... an inseparable part of it. Their rightful place is in the centres of conflict, that is to say, in the streets and on the walls of the factories.*

The Occupation Committee of the Autonomous Popular University of the Sorbonne announces these "words of command for dissemination by any means" at 7 p.m:
*Occupy the factories/Power to the Workers' Councils/Abolish class society/Down with the spectacular-commodity society/Abolish alienation/An end to the university/Humanity will not be happy till the last bureaucrat is hanged from the entrails of the last capitalist/Death to pigs/Free the four comrades jailed for looting on May 6*

**Paris**

Over 250,000 people go on wildcat strikes. Workers and intellectuals form the Committee for Maintaining the Occupations.

**Paris**

Trains stall, mail and telegraph services terminate, and postal savings offices close down. The subway and bus lines come to a halt. Air France, shipping services, and mines are all affected by strikes. One-time detractors of the protests, trade unions, call a general strike for wage increases. By nightfall, the number of strikers rises to two million. More factories are occupied. Nationalists release a tract calling for the end of flag and monument desecration, adjournment of anarchy in institutions, and the re-establishment of laws and authority. Major French directors withdraw their films from the Cannes Film Festival in support of the student/worker protests. The festival's jury resigns.

**France**

As 10 million go on strike, France reels in economic paralysis.

**Paris**

The Atelier Populaire distributes a leaflet declaring:
"We are against the established order of today. What is this established order? Bourgeois art and bourgeois culture. What is bourgeois culture? It is the means by which the forces of oppression of the ruling class isolate and set apart the artists from the rest of the workers by giving them a privileged status. Privilege locks the artist in an invisible prison."
The government orders the deportation of Daniel Cohn-Bendit. Left-wing politicians in the National Assembly submit a motion to censure the Gaullist government. The Assembly votes the motion down.

**Paris**

Protests against Daniel Cohn-Bendit's deportation occur.

ar. 16 | Fri. 17 | Sat. 18 | Mon. 20 | Tue. 21 | Wed. 22 | Thur. 23 | Fri. 24 | Sat. 25 | Sun. 26 | Mon. 27 | Tue. 28

**Paris**

An amalgam of workers, students, academics, and citizens continue to revolt. A new cross-class political discourse begins throughout Paris. The Central Communist Internationalist Organizational Committee:
*WORKERS, MILITANTS, YOUNG PEOPLE, we have entered, in millions upon millions, into a strike in order to seize the satisfaction of our fundamental demands... THE GUARANTEE OF WORK... We want THE REPEAL OF THE FOUCHET REFORMS, the measures of which are meant to exclude 2/3 of the students from the faculties... WE GO ON STRIKE FOR VICTORY!*
That evening a typesetter for the conservative paper *Le Parisien Libéré* blocks the appearance of a fallacious headline reporting a large trend in workers returning to their jobs. The workers of *Le Parisien Libéré* seize control of the production process barring Gaullist propaganda.

**Paris**

Right-wing civic organizations known as Committees for Defense of the Republic are established. In opposition to the Action Committees, their purpose was organizing Gaullist demonstrations. Overnight riots see 795 arrests and 456 injured. Charles de Gaulle returns from Romania and gives a poorly received televised speech wherein he proposes a referendum on the nation's confidence in his leadership. Having toured Amsterdam and Brussels giving speeches, Nanterre student leader Daniel Cohn-Bendit is barred from entering France. The government is so passionate about obstructing Cohn-Bendit's re-entry that they are prepared to open fire on 1,000 unarmed German students demonstrating at the French Border. Daniel Cohn-Bendit covertly returns to France sometime before the end of May. The Second Night of the Barricades follows with stone hurling and tear gas in the Latin Quarter. In Paris, one person is killed by a shard of shrapnel; a policeman dies in Lyon. Confrontational barricades and entrenchment spread outside the Left Bank to the rest of Paris, thus diluting police enforcement throughout the capital. Police bulldozers and fire trucks are utilized to combat the defensive renegade architecture (fences, paving stones, chains, concrete) that sprouts up in the streets. An attempt is made to loot and torch the Parisian stock exchange (the Bourse). The same workers who banned *Le Parisien Libéré*'s fabricated news the day before transform major printing plants into production centers for revolutionary paper and pamphlet production, allowing for widespread information dissemination.

**Paris**

French state radio and television, the ORTF, strikes against government interference in coverage of the Events. The strike is limited. Confrontations grow in the provinces. The French government, represented by Georges Pompidou and a young Jacques Chirac, begin talks with trade union leaders. Their three-day negotiations will result in the limited settlement known as the Grenelle Agreements.

**Paris**

Continuing from the day before, frantic attempts to push May's unrest into full-fledged revolution occur. Committees, unions, students, and left-wing political leaders discuss alternative governmental systems.

**France**

The Grenelle Agreements are drafted between unions, employers' federations, and the government. Proposed reforms include an increase in the minimum wage with fewer hours and organizational rights. Workers find the arrangement unacceptable. At Billancourt they jeer at CGT (General Confederation of Labor) leader Georges Séguy. UNEF calls for the first assembly of non-Communist, non-CGT left, i.e. unaffiliated radical students. The Union Confederation of Families states in a press release:
*SCHOOL AND FAMILIES is surprised that, while the government may have provoked negotiation concerning social problems, it has not set a date for the resolution of the problems of teaching and of the University, when the resolution of this question is of major interest for the formation of the youth of this country.*

**France**

There is effectively no government in France. The town of Nantes is governed by strike committees. François Mitterand (Socialist) nominates himself as the head of a proposed interim government. Conservatives criticize Mitterand, but Communists pledge support in an effort to oppose the more radical workers and students who want the total obliteration of the current political environment. The Minister of Education resigns.

**Paris**

The trade union movement (CGT) holds a large demonstration. Meanwhile, de Gaulle flees to Baden-Baden, in order to consult General Jacques Massu, chief of French forces in West Germany. The people of France believe this to be a sign of an imminent resignation, however de Gaulle hopes to garner armed support in the event of an expected coup in the following 48 hours.

**Paris**

De Gaulle delivers a terse speech to the nation, stating that he will not resign. The French National Assembly is dissolved in anticipation of new parliamentary elections. De Gaulle threatens to declare a state of emergency if citizens do not return to work. 800,000 de Gaulle supporters march from the Place de la Concorde to the Arc de Triomphe, signaling a conservative backlash and the return of popular support for Gaullism.

**France**

Parliamentary elections are announced for late June. Pro-Government demonstrations continue throughout France. Largely, work resumes. Order trickles back into the system, routed by brutal methods. The last surges of revolt spasm across France.

Raymond Marcellin is appointed Minister of the Interior. The new Minister sees student and workers' organizations as a revolutionary threat to the Fifth Republic, and fears that they may be the result of instigation by foreign agitators.

A seventeen year-old student is killed during a fierce four day clash involving students and workers versus police and CRS at the Renault factory in Flins. The death brings the local population to a boiling point, forcing the CRS to withdraw from the immediate area.

The workers of Renault-Flins and their student supporters call for a mass demonstration at their factory.

# JUNE 1968

Wed. 29   Thur. 30   Fri. 31     Sat. 1   Sun. 2   Mon. 3   Tue. 4   Wed. 5   Thur. 6   Fri. 7   Sat. 8   Mon. 10

**Paris**

UNEF (National Union of Students) protests against the elections, with the slogan: Elections = Betrayal
Fuel, which had become a scarcity, is made widely available again, resulting in grinding traffic jams.

**St. Denis**

Around midnight, four nationalists attack a picket line at a French National Railway (SNCF) depot.
Two strikers are wounded.

**Paris**

The ORTF goes on a full-fledged strike, dwarfing the limited scope of their boycott on May 25.

**Paris**

Making a concerted effort to fight the counter-revolutionary media programs of the Gaullist regime, a variety of committees release an "Informative Leaflet Against Disinformation," recapping the events of May and providing national coverage of the insurgencies.

Led by Josephine Baker, the Young Gaullists demonstrate at Trocadero.

**Renault-Flins**

Before dawn, a half-track blows down the doors of the Renault-Flins factory. A CRS unit, 5,000 strong, invades and forcibly ejects the picket line from the premises.

**Renault-Flins**

Various groups call protesters to the Renault-Flins factory in support of its striking workers.

The ORTF silently demonstrate.

**Renault-Flins**

The picketing continues directly outside the Renault-Flins factory. De Gaulle is interviewed on television by Michel Droit.

Charles de Gaulle:
*This explosion was provoked by groups in revolt against modern consumer and technical society, whether it be the communism of the East or the capitalism of the West. They are groups, moreover, which have no idea at all of what they would replace it with, but who delight in negation, destruction, violence, anarchy, and who brandish the black flag!*

**Renault-Flins**

The strike at Renault-Flins moves back inside the factory.

**Sochaux**

The two-day "Battle of Sochaux" commences when CRS troops invade the occupied Peugeot car factory.
At Flins, the high school student Gilles Tautin is killed evading a police charge.

The electoral campaign commences amidst more violence in the Latin Quarter. Until the run-off elections on June 30, street demonstrations are made illegal.

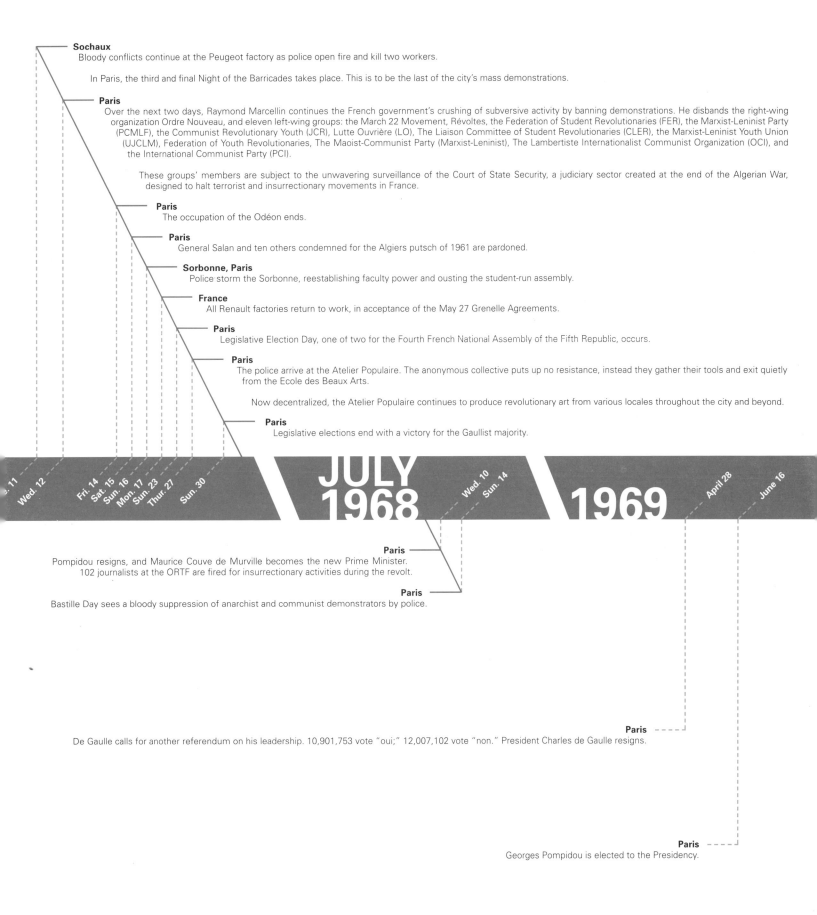

**Sochaux**
Bloody conflicts continue at the Peugeot factory as police open fire and kill two workers.

In Paris, the third and final Night of the Barricades takes place. This is to be the last of the city's mass demonstrations.

**Paris**
Over the next two days, Raymond Marcellin continues the French government's crushing of subversive activity by banning demonstrations. He disbands the right-wing organization Ordre Nouveau, and eleven left-wing groups: the March 22 Movement, Révoltes, the Federation of Student Revolutionaries (FER), the Marxist-Leninist Party (PCMLF), the Communist Revolutionary Youth (JCR), Lutte Ouvrière (LO), The Liaison Committee of Student Revolutionaries (CLER), the Marxist-Leninist Youth Union (UJCLM), Federation of Youth Revolutionaries, The Maoist-Communist Party (Marxist-Leninist), The Lambertiste Internationalist Communist Organization (OCI), and the International Communist Party (PCI).

These groups' members are subject to the unwavering surveillance of the Court of State Security, a judiciary sector created at the end of the Algerian War, designed to halt terrorist and insurrectionary movements in France.

**Paris**
The occupation of the Odéon ends.

**Paris**
General Salan and ten others condemned for the Algiers putsch of 1961 are pardoned.

**Sorbonne, Paris**
Police storm the Sorbonne, reestablishing faculty power and ousting the student-run assembly.

**France**
All Renault factories return to work, in acceptance of the May 27 Grenelle Agreements.

**Paris**
Legislative Election Day, one of two for the Fourth French National Assembly of the Fifth Republic, occurs.

**Paris**
The police arrive at the Atelier Populaire. The anonymous collective puts up no resistance, instead they gather their tools and exit quietly from the Ecole des Beaux Arts.

Now decentralized, the Atelier Populaire continues to produce revolutionary art from various locales throughout the city and beyond.

**Paris**
Legislative elections end with a victory for the Gaullist majority.

**JULY 1968**

Wed. 12 · Fri. 14 · Sat. 15 · Sun. 16 · Mon. 17 · Sun. 23 · Thur. 27 · Sun. 30 · Wed. 10 · Sun. 14 · **1969** · April 28 · June 16

**Paris**
Pompidou resigns, and Maurice Couve de Murville becomes the new Prime Minister. 102 journalists at the ORTF are fired for insurrectionary activities during the revolt.

**Paris**
Bastille Day sees a bloody suppression of anarchist and communist demonstrators by police.

**Paris**
De Gaulle calls for another referendum on his leadership. 10,901,753 vote "oui;" 12,007,102 vote "non." President Charles de Gaulle resigns.

**Paris**
Georges Pompidou is elected to the Presidency.

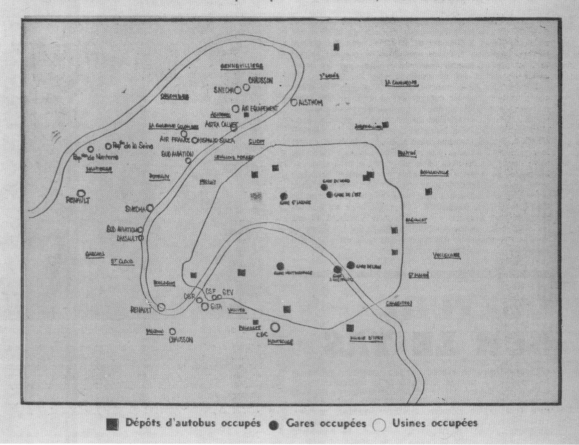

# Le front des luttes ouvrières

A Paris et dans la banlieue, voilà les principaux champs de batailles. La liaison des luttes étudiantes et ouvrières n'est pas une chose abstraite..
Allez manifester votre solidarité politique et matérielle, allez discuter...

■ Dépôts d'autobus occupés  ● Gares occupées  ○ Usines occupées

↑ Map of occupied factories, bus and train stations. *From* Action *no. 3, May 21, 1968.*

**Front of the workers' struggles**

Here are the main battlefields in both Paris and the suburbs. The connection between the students' struggle and that of the workers is not an abstract thing… Go to demonstrate your political and material solidarity, go to discuss…

■ Occupied bus stations  ● Occupied train stations  ○ Occupied factories

→ Map of St. Germain and the barricades. *From* The Beginning of an Epoch *by Create Situations, 1971.*

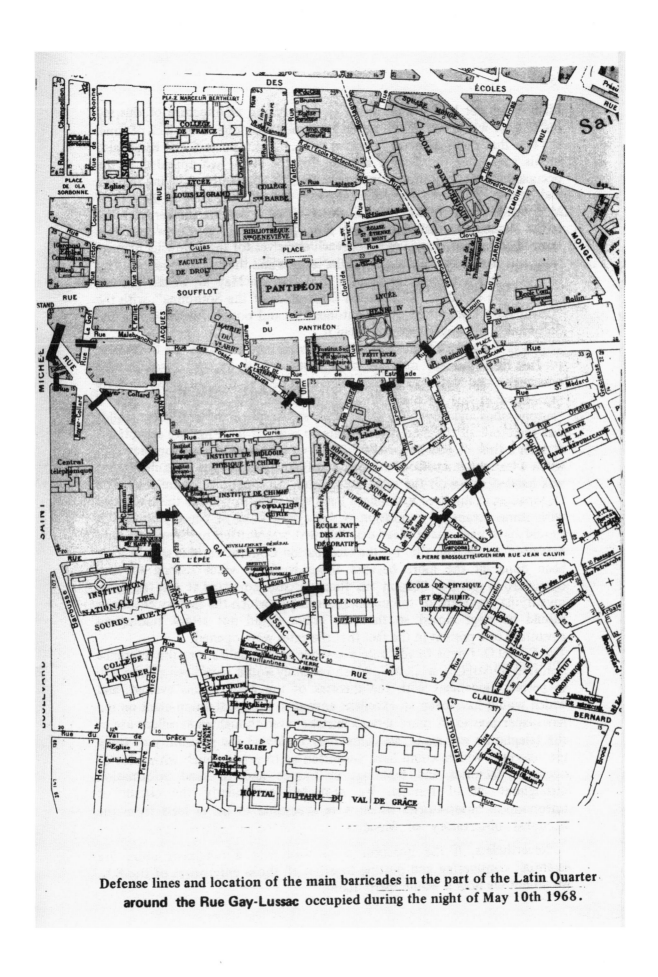

**Defense lines and location of the main barricades in the part of the Latin Quarter around the Rue Gay-Lussac occupied during the night of May 10th 1968.**

ENEZ LES
EMINOTS
N GREVE

C ET POUR

RAVAILLEURS

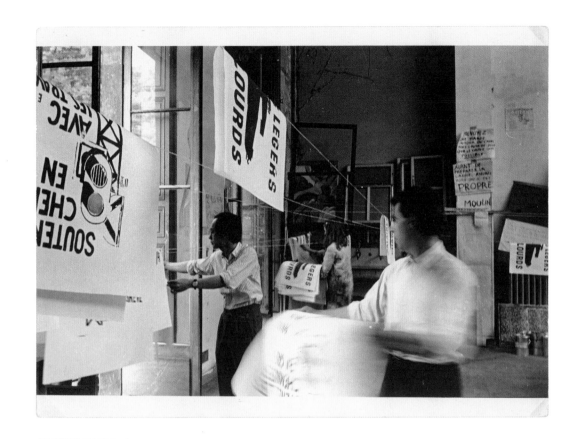

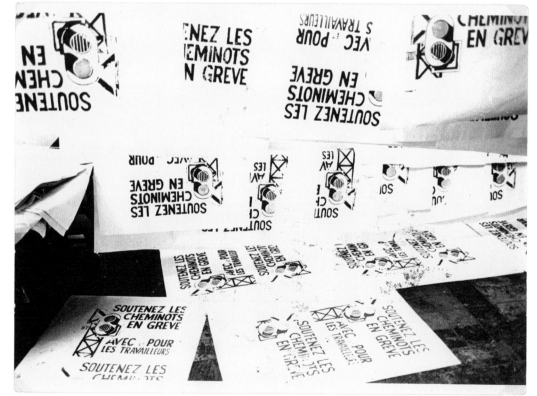

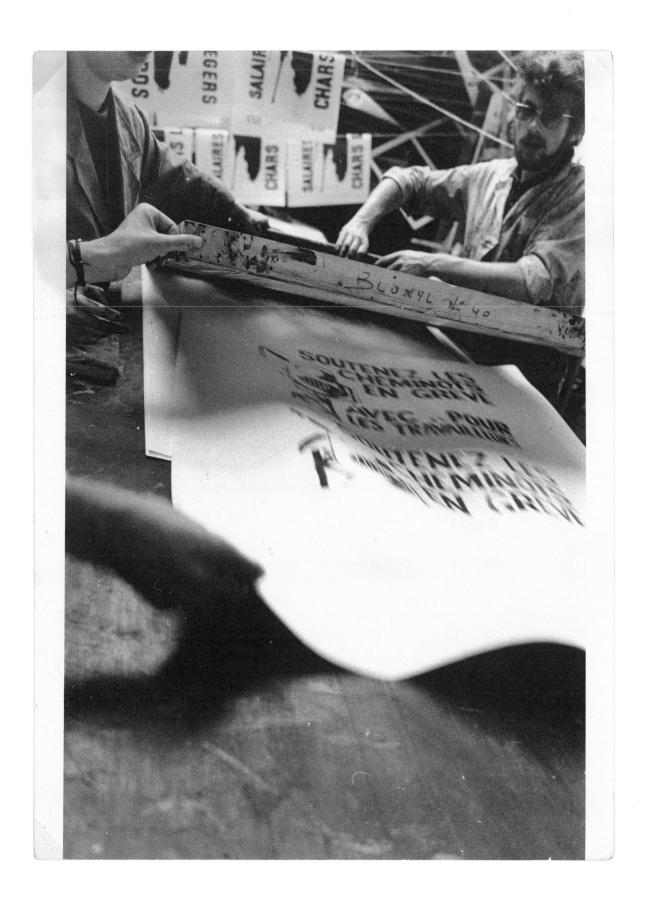

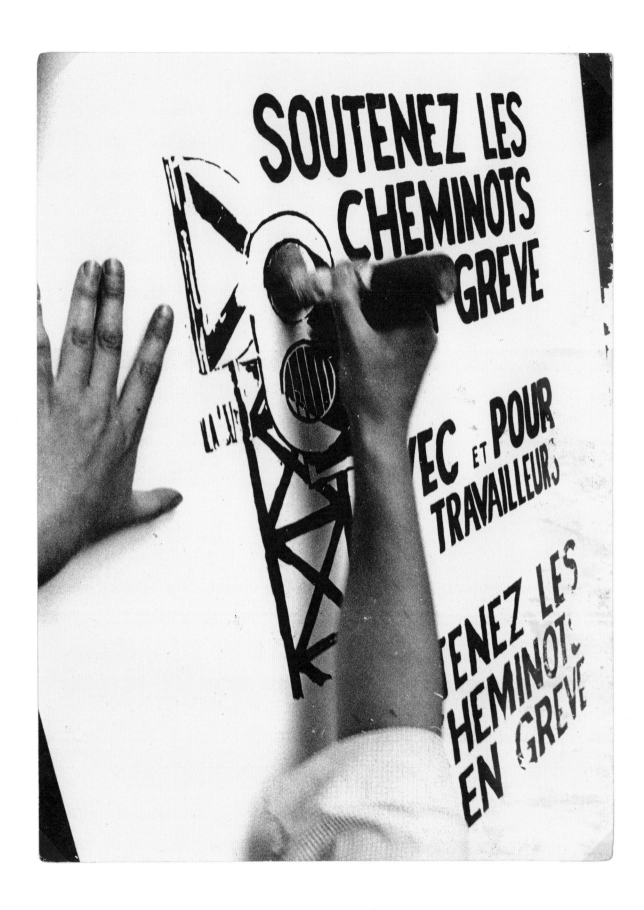

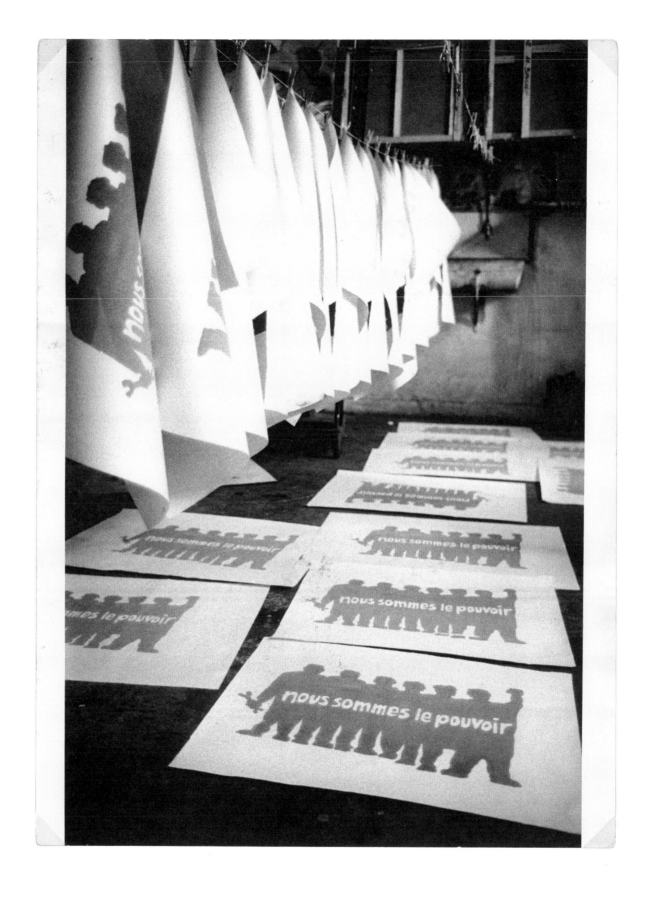

# LA POLICE S'AFFICHE AUX BEAUX ARTS

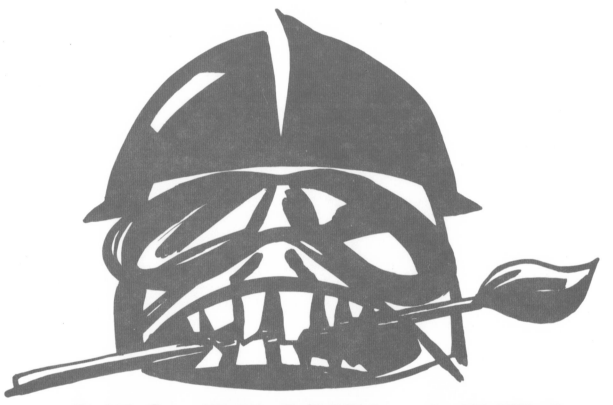

# LES BEAUX ARTS AFFICHENT dans la RUE

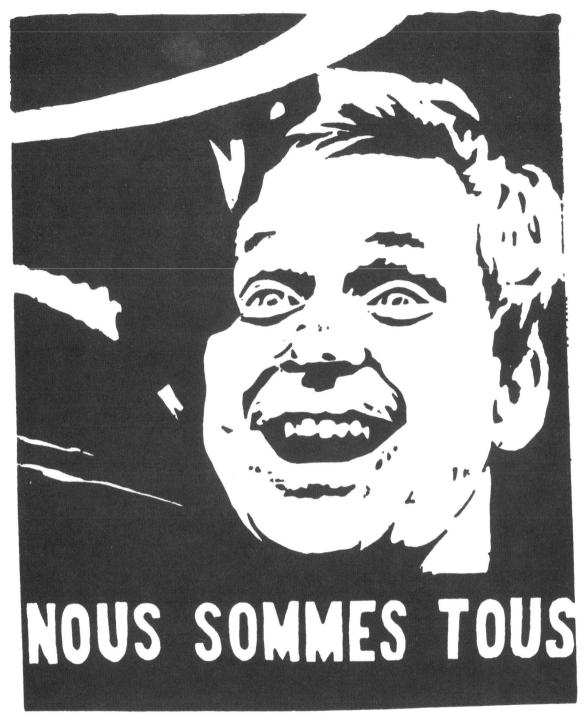

NOUS SOMMES TOUS

"INDÉSIRABLES"

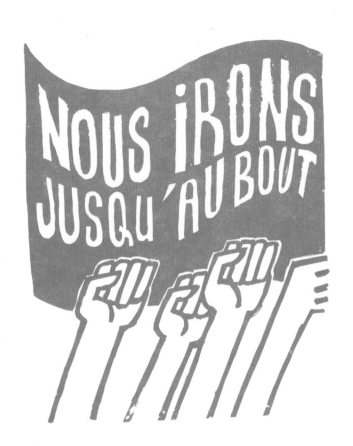

NOUS iRONS JUSQU'AU BOUT

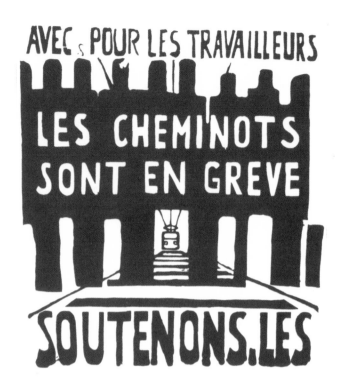

AVEC & POUR LES TRAVAILLEURS

LES CHEMINOTS SONT EN GREVE

SOUTENONS.LES

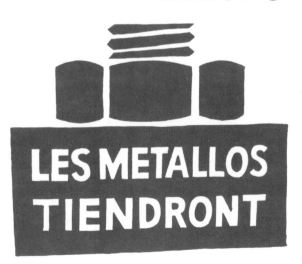

POUR LA LUTTE DE TOUS LES TRAVAILLEURS

LES METALLOS TIENDRONT

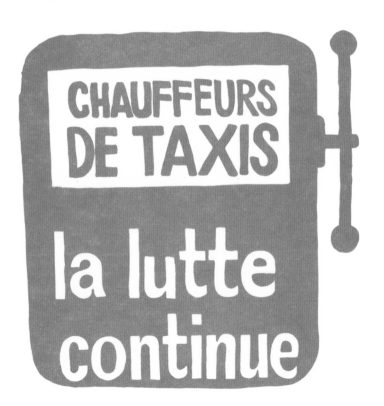

CHAUFFEURS DE TAXIS

la lutte continue

# VIGILANCE!

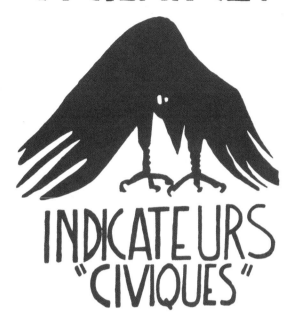

## INDICATEURS "CIVIQUES"

## SOLIDARITE AVEC
### LA GREVE DES POSTIERS

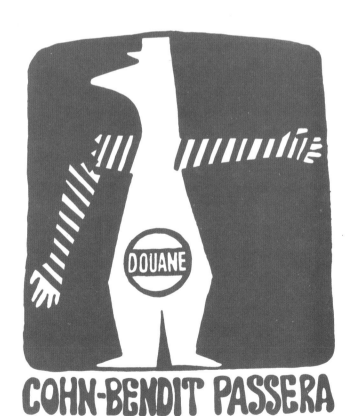

CONTRE les BRISEURS DE GREVE

JEUDI 6 JUIN   DEPOT LE BRUN
## LA GREVE CONTINUE

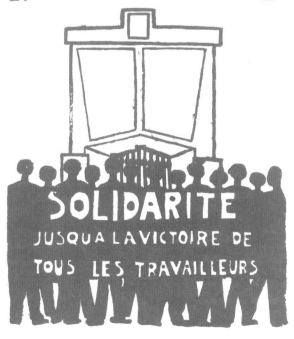

SOLIDARITE
JUSQU'A LA VICTOIRE DE
TOUS LES TRAVAILLEURS

DOUANE

## COHN-BENDIT PASSERA

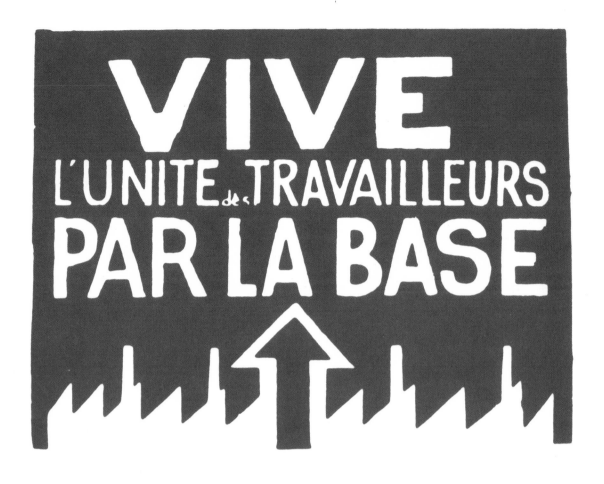

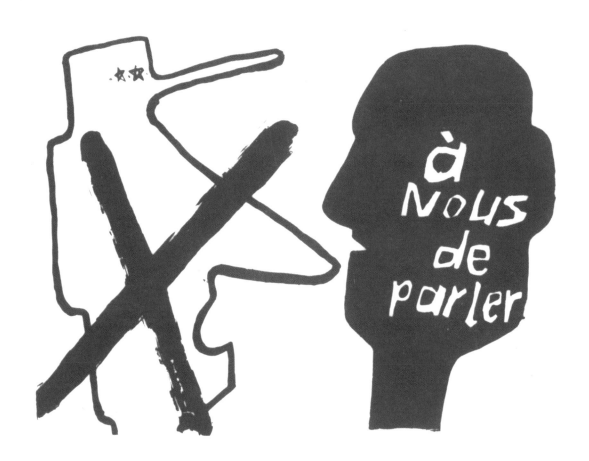

# FRONTIÈRES = REPRESSION

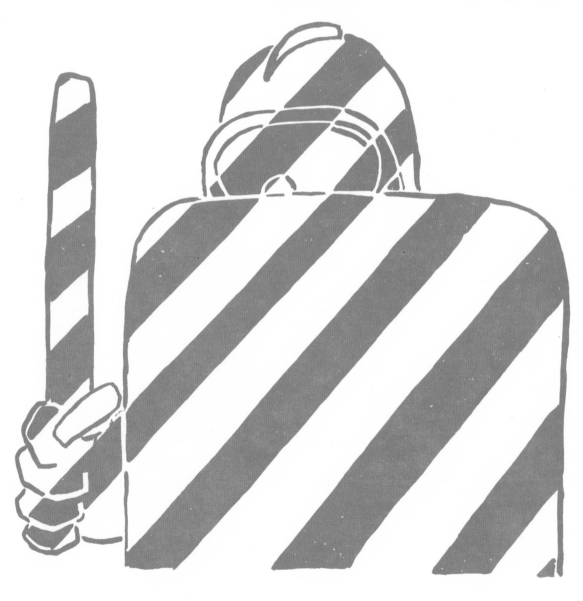

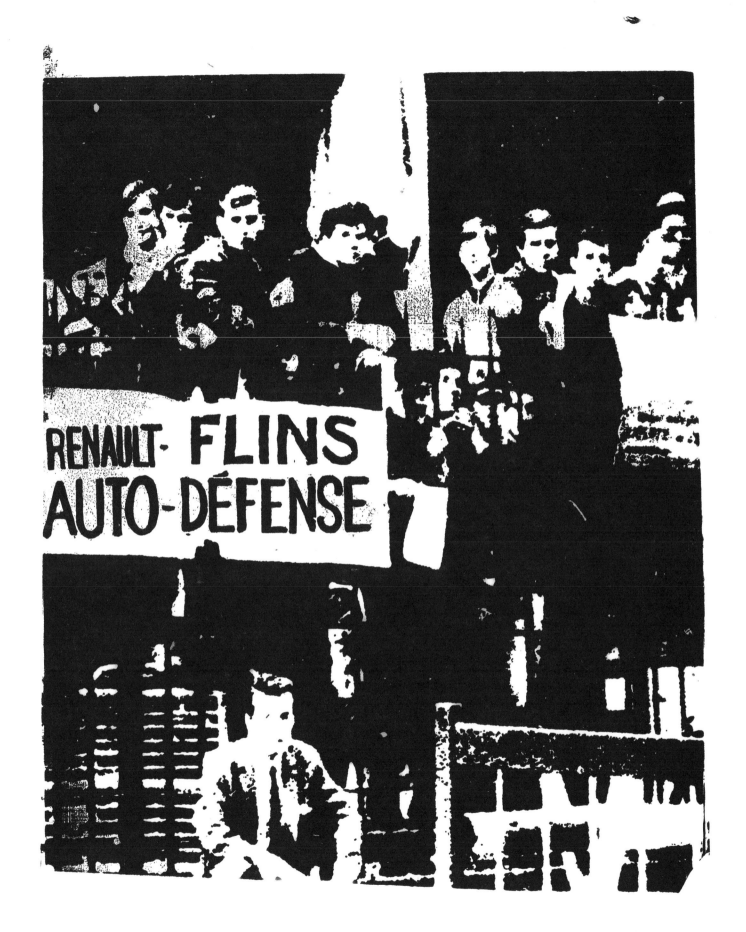

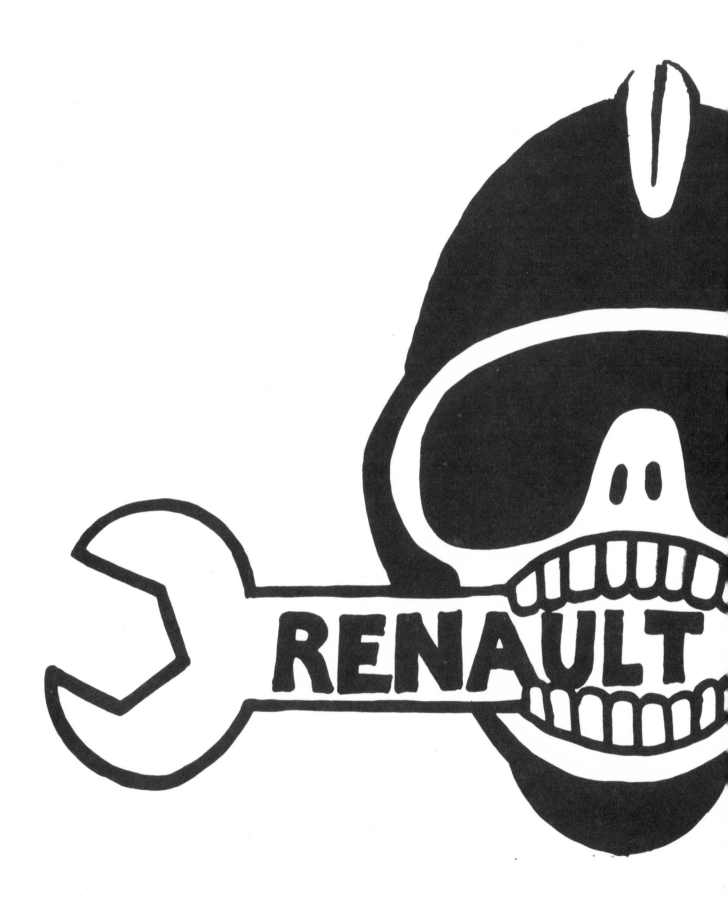

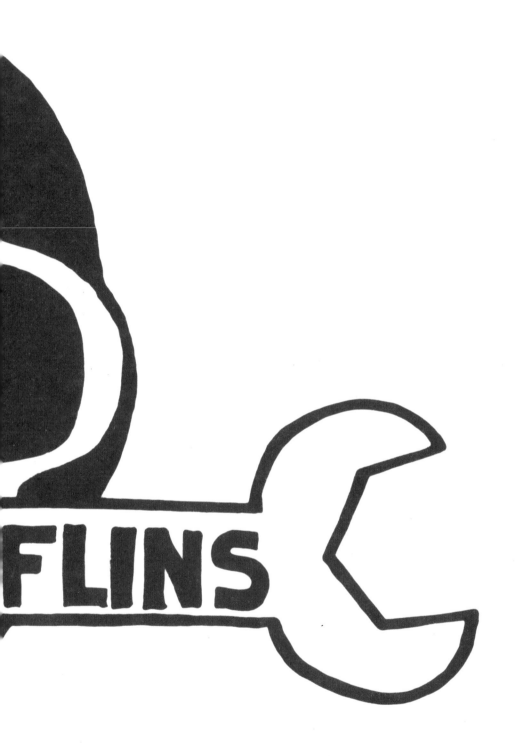

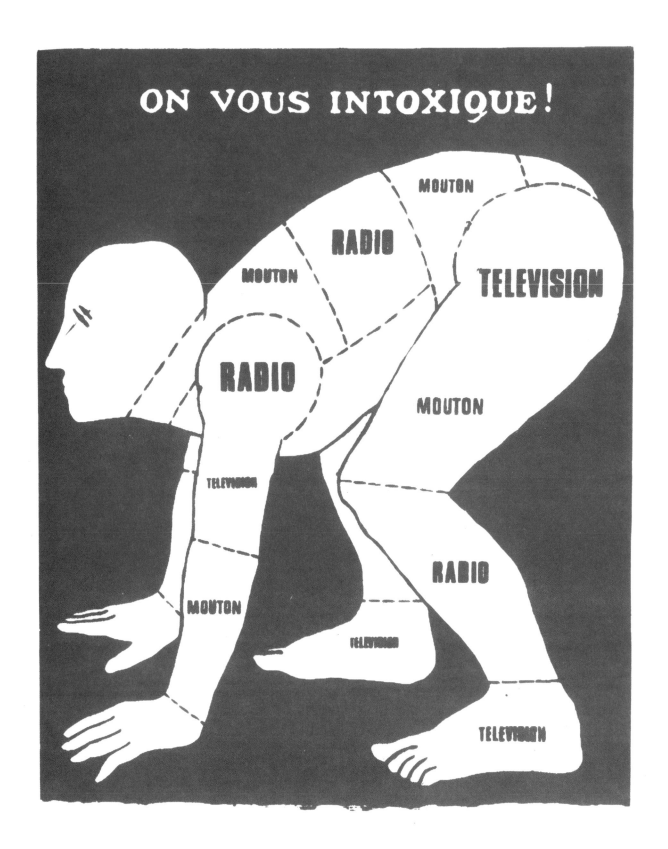

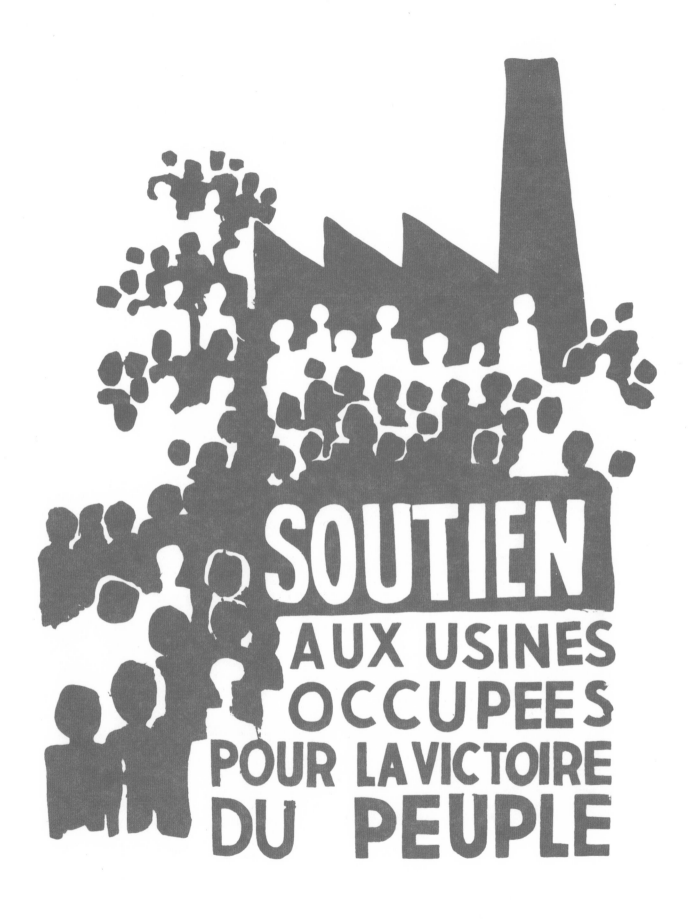

# SOLIDARITE AVEC LES MARINS PECHEURS

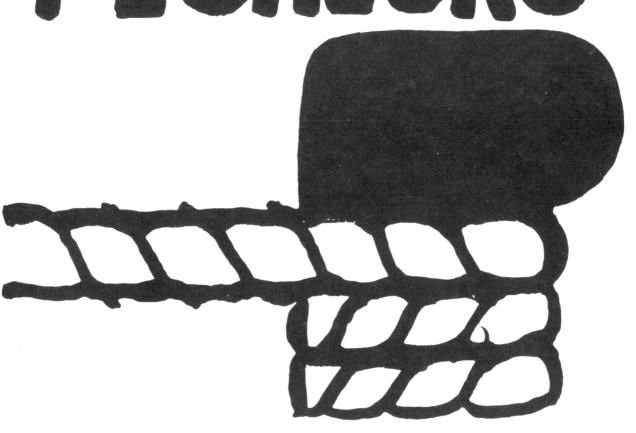

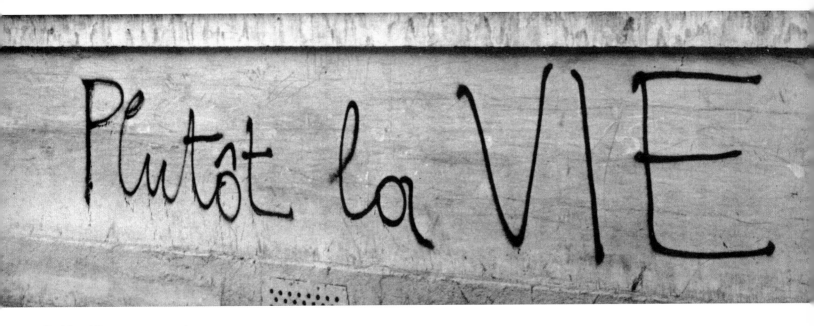

↑   More Life
*Monday, May 6.*

↓   Society is a carnivorous flower
*Friday, May 10. Near Place de la Contrescarpe.*

→   I come in the paving-stones
*Friday, May 10. Rue Royer-Collard.*

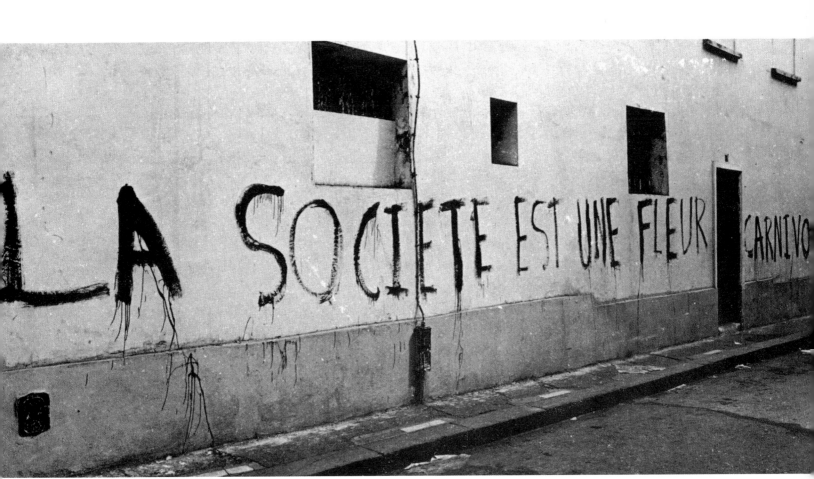

*Photographs by Jo Schnapp.*

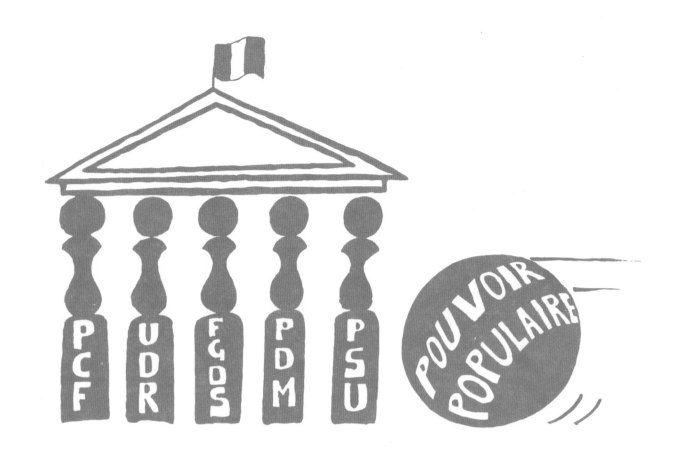

POU VOIR POPULAIRE

TOUS UNIS CAMARADES
JUSQU'A LA VICTOIRE

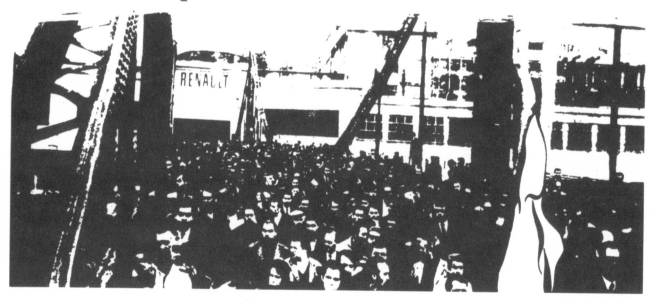

# ETUDIANTS TRAVAILLEURS

union

## COMITE d'action TRAVAILLEURS ETUDIANTS

# SOUTIEN POPULAIRE
# AUX OUVRIERS DE CITROEN
# EN LUTTE

## MARDI 18 JUIN XV$^{eme}$ Art

# TRAVAILLEURS ACTIFS ET CHOMEURS TOUS UNIS

REJOIGNEZ VOS COMITES D'ACTION DE QUARTIER

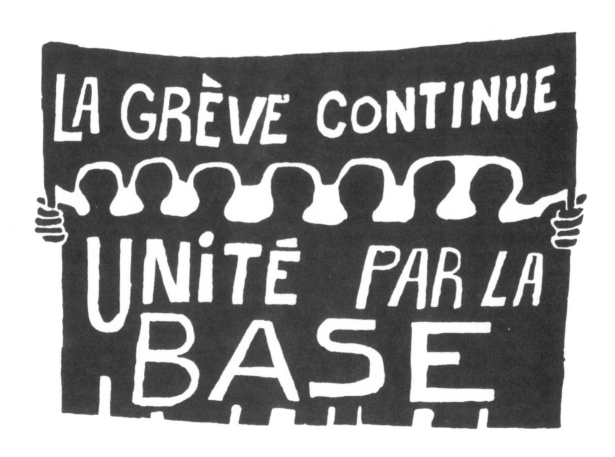

LA GRÈVE CONTINUE

UNITÉ PAR LA BASE

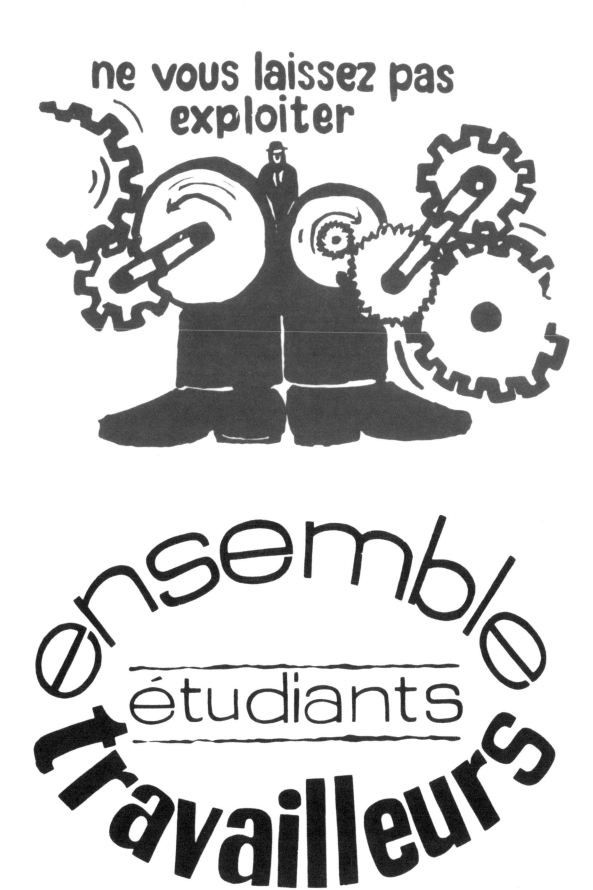

# TRAVAILLEURS DE RENAULT-FLINS LA VICTOIRE EST A NOUS

## BELLEVILLE

une partie de cartes = 5000 flics

Que cherche le pouvoir ?

• dresser les communautés les unes contre les autres
• faire oublier la grande grève actuelle
• présenter les travailleurs immigrés comme la pègre
• les diviser des français
• recommencer les ratonnades

HALTE A LA PROVOCATION POLICIERE

mais tous unis, les travailleurs français, immigrés poursuivront le combat contre l'ennemi commun.

# LE CONTINGENT NE SERA PAS BRISEUR DE GREVE

## OCCUPATION AUTODEFENSE
## FLINS.SOCHAUX LYON.StNAZAIRE PARIS.TOULOUSE

contrairement aux informations diffusées, tous les syndicats

**RATP**

CONDUCTEURS AUTONOMES Y COMPRIS

sont décidés à poursuivre le mouvement jusqu'à complète satisfaction

## solidarité EFFECTIVE étudiants travailleurs

# NE NOUS BATTONS PAS SUR LE TERRAIN PREPARE PAR LE POUVOIR LUI-MEME : IL EST TRUQUE

les capitalistes ont besoin des ouvriers

les ouvriers n'ont pas besoin de capitalistes

**APPEL AUX JUIFS ET AUX ARABES**

LE GOUVERNEMENT VOUS INTOXIQUE

NE VOUS LAISSEZ PAS FAIRE !

Les évènements de BELLEVILLE ont été déclenchés par des commandos de subversion CRS et HarKis en vue de semer la panique et le désordre dans ce quartier populaire.

DEJOUEZ LES MANŒUVRES RACISTES

Rejoignez vos comités d'action de quartier : siège: 28, rue Serpente, PARIS 6e

إعلان

الى اليهود والى العرب

ان الحكومة الفرنسية لتغركم بمرور بعضا فلا تكونوا ضحيتها

ان الحوادث التي حدثت في بلفيل كانت عواملها البوليس ور.س، ل، ليثيروا الرعب وارضجه في سكم الشعبي

بمهرا داخل لجنى العمل : 28 طريق سريانت - باريس السادس

# CITROEN

## VIVE LA RESISTANCE PROLETARIENNE

| 22 | MARS | Nanterre | + |
|----|------|----------|---|
| 3 | M A I | *CRS à la Sorbonne* | – |
| 10 | M A I | 1res barricades | + |
| 13 | M A I | Prise de la Sorbonne | + |
| | | Prise de l'Odéon | + |
| 14 | M A I | Occupation Sud Aviation | + |
| 24 | M A I | 2mes barricades | + |
| 27 | M A I | Charléty | + |
| 29 | M A I | *De Gaulle Massu* | – |
| 7 | JUIN | Flins | + |
| | | A suivre | + |

# TRAVAILLEURS ACTIFS ET CHOMEURS TOUS UNIS

## PAYSANS

LES GREVISTES ONT BESOIN DE VOUS
VENEZ LEUR VENDRE VOS PRODUITS

### DIRECTEMENT

DANS LES USINES ET DANS LES FACULTES

NOUS AVONS GAGNE UNE BATAILLE MAIS NOUS SAVONS QUE LA LUTTE POUR NOTRE MOUVEMENT SERA DURE

RENAULT – FLINS COMITE DE GREVE

## MAI · JUIN

1968 ... 68

début d'une lutte ← prolongee →

TENEZ BON CAMARADES TOUS UNIS JUSQU'A LA VICTOIRE

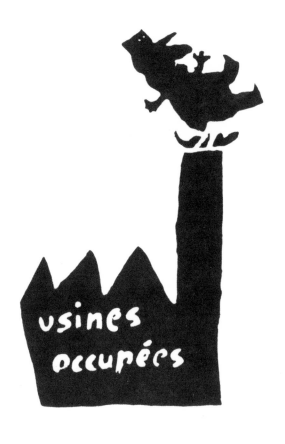

usines
occupées

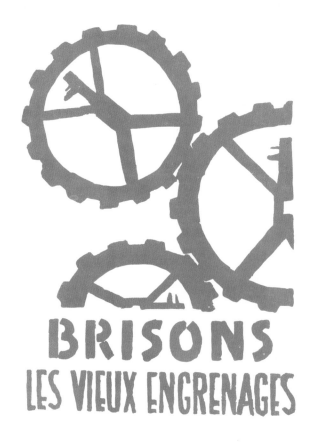

BRISONS
LES VIEUX ENGRENAGES

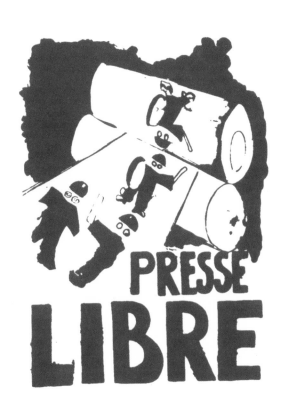

PRESSE
LIBRE

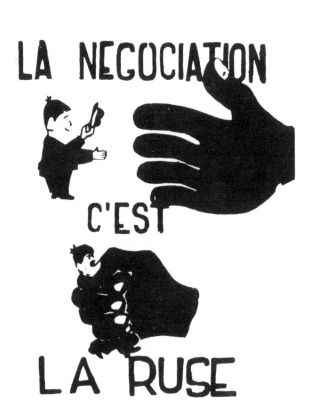

LA NEGOCIATION

C'EST

LA RUSE

# LA BEAUTÉ

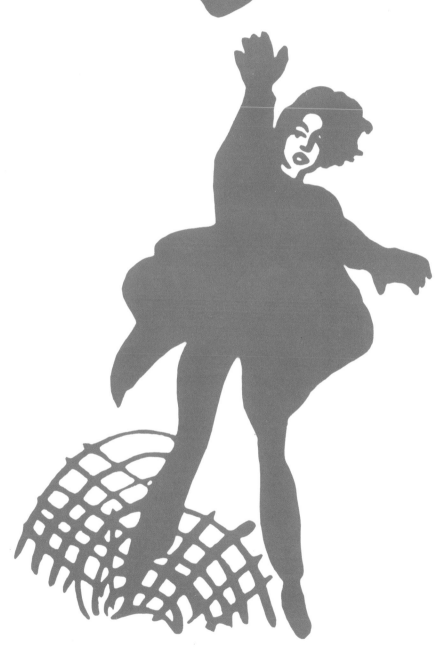

# EST DANS LARUE

# PAS DE RECTANGLE BL
## POUR

# INDÉPENDANCE &AU

ANC
N PEUPLE ADULTE:

NOMIE de l'O.R.T.F.

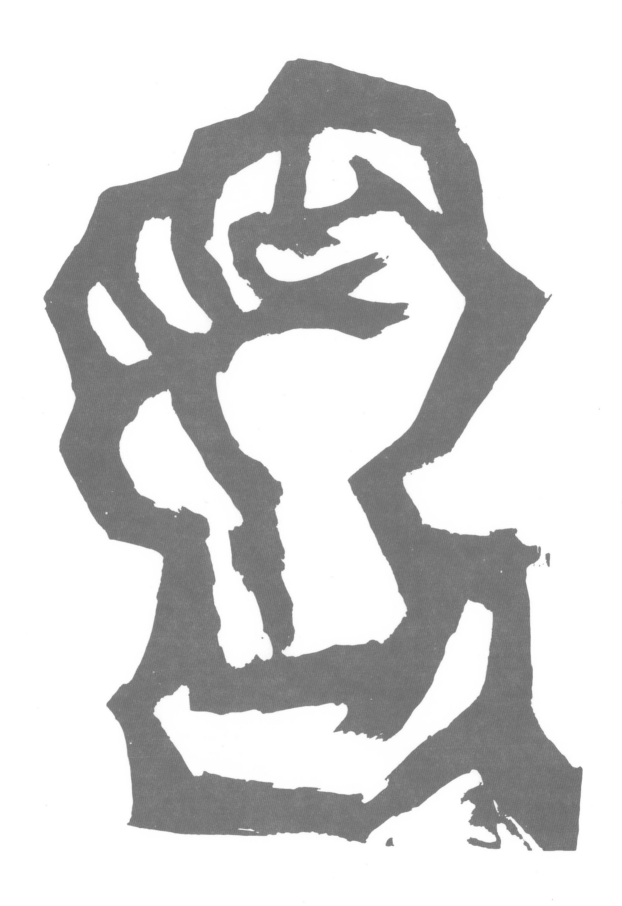

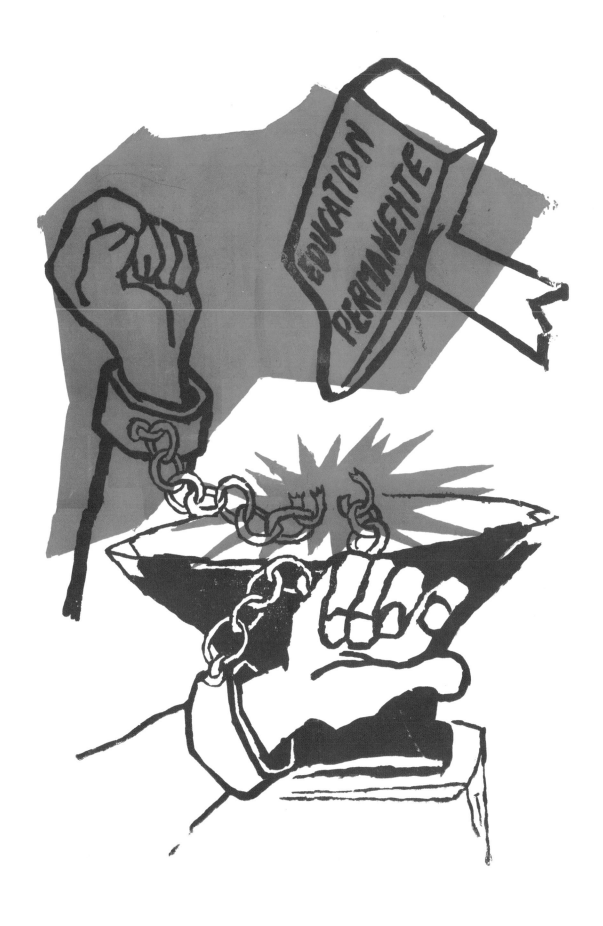

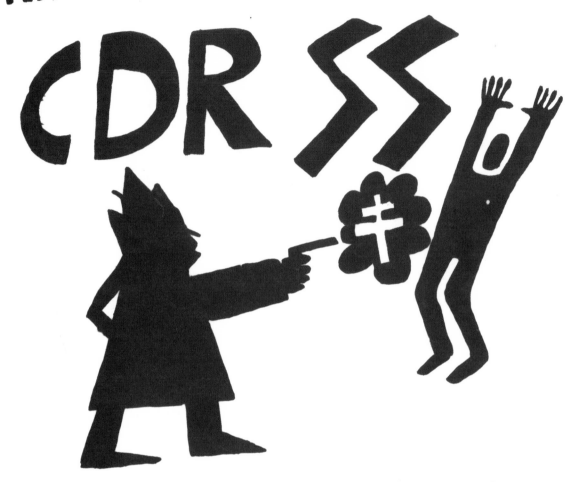

# HALTE A LA FASCISATION

# CDR SS

DEPOT DES BATIGNOLLES 7 BLESSÉS
FAC D'ORLEANS SACCAGÉE
MARC LANVIN TUÉ A ARRAS
CDRSS

# TRAVAILLER MAINTENANT

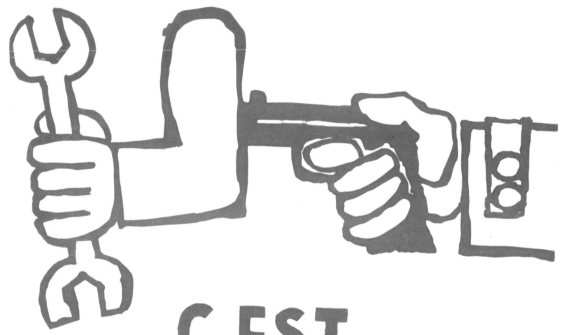

# C EST TRAVAILLER AVEC UN PISTOLET DANS LE DOS

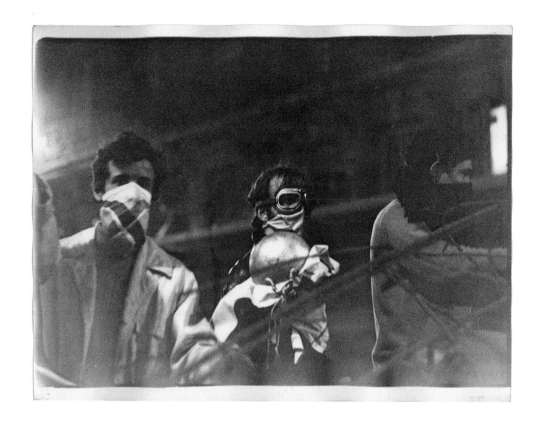

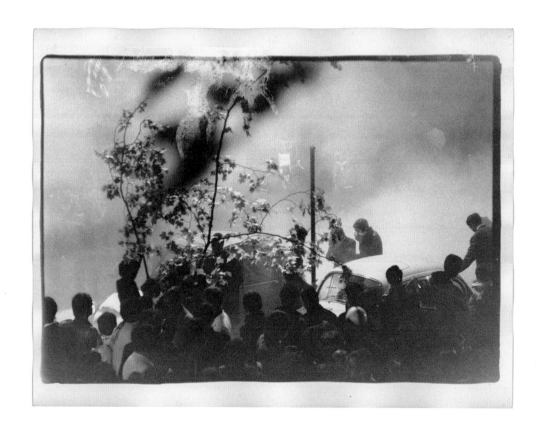

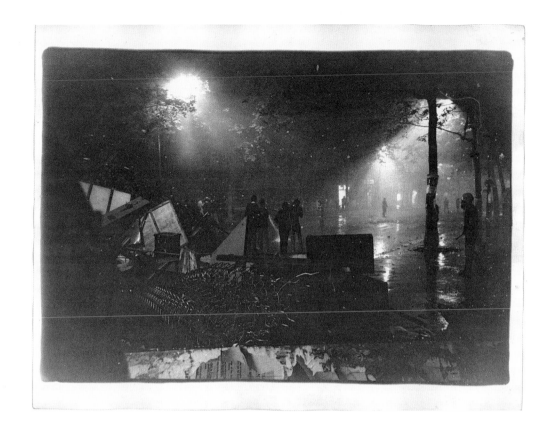

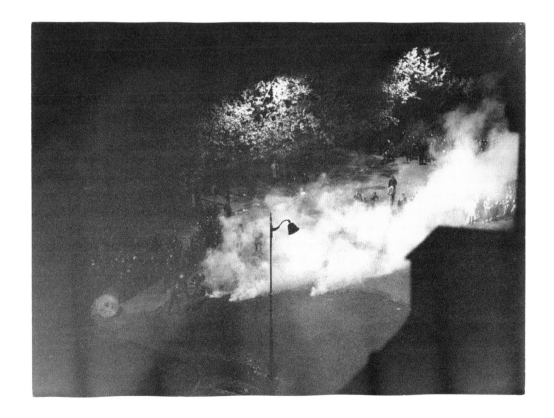

↑↑↓↓ The barricades in St. Germain, May 1968. *Photographer unknown.*

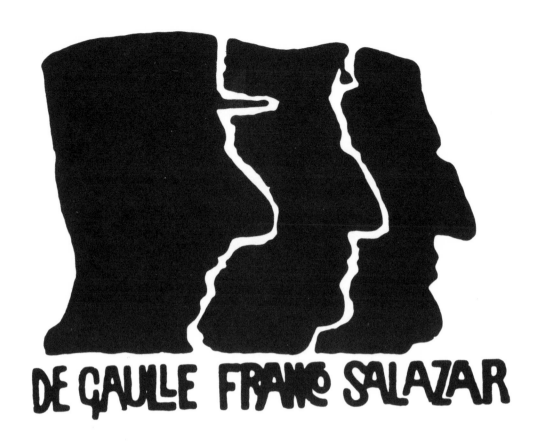

DE GAULLE FRANCO SALAZAR

TENEZ BON CAMARADES

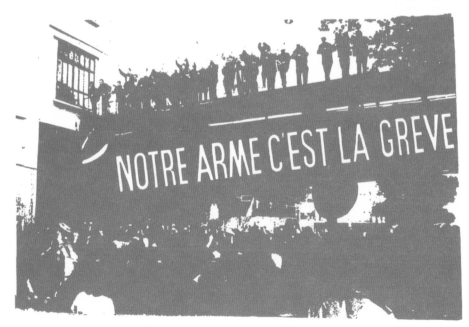

NOTRE ARME C'EST LA GREVE

# PAYSANS GREVISTES

## NON AUX INTERMEDIAIRES

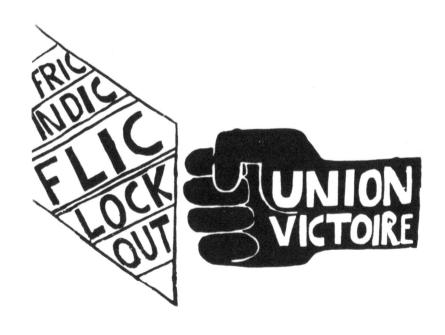

10F → 20F → 30F → 40F

10F VENTE DIRECTE → 10F

FRIC
INDIC
FLIC
LOCK
OUT

UNION VICTOIRE

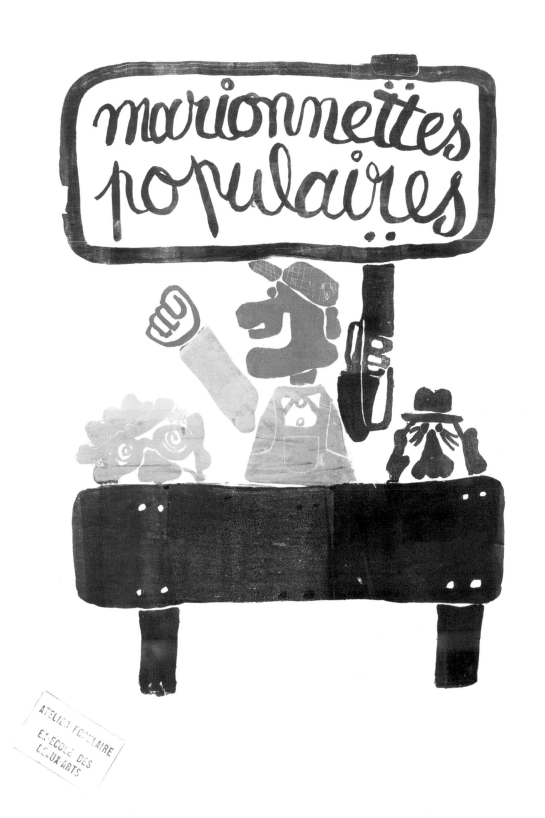

# REFUSEZ

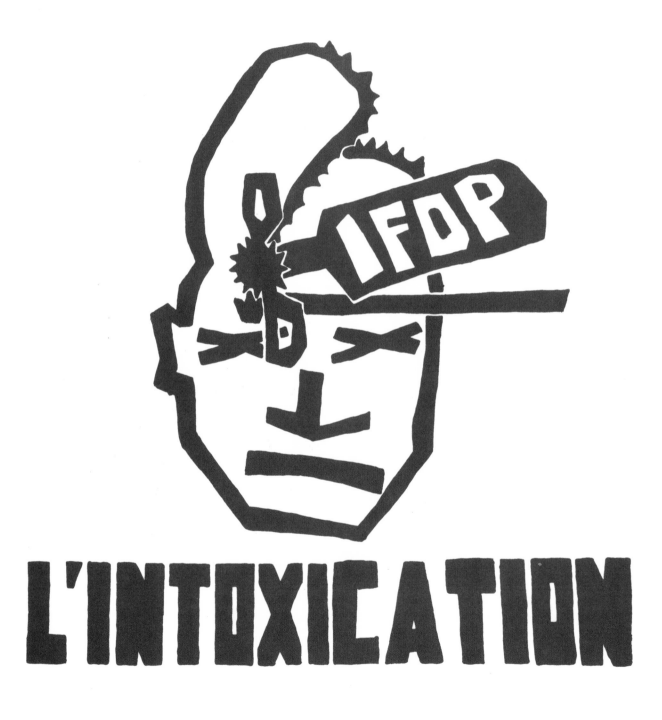

# L'INTOXICATION

NON
A LA BUREAUCRATIE

ntinue

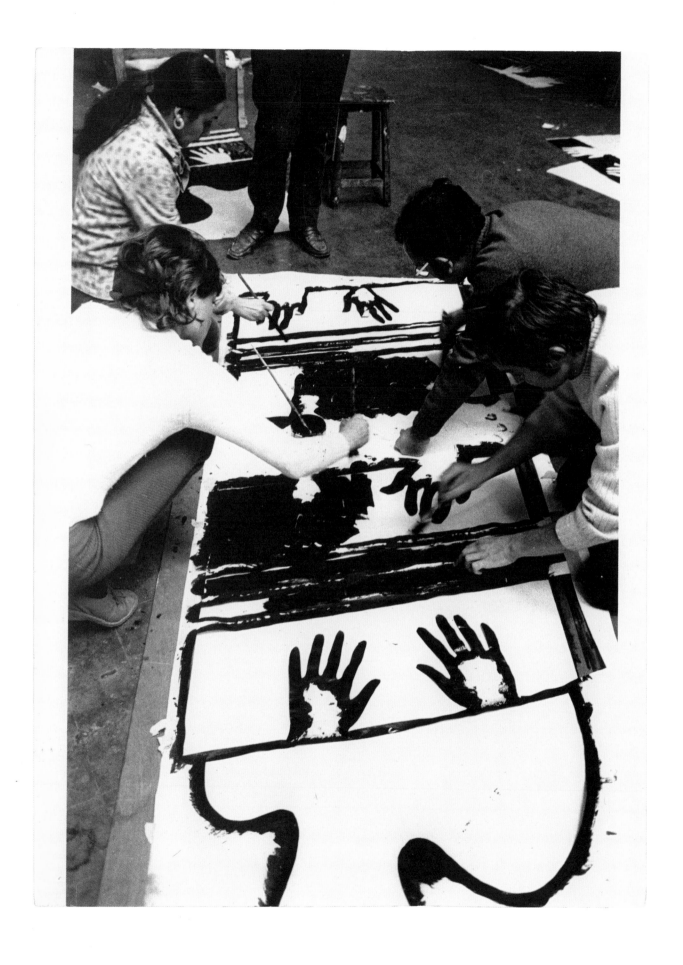

↳ Silkscreening at the Atelier Populaire, May 1968. *Photograph by Philippe Vermès.*

# LEUR CAMPAGNE COMMENCE

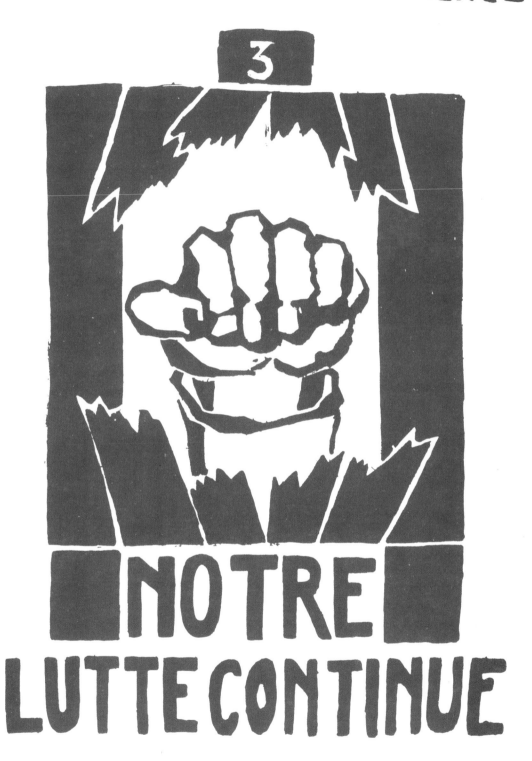

NOTRE LUTTE CONTINUE

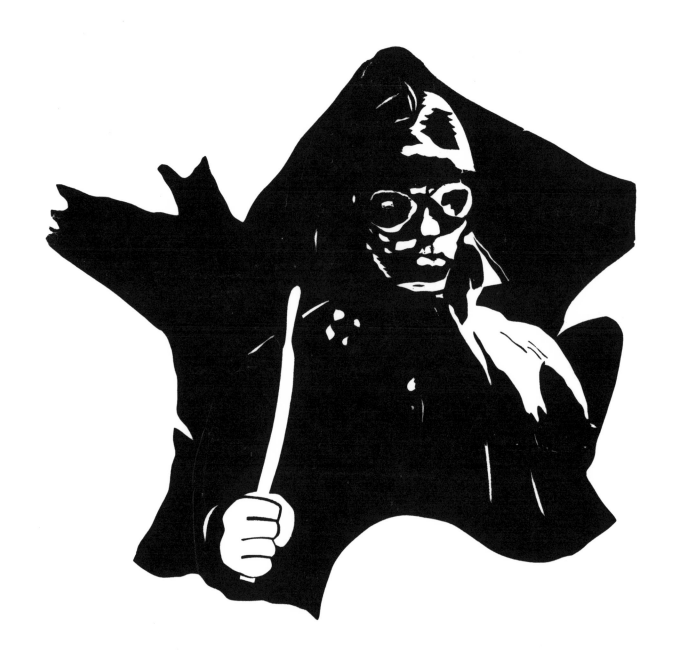

POUR LA VIOLENCE LA HAINE ET LA REPRESSION

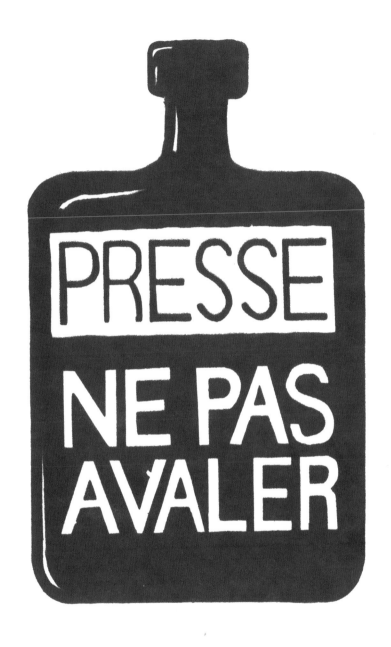

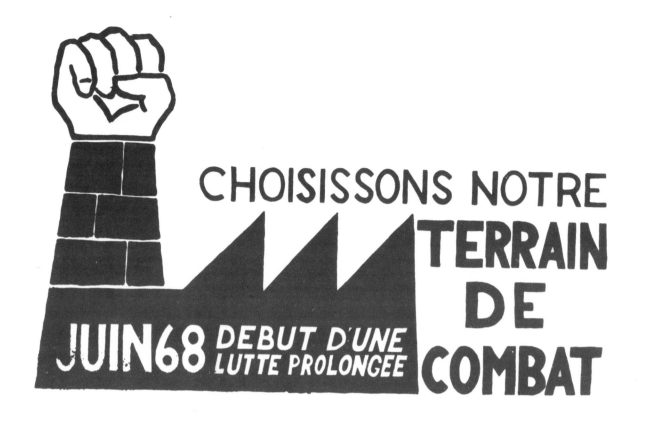

CHOISISSONS NOTRE TERRAIN DE COMBAT

JUIN 68 DEBUT D'UNE LUTTE PROLONGEE

LE POING DE NON RETOUR

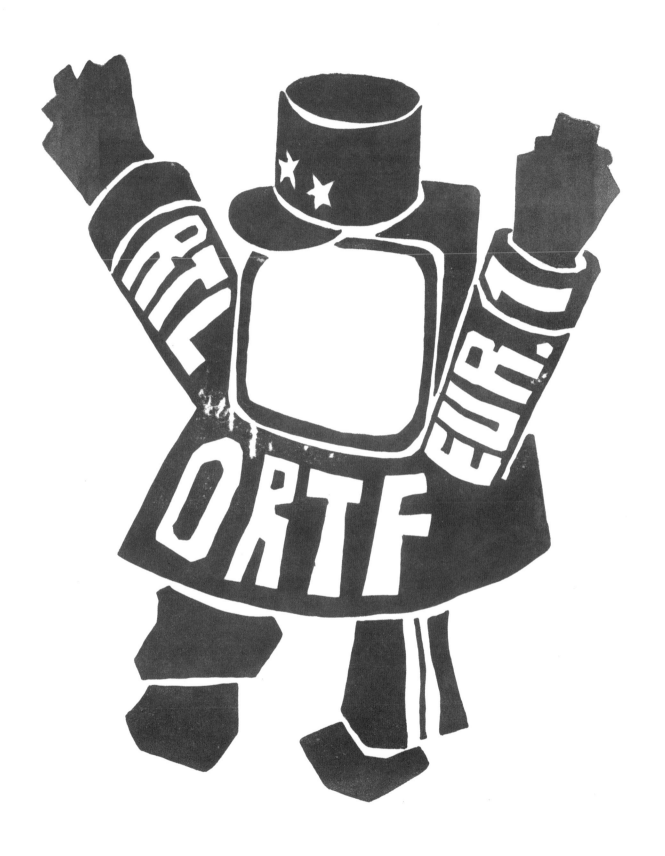

# LES ELECTIONS N'ARRETERONT PAS NOTRE ACTION

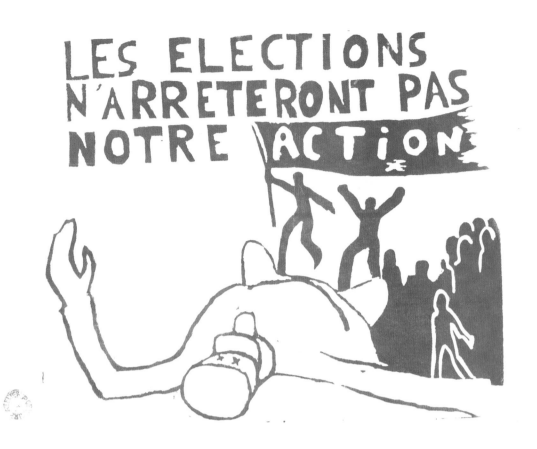

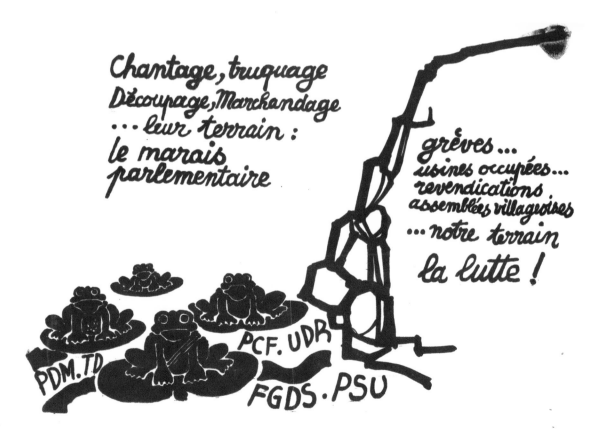

Chantage, truquage
Découpage, Marchandage
... leur terrain :
le marais
parlementaire

grèves...
usines occupées...
revendications
assemblées villageoises
... notre terrain
la lutte !

PDM.TD

PCF.UDR

FGDS.PSU

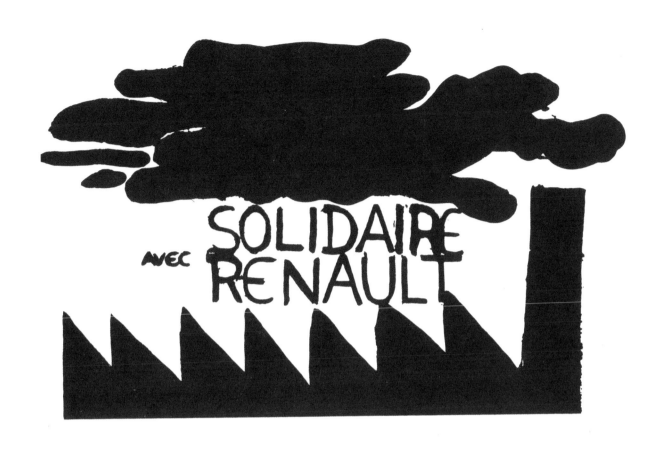

SOLIDAIRE AVEC RENAULT

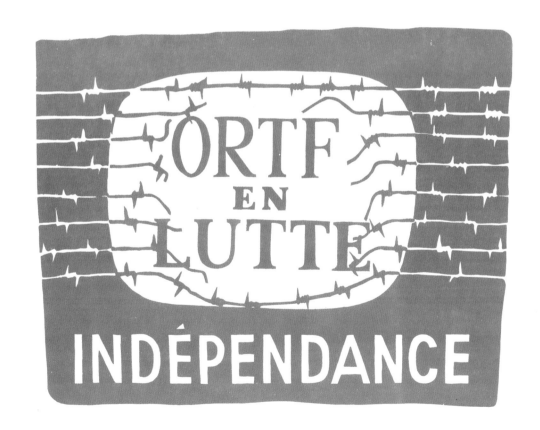

ORTF EN LUTTE

INDÉPENDANCE

# LUTTE

# LE CANCER

LUTTE C

LE CANCER

# CONTRE

GAULLISTE

143

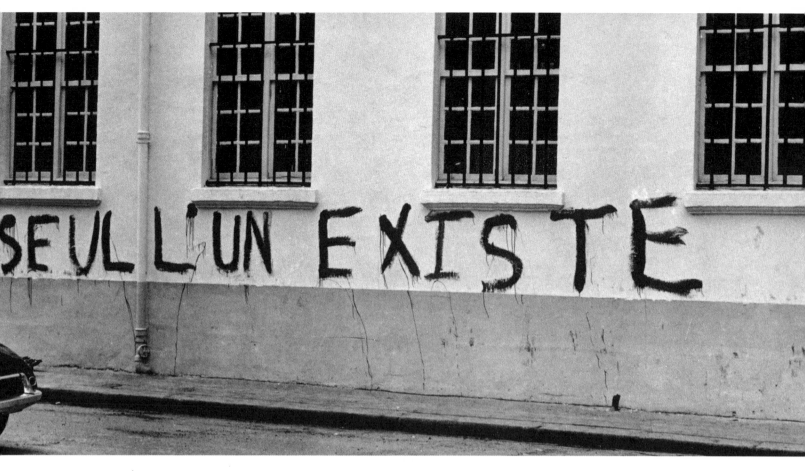

↑ Only the one exists.
*Friday, May 10. Near Place de la Contrescarpe.*

ON NE REVENDIQUERA RIEN
ON NE DEMANDERA RIEN
ON PRENDRA
ON OCCUPERA

professeurs, vous nous faites
vieillir

↑ Professors, you are making us old. We will demand nothing, we will ask for nothing; we will take, we will occupy.
*Monday, May 13. Sorbonne.*
*Photographs by Jo Schnapp*

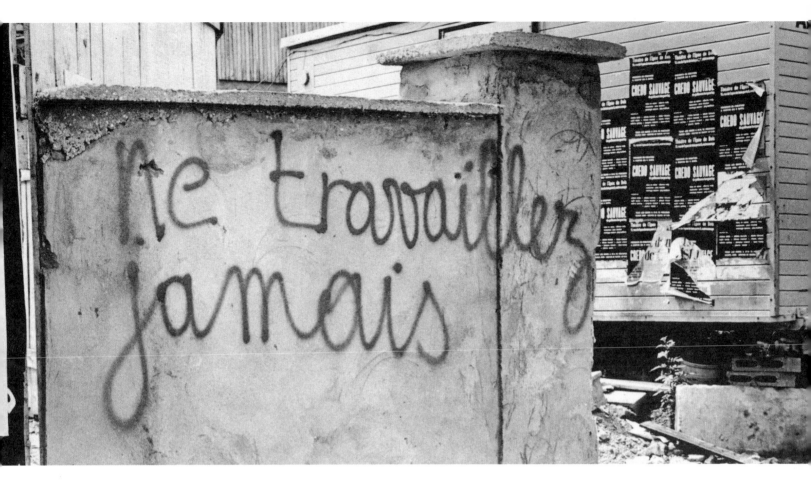

↑ Never work
*Monday, May 6.*

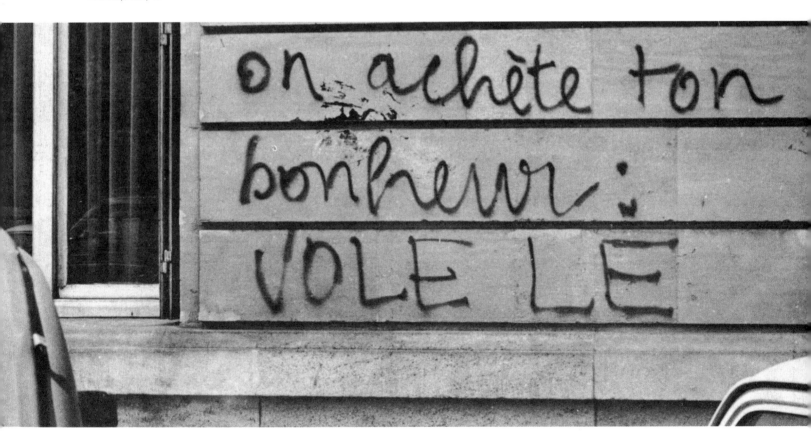

↑ Your happiness is being bought: Steal it!
*Monday, May 6.*

# JOURNAL MURAL ³

## LA LUTTE CONTINUE

## RENAULT_FLINS

<u>10 JUIN</u> - 4000 ouvriers, malgré le contre ordre de la direction de la CGT, sont entrés dans l'usine.

<u>11 JUIN</u> - L'usine est réoccupée par les travailleurs. Les militants de la CGT appellent tous les travailleurs à organiser immédiatement l'occupation massive de l'usine. Mais la direction syndicale, après avoir manifesté son accord sur l'occupation, demande aux travailleurs de rester chez eux jusqu'au lendemain. A 20 heures, il n'y a que 40 ouvriers dans l'usine; la direction en profite pour tenter de briser la grève: elle décrète le lock-out.
........ l'usine est fermée
........ les directions syndicales poursuivent les négociations.

<u>15 JUIN</u> - Contre l'avis des centrales syndicales, un meeting se tient aux Mureaux; il est décidé d'envoyer une délégation à l'enterrement de Gilles Tautin, le lycéen noyé lors de la répression policière le 10 Juin. 150 ouvriers de Flins, les membres du Comité de Grève, se joignent aux 15000 travailleurs étudiants et lycéens qui suivent le cercueil.

<u>17 JUIN</u> - Convoqués par la direction, 8000 ouvriers (sur les 11000 de l'usine) votent à bulletins secrets.
   La direction de la CGT appelle fortement à la reprise du travail, qui est votée à une faible majorité (58% des voix).
   Les grévistes de Flins ont tenu près de 5 semaines. Leur détermination ne faiblit pas, ils continuent la lutte.

## BATELIERS

   Les bateliers ont été parmi les premiers à se mettre en grève. Depuis trois semaines ils ont installé des barrages sur la Seine et les canaux du nord et de l'est.
Le patronat procédait à une augmentation progressive du temps de travail, notamment du travail de nuit.
- Salaire de base d'un ouvrier : 480 F. 16h. de travail par jour.
- Retraite à 65 ans ( 360F. par mois pour un couple de vieux travailleurs).

## FASCISME

15 Juin

- Le gouvernement libère les plus importants chefs de l'OAS:
   Salan (réclusion perpétuelle)
   Lacheroy (condamné à mort par contumace).
   Curutchet (réclusion perpétuelle)
   Argoud (détention à perpétuité).
   45 autres membres de l'OAS.

- Le gouvernement interpelle des ouvriers, arrête à leur domicile 17 étudiants, en fait passer d'autres en jugement, procède à des perquisitions, et expulse 153 travailleurs et intellectuels étrangers.

## DOCKERS

17 JUIN

Les dockers de Marseille décident, à l'unanimité de poursuivre la grève.
   C'est le 29ème jour de grève.
Par solidarité, les dockers de tous les ports français, sauf Dunkerque, décident de cesser le travail pour 24 heures.

## RÉPRESSION

Nuit du 10 au 11 juin.

- Un fourgon Peugeot de la Faculté de Médecine, appartenant aux Domaines, immatriculé 82653 D, reconnu comme ambulance par la préfecture de police, portant les croix rouges, est attaqué et saccagé par les forces de l'ordre, place Ed. Rostand (Paris 5), sans aucun contrôle d'identité

- Une partie du matériel est pillée = un brancard, une lampe d'opération, des médicaments, la batterie, la dynamo, etc...

- Les quatre occupants sont violemment matraqués: le chauffeur: deux côtes cassées - l'infirmière: polytraumatismes - l'interne: traumatisme crânien - l'externe blessé, trois points de suture - deux d'entre eux sont hospitalisés à Cochin.

- A noter que par deux fois cette ambulance venait d'aller soigner des blessés des forces de police au commissariat central de Paris 5ème.

Un exemple parmi beaucoup d'autres.

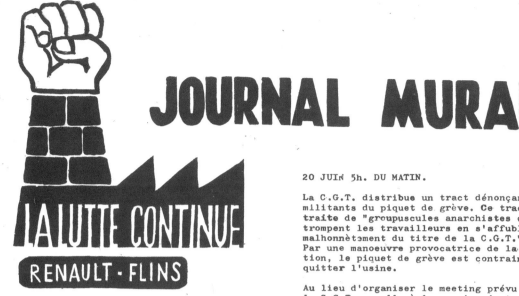

# JOURNAL MURAL 4

## LA LUTTE CONTINUE

### RENAULT - FLINS

**RAPPEL DES CONDITIONS DU VOTE DU 17 JUIN**

Lors du Meeting avant le vote :
- La CGT pousse à la "reprise victorieuse du travail".
- La CFDT et FO font appel à des prises de conscience individuelles.

Un vote à bulletin secret est organisé.

Au meeting, le "non" signifie le refus de reprendre le travail.
Mais sur le bulletin de vote, il faut bien regarder pour voir que ce "non" signifie le refus de poursuivre la grève.

Beaucoup de travailleurs s'y sont trompés, en particulier des étrangers (3000 travailleurs étrangers à Flins) qui ne savent pas toujours lire le français.

Ils ont donc voté "non" à la continuation de la grève, pensant voter "non" à la reprise.

**19 JUIN A 15h30**

Les ouvriers apprennent que la direction a pris des mesures de répression :

- dénonciation des contrats provisoires de travail, ce qui revient à licencier 40 travailleurs et à en réembaucher de nouveaux.
- augmentation des cadences : la production horaire de chaque chaine doit être portée de 60 à 67 voitures.
- diminution d'un tiers du temps de pose des ateliers de peinture ( 10 mn. au lieu de 15 toutes les deux heures).

A 15h40 les ouvriers commencent à débrayer. Ils prouvent ainsi que leur volonté de lutte n'est pas entamée. bientôt la grande majorité des travailleurs arrête le travail et tient un meeting.
Les directions CGT, CFDT recontactent la direction pour satisfaction des points ci-dessus.
Devant ce refus les syndicalistes prolétariens de la C.G.T. proposent la réoccupation immédiate de l'usine . Les délégués C.F.D.T. les appuient alors que les dirigeants C.G.T. s'y opposent, se contentant d'appeler à un meeting pour le lendemain matin 8h.
150 travailleurs constituent alors un piquet de grève malgré les maneuvres démobilisatrices des militants du PCF.

**20 JUIN 5h. DU MATIN.**

La C.G.T. distribue un tract dénonçant les militants du piquet de grève. Ce tract les traite de "groupuscules anarchistes qui trompent les travailleurs en s'affublant malhonnètement du titre de la C.G.T.".
Par une manoeuvre provocatrice de la direction, le piquet de grève est contraint de quitter l'usine.

Au lieu d'organiser le meeting prévu à 8h, la C.G.T. appelle à la reprise du travail : "aujourd'hui, la C.G.T. ne veut pas appeler les ouvriers à l'aventure d'une grève illimitée qui ne fait pas l'unité des travailleurs; par contre, nous (C.G.T.) les appelons à poursuivre leur pression permanente sous différentes formes, notamment par de <u>courts arrêts de travail</u> partout où l'union le permet." (C.G.T. Flins)

En faisant de tels appels, qui ne visent qu'à une pression sur la direction pour des négociations, la C.G.T. ne renforce pas l'unité de lutte des travailleurs, mais l'affaiblit.

Le travail a repris ... LA LUTTE CONTINUE.

### MÉTALLURGIE    20 juin.

Aprés une assemblée générale, les ouvriers mouleurs et modeleurs de plus de 20 petites et moyennes entreprises de la région parisienne réaffirment leur volonté de poursuivre la grève jusqu'à la satisfaction de leurs revendications: mensualisation, réduction d'horaire sans diminution de salaire, 13ème mois, et augmentation de salaire (12%)- reconnaissance des droits syndicaux.

### VIET-NAM    15 JUIN

Après l'offensive du Têt, destinée à montrer l'inéfficacité de la défense américaine, la deuxième offensive a permis de percer en de multiples endroits " la Ceinture de Défense entourant Saïgon.
M.Nguyen Van Tien, représentant du F.N.L. à Hanoï, souligne que désormais " à Saïgon nos forces augmentent en nombre et en qualité. Cela est possible avec l'appui de la population qui participe activement aux combats et des étudiants qui jouent le rôle de ferment dans le mouvement."

Le représentant du F.N.L a ajouté qu'il existait des comités révolutionnaires à l'échelon des quartiers dont la population s'était rendue maîtresse, et qu'un comité pour l'ensemble de la ville serait créé sur la base de ces comités de quartier.

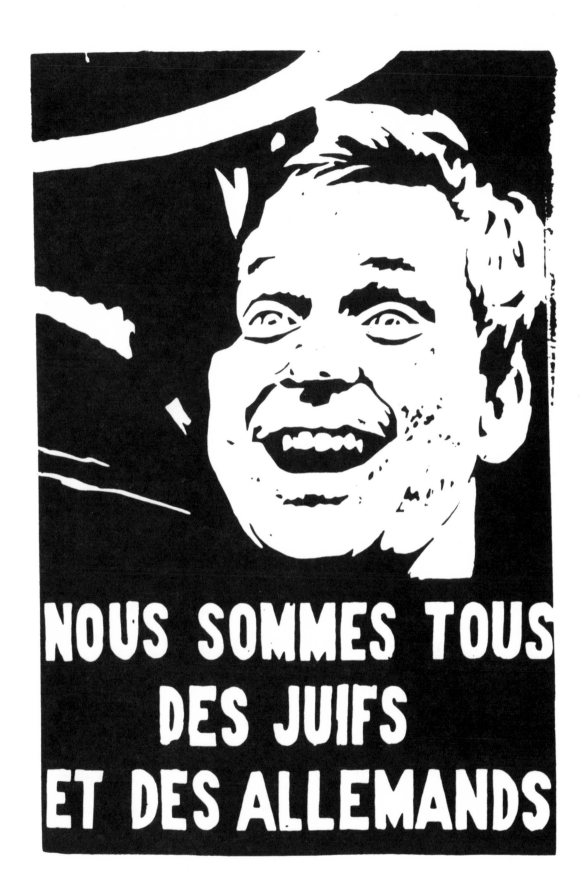

NOUS SOMMES TOUS
DES JUIFS
ET DES ALLEMANDS

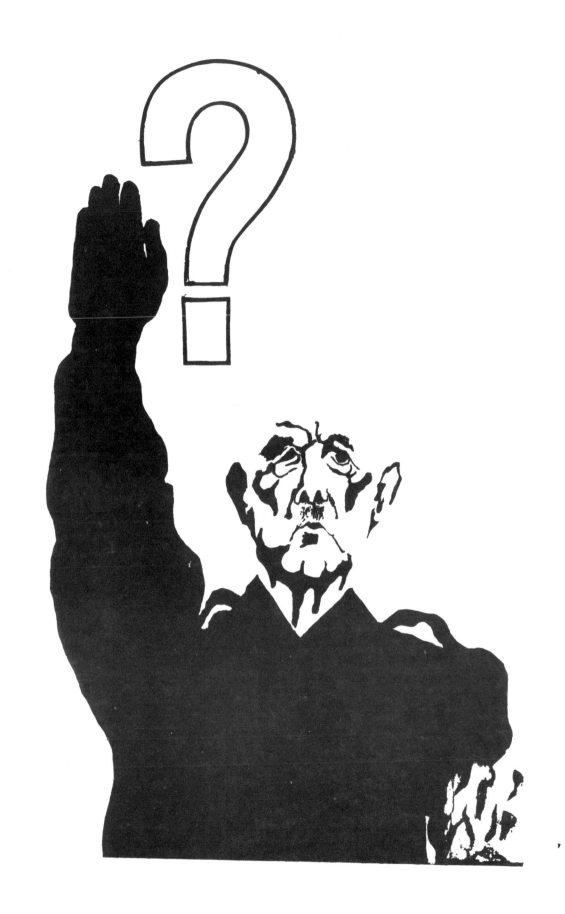

149

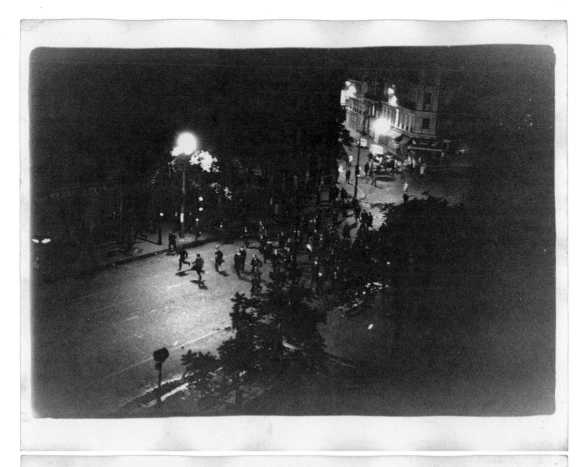

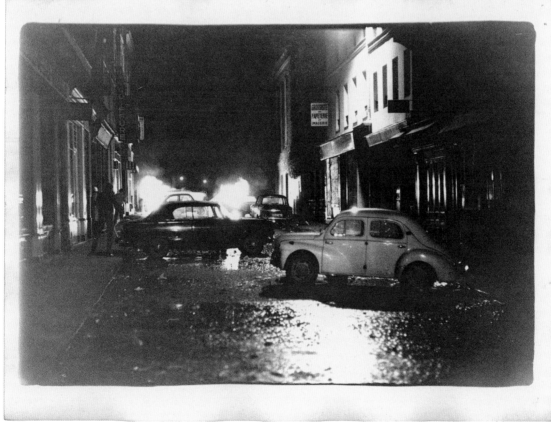

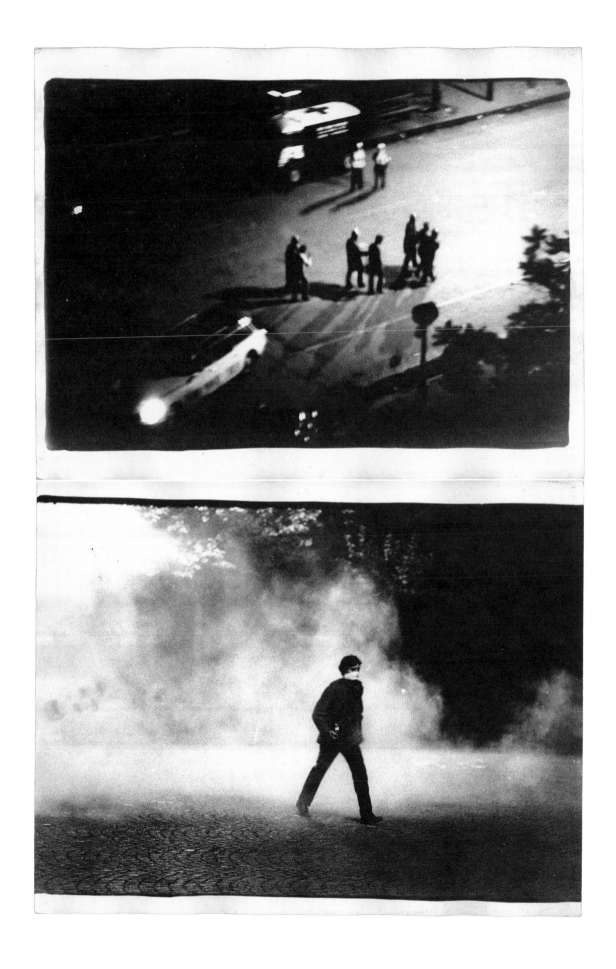

151

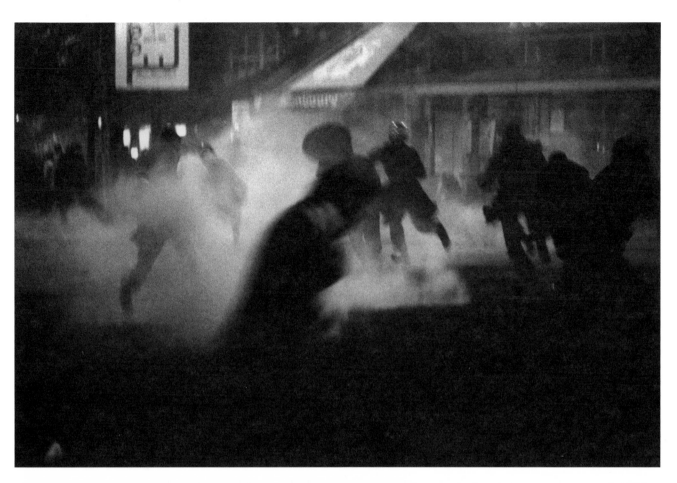

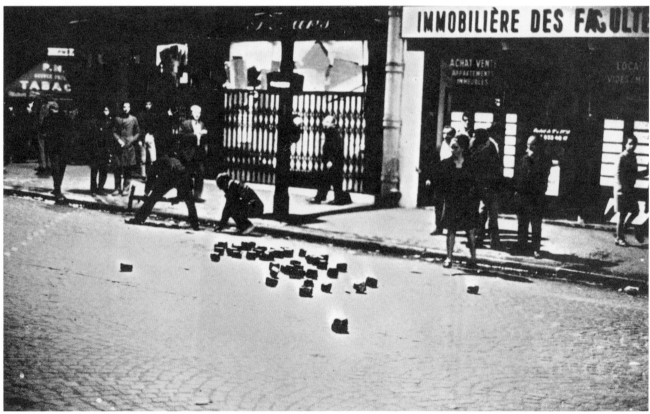

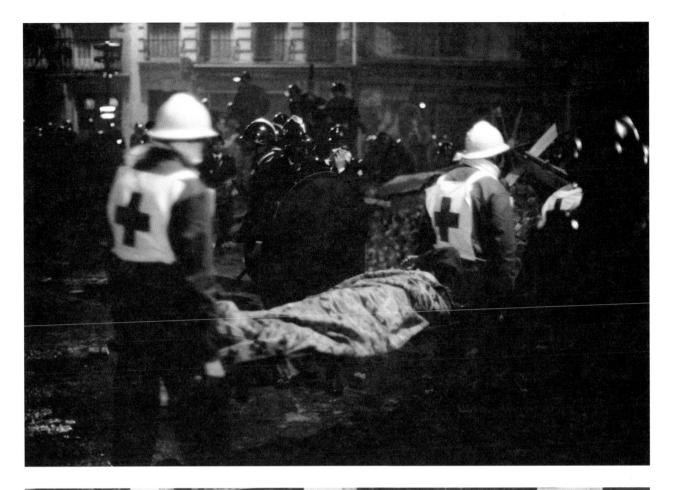

↓ Evacutation of injured student, night of May 10 to 11. *Photo by Bruno Barbey. Magnum.*

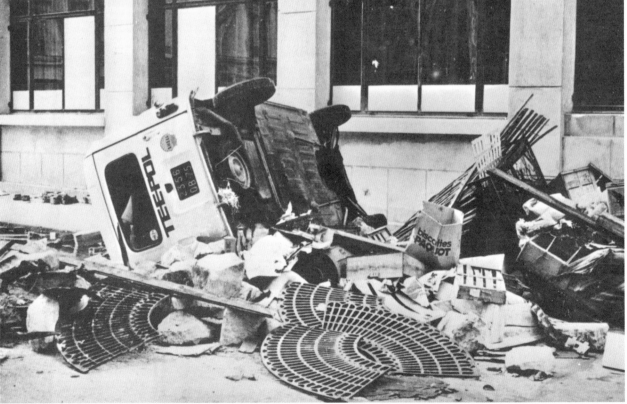

↓ The barricades in St. Germain, May 25, 1968. *Photographer unknown.*

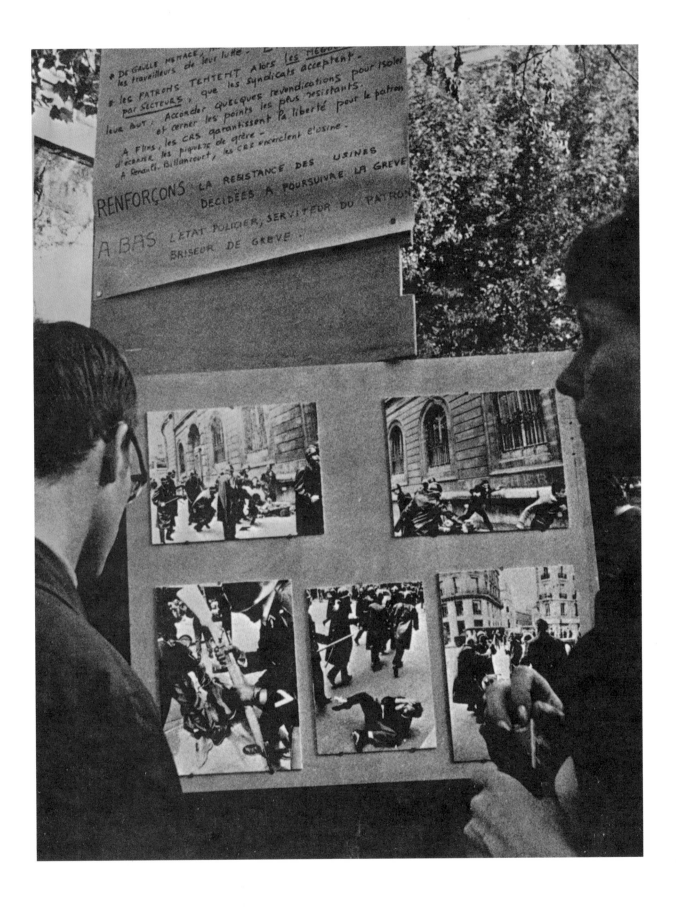

↑ Identifying police brutality. *Photographer unknown.*

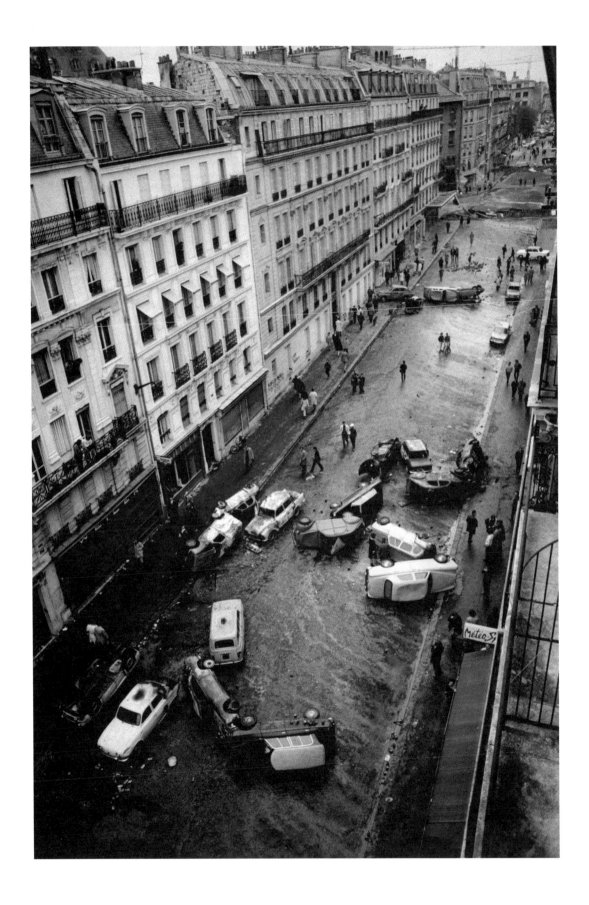

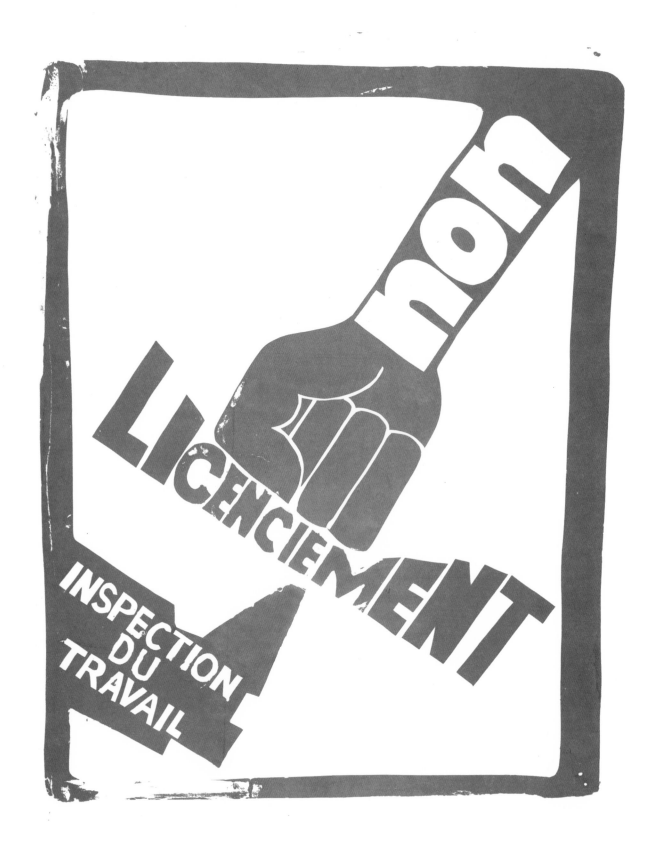

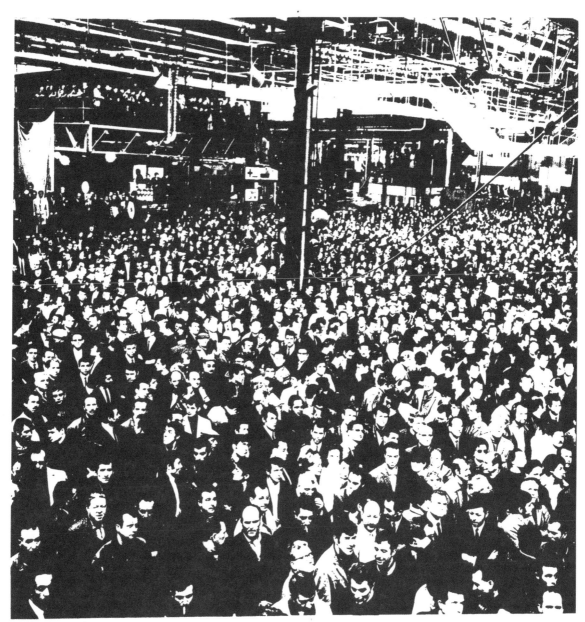

NOUS IRONS JUSQU'AU BOUT

# LE PATRON a besoin de toi

# TU n'as pas besoin de lui

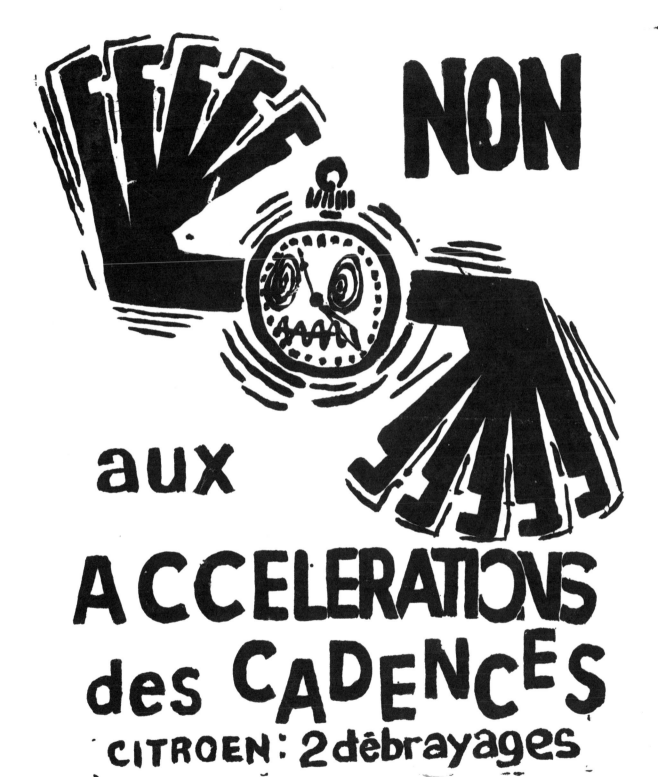

NON

aux

ACCELERATIONS
des CADENCES
CITROEN : 2 débrayages

# ST LAZARE
# 7 BLESSES

# CDR
# FASCISTES

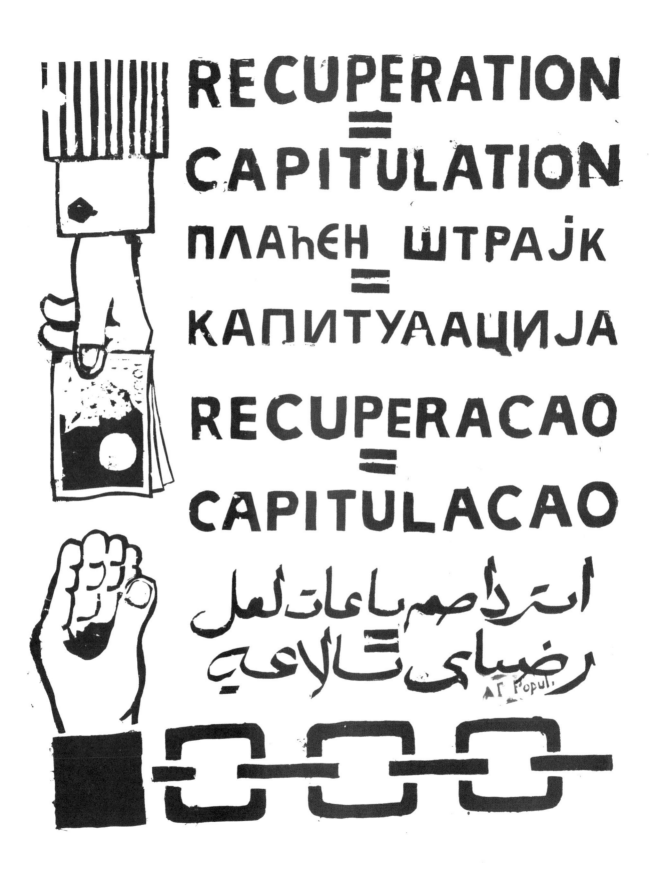

RECUPERATION
=
CAPITULATION

ПЛАЋЕН ШТРАЈК
=
КАПИТУЛАЦИЈА

RECUPERACAO
=
CAPITULACAO

LA LUTTE CONTINUE

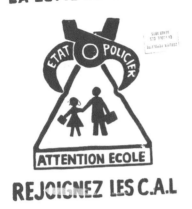

ÉTAT POLICIER

ATTENTION ECOLE

REJOIGNEZ LES C.A.L

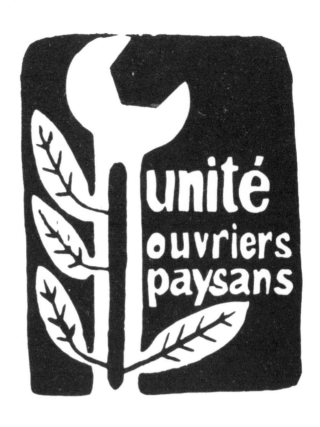

unité ouvriers paysans

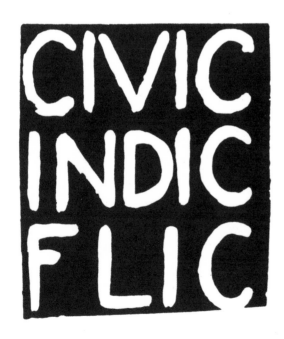

CIVIC INDIC FLIC

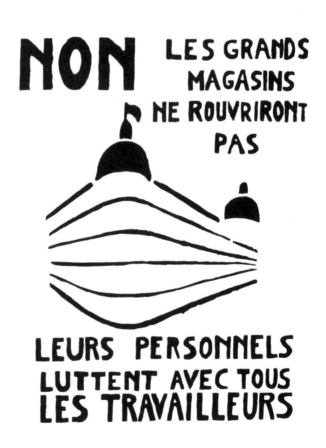

NON LES GRANDS MAGASINS NE ROUVRIRONT PAS

LEURS PERSONNELS LUTTENT AVEC TOUS LES TRAVAILLEURS

TRABAJADORES
FRANCESES
EMIGRADOS
UNIDOS

trabalhadores
francêses
emigrantes
unidos

عمال اجنبيون
وفرنسيون
متحدون

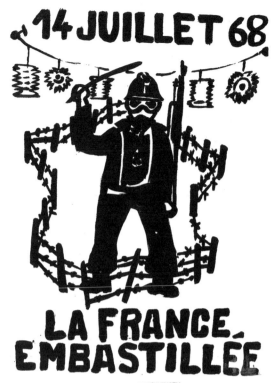

14 JUILLET 68

LA FRANCE.
EMBASTILLÉE

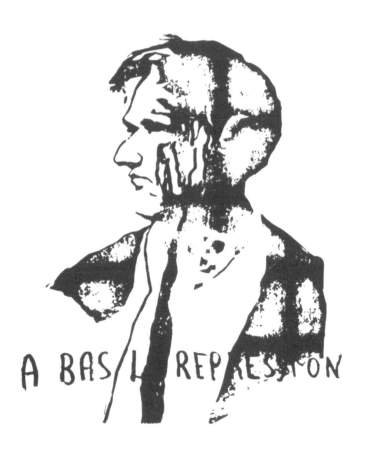

A BAS LA REPRESSION

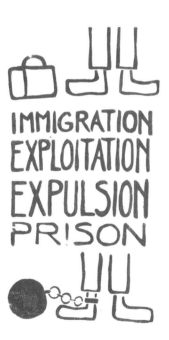

IMMIGRATION
EXPLOITATION
EXPULSION
PRISON

NON A L'ASSOCIATION
CAPITAL-TRAVAIL

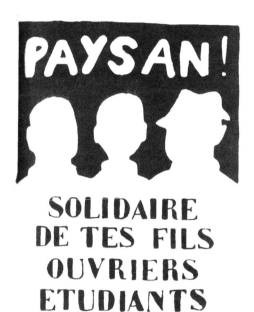

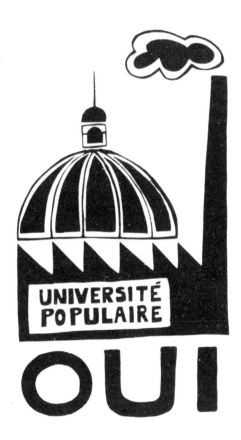

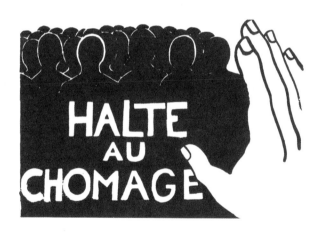

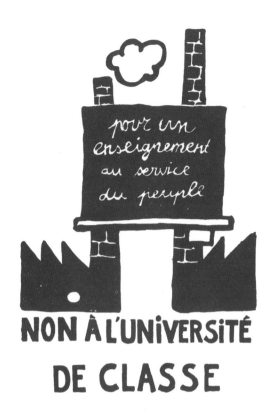

NON À L'UNIVERSITÉ
DE CLASSE

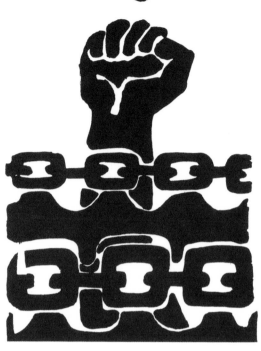

LA BASE
CONTINUE LE COMBAT

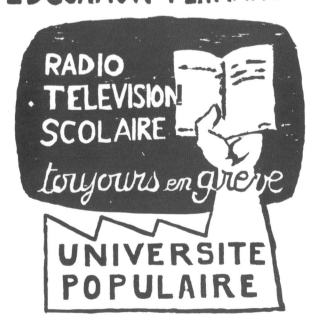

EDUCATION PERMANENTE

UNIVERSITE
POPULAIRE

PAS DE REPLATRAGE

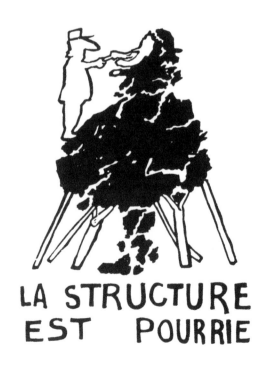

LA STRUCTURE
EST POURRIE

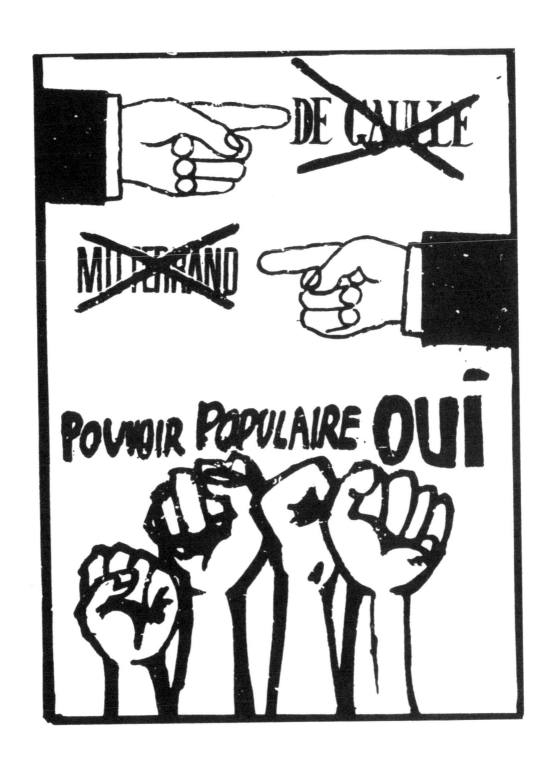

nous roulons
parce que nous avons
été trahis

nous voulons
une **CGT** propre
qui défende les interêts
de la classe ouvrière

# L'ELAN EST DONNE

## POUR UNE

# LUTTE PROLONGEE

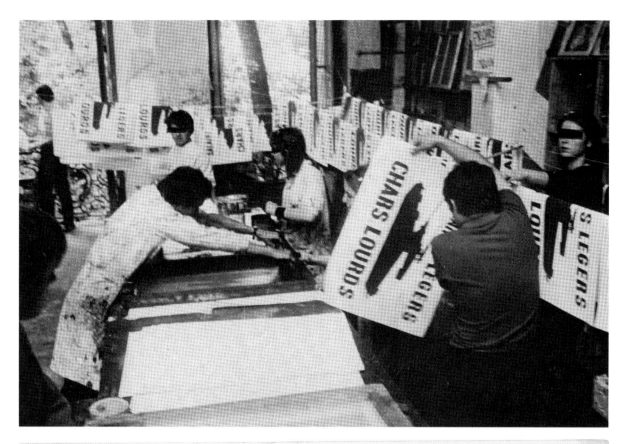

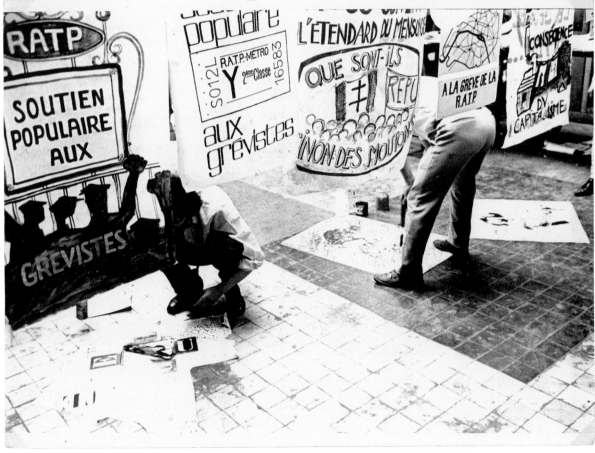

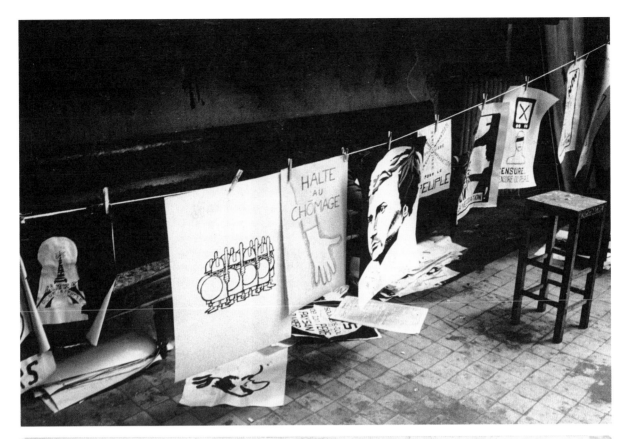

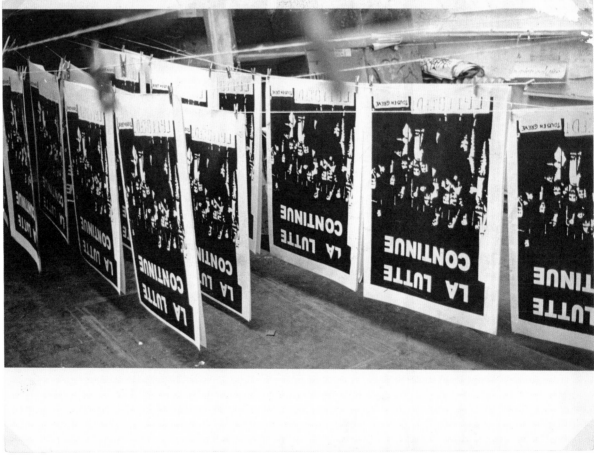

Silkscreening at the Atelier Populaire, May 1968. *Photograph by Philippe Vermès.*

171

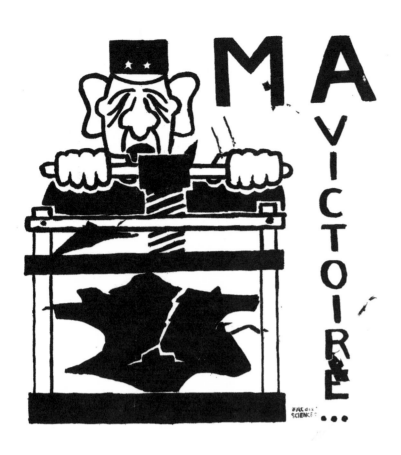

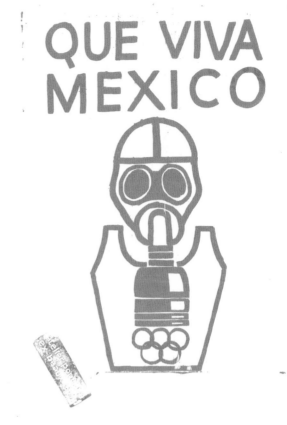

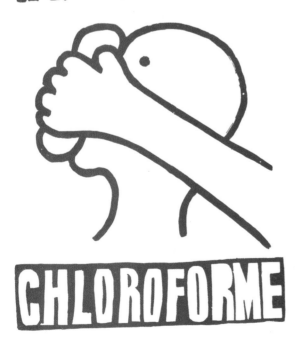

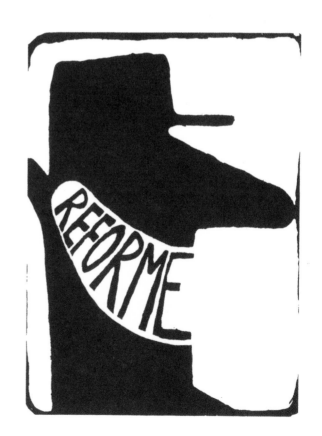

LA POLICE
A L'ORTF

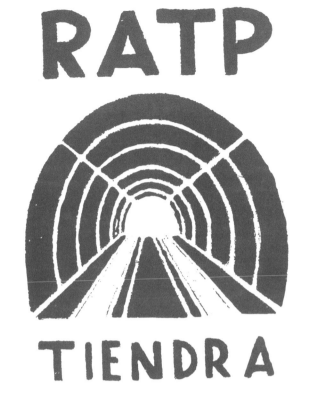

RTF

C'EST LA POLICE
CHEZ VOUS

RATP TIENDRA

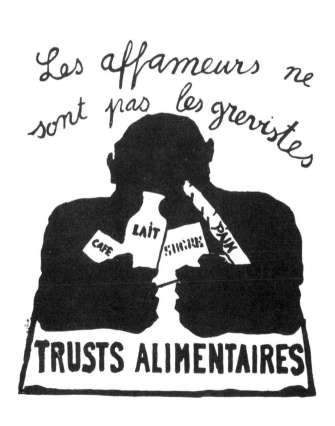

Les affameurs ne sont pas les grevistes

TRUSTS ALIMENTAIRES

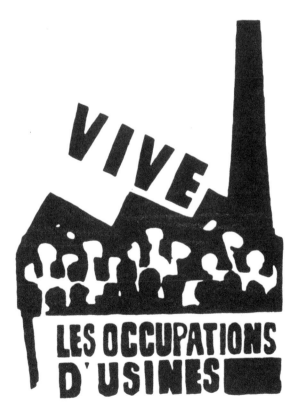

VIVE LES OCCUPATIONS D'USINES

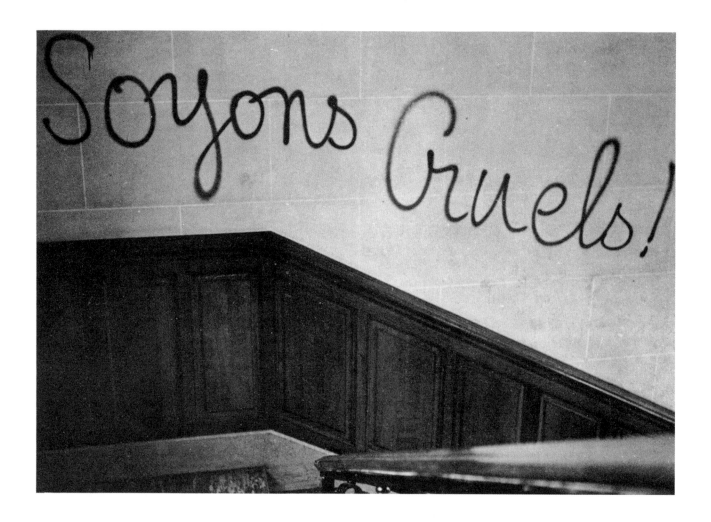

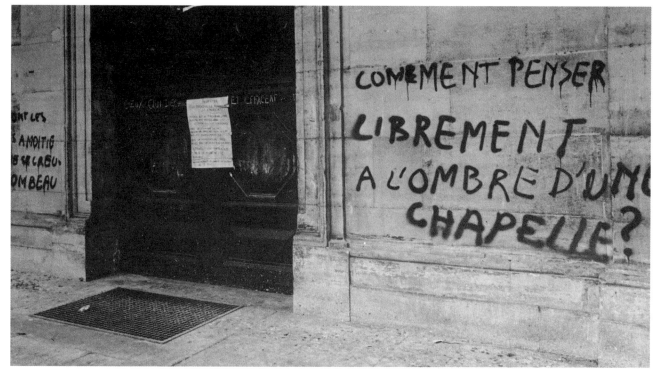

↑↑ Let's be cruel!
 *Monday, May 13. Sorbonne.*
↑  *Left:* Those who make revolutions halfway only dig a hole to fall into.  *Right:* How can you think freely in the shadow of a chapel?
 *Monday, May 13. Chappelle de la Sorbonne.*

↑ When the last sociologist has been strangled with the intestines of the last bureaucrat, will we still have problems?
Down with journalists and those who want to treat them gently
*Monday, May 13. Sorbonne.*
*Photographs by Jo Schnapp.*

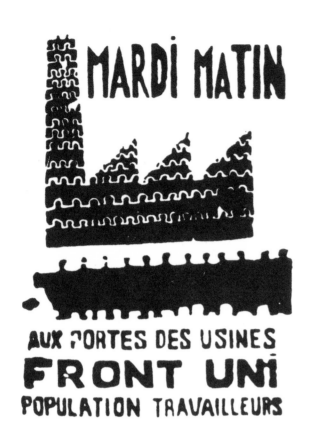

MARDI MATIN

AUX PORTES DES USINES
FRONT UNI
POPULATION TRAVAILLEURS

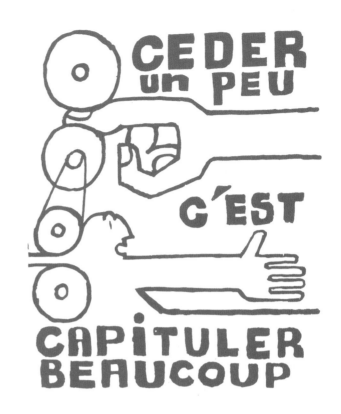

CEDER un PEU

C'EST

CAPITULER BEAUCOUP

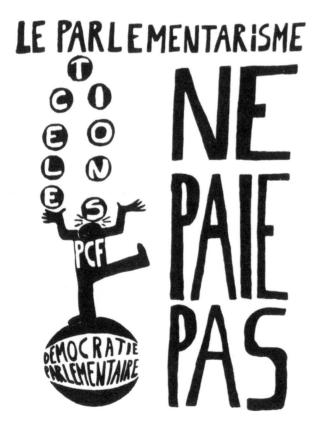

LE PARLEMENTARISME
ELECTIONS
PCF
DEMOCRATIE PARLEMENTAIRE
NE PAIE PAS

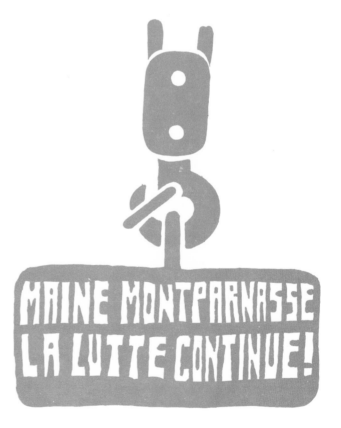

MAINE MONTPARNASSE LA LUTTE CONTINUE!

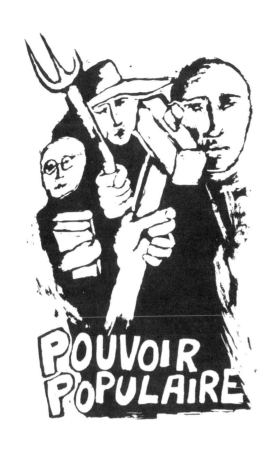

POUVOIR POPULAIRE

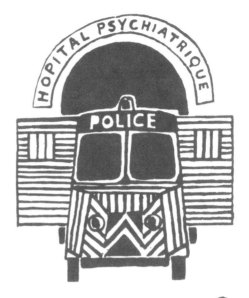

DÉNONÇONS LA PSYCHIATRIE POLICIERE !!

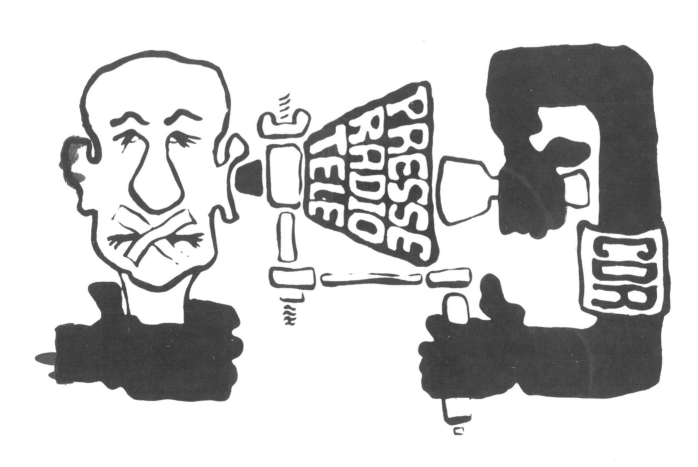

**comité d'action civique**

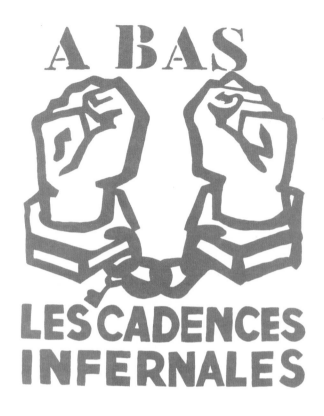

**A BAS LES CADENCES INFERNALES**

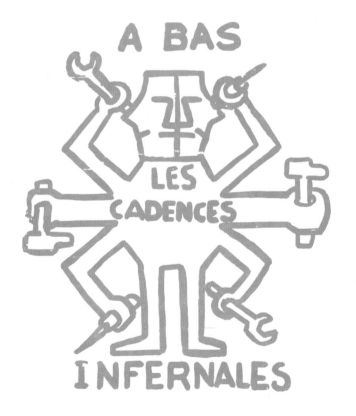

**A BAS LES CADENCES INFERNALES**

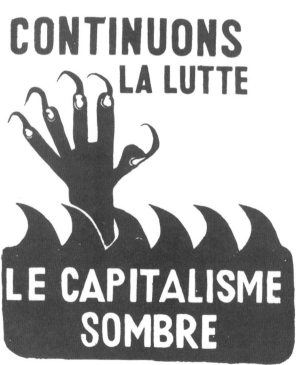

**CONTINUONS LA LUTTE**

**LE CAPITALISME SOMBRE**

# LES TRAVAILLEURS

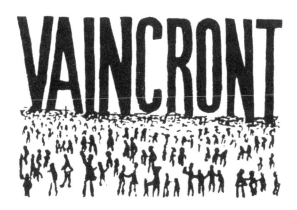

## VAINCRONT

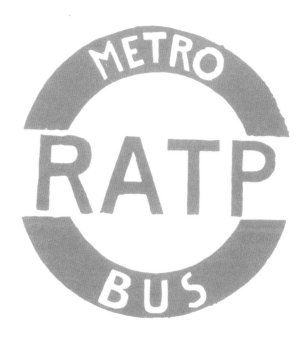

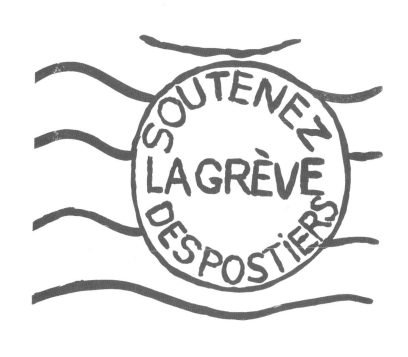

SOUTENEZ LA GRÈVE DES POSTIERS

METRO RATP BUS

LES GREVISTES SE BATTRONT
JUSQU'A LA VICTOIRE

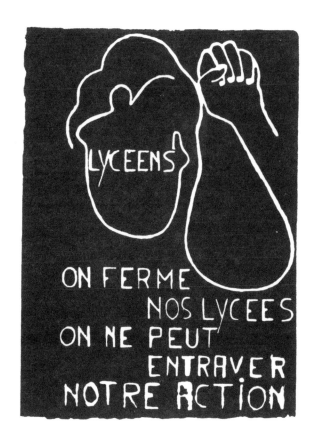

LYCEENS

ON FERME
NOS LYCEES
ON NE PEUT
ENTRAVER
NOTRE ACTION

# ELECTIONS

DIVERSION? ILLUSION? DERISION?
DIVISION? TRAHISON? RECUPERATION?

REGULIERES ?? *NON !*

truquées
- Listes électorales non revisées !
- Découpage des circonscriptions trafiqué !
- les jeunes de moins de 21 ans ne votent pas !
- 2.500.000 travailleurs (étrangers) ne votent pas !

DEMOCRATIQUES? *NON !*

facistes
- Des organisations progressistes sont dissoutes !
- le gouvernement libère les terroristes de l'O.A.S. !
- le pouvoir sème la répression dans les usines et dans la rue, par sa police et ses commandos C.D.R. !

LIBRES ?? *NON !*

intoxiquées
- L'O.R.T.F. est investie par l'armée !
- Europe et Luxembourg sont possedés par la bourgeoisie !
- La grande presse est à la solde du capital !

CES ELECTIONS SONT UNE MANOEUVRE DE DIVERSION
ET DE SABOTAGE CONTRE LA DEMOCRATIE REELLE, NEE EN MAI.

- EN MAI LE PEUPLE A CHOISI: ...
  LE POUVOIR AUX TRAVAILLEURS !

- EN JUIN LES POLITICIENS PANIQUÉS SE
  FONT COMPLICES DU POUVOIR CAPITALISTE
  EN CAUTIONNANT SES ELECTIONS

*Coordination des Comités d'Action.*

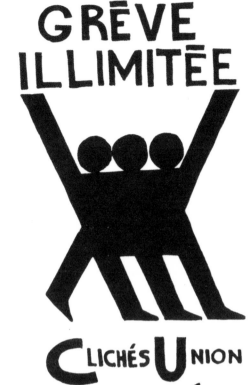

GRÈVE ILLIMITÉE

Clichés Union
MAI 1968

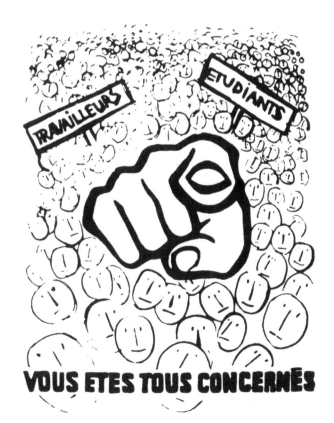

VOUS ETES TOUS CONCERNÉS

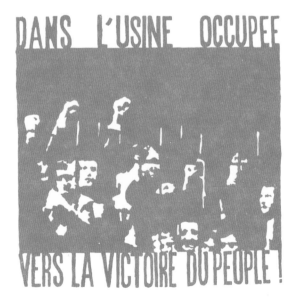

AUTOUR DE LA RESISTANCE
PROLETARIENNE
DANS L'USINE OCCUPEE

VERS LA VICTOIRE DU PEUPLE !

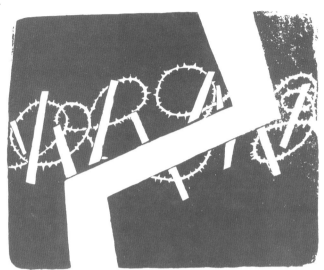

L'UNION DE TOUS LES TRAVAILLEURS BRISERA LES FRONTIERES

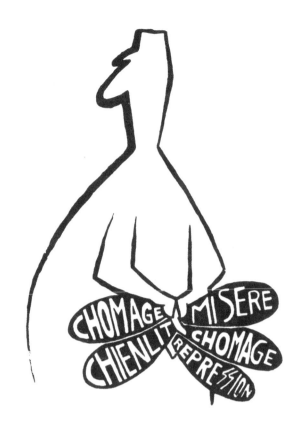

CHOMAGE MISERE CHIENLIT REPRESSION CHOMAGE

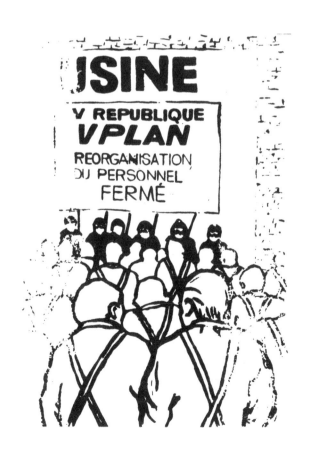

USINE V REPUBLIQUE VPLAN REORGANISATION DU PERSONNEL FERMÉ

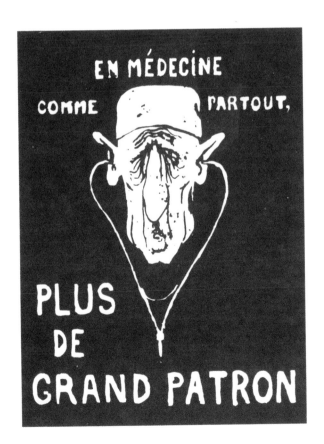

EN MÉDECINE COMME PARTOUT, PLUS DE GRAND PATRON

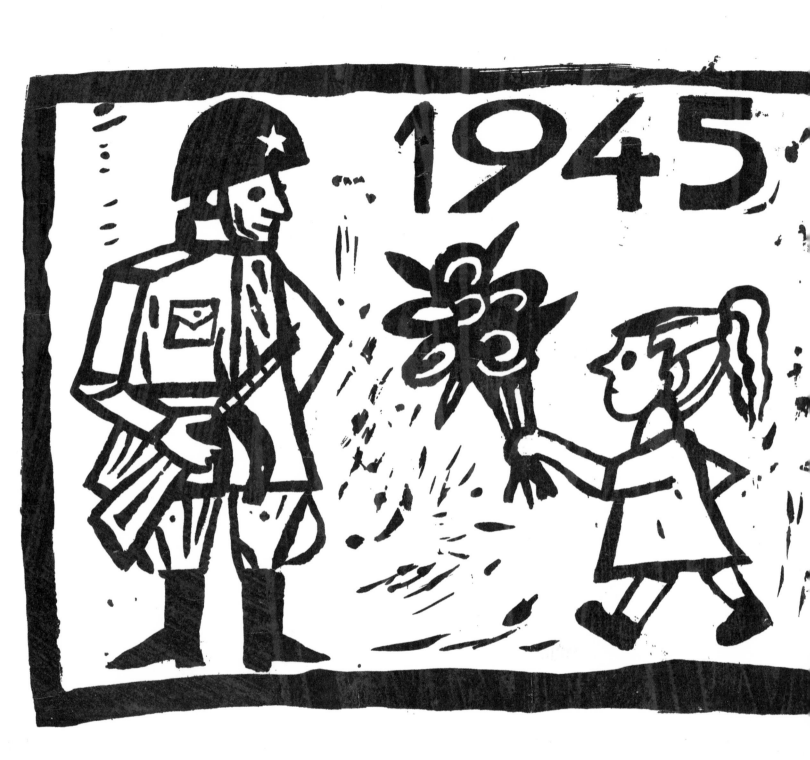

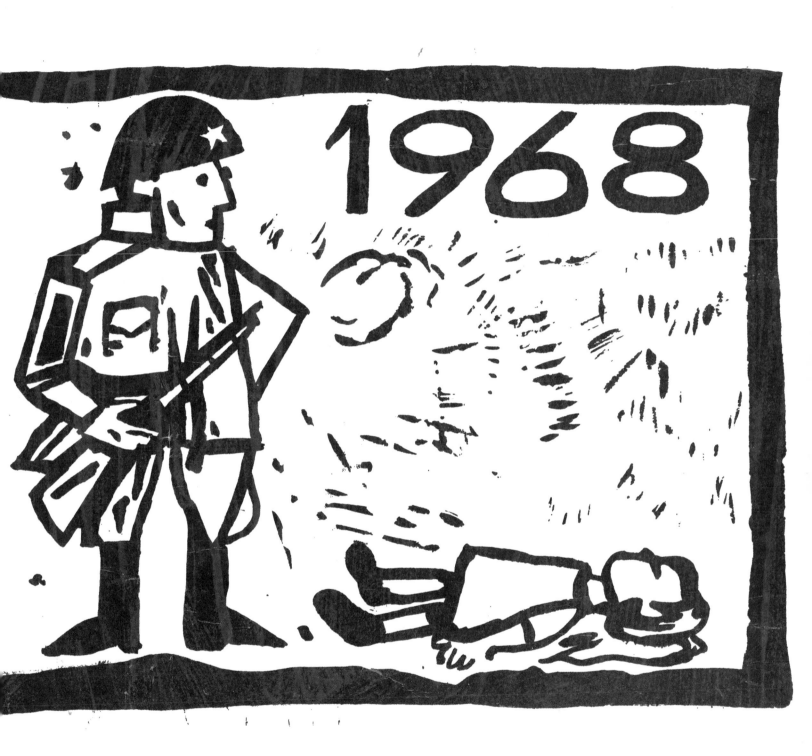

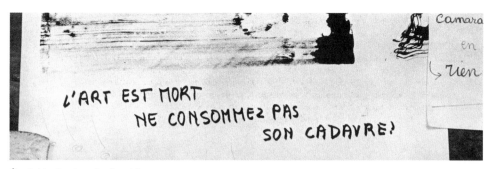

↑ Art is dead — don't eat its corpse
*Monday, May 13. Sorbonne.*

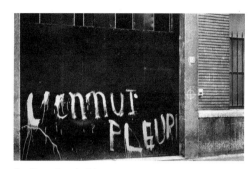

↑ Boredom in bloom
*Monday, May 6.*

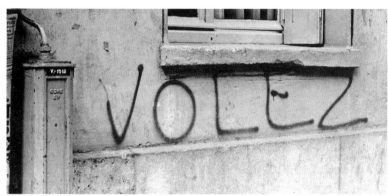

↑ Steal
*Monday, May 6.*

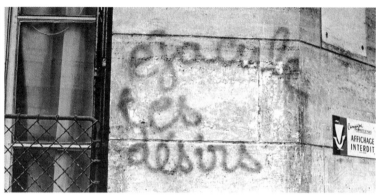

↑ Ejaculate your desires
*Monday, May 6.*

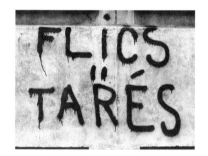

↑ Crazy cops
↓ Students and workers in solidarity
  SS = Cop + Cash = [the Gaullist republic]
  Comrades, if all people did as we do…
  *Friday, May 10. Institut de Géographie.*

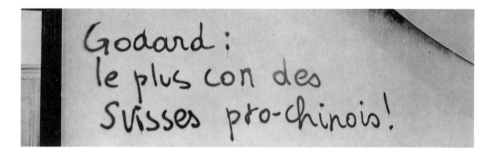

↑ Godard: the biggest idiot of all the pro-Chinese Swiss!
*Monday, May 13. Sorbonne.*

↓ The more you consume, the less you live
  *Monday, May 6.*

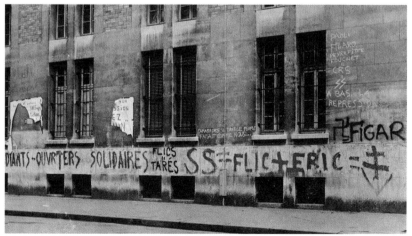

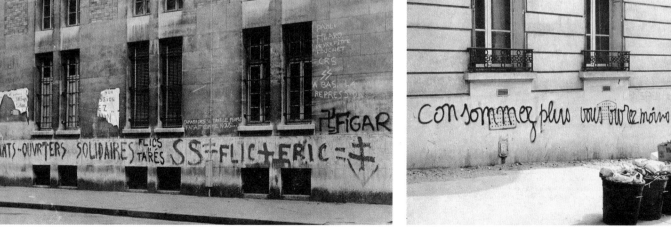

*Photographs by Jo Schnapp.*

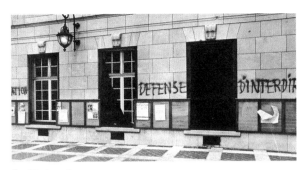

↑ No banning
*Friday, May 10. Rue d'Ulm.*

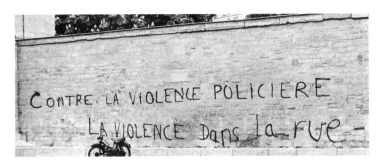

↑ Against police violence — violence in the street
*Friday, May 10.*

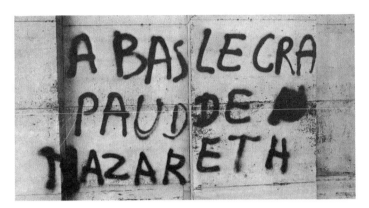

↑ Down with the toad of Nazareth
*Monday, May 13. Chapelle de la Sorbonne.*

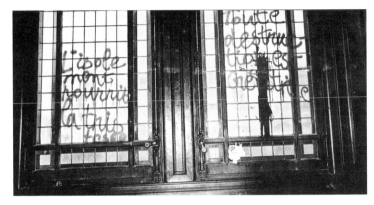

↑ Isolation feeds sadness / All destruction is a creator
*Monday, May 13. Sorbonne.*

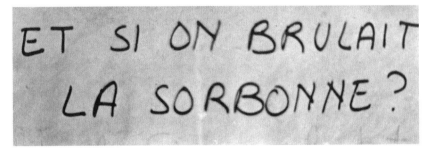

↑ And if we burned the Sorbonne?
*Monday, May 13. Sorbonne.*

↓ To live without dead time, to come without fetters
*Monday, May 6. Rue Saint-Sulpice.*

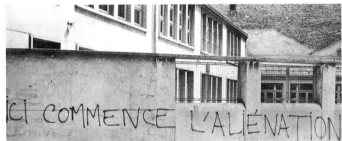

↑ Alienation begins here
*Monday, May 6. The gates of a school on Rue Jean-Calvin.*

↓ Run, comrade, the old world is behind you
*Monday, May 13. Sorbonne, Grande Amphithéâtre.*

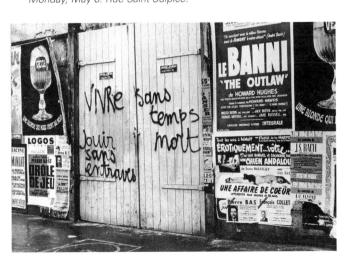

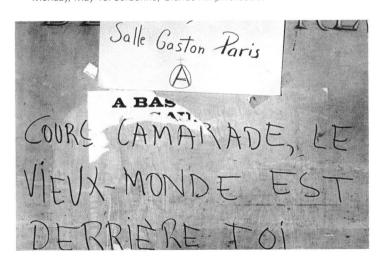

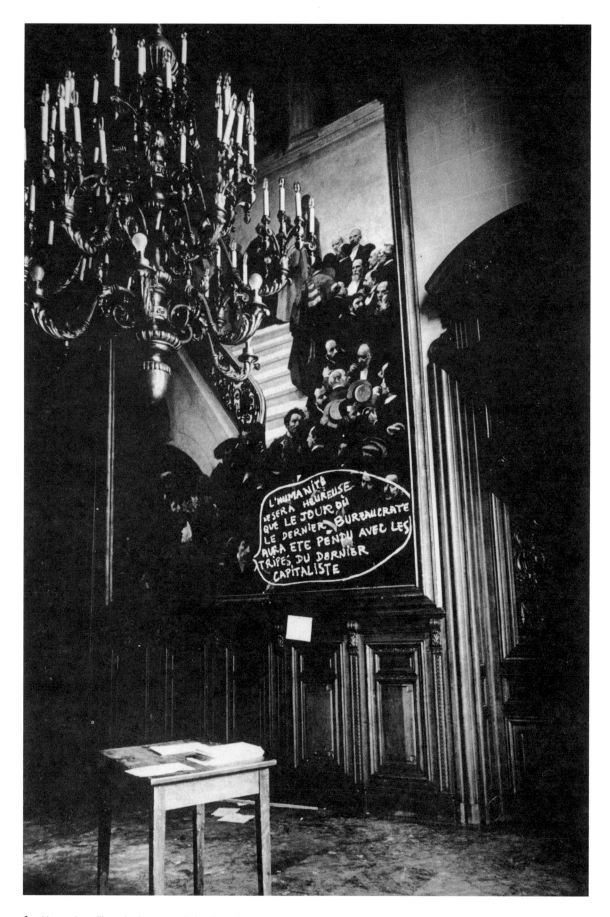

↑ Humanity will not be happy until the day when the last
bureaucrat has been hanged with the intestines of the last capitalist
*Monday, May 13. Sorbonne. On a painting by André Devambez in the stateroom of Staircase A.*

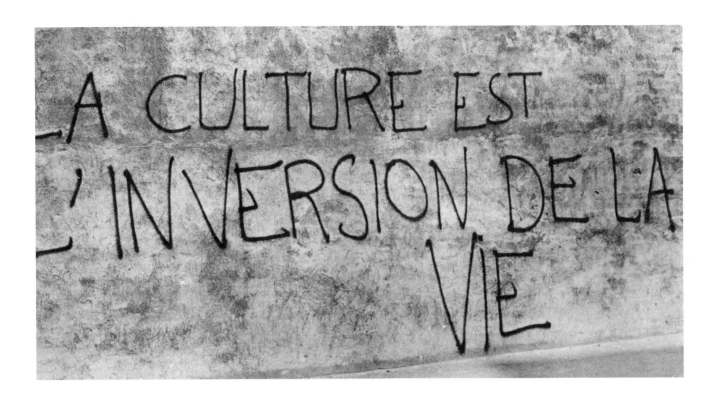

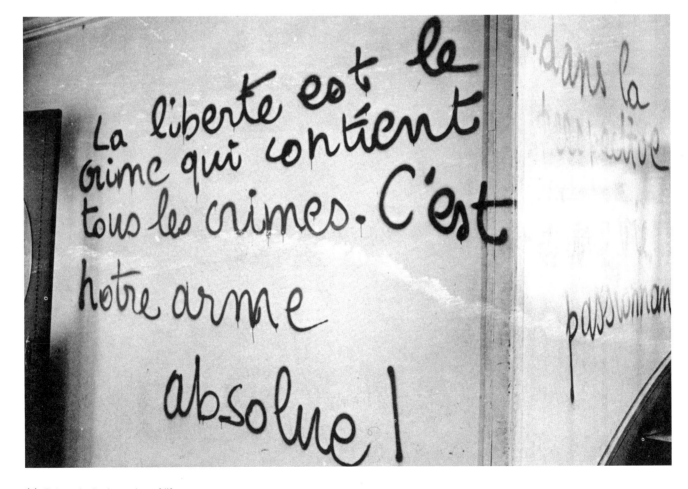

↑↑ Culture is the inversion of life
*Monday, May 6.*
↑  Liberty is the crime that contains all crimes; it is our ultimate weapon
*Monday, May 13. Sorbonne.*
*Photographs by Jo Schnapp.*

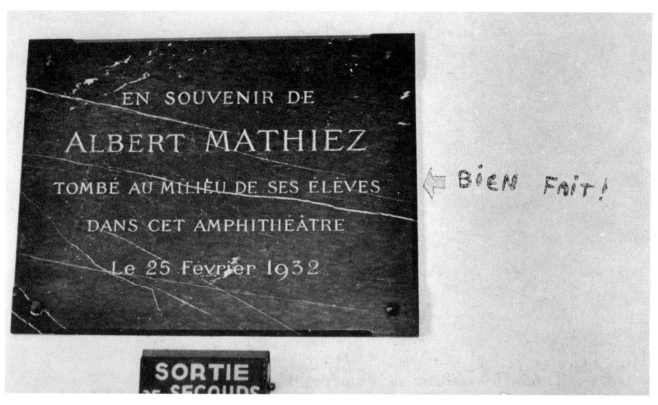

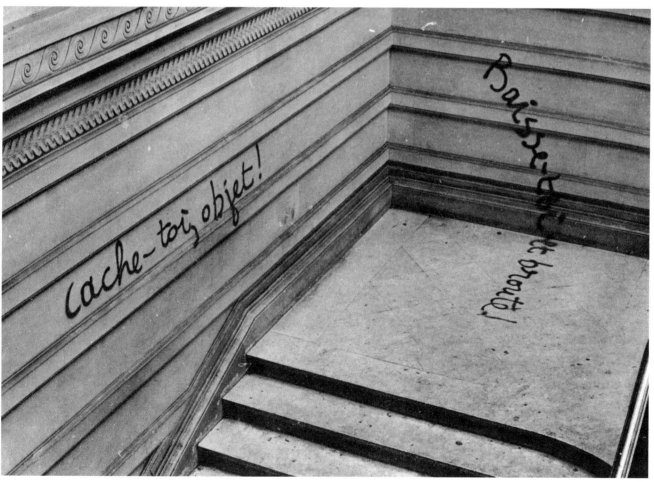

Photographs by Jo Schnapp.

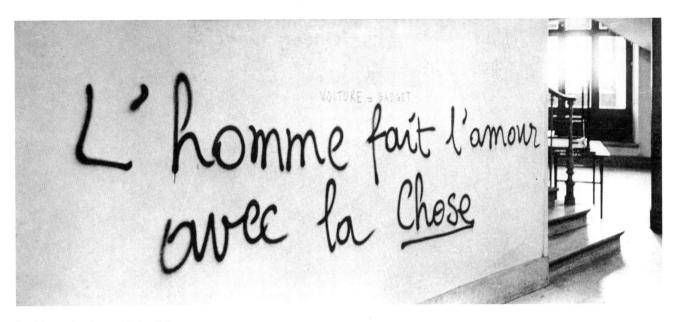

↑   Man makes love with the Thing.
←   [In memory of Albert Mathiez, fallen among his students in this amphitheater, February 25, 1932] — Well done!
     *Monday, May 13. Sorbonne.*

←   Hide yourself, object! Fall down and graze!
↓   I take my desires for reality because I believe in the reality of my desires
     *Monday, May 13. Sorbonne, near the Grand Amphithéâtre.*

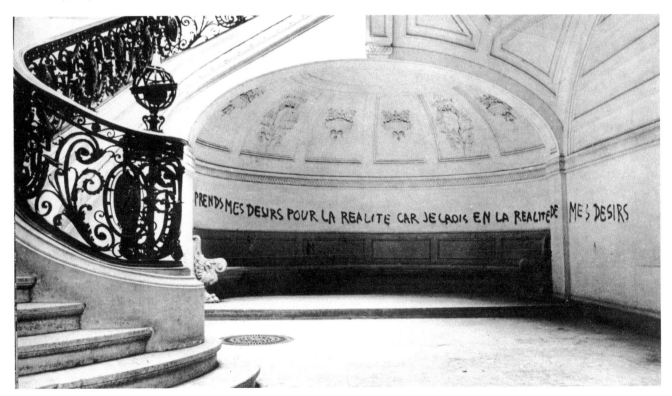

1

2

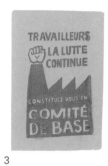

3

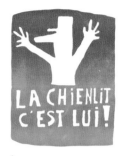

4

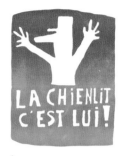

5

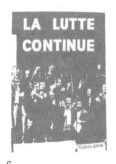

6

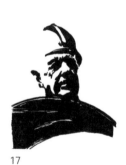

7

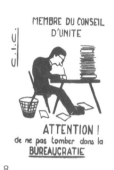

8

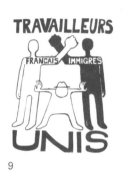

9

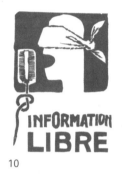

10

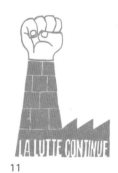

11

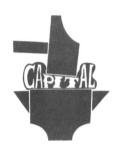

12

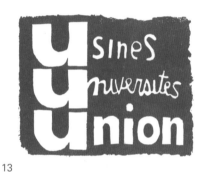

13

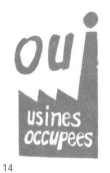

14

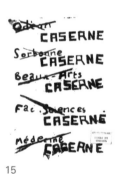

15

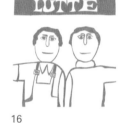

16

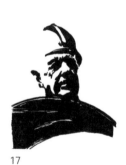

17

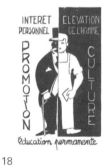

18

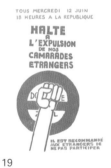

19

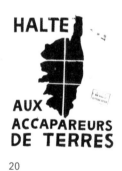

20

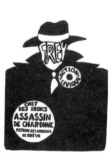

21

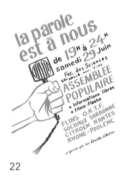

22

1 May '68—beginning of a prolonged struggle [p. 5]　　2 What's changed? [p. 6]　　3 Workers, the struggle continues—form grassroots committees [p. 8]
4 He's the shitty mess!—*May 19* [p. 16]　5 Be young and shut up [p. 17]　6 The struggle continues—all on strike [p. 23]　7 Light wages—Heavy tanks [p. 24-25]
8 Member of the Council of Unity: Warning!—Do not fall into bureaucracy [p. 27]　　9 Workers unite—French/Immigrant [p. 28]　　10 Free information [p. 29]
11 The struggle continues [p. 30]　　12 Capital—*Third week of May* [p. 31]　　13 Factories, Universities, Union—*May 14* [*The first poster produced by the Atelier Populaire*] [p. 32]　　14 Yes—Occupied factories—*May 28* [p. 33]　　15 Odeon, Sorbonne, etc… Barracks [p. 40]　　16 The same problem, the same struggle [p. 41]
18 Personal Interest—Elevation of Man—Promotion—Culture—Continuous education [p. 43]　　19 End the expulsion of our foreign comrades—All day Wednesday June 12-6 p.m. at La Republique—*June 12* [p. 43]　　20 Stop the land monopolizers [p. 43]　　21 Frey—civic action—Chief of the Informers—Murderer of Charonne—Boss of the strikebreakers—*June 7* [p. 43]　　22 Speech is ours… People's Assembly [p. 44]

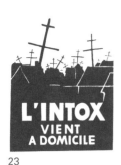

23

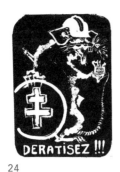

24

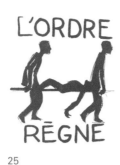

25

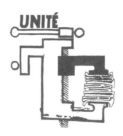

26

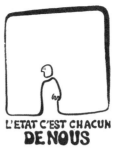

27

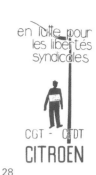

28

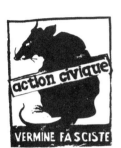

29

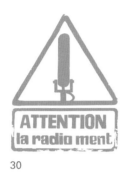

30

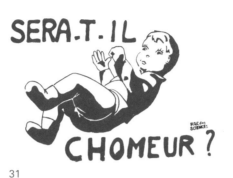

31

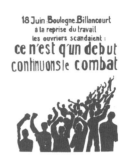

32

33

34

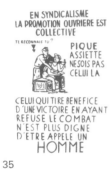

35

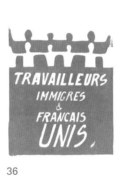

36

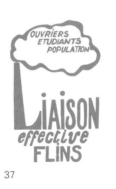

37

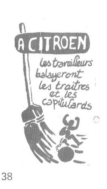

38

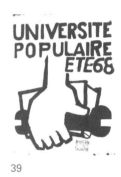

39

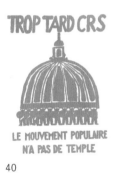

40

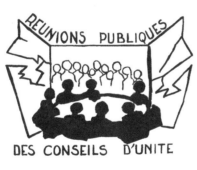

41

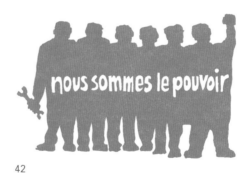

42

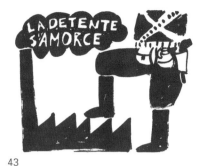

43

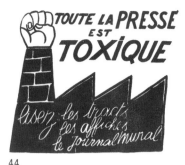

44

45

RENAULT FLINS
NOUVELLE ETAPE

VENDREDI, FLINS 5000 CRS BLOQUENT L'USINE
5h..... FACE AUX FLICS 9000 OUVRIERS S'UNISSENT
POUR CONTINUER LA GREVE
10h..... LES FLICS ATTAQUENT A LA GRENADE
OFFENSIVE LE RASSEMBLEMENT OUVRIER
LES CRS. SONT LES SEULS PROVOCATEUR
LE POUVOIR ET LA RADIO PRETENDENT QUE C
SONT LES ETUDIANTS QUI SE BATTENT
DE 10 heures AU LENDEMAIN LES OUVRIERS
ORGANISENT ET DIRIGENT LA RIPOSTE
POUR TOUT LE MOUVEMENT GREVISTE
DES SECTEURS REPRENNENT LA GREVE
PAR SOLIDARITE. LES TRIS POSTAUX FURENT LES
PREMIERS
SOLIDAIRES AVEC FLINS...
MOBILISONS NOUS SAMEDI DIMANCHE
LUNDI POUR CONTRIBUER AU RENFORCEMENT
DU MOUVEMENT DE GREVE

46

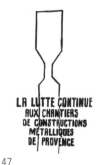

47

48

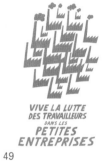

49

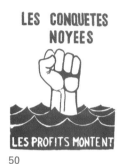

50

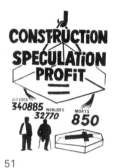

51

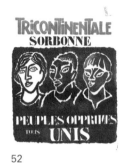

52

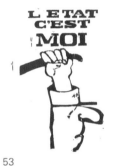

53

SOUTIEN
POPULAIRE
DE LA
GREVE
DE
L'EDF

54

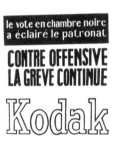

55

FLINS
PAS
FLICS

56

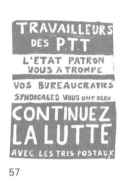

57

LE VOTE À BULLETIN
SECRET EST UNE
MÉTHODE DU PATRON
POUR BRISER L'UNITÉ
OUVRIÈRE.

UN OUVRIER QUI N'OSE
PAS DIRE SON OPINION
DEVANT SES CAMARADES
NE MÉRITE PAS LE NOM
D'HOMME.

58

---

**43** The situation is improving [*In response to police invasion of Renault Flins*]—*June 7 or 8* [p. 56-57]  **44** All press is toxic—read tracts, posters, the Wall Newspaper—*June 12* [p. 58]  **45** Theater of Unity—The Song of the Lusitanian Puppet by Peter Weiss—*June 13* [p. 58]  **46** Renault Flins—latest: Friday, Flins: 5,000 CRS bar the factory. 5 o'clock: Facing the cops, 9,000 workers unite to continue the strike. 10 o'clock: The cops attack the assembled workers with a grenade offensive. The CRS are the sole provocateurs! Power and the radio claim that it was the students who where fighting. From 10 o'clock onwards the workers organize and direct their response for the entire strike movement. Some sectors return to the strike in solidarity, starting with the postal sorters. SOLIDARITY WITH FLINS... Let's mobilize on Saturday, Sunday, Monday to strengthen the strike movement!—*June 7 or 8* [p. 58]  **47** The struggle continues at the metalworks of Provence—*First week of June* [p. 58]  **48** Gaullist participation—*Third week of May* [p. 59]  **49** Long live the struggle of the workers in small factories— *June 10* [p. 59]  **50** Achievements sinking—profits rising—*June 27* [p. 59]  **51** Construction, speculation, profit = 340,885 injured, 32,770 disabled, 850 dead [p. 59] **52** Tricontinental Sorbonne—Oppressed people all united [p. 60]  **53** I am the state—*Fourth week of May* [p. 61]  **54** Popular support for the EDF strike—*May 18 or 28* [p. 62]  **55** Kodak: The vote in the darkroom throws light on the bosses—counter-offensive—the strike continues!—*Early June* [p. 62]  **56** Flins not cops— *June 9* [p. 62]  **57** Workers of the PTT—The boss state has tricked you—Your union bureaucracies have deceived you—Continue the struggle with the mail sorters —*ca. June 27* [p. 62]  **58** Voting by secret ballot is the boss's way of breaking the workers' unity. A worker who doesn't dare to speak his opinion before his comrades does not deserve to be called a man.—*June 17* [p. 62]

192    TRANSLATIONS OF POSTERS

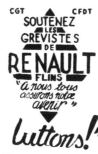
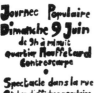
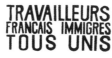
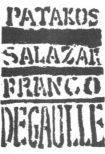
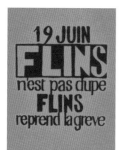
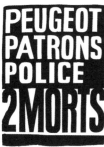
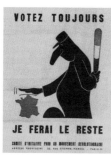
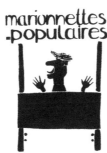
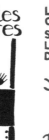
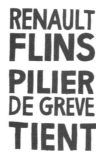
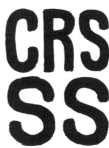

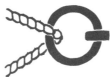

59 We will not be dupes! June 1936: the workers' achievements were reversed by the bourgeoisie in less than two years. The miners' strike of '63: The bosses won back what they had conceded in less than two months. How? Increasing prices; Inflation; Organized unemployment; The violation of union freedoms as soon as they were recognized. Under pain of suicide, the capitalist system is forced to take back what it has lost. Only with the workers in power can the satisfaction of our demands be guaranteed! [p. 62]   60 Support the strikers of Renault-Flins—It's up to all of us to assure our future—let's struggle! [*Requested by Flins workers*]—*May 25* [p. 62]   61 Working comrades! Against the provocations of the bosses and police; against defeatism and capitulation; for the satisfaction of all demands; rejoin our battle station against capital, the occupied factory! Let's organize self-defense! We will win!—*May 30* [p. 62]   62 Patakos, Salazar, Franco, de Gaulle—*May 31* [p. 62]   63 By stopping our machines in unison, we demonstrate to them their weakness [*Created for the Strike Committee of Contrexeville*] [p.63]   64 19 June: Flins is not fooled. Flins goes back on strike—*Third week of May* [p. 63]   65 People's Day—Sunday June 9 from 9 o'clock to midnight, Quartier Mouffetard, Contrescarpe. Spectacle in the street, People's poster workshop, Debates: News at the ORTF, the workers' struggles; People's party—*June 6* [p. 63]   66 Workers—French, immigrant—all united—for equal work, equal pay [p. 63]   67 Renault Flins, pillar of the strike, holds firm—*June 11* [p. 63]   68 CRS-SS—*Third week of May* [p. 63]   69 Power is calm—It has constructed its own electoral machine—let's battle on our terrain, the occupation of the factories—*June 16* [p. 61]   70 Peugeot Bosses Cops—2 dead [*After the death of two protesters at the Sochaux Peugeot factory*]—*June 13*  [p. 63]   71 Keep voting—I will do the rest—Initiating Committee for a revolutionary movement [p. 66]   72 People's puppets—*June 11* [p. 66]   73 The struggle continues—we support the strike of the boatmen—*June 21* [p. 66]   74 His master's voice [p. 66]   75 No! [p. 67]

**LA LUTTE CONTINUE**

76

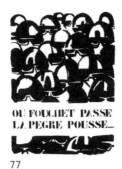

OU FOUCHET PASSE LA PEGRE POUSSE...

77

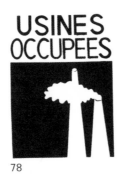

**USINES OCCUPEES**

78

FREY

79

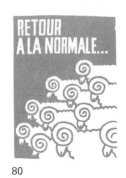

RETOUR A LA NORMALE...

80

une jeunesse que l'avenir inquiète trop souvent

81

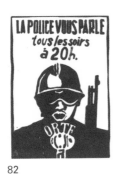

LA POLICE VOUS PARLE tous les soirs à 20h. ORTF

82

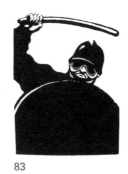

83

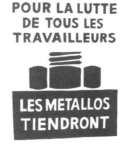

SOUTENEZ LES CHEMINOTS EN GREVE AVEC et POUR LES TRAVAILLEURS

84

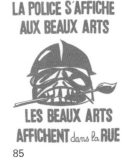

LA POLICE S'AFFICHE AUX BEAUX ARTS LES BEAUX ARTS AFFICHENT dans la RUE

85

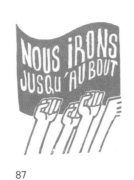

NOUS SOMMES TOUS "INDESIRABLES"

86

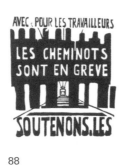

NOUS IRONS JUSQU'AU BOUT

87

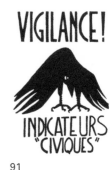

AVEC et POUR LES TRAVAILLEURS LES CHEMINOTS SONT EN GREVE SOUTENONS.LES

88

POUR LA LUTTE DE TOUS LES TRAVAILLEURS LES METALLOS TIENDRONT

89

CHAUFFEURS DE TAXIS la lutte continue

90

VIGILANCE! INDICATEURS "CIVIQUES"

91

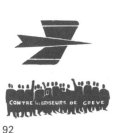

SOLIDARITE AVEC LA GREVE DES POSTIERS CONTRE les BRISEURS DE GREVE

92

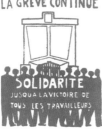

JEUDI 6 JUIN DEPOT LE BRUN LA GREVE CONTINUE SOLIDARITE JUSQU'A LA VICTOIRE DE TOUS LES TRAVAILLEURS

93

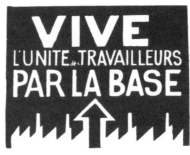

DOUANE COHN-BENDIT PASSERA

94

VIVE L'UNITE des TRAVAILLEURS PAR LA BASE

95

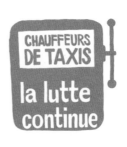

---

76 The struggle continues—*Fourth week of May* [p. 67]   77 Where Fouchet passes the mob pushes…—*May 25* [p. 67]   78 Occupied factories—*Third week of May* [p. 67]   79 Frey [*Minister of the Interior*]—*Early June* [p. 68-69]   80 Back to normal…—*June 2, reprinted June 27* [p. 70]   81 A youth who worries too much about the future [p.71]   82 The police speak to you every night at 8 p.m.—*May 25 or June 3* [p. 72]   83 *May 17* [p. 73]   84 Support the striking railway workers—with and for the workers—*June 2* [p. 84-85]   85 The police post themselves at the School of Fine Arts—the Fine Arts students poster the streets—*Fourth week of June* [p. 90]   86 We are all "undesirables"—*ca. June 22* [p. 91]   87 We will go on until the end—*First week of June* [p. 92]   88 With and for the workers, the railway workers are on strike—let's support them—*First week of June* [p. 92]   89 For the struggle of all workers—the metalworkers will hold firm—*Second week of June* [p. 92]   90 Taxi drivers—the struggle continues—*Second week of June* [p. 93]   91 Vigilance! "Civic" informers—*June 2* [p. 93]   92 Solidarity with the postal workers' strike—against the strikebreakers [p. 93]   93 Thursday June 6—Le Brun station—The strike continues—Solidarity until the victory of all workers—*June 6* [p. 93]   94 Cohn-Bendit will pass—*ca. June 22* [p. 93]   95 Long live the grassroots unity of the workers [p. 94]

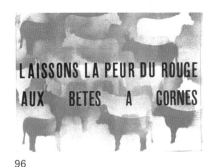

96

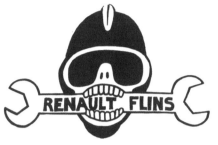

97

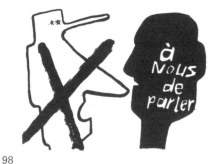

98

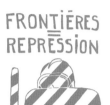

99

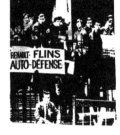

100

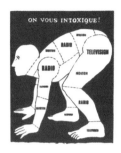

101

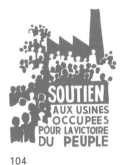

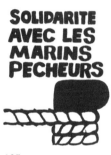

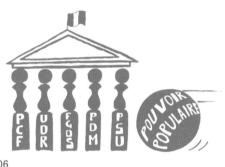

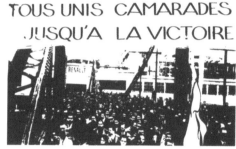

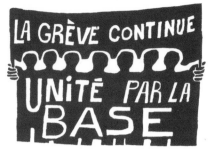

111

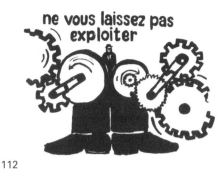

112

ensemble
étudiants
travailleurs

113

TRAVAILLEURS DE
RENAULT-FLINS
LA VICTOIRE
EST A NOUS

114

BELLEVILLE

une partie de cartes = 5000 flics

Que cherche le pouvoir ?

• dresser les communautés
les unes contre les autres
• faire oublier la grande
grève actuelle
• présenter les travailleurs
immigrés comme la pègre
• les diviser des français
• recommencer les ratonnades

HALTE A LA PROVOCATION POLICIERE

mais tous unis les travailleurs
français, immigrés poursuivront
le combat contre l'ennemi
commun.

115

LE CONTINGENT
NE SERA PAS
BRISEUR DE GREVE

116

OCCUPATION
AUTODEFENSE
FLINS.SOCHAUX
LYON.STNAZAIRE
PARIS.TOULOUSE

117

Contrairement aux informations diffusées,
tous les syndicats
RATP
CONDUCTEURS AUTONOMES Y COMPRIS
sont décidés
à poursuivre le mouvement
jusqu'à complète satisfaction

118

solidarité
EFFECTIVE
étudiants
travailleurs

119

NE NOUS BATTONS PAS SUR
LE TERRAIN PREPARE PAR
LE POUVOIR LUI-MEME :
IL EST TRUQUE

120

les capitalistes
ont besoin des
ouvriers

les ouvriers
n'ont pas besoin
de capitalistes

121

APPEL AUX JUIFS
ET AUX ARABES
LE GOUVERNEMENT VOUS
INTOXIQUE
NE VOUS LAISSEZ PAS FAIRE !

Les évènements de BELLEVILLE
ont été déclenchés par des
commandos de subversion CRS
et Harkis en vue de semer
la panique et le désordre dans
ce quartier populaire.
DEJOUEZ LES MANŒUVRES RACISTES

Rejoignez vos comités d'action de
quartier : siège : 28, rue Serpente, PARIS 6.

122

111 The strike continues, united by the base—*May 23* [p. 108]  112 Don't let yourself be exploited—*Fourth week of May* [p. 109]  113 Students, workers together [p. 109]
114 Workers of Renault-Flins—Victory is ours—*Third week of May* [p. 110]  115 Belleville: A card party = 5,000 cops. What is power looking for? To set communities against one another; To make us forget the current big strike; To present immigrant workers as scum; To divide them from the French; To begin racist attacks again. STOP POLICE PROVOCATION!—*June 5* [p. 110]  116 The Contingent [*national servicemen*] will not be strike-breakers [p. 110]  117 Occupation self-defense—Flins...etc.—*June 11* [p. 110]  118 Contrary to the distributed information, all of the RATP unions—including independent conductors—have decided to continue the movement until complete satisfaction—*Late May* [p. 110]  119 Effective solidarity—students, workers—*Late May* [p. 110]  120 Let's not fight on the terrain prepared by power itself—it's rigged!—*Mid-June* [p. 110]  121 The capitalists need the workers—the workers don't need the capitalists [p. 110]  122 Call to Jews and Arabs—the government is poisoning you—don't let them do it! The events at Belleville were set off by the subversion commandos of the CRS and Harkis [*Muslim collaborators*] with the aim of spreading panic and disorder in this peoples' district. Foil these racist maneuvers! Join your district's Action Committee at 28 Rue Serpente, Paris 6.—*First week of June* [p. 111]

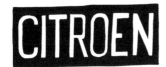

**CITROËN**

VIVE
LA RESISTANCE
PROLETARIENNE

123

**TRAVAILLEURS**

ACTIFS ET CHOMEURS

**TOUS UNIS**

124

125

**PAYSANS**

LES GREVISTES ONT BESOIN DE VOUS
VENEZ LEUR VENDRE VOS PRODUITS
**DIRECTEMENT**
DANS LES USINES ET DANS
LES FACULTES

126

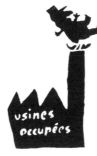

MAI·JUIN
68
1968 ... début d'une lutte
prolongée

127

NOUS AVONS GAGNE UNE
BATAILLE MAIS NOUS
SAVONS QUE LA LUTTE
POUR NOTRE MOUVEMENT
SERA DURE      RENAULT–FLINS
COMITE DE GREVE

128

TENEZ BON

**CAMARADES**

TOUS UNIS

JUSQU'A LA **VICTOIRE**

129

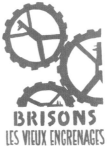

usines
occupées

130

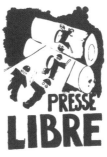

BRISONS
LES VIEUX ENGRENAGES

131

PRESSE
**LIBRE**

132

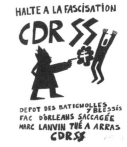

LA NEGOCIATION

C'EST

LA RUSE

133

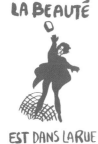

LA BEAUTÉ

EST DANS LA RUE

134

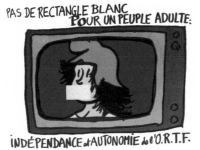

PAS DE RECTANGLE BLANC
POUR UN PEUPLE ADULTE

INDÉPENDANCE et AUTONOMIE de l'O.R.T.F.

135

136

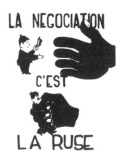

137

HALTE A LA FASCISATION

CDR SS

DEPOT DES BATIGNOLLES
7 BLESSÉS
FAC D'ORLEANS SACCAGÉE
MARC LANVIN TUÉ A ARRAS
CDRSS

138

---

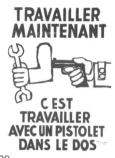

TRAVAILLER
MAINTENANT

C'EST
TRAVAILLER
AVEC UN PISTOLET
DANS LE DOS

139

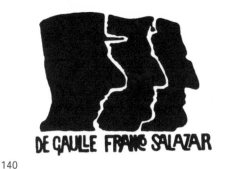

DE GAULLE FRANCO SALAZAR

140

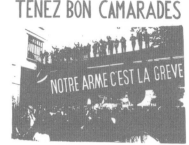

NOTRE ARME C'EST LA GREVE

141

PAYSANS GREVISTES
NON AUX INTERMEDIAIRES

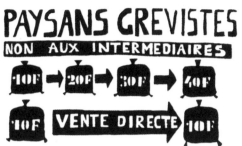

10F → 20F → 30F → 40F

10F VENTE DIRECTE 10F

142

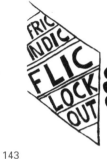

FRIC
INDIC
FLIC
LOCK
OUT

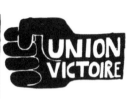

UNION VICTOIRE

143

marionnettes populaires

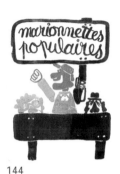

144

REFUSEZ

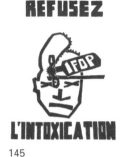

L'INTOXICATION

145

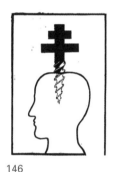

146

je participe
tu participes
il participe
nous participons
vous participez
ils profitent

147

NON
A LA BUREAUCRATIE

148

la lutte continue

149

A BAS
LES
"CADENCES"
INFER'NALES

150

LEUR CAMPAGNE COMMENCE

NOTRE
LUTTE CONTINUE

151

POUR LA VIOLENCE LA HAINE ET LA REPRESSION

152

PRESSE
NE PAS
AVALER

153

CHOISISSONS NOTRE
TERRAIN
DE
COMBAT

JUIN 68 DEBUT D'UNE
LUTTE PROLONGEE

154

**155**

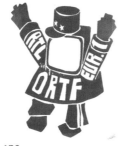

**156**

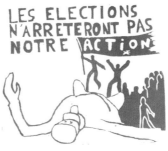

**157**

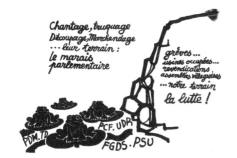

**158**

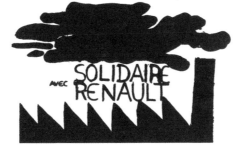

**159**

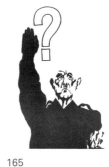

**160**

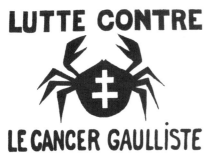

**161**

**162**

**163**

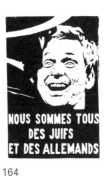

**164**

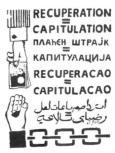

**165**

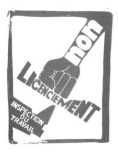

**166**

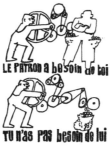

**167**

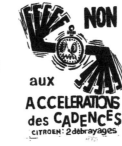

**168**

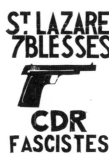

**169**

**170**

**171**

---

**155** The fist of no return—*Third week of May* [p. 138]   **156** ORTF, RTL, Eur. 1 [*Radio and television stations*] [p. 139]   **157** The elections will not stop our action [p. 140]   **158** Their terrain: blackmail, vote rigging, dividing, haggling… the parliamentary swamp. Our terrain: strikes, occupied factories, demands, village assemblies… the struggle! [p. 140]   **159** Solidarity with Renault—*Third week of May* [p. 141]   **160** ORTF in the struggle—Independence—*May 25 or June 3* [p. 141]   **161** Struggle against the Gaullist cancer [*Created by the poster workshop at the College of Medicine*] [p. 142-143]   **162** Wall Newspaper #3 [*see translation on p. 238*]—*ca. June 17* [p. 146]   **163** Wall Newspaper #4 [*see translation on p. 238*]—*ca. June 20* [p. 147]   **164** We are all Jews and Germans—*ca. June 22* [p. 148]   **165**—*May 31* [p. 149]   **166** No—Layoffs—Inspection of work [p. 156]   **167** We will go on until the end [p. 157]   **168** The boss needs you—you don't need him—*Third week of May* [p. 158]   **169** No to accelerations of production rates—Citroën: 2 stoppages—*Late July* [p. 159]   **170** St. Lazare—7 wounded—CDR fascists [p. 160]   **171** Recuperation equals capitulation—*Second week of July* [p. 161]

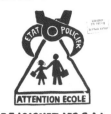
LA LUTTE CONTINUE

REJOIGNEZ LES C.A.L
172

173

174

NON LES GRANDS MAGASINS NE ROUVRIRONT PAS
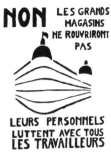
LEURS PERSONNELS LUTTENT AVEC TOUS LES TRAVAILLEURS
175

TRABAJADORES FRANCESES EMIGRADOS UNIDOS
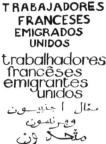
176

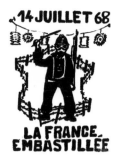
177

178

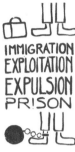
179

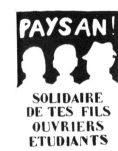
180

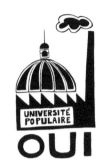
181

182

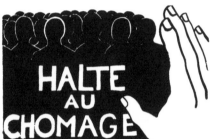

183

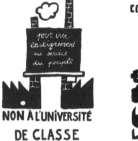
184

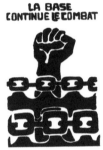
185

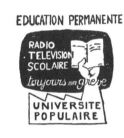
186

187

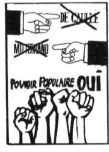
188

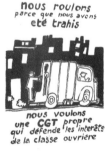
189

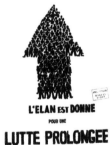
190

191

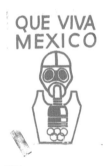
192

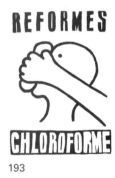
193

---

172 The struggle continues—police state—warning, school—Rejoin the CAL (high school action committees) [p. 162]  173 Worker-farmer unity—*June 2* [p. 162]
174 Civic Informer Cop—*June 3* [p. 162]  175 No: the department stores are not reopening—Their employees struggle with all workers—*June 6 or 10* [p. 162]
176 French and immigrant workers unite—*Second week of July* [p. 163]  177 July 14 1968—France in the Bastille—*July 16* [p. 163]  178 Down with
repression—*July 16* [p. 163]  179 Immigration, exploitation, deportation, prison—*Second week of July* [p. 163]  180 No to capital-labor association—*May 20* [p. 165]
181 Farmers! Solidarity with your worker/student sons—*Early June* [p. 165]  182 People's university—Yes [p. 165]  183 End unemployment—*Fourth week of May*
[p. 165]  184 No to the classist university—for an education system at the service of the people—*Fourth week of May* [p. 166]  185 The base continues the battle
—*May 23* [p. 166]  186 Continuous education—school, radio and television—Still on strike—People's University—*Late May and second week of June* [p. 166]
187 No papering over the cracks—the structure is rotten—*Third week of May* [p. 166]  188 De Gaulle, Mitterrand, no; People power yes—*May 25* [p. 167]
189 We're rolling out because we have been betrayed—We want a proper CGT that defends the interests of the working class [p. 168]  190 Spirits are high for a
protracted struggle—*Mid to late June* [p. 169]  191 My victory [p. 172]  192 How does Mexico live? [p. 172]  193 Reforms—Chloroform [p. 172]

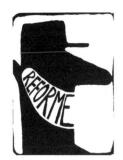 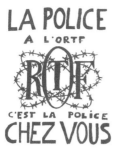 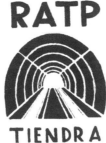 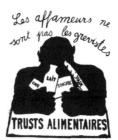 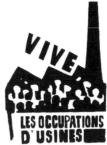 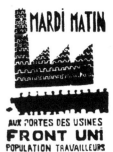

194    195    196    197    198    199

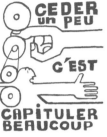 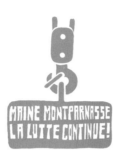 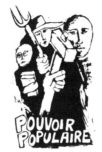 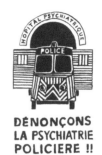 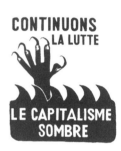

200    201    202    203    204

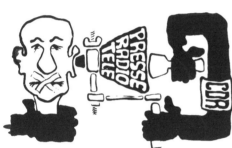 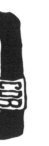  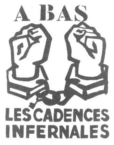 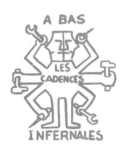

205    206    207    208    209

**194** Reform [p. 172]    **195** Police at the ORTF means police in your home—*May 25 or June 3* [p. 173]    **196** RATP will hold firm [p. 173]    **197** It's not the strikers that cause starvation—Food trusts [*Requested by milkmen for their trucks*] [p. 173]    **198** Long live the occupation of factories—*June 10* [p. 173]    **199** Tuesday morning at the factory gates—United front—population, workers—*May 28* [p. 176]    **200** To give up a little is to surrender a lot—*May 28* [p. 176]    **201** Parliamentary government doesn't pay—*June 23* [p. 176]    **202** Maine Montparnasse—the struggle continues!—*May 30* [p. 176]    **203** People power—*May 29* [p. 177]    **204** We denounce police psychiatry!—*Late May* [p. 177]    **205** CDR—Press, radio, TV [p. 177]    **206** Civic Action Committee—*June 10* [p. 178]    **207** End diabolical production rates—*June or July* [p. 178]    **208** End diabolical production rates—*May 20 or June 26* [p. 178]    **209** Let's continue the struggle—Capitalism is sinking—*Fourth week of May* [p. 178]

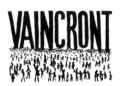

**LES TRAVAILLEURS**

**VAINCRONT**

210

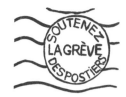

**SOUTENEZ LA GRÈVE DES POSTIERS**

211

**METRO RATP BUS**

LES GREVISTES SE BATTRONT
JUSQU'A LA VICTOIRE

212

LYCEENS

ON FERME NOS LYCEES
ON NE PEUT ENTRAVER
NOTRE ACTION

213

214

**GRÈVE ILLIMITÉE**

CLICHÉS UNION
MAI 1968

215

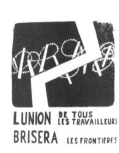

VOUS ETES TOUS CONCERNÉS

216

**AUTOUR DE LA RESISTANCE
PROLETARIENNE**

DANS L'USINE OCCUPEE

VERS LA VICTOIRE DU PEUPLE !

217

L'UNION DE TOUS LES TRAVAILLEURS
BRISERA LES FRONTIERES

218

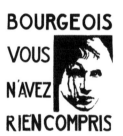

219

USINE
V REPUBLIQUE
V PLAN
REORGANISATION
DU PERSONNEL
FERMÉ

220

EN MÉDECINE COMME PARTOUT,

PLUS DE GRAND PATRON

221

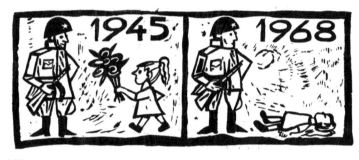

222

**BOURGEOIS VOUS N'AVEZ RIEN COMPRIS**

223

---

**210** The workers will overcome [p. 179]   **211** Support the postal workers' strike [p. 179]   **212** RATP—the strikers will fight until victory [p. 179]   **213** High school students—Our schools are closed—Our action cannot be hindered [*Created by the High Schools Action Committee (CAL) of Louis-Le-Grand*] [p. 179]   **214** Elections: Diversion? Illusion? Derision? Division? Treason? Recuperation? Above board? No! Rigged: Electoral lists are not revised; Tampering with district divisions; Under 21s cannot vote; 2,500,000 (foreign) workers cannot vote! Democratic? No! Fascist: Progressive organizations are dissolved; The government frees the OAS [*right-wing paramilitary organization*] terrorists; Power spreads repression in the factories and in the streets through the police and its CDR commandos! Free? No! Poisoned: The ORTF is besieged by the army; Europe and Luxembourg are owned by the bourgeoisie; The major media are on capital's payroll! These elections are a diversionary maneuver to sabotage the true democracy born in May. In May the people chose: Power for the workers! In June the panicking politicians made themselves the accomplices of capitalist power by supporting their elections [p. 180]   **215** Unlimited strike—Clichés-Union [*photography school*], May 1968 [p. 180]   **216** Workers, students—this concerns all of you [p. 180]   **217** All around proletarian resistance—in the occupied factory —toward the victory of the people! [p. 180]   **218** The union of all workers will break through the borders [*After the deportation of Portuguese workers*] [p. 181] **219** Unemployment, misery, repression, shitty mess [p. 181]   **220** Factory—5th republic—5th plan—Staff reorganization—Closed [p. 181]   **221** In the school of medicine like everywhere else, no more big boss [p. 181]   **222** 1945-1968 [pp. 182-183]   **223** Bourgeois, you have understood nothing [p. 270]

1

2

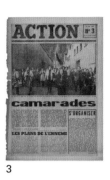

3

4

5

6

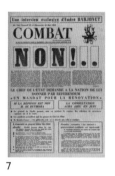

7

8

9

10

11

12

13

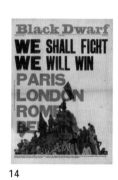

14

15

16

17

18

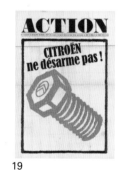

19

20

21

22

23

24

25

The texts that follow are translations of original documents from May and June of 1968 from the collections of Philippe Vermès and Johan Kugelberg. They were chosen from a wealth of archival material in order to provide the reader with a contemporary unfiltered voice describing events, emotions and thought processes. They are broadsides, leaflets, pamphlets, handbills, newsletters and newspapers, a full listing of which can be found in the bibliography.
Translated by Gabriel Mckee.

# 1

**The striking students of the Ecole des Beaux Arts issued this statement—the founding text of the Atelier Populaire—on May 15, likely following a meeting of student-teacher commissions that met on May 14 to discuss the redefinition of the university system. The text seeks to carve out a clear place for art in the struggle against capitalism and repression. Later statements went into more detail on the role of the artist in a radically transformed society, but the basics of the Atelier Populaire's philosophy is thoroughly illustrated in its initial document.**

## WEDNESDAY 15 MAY 1968 12 NOON

Why are we prolonging the struggle? What are we fighting against? We are fighting against the bourgeois university, we want to organize the struggle against all of its aspects:

1. We find fault with the social selection that takes place at every level of education, from primary to superior, to the detriment of working-class children and the children of poor farmers. We want to struggle against the system of tests, of competitive exams, the primary means of this selection.

2. We find fault with the terms of teaching and the pedagogical forms of its diffusion, because everything is organized so that the products of the system do not acquire a critical conscience with regard to both knowledge and to social and economic reality.

3. We find fault with the role that society expects of intellectuals: to be the guard dogs of the system of economic production, to be a technocratic cadre, to act so that everyone is happy in his place, especially when his place is one of exploitation.

What do these criticisms mean for someone who is in a school of architecture? For someone in a school of painting or sculpture? Of course, it's up to the commissions to define precisely, but we can already say this for those in the architecture school:

We want to fight the domination of teaching the profession, in the form of the Order of Architects or other corporate organizations. We are against the system of bosses as a pedagogical method; we are against the conformist ideology that the system diffuses. The teaching of architecture must not be the simple repetition of that which the boss does until, finally, the student is a slavish copy of him. We want to fight the conditions in which architecture is subordinated, in effect, to the interests of public or private developers. How many architects have they accepted to carry out projects such as Sarcelles, big or small? How many architects include in their specifications the conditions of the workers on the building sites as regards their hygiene, protection and safety and if they did so would any contractor carry out their proposals? We all know that in France there are three deaths every day in the building industry.

We want to fight the particularly conservative content of the teaching itself which contains little that is rational or scientific and in which habitual patterns of thought and opinions continue to take precedence over objective knowledge. The ideology of the Prix de Rome is still very much alive! In short, we want to be aware of real links between the school and society; we want to fight its bourgeois character.

We must recognize that we cannot carry out this fight alone. We must not delude ourselves that academics can establish in their colleges the means for real autonomy from the entirety of bourgeois society. It is alongside the workers, the principal victims of the process of social selection which takes place in the teaching system, that

academics should fight. The struggle against the bourgeois university should be organically linked to the struggle of all the workers against the system of capitalist exploitation. Therefore, we must reconsider the links that actually govern the profession and its teaching:

— Reconsider the current separation of E.N.S.B.A. (École Nationale Superieure des Beaux Arts) from higher education.

— Refuse to carry out any form of preselection for entry to the college.

— Struggle against the current system of tests and competitive exams.

— Prepare ourselves for the struggle against the decrees of reform.

— Establish real links with the struggle of the workers.

On all these questions we must have the most open debate. All of the teachers must express their opinions. Forms of organizing the struggle must be found.

*— THE STRIKE COMMITTEE OF THE ÉCOLE NATIONALE SUPERIEURE DES BEAUX ARTS*

# 2

**The following document from early in the Events, written on or around May 14, details the origins of the struggle and explains the organization of the Action Committees. Its focus is on the needs and demands of students, but the beginnings of a sense of connection to the demands of the newly-minted industrial strikes is clear.**

## CALL

Since Friday, May 3, tens of thousands of undergraduates, high school students, teachers, and young workers have engaged in a new kind of combat, in the streets and colleges alike.
Beginning at Nanterre with the questioning, through proper methods of action, of the bourgeois university's terms and methods, the movement today poses the question of overthrowing the Gaullist regime.

## HOW DID IT COME TO THIS?

The groundswell, provoked by the attempt of the government and the French academic authorities to break by force the slowly developing agitation, had causes that it is important to investigate and understand. The resistance and combative spirit of the students provoked a sort of supportive enthusiasm from the people who dared to resist the CRS, mobile guards, and other police. Certainly the workers were moved by the brutality of the police repression, but it was the fact of seeing the students not behaving like sheep and resisting by fighting that constituted the new state of affairs. Since Monday the sixth, at the end of the morning, we see young workers beginning to come out to fight alongside the students. The rancor, the cold-heartedness provoked over the years by police

persecution, and the daily vexations all exploded. The anti-strike repression, the CRS in the factories, the pigs' raids against the children of the poor suburbs, all the daily manifestations of a State largely based on the strength of its police—all of this resurged. Abruptly freed by the announcement of combat, numerous energies came to join with the students "against the cops". Of the many possible points of attack against a ten-year-old regime, symbol of all of the conservatism of the French bourgeoisie and of the attempts made in its heart at "modernizing" the exploitation of workers, it is the hatred of the police, the hatred of repression, that is the principal driving force of the action. A lesson to consider!

## THE UNCERTAINTY OF THE MOMENT

3,000 on May 3, 15,000 on the sixth, 40,000 on the seventh, over 10,000 behind the barricades on the tenth, we were more than a million on May 13 for the general strike. And nevertheless... since May 13, there is a growing malaise. The words "burial" (of the movement) and "recuperation" (by the parliamentary parties) are mentioned constantly. Many fear that the [...] support and reserves that were given to us by the leaders of the central workers' organizations were a poisoned chalice. We have occupied the colleges, occupied the Sorbonne, but nothing is settled as long as Pompidou plays at being "savior-returned-from-distant-lands". This period of uncertainty is the natural consequence of the two essential characteristics of the movement: its disorganization and its programmatic deficiencies. While they safeguard us against the ossification of thought and sectarianism of many extreme Left groups, these two elements risk driving the movement at large to collapse if we do not take care.

## TWO TRENDS

Indeed, two trends become clear from the many discussions of these last three weeks. On the one hand are those who wish to profit from the "academic crisis" to make the government operate in the place of "academic reforms". These are often the same ones who readily agreed with seeing the occupation of the Sorbonne as a return to the pathetic folklore of yesteryear. On the other hand are those who, during the week of the barricades, revived the hope of revolutionary action. These wish for the overthrow of the regime more than the "joint management of the University", alliance with the workers more than alliance with the "great profs" who yesterday declared themselves our enemies and today pretend to be sweet. The occupation of the Rhodiaceta Tuesday morning, and of Sud-Aviation in Nantes today, shows the way. The point is not to simplistically oppose all academic demands with general political demands. All are legitimate and necessary. The point is to organize a hierarchy of their importance.

## POLITICS AT THE FIRST RANK

The same two trends become clear on the frontlines. On the one hand, those who accept sinking into the colleges to resume a "normal, improved life"; on the other, those who want to transform our reconquered colleges into an externally-focused base of action. Against the cops, it used to be necessary to say "the Sorbonne for the students". Now that we have it, it's necessary to cry "the Sorbonne for the workers". We must use our conquered colleges as the red base where the movement organizes itself, from which propaganda groups go out toward the poor suburbs and the working-class districts, where the daily outcome of the struggle lies. Now, it's necessary to—

## GO TOWARD THE WORKING CLASS

Not to organize ourselves, but to take advantage of the audience that has given us our courage and explained the necessity of overthrowing the regime. In the poor suburbs we must go to restore the sincerity of our struggle, to say why we are against capitalism. We must also go to learn the concrete truth of that which we know from books: the exploitation of work. Now, finally, we must take back the streets, for it is there that the confrontation is taking place and that the alliance with the workers is being made.

## THE SORBONNE IS OUR BASE; IT IS NOT THE BATTLEGROUND

Three trends are expressed about the question of organization. The leaders only intend to profit from the situation in order to strengthen their own group, unaware that if the masses refuse to enter it is not uniquely the consequence of their weak politicization, but because they refuse their leaders' sectarian quarrels or their opportunistic parliamentarism. Others propose to organize as little as possible in order to guard the movement's creative spontaneity. These comrades are fooling themselves as well, for they do not understand that, while it is possible for 500 to organize themselves spontaneously to make a barricade, it is totally impossible to overthrow the regime using the same means. It's necessary to organize the base, in action, for action.

## ACTION COMMITTEES EVERYWHERE

Their form can be diverse: the disciplinary base, the base of small districts, the base of the workplace, etc. But they have this in common: they are units of small size, of 10 to 30 people, because they are made for discussion, and they are above all made for action. When there is an assembly of 200 people, split it into 10 Committees! Each Committee gets together every one or two days. Each Committee sends a delegate to the daily coordination meeting, at 2 p.m., at the Sorbonne, staircase C, first floor, (at 6 p.m. for those who can't make it at 2 p.m.). Each committee makes contact with nearby Committees (for example: all the Committees of the 15th arrondissement or all the "Institutional" Committees or all the "Science" Committees, etc.) to establish intermediate coordination. Each Committee realizes its own initiative and sign.

Each Committee gives its advice on which course to follow and posts it. A solitary person doesn't wait to be given his instructions; he regroups some comrades, and can make contact with the co-ordinators. The members of the Committees participate in debates in the lecture halls, in the committees, etc., but they do not set this against participation in their Committee. These debates are for the elevation of the general level of realization through discussion, without taboos, on all subjects, but that's it; they are not the place for organizing action.

*NO TO ACADEMIC REFORMISM AND TO APOLITICAL FOLKLORE LET'S OPEN THE VOTE TO THE REVOLUTIONARY PROTEST OF THE REGIME*

*— The Coordination of the Committees of Action*
*Written to Sonia Creuzot, 12 Rue N.O. des Champs*
*Paris, 6th Arrondissement*

**3**

*This article from the radical newspaper* **Action** *focuses on the cultural implications of May '68, and underscores the Situationist basis of the Events. Seen through the lens of Situationism, the students occupying the Odéon Theater become "the workers of the spectacle", and the violence of the barricades becomes not just a political act, but the eruption of a new revolutionary culture. The Events themselves point the way to a radically transformed culture that truly embodies "the revolution of everyday life".*

*ACTION*: Issue no.3—May 21, 1968
**CULTURE ON THE FLY**

Direct action, practically challenging the system, has come to affect the cultural milieu. This began with the warning shot of the Odéon, occupied during the night of May 16-17. Then, like a powder trail, theaters, radios, museums, and movie theaters saw the blooming of occupying action committees in illustrious places, sweeping up the dust of a society that is seemingly sane, but profoundly rotten. At the Théâtre de France, symbol of the official cultural elite of the regime, the debate, although confused, very quickly went to the root of things: the harmless ballet of those who wish to democratize the existing order came into opposition with those who challenge all that "Culture" itself signifies in a society of consumption in exploitation. Culture, a product of consumption to fill leisure time, is the sad price of submission to exploited labor, to the regime of labor. Therefore, it participates in submission itself. From this confused debate, a general line stands out: each man must be able to create his own culture. To the culture of the University, to these dead festivals of the spirit, must be opposed a living culture that takes root in everyday life.

## SABOTAGE THE SPECTACLE

The events that have taken place since May 3 give a spectacular example of the ideological and scientific upheavals that shake everyday life. Attacked by these upheavals and their contradictions, man today wants to change the world and to change himself. Planned several days into his future, the man who comes to create himself thinks of himself as responsible for his future; he is a rebel, violent; he wants to construct a better man than what society dictates. The rebel that results from the barricades (even when he did not participate) expresses his idea of culture through one of Armand Gatti's plays, *The Thirteen Suns of the Rue Saint-Blaise*: "stuttering, quick-tempered, generous… with a bit of transitory truth to find every day to recover a little warmth in the indifference and remoteness of a world we don't understand." It is with this perspective that the students, the workers of the spectacle, have worked in the Odéon Theater. Despite the criticisms that have been brought to this occupation (little participation from actors, etc.), it is interesting to note that the Revolutionary Action Committee that now directs the theatre stated in a pamphlet that its goal was "the systematic sabotage of the cultural industry and in particular the industry of the spectacle, in order to give way to a truly collective creation." It is also with this perspective that theater action committees were created among the students, among the young workers, among the artists, in order to promote a revolutionary art that represents the true aspirations of the proletariat. These comrades have already planned concrete actions, such as presenting spectacles on the events of the last fifteen days to the striking workers at Renault. We emphasize as well that in some theaters, the actors, technicians, and administrative personnel have come together to create revolutionary management committees, in order to put theatrical activity at the service of the people. In the domain of the cinema, the reaction, the realization has been just as notable. All at once, directors, actors, and technicians of film have taken their destiny in their hands by creating committees wherever possible. These groups organize and reflect on the function of the filmmaker in a revolutionary society. They have already accomplished a great task of information throughout the film world. During the night of Friday to Saturday, a thousand film professionals decided to boycott the Cannes Film Festival. This demonstration represented "the classic example of a demonstration of consumption culture."

## MAQUIS OF PAINTING

Without wishing to describe the entirety of existing action committees in the cultural sector, it is necessary to indicate here the particularly interesting work that a certain number of young painters have undertaken without the action committee of the Plastic Arts. In this almost completely disorganized sector (no movement, no union), they have succeeded—thanks to their committee—in gathering together a great number of people interested in the fundamental reform of art with a revolutionary perspective of their participation

in future society. Day after day, they hold a permanent forum in an amphitheater at the Ecole des Beaux-Arts. From now on, they plan to participate concretely in the movement, and thereby to help the coordination of action committees: first of all, by selling their works to profit the movement, and moreover in putting their art at the service of this nascent revolution (to make posters, etc.). Some of them have also decided to withdraw their works from all museums and galleries. Now that these groups exist, now that a common position has begun to take shape, these committees must put this cultural agitation into opposition with the notion of cultural leisure. That is to say, to create a quasi-autodidactic culture on the fly, a kind of maquis of understanding and discussion that mixes ideas at the level of everyday action and takes over every manifestation of the modern world. Starting now, man must create a culture that corresponds to him with neither alienation nor treachery, with which he must arm himself in order to free himself from his prisons.

*This essay on the philosophy of the Atelier Populaire seeks to redefine the entire nature of the relationship between the artist and society. It is particularly critical of the idea of "novelty" in art, which it describes as a means of reinforcing art's bourgeois commodification. Above all, though, it argues for the destruction of the entire idea of "the artist" as a type or class of person, as the final paragraph makes clear: the progressive artist must "break with the intellectual domain of his formation, and open himself to the educative power of the masses while arming himself with the study and practice of the theory that will legitimize his new class position: that of the proletariat." By this point in May, many students were radically rethinking their place in society, and saw the workers' struggle as a sign of a reinvented society around the corner.*

**Essay on the development of:**
**People's Workshop: Yes**
**Bourgeois Workshop: No**

In agreement with the text published on May 21, 1968, we intend to repeat some points that, in our opinion, call for development. Let's keep in mind that this text defined the position of the PEOPLE'S WORKSHOP in the face of the Reform Commission's debates. Whereas the role of the Ecole des Beaux Arts (however it is to be reorganized or "modernized") is to spread and reproduce the point of view of the bourgeoisie as far as the plastic arts are concerned, to form and produce artists destined to live up to their expectations—

it is false to think that its "modernization" can undermine its function in the least, if not modified (everyone knows there must be other conditions). The related belief is to facilitate the maintenance of its role as propagator and reproducer of bourgeois ideology. The point is not to modernize, that is to say to ameliorate what it already is—this would assert at its base that the general outline is good (see the text of May 21). Let us explain ourselves: The introduction of new techniques, new materials, the appeal to those artists that the international market places at the head of modern art, will lead to nothing other than what has already been envisaged and proclaimed, to make the school chase after modern art, to lead numerous students on a journey to lost goals, or else to stimulate the reigning misconception: that TO A NEW FORM THERE IS A NEW CONTENT. The justifiable nausea that each of us feels for academicism (Chapelain-Midy) must not make us lose sight of this rhetoric of novelty that has overrun cultural life. It is a fact that the bourgeoisie encourages and promotes novelty; that this is one of the principle criteria of its aesthetic ideology: …Has this already been done? Has this already been seen? Has this already been imagined? …The artist's job is to produce novelties, while the critics must orient the cultivated public concerning intellectual consumption and trade of these novelties. It is difficult for the public to find its way around in the multitude of so-called options (Pop Art, pure abstraction…), that is to say the departments by which aesthetic analysis administers artistic production. It needs the critics' pseudo-theorization (of a P. Restany, for example) to legitimize its intellectual support, and its purchase. Basically, we see the mechanisms that this production of novelty obeys: "MAKING NOVELTY" more and more quickly, for less and in less time: such is the law. That which is novelty today, tomorrow falls out of fashion for another novelty, and that one for yet another, novelties that the intelligentsia and the market assimilate and sell more and more easily. So the Market interferes in the production of aesthetic effects at a new level: economic and especially ideological. Bourgeois culture entails an enormous consumption of goods and cultural values; artists and public are led in the game, excited and calmed and, by consequence, exhausted of sensibility and thought, of aesthetic invention and aesthetic consumption (appropriation and tasting). It surprises (Tinguely, César), it fascinates (Op Art), it plays with our nerves (Happenings)—but in no case does it stimulate reflection or make us aware. Novelty is always about connection to that which has already been "created," in reference to the thesis and work of such-and-such artist. The reigning misconception (see the text of May 15) being: art has captured its autonomy, which has been proclaimed very officially (Malraux). We are still in the framework, however apparent the rupture with the dominant ideology, of the relation between art and the history of art, never in the one framework that interests progressive students and artists, of the relationship between art and historical reality of the world in which we live, of which they want to take hold and

transform. Why does the bourgeoisie encourage and promote novelty? Because novelty calls nothing into question. Taken as an end in itself, it serves to reinforce the ideology of Art for Art's Sake, the better to give artistic production the mask of universality. But a progressive student, a progressive artist, well knows that there exists neither an art above the classes nor an art that develops outside of politics, and that every class places in its art political criteria first and aesthetic criteria second. Why is novelty thought to be so encouraged and protected? Because it calls nothing into question. Many believe that durability of value is threatened by the change of forms; nothing of the sort. The bourgeoisie leaves them to teethe on their representations—it gives enough of an impression of being challenging, while knowing that its core beliefs will be spared, that the process of transforming capitalist society will not be engaged in the same way. Protests and revolts are integrated. Artists contribute to changing tastes. Thus they accomplish their task well: renewal. Finally, calling nothing into question—just as one who could seem to be a true protester, some dear agitator, the voice of the political and social struggles, is veiled by the membership of these aesthetic categories that neutralize the contribution of their work. The experience of "freedom" of creation obsesses, exhausts, and deprives the artist of critical means. This acts as a censor—the artist thinks in terms of freedom, so he must think in terms of servitude! (How can art be an instrument of liberalization when it solicits freedom?) The idea that it creates, the course in which it is led: to always make the new more quickly, always in less time, satisfies him of his situation (it is maintained by his activity in an atmosphere of risk). His situation—that is to say his ideological and political links with the ruling class, which, furthermore, depends on money. The bourgeoisie suppresses its class conflicts and crises, with psychological, neurotic justifications. It translates social crises into terms of unease (maladjustment), into terms of individual revolts— in order to conceal its contradictions within the superstructure. FREEDOM OF CREATION IS NECESSARY FOR HIM. Through the experience of freedom of creation which is his awarded deed, the artist does not act like an individual who blows off steam or evades historic reality: he is deprived of his means of apprehending the economic, political, and social reality in which he lives. His practice does not permit him to have a grasp on reality. Fifty years of ethical and aesthetic "rupture" proves that the change of forms does not challenge at all the power of bourgeois ideology on the landscape of art, and the economic and political power of the bourgeoisie through art... In addition, novelty is encouraged because it is through the fluctuating layers of the intellectual bourgeoisie which constitutes the cultivated public (that is to say the privilege of culture), that it is led to delude itself about real freedom. In effect, illusory freedom with which the artist plays and which the public feels before such a canvas, the likes of Tinguely's machine, etc.… diverts his attention from the real world, the reasons to lead the struggle. The diffusion of

bourgeois culture by the Houses of Culture is, notably, the attempt to extend this demobilizing conjuration to new social classes (teachers, executives, etc...). The Atelier Populaire has denounced this in one of its texts. A project in contradiction with the very essence of bourgeois culture: CULTURE THAT DOES NOT CULTIVATE CULTURED PEOPLE. It is also necessary to see the many forms, the multiplication of propositions and "options" as the maintenance and the attempt to extend the privileges of class. Formalism makes it necessary to have more and more to feel, to see, to perceive a special preliminary language, known to a few and foreign to the masses. It is compelled to take its place at a point where the bourgeoisie imposes itself on the matter of art. This coercion is exerted from nursery school, where the children's drawings are judged according to aesthetic criteria, according to fashion and taste—when these pictures show what is required, to give an account, when each shape, each color constitutes a significant, very coherent whole. Then natural gifts, a certain innate vision of the world, will be credited the one whose drawing is the closest to the aesthetic canons that make up the jurisdiction (this is beautiful, this is violent, this is fresh and new). Of those who have these gifts, we say that they create. The multiplicity of the most unexpected aesthetic effects, surprise, seeing the stupor that they create, today reinforces this misconception that the artist is a creator, and contributes to making art more and more foreign to the masses, who are fooled and tend to make it sacred, are encouraged to see in all work... not a work, but the projection of an individual. The popular expression "It's a Picasso" perfectly denies the social connection of Picasso with the world. Today, the notion of work is at most devalued, and the idea that the artist is a creator, "one who invents from many pieces something unique, etc...." (see the text of May 21), is so reinforced that it is enough for a Marcel Duchamp or one of his followers to affix their signature on an ordinary-looking manufactured object in order that the system of bourgeois cultural values permits the decree: this is art. Thus is reinforced and exalted more than ever the ideology of the creative act. Along the same lines, it's necessary to denounce all those who have, after surrealism, attributed a power to art that is revolutionary in and of itself, pretending that their artistic practice is the counterpart to a revolutionary practice. In this way, they neutralize their action and exclude themselves from the struggle. (For example: for the review "Opus" the pattern is the following: Art is essentially violence, and violence is revolution.) Once again, it is false to base a radical change in the school upon its modernization alone. We must know that the contradictions between the school and modern art which certain people would wish to see put right can be easily reduced. Let's not lose sight of the fact that radical change can only be brought about by introducing new techniques, putting at the students' disposal new materials and infinite resources. Let's not lose sight of the difference between art and science: ART GIVES US REALITY IN THE FORM OF "VISION," "PERCEPTION," AND "FEELING", and SCIENCE IN THE FORM OF KNOWLEDGE (in the strict sense: of concepts). We make a distinction between science and scientism. Let's not lose sight, on the other hand, of the replacement, for example, of an old academic master by an artist at the forefront of modern art—that is, his replacement by an artist who satisfies the elements of the bourgeois aesthetic ideology: autonomy of art and the freedom of creation that follows from it, that is to say he places himself in the situation of supporting the coercion of these elements. A student, a progressive artist—one who wants to change his class position and consequently adopt a new class attitude—cannot accept this "privileged status" (see May 15) that the bourgeoisie attributes to him. He cannot be satisfied with this illusory freedom that rests on the misconception that art can be an autonomous world. He can only progressively, but thoroughly, break with the intellectual domain of his formation, and open himself to the educative power of the masses while arming himself with the study and practice of the theory that will legitimize his new class position: that of the proletariat.

TEXT SUBMITTED TO THE CRITICISM OF EVERYONE.

— *A Group of the Atelier Populaire*

# 5

*Radical students were painfully aware of the privilege surrounding their position in society, and redefining the class implications of education was a major concern in their discussions. The demands outlined in this document—opening the university system to working-class youth; greater incorporation of students into school administration—show a desire to open the system of higher education to all classes. However, there's a certain irony in the fact that the exchange this document outlines is one-way: the students want to offer workers access to education, but they don't seem terribly interested in spending a semester working in a factory.*

## THE COMMISSION FOR CRITICISM OF THE BOURGEOIS UNIVERSITY

May 22, 1968

The members of the commission "Criticism of the Bourgeois University": Considering the expansion of the strike movement to all of the working sectors of the population, an expansion which radically transforms the meaning of the student protest movement in the University; Considering the impossibility of authentic change in the University, in its social role and function, apart from a complete change not only of the current political regime, but of the current social system; Considering the deep ambiguities contained in the

demand for University autonomy, which carries the seed of the regionalist and corporatist deviations that certain people have already attempted to develop; Considering that the governmental watchword "participation" cannot in any case be accepted, since it signifies, in effect, the acceptance of dialogue with a political regime that has shown in the past its inability to settle the problems of students and workers, and which cannot be trusted to define the University's own objectives in the future; Considering that such participation and such dialogue would have the ultimate effect of reinforcing the involvement of the masses in general, and of students in particular, in the system, supporting and reinforcing the power of the wealthy classes over the workers and preventing all protest against this system for a long time.

The commission proposes the following motion to the General Assembly:

1. Call the students of the ex-Ecole des Beaux Arts to struggle against the governmental watchword "participation" in order to demystify the real objectives; and demand that their political and trade-union organizations, in connection with workers' organizations, organize a vast campaign to argue against this watchword.

2. Remember that there can only be true autonomy for the University with the following conditions:

— Independence, in theory and in practice, in regard to bourgeois political power.

— Majority representation of students at all proceedings of decision making and management of the University.

— Public funding coupled with the right to inspect and challenge the University budget.

— The dependency of the academic administration in regard to management proceedings.

— Dissolution and integration of all the old great schools in the University.

— Finally, remember that this demand for autonomy only concerns the refusal of the bourgeois state's power over the University.

3. Declare that the demand for university autonomy can only be one means among others for transforming the social role of the university, and that this transformation would surely result in the general transformation of society.

4. Call on all students to work at this transformation through militant participation in their political and trade-union organizations, and remember that these can only find their full effectiveness in developing joint actions toward the objectives of the workers' struggle, and therefore demand that all means that reinforce the unity of the students' and workers' struggle be studied and applied.

5. Propose that the student protest movement define the objectives of its struggle as follows:

— The permanent opening of the autonomous university to all, the terms of this opening being to learn through the students' and workers' organizations.

— Extension of student privileges to all young workers: dining halls and dormitories, vacations, military service, etc.

— Free use of academic offices and equipment to organize the persistence of a democratic dialogue.

— Studies of the content and methods of teaching in order to closely blend theoretical training and practical training, activities of education and activities of production.

**6**

*Toward the end of May, the national government became directly involved in the Events. De Gaulle had been out of the country from May 14 (the day after the general strike began) to May 18, and he issued statements denouncing the protestors the day after his return. The government revoked Cohn-Bendit's residency permit, but rather than silencing him this simply served to solidify his role as an icon of the movement. (A poster from this period depicts a wild-eyed Cohn-Bendit over the text: "We are all 'undesirables'.") Left-wing politicians in the National Assembly began debates on a motion to censure de Gaulle and Mitterrand on May 21, but their motion failed the following day. For radical students and workers, this was simply a sign of the inability of parliamentarism to address social problems, as this document states: "No censure will be as strong and definitive as this one, given by 10 million strikers." The authors of this document are hopeful about the possibility of the movement blossoming into a full revolution. The protests announced at the end of this handbill took place the same day as de Gaulle's call for a referendum on his government.*

**DE GAULLE AT THE DOOR!**

The Motion to Censure did not pass, and already the ministers lift up their heads, forgetting their fear of the day before, and already some hesitate to continue the struggle. Both sides are fooling themselves just as much as the other. We do not need an impotent and hostile parliament to recognize our force. No censure will be as strong and definitive as this one, given by 10 million strikers. Power? It has lost its factories, its control of economic activity, its riches. Power has lost everything; it has nothing left but power. IT IS FOR THE TAKING. But already the CRS attempts to attack the picket lines of strikes that are isolated from one another and therefore vulnerable. In the street, we oppose them in a united front. Today, the small farmers, in turn, show their opposition to the regime.

## WORKERS, FARMERS, STUDENTS, AGAINST THE CAPITALIST SYSTEM, TOGETHER IN THE STREET

In France, foreign workers, the most exploited, those at the greatest risk, are shoulder to shoulder with us. De Gaulle claims to forbid one of our comrades to return. If Cohn-Bendit is a foreigner, we are all foreigners!

## NO BORDERS!
## COHN-BENDIT WITH US!

In Belgium, in Germany, in Italy, in England, in Holland, in all capitalist countries, struggles similar to ours or unified with our combat are developing.

## LONG LIVE THE INTERNATIONAL SOLIDARITY OF WORKERS AND STUDENTS

Our industry, regional, and faculty Action Committees are already bringing together thousands of workers and students who do not want their struggle to be in vain:

## EVERYONE TO THE DEMONSTRATION

Friday May 24
At 5:00 p.m.
Place Clichy,
Stalingrad,
Porte des Lilas,
Porte de Montreuil,
Place Denfert,
We will gather at the Gare de Lyon at 7 p.m.

## THE STRUGGLE CONTINUES!

— The Action Committees

# 7

*The newspaper* Combat *began its life as a newsletter of the French resistance during World War II, but by 1968 it was primarily a Stalinist publication. Though wary of the Situationist students' opposition to party communism, Combat put its support behind the student movement. The following entry is part of a series of first hand reports of the events by journalist Jean-Claude Kerbourc'h, who sees poetry in the violence of the barricades. Kerbourc'h's reports were collected into a book,* Le Piéton de Mai (The May Pedestrian). *The date of this particular promenade is May 23, just before the second Night of the Barricades.*

**COMBAT: No. 7421—May 25-26, 1968**
## THE PROMENADES OF A WAKING DREAMER

*V. My Shady Night*
by Jean-Claude Kerbourc'h

Oh! what a night! Once again the black and shining walls of helmeted CRS, blocking the streets. Once again the rioters hastily unearthing paving-stones. Once again the tear gas grenades, boys and girls crying. Once again, Paris, ready to topple into insanity, to sink with all hands like an old boat, with its detritus, its black jackets and its CRS, in an immense maelstrom. But before the night, a few words on the day. A heavy, thick afternoon. A strange "Sunday." The abundance of people. Immense. Absurd. The promenade of Mr. Dupont with Mrs. Dupont and little Dupont in the "hot streets." The fixed stares on the charred carcasses of cars. These symbols of well-being, of speed, of escape, immobilized by the sidewalks: pathetic pile of twisted scrap metal. Rue Gay-Lussac rechristened: "May 11 Street," filth everywhere, dragged across the paving-stones. An under-developed Paris. A more strange Paris: stranger. The Odéon Theatre sold out. Discussions overflowing into the street, like simmering lava. A woman sells a journal called *La Lumière (The Light)*. Ecstatic eyes cast outside the face, then closed on an interior dazzle, she cries in a monotonous voice: "I bring you the torch of light! You must understand that everything is summed up in me! Child, you did not want to lean toward me, but I have come to you! I am your being and your light! I am all love! I am all love! I am all love!" "What a love!" someone comments. This phrase gushes out from another group: "Sir, I notice one thing, which is that it is still the artisan that is the unhappiest… Come on!"

## FROM JAZZ TO TEAR GAS

At Saint-Germain-des-Prés, there is jazz in the street. Atmosphere of the years '44-'45. Passers-by wonder about the look. But some have the empty eyes of those who do not understand. The unusual is everywhere, omnipresent, triumphant. It impregnates the walls of the houses. It transforms the architecture and renders it unstable. Yesterday, the skies of Paris were blue like an orange. Everything was on the point of turning into the eternity of dream. The trash cans themselves became sumptuous. And the cars of the mobile guards, gathered near the ticket offices of the Louvre, resembled these smooth and monstrous beasts who, in the stories, are always the guardians of fantastic worlds. But all of a sudden there is the brutal awakening: Place Saint-André des Arts, the attack of the nervous demonstrators. The response of the CRS, the grenade launchers in action. Asphyxiation, tingling, tears. Stones thrown by one and all. A combat at once chemical and neolithic. The ebb tide. Taking advantage of a relative calm, a German student exclaims: "De Gaulle, this is nothing. He understands nothing! I understand

politics better than de Gaulle!"; another German speaks. A very severe gray costume. White shirt. Striped tie: "You explain poorly to the French what they must know. You must use other methods." The world topples over. We are close to the precipice. The abyss is there, gaping. The call of the emptiness. The desire to put one's fingers in one's ears, to cover one's eyes. An irresistible urge to plunge into the night and never return. But the night is illuminated by poisonous wreaths. The CRS throw lit rockets. Once again the bursting of grenades. Once again the eyes full of tears. A screen of tears makes the CRS, demonstrators, police cars, clubs, grenades, disappear instantly… This does not last. The stewards of the UNEF form a chain. They, the odd demonstrators and the numerous "tourists," destroying a meager barricade made primarily of garbage cans and trash.

*This is not how you make a revolution, you bunch of chickens*, someone shouts. *Wait until tomorrow*, the student replies. *I've been waiting for tomorrow for 30 years*, says the other aggressively. *You've already taken some lumps? Do you want to get some more?* replies the student. Another student makes for two young women: *What the heck are you doing there? If you came to be raped, this is not the time, bugger off!—Disperse! Disperse!* cry one hundred voices. One hears: *…Go to bed, there is no movie tonight! There's nothing to see!* This is the steward of the UNEF, near the cordon of CRS who are blocking the Boulevard Saint-Germain up to the church, so intimate, so rustic, so peaceful. *I haven't slept in three nights,* a CRS says to me, *and my wife is going to have a nervous breakdown. So who's going to take care of my 10 month-old kid in the meantime?* I say: *Wait while I write that down.—No,* says the CRS, who looks close to suicide. *That's not the problem. A CRS is a cop, that's not important. It's good to kill, and that's all.* And he adds, with a bitter wrinkle deforming his mouth: *CRS-SS! CRS-SS! To say that I made the Resistance! I've come to hope that they come back, the SS!*

### AN AMBIGUOUS HATRED

But tonight on the boulevard Saint-Germain, the CRS have not been used. The "front" is elsewhere. I went into the street of the School of Medicine with some medical students and nurses. There was an attempt to stop me: *No 'civilians' in there.* I respond that I am doing my job just like they are doing theirs. *Very well,* responds a hospital porter, *if you want to get your teeth kicked in…* Boulevard Saint-Michel. An atmosphere of apocalypse. Perhaps because these streets are too familiar to me. The Latin Quarter is neither the jungle of Vietnam nor the bush of the Congo, nor the jabals of North Africa, nor the hillsides of Verdun. At least not anymore. There is no need to despair. This rings out from everywhere. The trees have been torn down. At the level of the Sorbonne, through a gray curtain, loaded with white streaks, one senses a strange effervescence. Bluish, simmering. A black package of hate. I rush toward the no-man's-land

between the CRS and the demonstrators. A flurry of stones. The Paris-Match photographer, Phillippe le Tellier, is on the receiving end of one. The demonstrators hurl themselves at the CRS. Kamikazes loaded with paving stones. The hospital porters rush out; they return with a harvest of unconscious bodies. This is not a true street combat. There is too much of the world. And then these stones, these stinking tear gas grenades, which contribute to the creation of a state of nightmare, of psychoses, more than of real and definitive dangers. And for all that, it is a street combat all the same. The uneasiness comes, without a doubt, from there. From this ambiguity. And from this hate that seems living, palpable, like some kind of huge jellyfish. The CRS throw themselves at the assault. They cross over the first line of demonstrators. So, here comes the "cavalry's" turn! Here's an "assault tank": it is an enormous bulldozer that suddenly imposes its enormous mass in this oily night. It knocks down the trees. It spits, it burps, like a huge prehistoric animal. The demonstrators are pushed back to Place Edmond Rostand. I see Hernu, Mermaz, Filloud. It is a delegation of the "youth" of the FGDS. They want to play at "good service." A surprising sight in this atmosphere sticky with gas, overflowing with a hatred that is stifling, ecstatic, infinite because undefined. *We are in solidarity with the UNEF, but not with this!* says Hernu. Here is the delegation coming up to the Rue Monsieur Le Prince. One hears:
*Tie the deputies to a post!*
*A sold-out generation!*
*But let them advertise in peace, then!*

### AN ACCORDION WALTZ

I dash toward the demonstrators. I have seen the CRS on the tail side. These here on the head side. The air darkens suddenly. One swims in the murk, in a night blacker than night, and yet soaked with purple floodlights and yellowish streaks. The small stun bombs make their din heard. The gas grenades put up monstrous screens. When this strange night dissipates, the demonstrators are "taken down." By transistor radio, it is heard that there is still fighting near Maubert Mutualité. But the Odéon is much closer. Where do we always talk? Those who prefer a tennis match to storming the Bastille still celebrate their strange, barbarous, and still sometimes solemn mass there? Of course! A man in a faded and torn blue shirt, cut off at a red pair of pants that is glimpsed in the opening of an old, too-large coat, stands up on the third balcony. *But I've been here five days;* he said. *I only went out to buy a liter of wine! I was stopped by a cop who demanded my papers. My papers—I had them!* The cop said to me: *And your home?* so I responded: *My home is the Odéon. And when it's our turn, might we ask your job, comrade?* said a voice from the orchestra. *Tramp!* the other responded arrogantly. *It's disgraceful! It's disgraceful!* cries someone who appears suddenly at the door, *you listen religiously to this tramp, when there's fighting outside! He has the right to express himself! He has the right to*

*express himself!* a hundred voices cry. When I leave the Odéon, the tramp sings an accordion waltz in a voice rendered thick and rough by wine, like an old piece of scrap metal. A healthier night envelops me. A night that still hides its lovers in carriage doors and guards its poets. At Montparnasse, the boss of "Club Basque" has turned off the radio. *This is not the time to worry the clientele*, he says. *It's bad for business, this thing.*

# 8

*A two-page letter from Paris' Chief of Police, Maurice Grimaud, to the city's entire police force. He urges them to be careful and reasonable in the use of force against protestors, but he is also clearly angry about students' violence toward the police. It's unclear if this document was distributed by Gaullists (as a means of showing that the police were reasonable and level-headed) or by students (hoping that the hypocrisy would be apparent to a populace who had witnessed the violence the police had unleashed on the students).*

### Letter from M. Grimaud to the Agents of the Parisian Police
Paris, May 29, 1968

I address myself today to the entire House: to the security guards as well as the noncommissioned officers, to the officers as well as the chiefs, and I want to talk to them about a subject about which we do not have the right to be silent: the excessive use of force. If we do not explain ourselves very clearly and very frankly on this point, we may win the battle in the street, but we will lose something far more precious: our reputation. I know that, in your great majority, you condemn certain methods. I also know, and you know it as well as I do, that some deeds have occurred that no one can accept. Of course, it is deplorable that the press does not talk about all of the outrages and blows that the police have been subjected to in keeping their calm and simply doing their duty. I have gone to the bedsides of our wounded and I can tell of the savagery of some attacks, from a paving stone thrown head-on to a burst of chemical products intended to blind or seriously burn. All of this is sadly true. It is for this reason that I understand that, when men who have been assaulted in this way for a long time receive the order to clear the street, their action may often be violent. But, after the inevitable shock of contact with aggressive demonstrators whose aim is to push back, men of order like yourselves must immediately resume all of their self-control. To strike a demonstrator who has fallen to the ground is to strike oneself, in appearing in a light that affects every function of the police. Again, it is worse to strike demonstrators after arrest and

when they are taken into police premises to be interrogated. I know that what I say here will be misinterpreted by some, but I know that I am correct and that, deep down, you acknowledge it. If I speak thus to you, it is because I am in solidarity with you; I have already said it and I will repeat it: all that the Parisian police do concerns me and I will not separate myself from them in terms of responsibility. It is because of this that we must also all be in solidarity in the application of the directives on which, I am convinced, the future of the Prefecture of Police depends. Say it well and repeat it among yourselves: every time an illegitimate act of violence is committed against a demonstrator, there are dozens of comrades who will wish to avenge it. There is no limit to this escalation. Say also that when you demonstrate your composure and your courage, those who oppose you are obliged to admire you, even if they do not say it. In conclusion, we will remember that being a police officer is not a job like others; when one chooses it, one thereby accepts difficult demands, but also greatness. I know the ordeals that many among you are experiencing, I know your bitterness before the discourteous remarks or the bullying aimed at you or your families, but the only way to rectify this deplorable frame of mind from part of the population is to constantly show your true face and to wage a relentless war against all those who, by their ill-considered acts, might give credence to precisely this unpleasant image which they seek to give to us. I repeat that you have all my confidence and my admiration for having seen you in action during twenty-five exceptional days; and I know that, men of heart that you are, you will support me totally in that which I am undertaking and that you have no other goal than to defend the honor of the police before the Nation.

— *Maurice Grimaud*

*This letter was addressed to all members of the Parisian police.*

# 9

*This document, written by The Central Communist Internationalist Organizational Committee, illustrates the (ultimately successful) attempts of traditional political bodies to reign in the spirit of revolt that May '68 unleashed. After a spirited introduction urging struggle across all classes of society, the authors finally provide a list of demands for raises and shorter hours for workers and fewer restrictions on students in higher education—not the total restructuring of French society and the abolition of the wage system that more radical groups sought. Left-wing groups feared the students' rebelliousness almost as much as conservatives did, and they scrambled to channel revolutionary fervor into established, non-threatening pathways.*

## WORKERS, MILITANTS, YOUNG PEOPLE

May 3, 1968:
The students, leading the combat against the Fouchet Reforms, respond to the challenge of the police state. Until May 11, they will struggle alone against the power of the bourgeoisie.

May 13, 1968:
About 1 MILLION workers and students march in the streets of Paris.

May 14, 1968:
With the occupation of Sud-Aviation by the Metalworkers of Nantes, joined a few days later by millions of workers, the working class puts up the strength of its class in the factories against Capital and the State.

May 24, 1968:
In all of France, agricultural workers, smallholders, and workers go once again to protest in demonstrations against the government.

Thus all sectors of the working population and the youth, workers and students, high schoolers and apprentices, employees and technicians, in the cities, farmers in the countryside, have entered the struggle. Workers, militants, young people, this is class struggle: the struggle of workers against bosses, of the exploited against their exploiters, of young people against decline and deskilling, it is the class struggle of all of the working masses, of the youth, proclaiming their right to life, to work, to study, against a capitalist regime that, to assure its survival, argues about their elementary rights. This combat is not an addition of particular combats, one factory, one other, one office, one high school. This is all of the workers of all industries, all of the employees in all of the offices, all of the students in all of the high schools, all of the students in all of the colleges, all of the apprentices, all of the farmers in the country who lead a general combat. WORKERS, MILITANTS, YOUNG PEOPLE, we have entered, in millions upon millions, into a strike in order to seize the satisfaction of our fundamental demands. We want what the metalworkers of Renault and the workers of the RATP in Championnet want:
— No salaries less than 1,000 Francs per month.
— The repeal of ordinances, and in particular the repeal of ordinances on social security.
— The immediate return to a 40-hour week.
— The guarantee of work.

We do not want to be unemployed! We do not want lay-offs! We want THE REPEAL OF THE FOUCHET REFORMS, which intend to exclude 2/3 of students from the colleges. We, high school students and apprentices, want the possibility of continuing our studies, which assure us a skilled job. We want THE DEFINITIVE REPEAL OF THE 5th PLAN. WORKERS, MILITANTS, YOUNG PEOPLE, we must seize these demands against the de Gaulle government. We know that de Gaulle and his police state will refuse to give us satisfaction. But our immense force is such that we are already able to advance toward victory. We are not on strike in millions upon millions to regain the ancient conditions of work and exploitation at the factory, the office, and the building site. WE GO ON STRIKE FOR VICTORY! WORKERS, MILITANTS, YOUNG PEOPLE, we have the responsibility, we, the millions of strikers, to seize our victory. For this reason it is necessary:
— That the STRIKE COMMITTEE of each industry make contact with one another at a local level to constitute the INTERPROFESSIONAL STRIKE COMMITTEE.
— That the local interprofessional committees make contact with one another at département and regional levels to constitute the CENTRAL DEPARTMENTAL or REGIONAL INTERPROFESSIONAL STRIKE COMMITTEE.
— At the national scale, the delegates of the strike committees and the workers' organizations must constitute the GENERAL CENTRAL STRIKE COMMITTEE.

WORKERS, MILITANTS, YOUNG PEOPLE: it is for the effectiveness of the movement that we unite in millions and millions to attain our objectives. These are the organisms of the general strike: STRIKE COMMITTEE, local and interprofessional strike committee, central interprofessional departmental strike committee and general central strike committee, which must be invested with powers of direction to apply the decisions formulated by the Assemblies of strikers in the industry, and the Assembly of all of the strikers of the locality. WORKERS, MILITANTS, YOUNG PEOPLE, this general movement is OURS; WE MUST WIN AND WE WILL WIN. VICTORY RESTS UPON US. ONWARD! The Pompidou-de Gaulle government must disappear. We can make it capitulate.

May 23, 1968

*— The Central Communist Internationalist Organizational Committee for the reconstruction of the 4th International*
*This tract is paid for by the contributions and subscriptions of militants.*
*Subscribe: CCP SEDES, 11 668 45 Paris. "Truth":*
*39 Fg du Temple, Paris, 10th Arrondissement.*

# 10

On May 27, Union leaders signed the Grenelle Agreements, offering limited benefits to workers but addressing only a few of their demands. The workers generally rebelled against the agreement, refusing to end the strike. This document, written by radical members of the CGT, illustrates their anger at what they saw as the treachery of their union's leadership.

## NO TO TREACHERY!
## GOVERNMENT OF THE PEOPLE!

Renault, Billancourt, Cléon, Berliet, Snecma, Rhodia Vaise, Citroën, en masse the workers refuse treachery with cries of GOVERNMENT OF THE PEOPLE. The workers refuse the surrender agreement signed by the opportunist union leadership: the sell-outs, contemptuous of the essential demands and aspirations of the workers, want to present as a victory:

— The SMIG [minimum wage] at 520 francs
— Return to 40 hours… in three years!
— 4% real growth of salaries (7% on June 1, 3% in October, less than what had been obtained during the beginning of the year!)
— Social security: 5% cut in patient contributions and parliamentary debate!
— Workers' freedoms: GOVERNMENT BILL!
— PAYMENT FOR STRIKE DAYS: an advance of 50% WITH RECUPERATION IN WORK DAYS FROM HERE TO THE END OF THE YEAR!

The traitors will be swept aside: the popular revolutionary movement in France HAS NO PRECEDENT. The largest groups of the working people—students, commercial architects, farm workers—form a great indestructible wall around the working class. It is this unprecedented popular revolution that the capitulators are trying to surrender to the minister of social affairs. Worker, the people are counting on your resistance, on your immense strength. Refuse treachery. Demand the expulsion of the bureaucrats and the capitulators. Around the proletarian union activists of the CGT, we must make each factory into a fortress of the proletariat and of the popular Revolution.

## IMMEDIATE EXPULSION OF THE
## CAPITULATORS IN THE UNION ASSEMBLIES

The CGT must be educated today about the class struggle by the proletarian union activists EVERYWHERE AT ALL LEVELS. Each strike committee must be reinforced, must reflect the combat aspirations of the working class. SELF DEFENSE against repression in each factory. FOR THE SATISFACTION OF ALL OF THE WORKERS' DEMANDS, FOR THE GOVERNMENT OF THE PEOPLE.

Composed by active representatives of the people who organize themselves from the foundations in the factories, in the dormitories, and already in the villages. EACH FACTORY MUST BE A BASE OF FIERCE RESISTANCE TO TREACHERY AND REPRESSION. THE PEOPLE'S REVOLUTION WILL WIN!

— *The proletarian union activists of the CGT*
— *Read* The Cause of the People, *journal of the Popular Front.*

# 11

The students, too, were angry about the Grenelle Agreements. Despite the title of this document, it seems likely that the students had more to fear than the bourgeoisie did—the "provisional satisfactions" the agreements offered to the workers, and the fact that the movement was being steered in the direction of negotiation and parliamentarism, could only serve to slow the momentum of the movement they had begun.

## THE BOURGEOISIE IS AFRAID!

*Power Provoked and at Bay*
It reassembles all of its cops, its secret agents, its foremen, and fascist elements. The CRS and the Gaullist commandos have launched tear gas grenades on the picket lines; several centers of the PTT and the ORTF have been attacked, both in Paris and in the provinces.

*Power Lies*
The entire press throws out false noise of a return to work, remaining totally silent on the workers' resistance. At the Lyon train station, from over 5,000 workers and employees, only 60 scab managers have returned to work; the press fantasizes about a return to work at the RATP when the continuation of the strike has been voted upon in all depots at 90%.

*Power Deceives*
It grants some provisional satisfactions to the workers and tries to lead their struggle astray on parliamentary terrain, where it always deceives the people.

*More Than Ever the Workers Organize Their Response*
They go to look for striking workers to reinforce the mass occupation of the factories. All of the working population, small shopkeepers, employees, and intellectuals unite around them.

*They Organize Their Self-Defense by Every Means*

Already at Rennes the postal workers have been fighting against the CRS for an hour and a half. Already the strikers break down the secular separations between the town and the country, between the industries themselves. Already the strikers of the CSF at Brest have put their production at the service of the workers, at the service of struggles against the boss system. The decisive battle today is led against the bosses in the occupied factories. LET'S REMAIN UNITED AND DETERMINED FOR THE SUPPORT OF THE OCCUPIED FACTORIES. LET'S ORGANIZE THE UNITY OF THE POPULAR FORCES AT THE GROUND LEVEL AND IN ACTION FOR THE SELF-DEFENSE OF THE MASSES. FOR THE OVERTHROW OF THE BOURGEOIS STATE. The workers go back to the heroic example of the Paris Commune; they will lead the struggle until the abolition of the boss system and the wage system.

ALL POWER TO THE WORKERS.

June 3, 1968
*— Coordination Committee of the Action Committees*
*Movement of support for the struggles of the people*
*Movement of March 22*

# 12

**In reaction to Gaullist propaganda in the mass media, this document reports on the status of strikes at several factories, detailing which were still on strike and which had resumed work. Since the media rarely reported violence against the strikers, a third section lists factories where right-wing groups had attacked workers.**

## INFORMATIVE LEAFLET AGAINST DISINFORMATION

Tuesday, June 4

This informative leaflet, written by militants from the Action Committees, the committees of the Movement of March 22, the Committees of Support for the Struggles of the People, is intended to inform the entire population on the day-to-day reality of the struggles led by the workers. We will thus be able to oppose the campaign of disinformation orchestrated by the government and which is aimed, through the intermediary of the press and the radio, at demobilizing the workers. Gathered close to the striking industries, and close to the population of the districts, this information is the workers' truth in the face of the Bourgeoisie's lies.

SUMMARY:

1. The Strike continues and grows...
2. The Strike has ended...
3. The Picket Lines have been attacked...

## 1. GROWTH OF THE STRIKE

The workers respond to the contempt of the bosses for their demands with an exemplary determination. For them: THE STRUGGLE CONTINUES. This determined struggle manifests itself above all in the leading sectors.

CITROEN: The management refuses to consider the union's counter-proposals. The Strike continues.

PEUGEOT-Sochaux: The picket lines are maintained. The unions have rejected their employers' proposals, which were clearly far from fulfilling the demands of the workers.

BERLIET: In LYON-Ville 300 non-strikers allegedly entered the factory on Friday. The strikers reoccupied the factory on Saturday.

SAVIEM: The unions call for the reinforcement of the strike.

EDUCATION: The National Union of Teachers, the National Union of Secondary Education, and the National Federation of Education call for the continuation of the strike.

TRANSPORTATION: SNCF—The strike continues. At Mulhouse, where a train was set in motion by some executives, the railway workers lay down on the tracks and stop its departure. 90% OF STRIKERS FOR THE STRIKE! RATP—90% OF THE STRIKERS declare themselves in favor of continuing the strike. The union delegation has left the negotiations.

ORLY: Traffic blocked. The control tower provides take-off and landing only.

SUD-AVIATION: No satisfaction of the workers' demands, therefore continuation of the strike, with determination.

TAXIS: No resumption of work.

While continuing their struggle, the workers also organize themselves at SAVIEM. The entranceways have been welded shut and incendiary missiles are prepared. At the RATP, the employees have rendered the cars unusable by anyone outside the depot.

## 2. THE STRIKE HAS ENDED...

In general, work has resumed in businesses where the workers have obtained satisfaction—that is, in certain businesses in Nantes, Limoges, and Clermont-Ferrand. Work has resumed in the steel industry of Lorraine. In the Parisian freight forwarding companies, work has resumed. At Nouvelle Messageries (NMPP), the workers have obtained a raise of 200 francs per month! In the north, the resumption of work is almost universal in the textile industry. At BELFORT, the CFTC called on the CGT and the CFDT to make the occupation of the factories count. In the department stores of Paris,

the personnel declared themselves on Tuesday. The bosses announced that "in any event, work resumes at 10 a.m. Tuesday."

### 3. THE PICKET LINES HAVE BEEN ATTACKED

For the bourgeoisie, which wants to stop the strike, ALL MEANS ARE VALID. At BHV rue de Rivoli, a commando from Occident, and a few from the Civic Action Service (SAC), attacked the pickets—3 wounded. At the SNCF depot in Saint.-Denis, at midnight on June 2, 4 men in Dauphine attacked the picket line. (Two strikers wounded.) At the Lyon train station on June 1, some executives, accompanied by outside elements (Planchet, UD, Ve), attempted to break through the picket lines.

# 13

*A collection of first-hand accounts of police brutality, overzealous arrests, and racism. This document, which describes events of May 23-25, details the sort of occurrences that led to Maurice Grimaud's letter to the Parisian police on May 29.*

### TESTIMONIES OF REPRESSION

Read first and then distribute widely

The stories quoted in this document were brought to the "EVIDENCE AND JUDICIAL ASSISTANCE COMMISSION," made up of a group of lawyers, doctors, sociologists, professors, and students. This commission currently has more than 300 stories recounting the behavior of the forces of order in Paris between May 3 and May 26, 1968. The evidence quoted in this document concerns events that occurred on May 23, 24, and 25 exclusively. However, similar events reported in another document have been observed since May 3. In the extracts from the testimonies published here, the original wording of each witness has been respected. The commission can certify them to be authentic and retains the originals.

*— Evidence and Judicial Assistance Commission*
*UNEF, SNE-Sup, Victims' Committee*
*(Document handed out during the press conference of June 4)*

### Arrests Outside of any "Hot Spots;" Furious Attacks on Individuals

…"Boulevard de Port-Royal, Saturday at three o'clock in the morning, the boulevard is deserted, except for one boy about 40 meters from me… At this moment a Police Rescue car arrives. I paid it no attention, being outside of the 'hot spots,' and also because it was a police car as seen every day and not a CRS car. It stopped at the point of the boy who was ahead of me, 10 CRS got out, surrounded him and clubbed him…"

*— Testimony of a passer-by, assistant film editor.*

…"At 8:30 on Friday May 24, I found myself blocked and on my own inside the forbidden perimeter… Arriving at the middle of the Place de la Bastille, I am shouted at… I was alone, unarmed, without a helmet, with an identity card. The CRS, without questioning me, without asking for my papers or searching me, begin to hit me: blows from fists, from boots; several other CRS approach and begin to hit me on the head and above all on the body. I try to escape, then I run into two other CRS wielding clubs… I pass out… I try to get back up, and they begin the beating again… I pass out again. Finally, a motorcyclist from the PP [Parisian Police] tells me to go away. Half-senseless, I make it fifty meters and I am lucky enough to run into a volunteer ambulance… I emphasize that the CRS who had hit me maintained their composure, and were calmly next to their car in the middle of the Place de la Bastille, which was blocked… My parents will not lodge a complaint, there's no point in doing so since it will be impossible to find them again and I wasn't able to recognize them…"

*— Testimony of a 16-year-old high school student*
*who will be admitted to surgery at Cochin Hospital*

"I found myself at Place Saint-Michel on Friday, May 24, at about 11 in the evening… I saw the CRS nearby me hounding an old man who was clearly returning to his home. He had his keys in his hand and lived a few doors further away. The poor man lost a lot of blood."

*— Testimony of a wounded young woman*
*taken to the hospital by first-aid workers*

"After the protesters had fled, a car coming from the Place de la République at a slow speed was stopped by the CRS… the driver was pulled out of the car, clubbed on the ground, wounded. A Red Cross car arrived; the ambulance drivers wanted to pick up the wounded; the CRS stood in their way and took the driver away."

*— Testimony of a 49-year-old librarian*

### Obstacles to the Intervention of First-Aid Workers, Violence Against First-Aid Workers, Racism

"On May 25 at 4:00, in Rue Danton, I saw a young protester, 15 or 16 years old, caught between two CRS charges. Before my very eyes, he was beaten up with an unprecedented savagery. He bled a lot from his face in particular. I went down in my van and claimed the wounded. A motorcycle policeman (on foot) threatened me with a paving stone from a distance: 'This is none of your business, get out of here.' Following which the CRS added: 'That one is ours, don't even think about taking him…'"

*— Testimony of a first-aid worker*
*prevented from bringing aid to a minor*

"…I was in a 2CV with a nurse, an extern; we came across a barricade; the CRS searched the cars and asked for our authorization to be in a vehicle with a red cross. She had her extern papers; they

let her pass while they brought me into a van. Even before entering they hit me with clubs; inside the van they continued to give me blows with pistol and rifle butts on my face, legs, hands, and above all my head…At Beaujon I asked the officer not to leave me like that, in the state that I was in; they called a police ambulance that brought me to Beaujon Hospital. I had contusions on my head, face, thighs, on my hand, split lips. Moreover, this was after what I had experienced the day before at Beaujon (wounded left all morning without treatment) when I had volunteered to gather the wounded in a first-aid car"…

—*Testimony of a volunteer hospital porter who had already been wounded on May 23. The witness is French, but his physical appearance indicates a North African origin. Other testimonies indicate that this was doubtlessly related to the treatment that he suffered.*

### Violence Perpetrated Inside the Apartments of Riverside Residents

"During the night of May 24 to 25, at 1:30 in the morning, in the vicinity of 27 Boulevard Saint-Michel. At the moment of the CRS charge on the barricade built at this spot on Boulevard Saint-Michel, I was asphyxiated by gas from the grenades and took refuge in the entrance of the building at 27 Boulevard Saint-Michel with about ten people who were in the same state. We were sitting on the ground, trying to catch our breath when, letting out howls like I've never heard before, about ten raging CRS kicked in the door, clubs and shields in hand, insulting us and yelling that they were going to massacre us all. Then there was general rush of all of us into the stairwells, knocking on all of the doors to open up for us, but in vain. On the second floor, a boy who was in front of me, holding a pregnant young woman by the hand, kicked in the door to one apartment with the intention of protecting his wife. I rushed in behind them, with another couple, while the rest of our comrades continued running up the stairs. The apartment that we entered was unoccupied and didn't have a single piece of furniture for us to hide behind. The young couple—the woman was three months pregnant—took refuge in the bathroom, and almost immediately the CRS broke down the door and, still howling as before, rushed for this couple. I was hiding in the side room, the only room that, miraculously, they did not enter. But I heard this woman's screams, shouting "I am pregnant" and being bombarded with a lot of "Here, bitch, you'll see if you're pregnant," etc. I'll skip this part, because I could go on for ten pages. They hit her husband to their hearts' content, also hitting another boy who was there, and took the two of them, leaving the pregnant woman nearly unconscious in the entryway, with her head completely swollen and in a disturbing state. As I helped her get back up, she screamed, *My husband, my husband, they're going to kill him, he already has a skull fracture…etc.* Then we went out onto the landing, and a door on the second floor opened up, from which a man quickly took us into his home where all the others were taking refuge. We made this very traumatized woman lie down, and we all stayed

entrenched through the night until 5 in the morning, the building being completely surrounded. The entire time, we saw them clubbing the wounded, arresting solitary passers-by and hassling them, and finally throwing grenades against the buildings. It wasn't until 5 in the morning that we were able to call for help. The young pregnant woman began to have contractions, and the nurse who examined her said that she was at risk of losing her baby. She was immediately transported to Baudelocque Hospital. [Here the testimony specifies the name and address of this young woman.] I have heard no news since then.

P.S. At the moment that the CRS entered the building, there was a black man sitting on the bench listening to a radio. He said to them: "I live in the building, please leave." They insulted him, calling him an "ugly nigger," then they violently clubbed him.

— *Testimony of a 28-year-old woman.*

### Treatment Inside CRS Vehicles, Scapegoats, False Accusations

"…We have to stay facing the car, our hands in the air. New ones arrive gradually until there are about 30 of us (Friday, May 23, at 10:45). They are clubbed even though they are already against the car. About half do not appear to be demonstrators: women in spike heels, men in three-piece suits, etc.

— Threatened to "make us dance" while fiddling with bombs at our feet

— Blows to the head if we try to speak

— Blows to the fingers if our arms are not high enough

— A boy made to hold his arms out as if crucified with a paving stone in each hand

— Constant verbal abuse

— A black and an Arab, not demonstrators, were very badly mistreated; the black is isolated in order to be hit more

— A boy is clubbed until he collapses

Personally, I only received one blow to the head; after three hours with my arms in the air, a chief passed, looked at my driver's license and my occupation and let me leave… 200 meters away, I asked a CRS how to leave the surrounded quarter; he put me in a van where a single Algerian was being beaten"…

— *Testimony of a 25-year-old female decorator*

### Treatment in police stations and at Beaujon Hospital

"…At the time of the questioning, though I did not try to flee and obeyed orders, I was struck in various places with blows from clubs, feet, and fists. Arriving outside the station, I was insulted while receiving blows from clubs on my legs (thighs) of which I still bear the marks. In passing through the door of the police station, I received a punch in the face—of which I still bear the mark—and a kick. Inside the police station, some CRS threatened to rape me, talked about undressing me, and insulted me. Note that I was the only girl inside the station at this time. I insist on establishing that, in the police station of the 5th arrondissement, it was principally one

man in civilian clothes, bald, in the area of 35-40 years old, overweight, about 6 feet tall, dressed in gray, who I heard called Jules, who kicked, punched, and insulted me. Later I was transported to Beaujon and held there until Sunday morning at about two, when I was released without charge. If the wounds that I myself received after I was brought in for questioning were not very serious, I must establish that I observed the following things:

1. After being brought in for questioning, while we were being searched, a CRS placed himself behind the person next to me and, without searching him, turned back toward his colleagues, holding some bolts in his hand and pretending that he had taken them out of the boy's pocket. The boy was then badly clubbed by several CRS. Most of my comrades, especially the one who was right in front of me, were clubbed, punched, and kicked all the way to the police station.

2. Inside the police station, we were put together and hit with blows from clubs, all of us: the wounded were prevented from sitting, whatever their state. One time when I was in the cell, I observed that the detainees who arrived after me, boys and girls, had been punched and kicked by the man in gray named Jules, and clubbed by some young CRS. On two occasions, some boys were brought out of the cell just after they were thrown into it in order to be beaten again—they were told that they hadn't yet gotten what they deserved. A little later, brought with the girls into the reception room, I was able to ascertain that several CRS were getting drunk on red wine—this was after the departure of a police officer who I heard called "Mister Prefect" and who must have been Mr. GRIMAUD.

*— Testimony of a 22-year-old female student*

### Testimony of a 26-year-old student teacher on "questioning to verify identity" and the treatment that it has led to in police stations

I would like to bring to your attention the following facts, of which I was the witness and victim, as well as the 900 other people "brought in for questioning" to verify their identities during the night of May 24-25. Arrested at daybreak when I was returning to my home, I was driven to the police station of the 5th arrondissement, Place du Panthéon, where I was able to ascertain that the questioning was undertaken in the following fashion: from their arrival, most of the "questioned" people, men or women, adults or adolescents, were violently struck with punches, kicks, and clubs by the CRS, who injured them without giving them the chance to explain their presence in the street at that hour. The agents of the police, either consenting or afraid, intervened only very rarely. I was able to hear an officer making the following comments: "Gentlemen, (addressing the CRS officers), contain your men, I can no longer do my work" and "Calm down, take a coffee break." Some of the detainees (myself among them) were thrown into jail cells. The others, beaten so savagely that they remained unconscious, were either driven by Red Cross porters to the treatment center at the side of the 5th arrondissement Town Hall or brought by ambulance directly to a hospital. I can certify that these people were unharmed until their arrival at the police station and that it was there that they were beaten, then handed over to first-aid workers of the Red Cross, who waited until the CRS were finished with their "work" and disposed of these people who were so damaged and blood-drenched that their presence became embarrassing. It is impossible for the first-aid workers to testify, but one can imagine that a great part of the 1,000 counted wounded became so in police stations. At about five, we were brought out in cars to Beaujon. At Beaujon, we got out of the cars and were locked up in an enclosure surrounded by barbed wire. There we found other people who came for the most part from the police station of the 4th arrondissement, where they had been treated with at least as much violence as those coming from the 5th. Very rare were those who didn't have either two black eyes, or split lips, or bruised shins, or blood-soaked hair, or toes crushed by a blow from a gun butt; every wound had been inflicted—it cannot be said enough—inside the police stations. Out of the 500 or 600 people locked up there, very few had been arrested at the hot spots of the demonstration: in general they had been "taken in for questioning" off the street and it is not surprising that the official statistics should victoriously mention a tiny percentage of students, since it is evident that Asiatic and north African immigrants were deliberately arrested, treated with a particular violence besides, and individuals of a more or less suspicious appearance according to the criteria of our society, which allows the authorities to count more "foreign" elements and "ex-convicts." From eight in the morning to seven at night, we were sent two by two every three or four minutes into a room in the center in order to give our name and address. Those who were not charged with any crime—that is to say virtually everyone—were then locked up in a room. At about three, a group of CRS came into Beaujon to rest and have something to eat... It is impossible for me to capture here the violence of the abuses and threats that were directed at us. About thirty CRS set up all around the fences at the edge of the route leading from the enclosure to the room where we were being interrogated. They moved the fence so that the path was as narrow as possible. Thus, when two of us left the enclosure, they were subjected to either spit, or punches to the gut or face, or blows from clubs, for about thirty meters. Most of the CRS were laughing with an indescribable hatred, and I must say that during the half hour that this "exit exam" or "running of the bulls" (as they called it) went on, not one police officer—and there were dozens of them—intervened to stop them. We had to wait for the intervention of a high-ranking police officer who, coming out just at the moment that a CRS gave a violent blow with his fist, made them move away from the fences. I have abstained, during this report, from stating precise instances of brutality; I could do so, because I was witness to particularly odious deeds, but it seems

more important to me to denounce a frame of mind: to put forth the "composure" of the servants of order is actually nothing more than an unspeakable hypocrisy.

## Testimony of the treatment inflicted on minors at Beaujon

Being 17 years old, I was in the minors' cell at Beaujon on Saturday. In the cell (3m x 5m) there were, when I arrived (at about 9 in the morning), 25 people, and in the middle of the afternoon, about 60. Some bore the traces of blows and most complained of having been clubbed. I noticed a young boy about 16-17 years old who had clearly been the victim of a meticulous beating. He no longer had any clothing except for a bathing suit, socks, and a light vest, as well as an anorak that had been loaned to him, but no shoes, pants, shirt, sweater, or jacket. His legs were streaked with red and black marks, and the inside of his thighs bore long red blotches resembling burns. He remained prostrate in the corner of the cell without saying a word and got up every half hour to vomit. Then the guards were called who, without hurry, opened the door and led him out to the W.C. Everyone in the cell called for him to be driven to the hospital. After several hours, during which he continued to vomit, guards came to look for him and he was not re-examined.

## Testimony of a seriously wounded 18-year-old high school student, currently hospitalized, who was the victim of an attempted drowning

I came back from the demonstration with my comrade Jacky during the night of Friday May 24 to Saturday May 25. It was about two in the morning and we intended to return to Lycée d'Aulnay, which required us to cross the Seine. We saw a bridge on which there only appeared to be two CRS motorcycle cops. Three people had already gone by them before us. That is what reassured us and encouraged us to cross this bridge. Then two other people joined us. No sooner had we passed by the two motorcycle cops when they turned and clubbed the two people who had joined us. My comrade and I started to run in order to finish crossing the bridge. But then we saw a wall of CRS appearing suddenly from behind some civilian cars and blocking the way. We retraced our steps and, breathless, I watched the CRS on one side and the motorcycle cops on the other, approaching and giggling while my comrade managed to escape. Cornered against the wall of the bridge, I climbed up to avoid a club-blow when a CRS said to me: "Go ahead, jump!" Panicked, I repeated this phrase and went down the other side of the wall, where I spotted a narrow ledge on which I could put my feet. My fingers, which were wrapped tightly around the streetlight that protected my head from the blows, were constantly hit with club-blows to make me let go and fall into the water. This lasted a good minute until a plainclothes police officer intervened and held me by the collar of my jacket. He told me to cross back over the parapet of the bridge and that he wouldn't hurt me (incidentally, I had not been struck in his presence). Some first-aid workers who saw the scene asked to take me with them, and were refused. After having frisked me once and looked at my hands, the CRS made me get into a car where I found myself alone. I was driven in this vehicle to another bridge and transferred to another car, where a CRS questioned me about my identity. While leaving this vehicle I was made to put my hands on my head and then I was clubbed once again. Then, I was made to go back into the rear of this same car, where I found 5 or 6 other people. We waited a bit, then we were transferred once again into another vehicle, which was a blue car from the police station. I was clubbed once again during this transfer by those who were driving us to the headquarters of the 4th arrondissement. Hidden from the outside by some cars, we were made to go down between two rows of CRS who hit us with blows from their clubs, feet, fists and cuffs. After being brought into the station, we were crammed into a corner. Inside, there were people in civilian clothes who had the list of arrestees and who called us to bring us into the cell. At first, they called two 17 to 20-year-old boys, who were accused of having a pistol. I did not see them again. In order to go into the cell, it was necessary to pass between the counter of the station and a row of CRS and mobile guards who hit us coldly, deliberately, and with a particular brutality. I received blows on my head, in the stomach, and on the legs. But I stayed standing, because before me a young man who had fallen beneath the blows was literally "smashed in" by kicks. Then I was pushed into a cell of about 2.5 x 4 meters, in which there were about 60 to 80 of us. About ten more people came in after me. We stayed here until our transfer to Beaujon, where we arrived at around eight in the morning. Before leaving the police station, I witnessed the following things:
— In our cell, a young woman had demanded to leave because she was ill; the CRS let her come out, then we watched while they clubbed her; we no longer dared to ask for help if we passed out; we still wanted to send out a boy with a heart condition who was "out cold", permission was refused.
— While the second wave of arrestees was arriving, I saw one particular young girl, tall and blonde, who had been clubbed and had fallen to the ground; a CRS wanted to rape her; everyone shouted; then an officer approached and said to them politely: "That's enough, gentlemen", and in the end the girl was not raped.
At Beaujon, we were cooped up from eight in the morning to seven in the evening on the stage, in the rain. We were given two sandwiches. Some CRS who were on break, arriving at about 4 p.m., once again clubbed some of us who passed within their reach. Afterwards, I was put in the gymnasium, where I joined the others. Then I was let go at about 2:30 a.m. I began to have sharp pains the following Tuesday; my state necessitated hospitalization. I have given this testimony freely.

*L. 19.5.50*
*Signed June 3 1968*

# 14

---

*The British communist newspaper* Black Dwarf *launched in May 1968, borrowing its name and enumeration from a radical and satirical journal published in the early 19th century. The first issue of the resurrected periodical included extensive background information on the Events in general and a detailed account of the first Night of the Barricades.*

*BLACK DWARF*: Vol. 13, No. 1—1 June 1968

## THE NIGHT OF MAY 10

**6 p.m.:** At Place Denfert-Rochereau, a demonstration called by UNEF and 22 MARCH GROUP collects 30,000 people blocking traffic for two miles. The crowd is asked by Cohn-Bendit and other leaders where it wants to go. They decide upon the Prison de la Santé, the Ministry of Justice then the ORTF (the French BBC) which has been insulting and disgustingly untruthful in its reporting. While marching at least 5 or 6,000 more join in. We circle the Santé Prison which is defended by thousands of armed police then turn towards the right bank and the ORTF. By clever stationing of police, we are forced to turn up the Boulevard St. Michel instead of down St. Germain. This was our big mistake, not to push through there and then. We realised then we were falling into a trap. The enormous demonstration was halted in Boulevard St. Michel by gigantic forces—we were encircled.

**12 a.m.:** March 22 Militants begin to dig up cobblestones. Some UNEF people and bystanders try to stop us. Dean of University asks to see representatives, of professors and students. Cohn-Bendit and four others go to see him. They come out an hour later saying, "nothing happened." Decision is taken to occupy the Latin Quarter peacefully, not to provoke police but to defend ourselves if attacked. This was followed to the very end; barricades were defences and all participants merely defended themselves from police attacks. We just wanted to hold the Latin Quarter to show police who had been occupying the Sorbonne for five days that they must leave. "We will occupy the Latin Quarter without bothering the police, until the police are gone," said Cohn-Bendit. This statement was supported by most of the university staff. It must be clear that what happened on this historical night was totally improvised: no direction, no preparation, very little coordination. It was a spontaneous explosion.

**1 a.m.:** Literally thousands help build barricades (Europe no. 1 Radio reported that more than 60 barricades were built in different streets), women, workers, bystanders, people in pyjamas, human chains to carry rocks, wood, iron. A tremendous movement is started. Our group (most have never even seen the others before, we are composed of 6 students, 10 workers, some Italians, bystanders and 4 artists who joined later; we never even knew each other's names) organises the barricade at angle of Rue Gay Lussac and St. Jacques. One hundred people help carry the stuff and pile it across the street. From then on I was so busy coordinating work at our barricade that I don't know what happened elsewhere. Witnesses say it all happened at the same time and more or less in the same way all over the Latin Quarter. Our barricade is double: one three foot high row of cobblestones, an empty space of about 20 yards, then a nine foot high pile of wood, cars, metal posts, dustbins. Our weapons are stones, metal, etc, found in street. Of course the majority of people simply look on. We organise a cordon to keep photographers and bystanders away from us. A great deal of spontaneous help is given from inhabitants of nearby houses who offer water, sugar and cloth as protection against gasses and warn us of police movements. It is their support which keeps our enthusiasm from flagging in the seemingly endless time of waiting for the inevitable police attack.

**2 a.m.:** It is now obvious that police are preparing a powerful attack. Radio announces we are surrounded and that government has ordered police to attack. (The Chief of Police insisted on the order in writing.) Some bystanders leave. We continue building up barricades organising supply of rocks and medical centres every 100 yards. I try to coordinate runners between different barricades near ours but we lack time and are caught by attacks before we can get it together. Practically no news from other points of our territory. Someone finds a French flag, we tear off blue and white panels—red flag now floats over our barricade. I am told many red and black flags flew on other barricades. In front of us we turn over cars to prevent police from charging with their buses and tanks. (Radio said tanks were coming but we never saw any.) It also said 15,000 workers were on the way to help us from St. Denis but were surrounded by the army. (They never materialised either, although a great many workers were already helping us to construct barricades.) I must insist again that the general mood was defensive not offensive, we just wanted to hold the place like an entrenched sit-down strike and if we had not been savagely attacked there would not have been any violence at all. After days of occupation of the Sorbonne and surrounding area by heavily armed police it was the least we could do to hold our ground—the Latin Quarter. Police attack on Place de Luxembourg. Their tactics are simple: at 100 yards distance they launch gas grenades by rifle which blind, suffocate and knock us out. This gas is MACE (Vietnam and Detroit mace). Also small explosive grenades, one student near us picked one up to throw it back, it tore his whole hand off (reported in *Le Monde*), tear gas and phosphorus grenades which set fire to the cars. We defend as best we can and later we find out that practically every barricade withstood police at least an hour, sometimes four hours, regardless of blinding and suffocating gases. The police are slowly advancing up Gay Lussac (crowds are running away, we have a hard time calming them down and channeling them towards exit down Gay Lussac where police are fewer). But then police attack at three points simultaneously: at two extremities of Gay Lussac, at our barricade and at Rue d'Ulm.

Casualties are heavy on our side, mostly people knocked unconscious by gas, some temporarily blinded. Thousands of voices shout together: 'De Gaulle assassin,' 'Liberez nos camarades,' 'Revolution,' 'A bas l'Université bourgeoise.' Some make molotov-cocktails. I try to dissuade them for fear of police massacre not so much of us but of thousands of onlookers, just standing there, fascinated. The general feeling is of a trance. We feel liberated. Suddenly we have turned into human beings and we are shouting 'WE EXIST, WE ARE … [line missing in original] … an incredibly heroic gesture, grabs a red flag and leads us towards the cops through the gas and grenades. To our utter surprise we outnumber the enemy and they retreat. Crowds behind us cheer wildly. We come back behind our barricade, only one slightly wounded. But gases are our worst enemy, we can't breathe, we can't see. Finally we are forced back. Our barricade burns. At this point all I can remember is that I fainted from lack of air. I come to in a corridor two girls slapping my face and putting wet cloths on my eyes. Water is the only thing that helps. They tell me a student carried me there. I look outside: police are everywhere, our barricade across the street burning. Yellow gas fumes are so thick you can't see. I try to run out, thinking to rejoin our forces further down but police are charging from both sides with grenades and big lethal truncheons; we are cornered. We organise inside building at least 60 students, some wounded, others fainting. We try to barricade the door. Some desperately ring door bells inside the house, nobody dares answer. We crowd staircases. Police arrive, break down door, grab a few and beat them to a pulp, throw in three gas grenades which are murder to our lungs and eyes. Police leave to come back later. A girl on the second floor tells us to come in, we crowd in like sardines and she gives us water. Outside: explosions, explosions, explosions.

6 a.m.: Still fighting outside. We all vote to call Red Cross anyway because one of us is bleeding badly. We are scared of Red Cross because they sometimes turn us in to the police, but other times protect us, you never know. It is a fact that many Red Cross that tried to help wounded or faint students were also beaten by police (see *Le Monde* for details of this kind, of police armament, gas, etc. …) The police are searching house by house, room by room. Anybody with black hands and gas spots on clothes (gas attacks leather) or wounds is beaten and arrested. (More than 500 arrested in all.) We 60 decide to leave together in case we have to fight our way down the street: Helmets are given to girls. The sun is up. We run into the open in a body: fantastic: what a sight! Smoking barricades everywhere, overturned cars, street unpaved, for half a mile. Painted words on walls: Vive la Commune du 8 Mai, A BAS L'ETAT POLICIER … I can't help it, I run over to see our barricade. It still stands, deserted; some onlookers, stunned, the unbelievable sight of the empty battlefield. This rue Gay Lussac was ours all night till about 4.30 a.m. OURS. I ask a student for a piece of his dirty red shirt, we tie it to a stick, put it back on our barricade and run, police are charging on other side of street. I can hardly walk from pain. We circle round to Rue d'Ulm, there to police arresting every-

body including those in medical centre. Barricades and cars smoking in every street and every corner. Passers-by warn us where police are; many people in cars and taxis volunteer to take us out of police zone. Everywhere we see enormous police buses full of our people tired, beaten, bloody prisoners. The revolution has begun. If you want to help us there is one way. DO THE SAME THING.

—*Jean-Jacques Lebel*

# 15

*An extremely brief handbill, no doubt composed in a hurry, urging Paris-based students to travel to the suburb of Flins to help to retake the Renault factory there from the police. The Flins factory was a key locale in the strike, with major symbolic value for protestors and police alike. Its importance caused it to be the site of some of the worst violence of the Events, and on June 10 a high school student named Gilles Tautin was killed there. Other documents in the archive describe both the police invasion itself and the students' travels there to support the striking workers.*

In Renault, at Flins, the CRS has invaded the factory.
The strikers demand help from the entire population.
**NO TO THE CAPITULATORS!**
**NO TO THOSE WHO STOP THE WORKERS**
**FROM CONTINUING THEIR STRIKE!**
**NO TO PRE-ELECTORAL MANEUVERS!**
**LET'S ALL GO TO FLINS**
**THE STRUGGLE CONTINUES**

Movement of March 22
June 5

# 16

*A more detailed account of the police invasion of Renault-Flins, providing details about meeting places where a convoy of protesters met up to travel to the factory.*

## EVERYONE TO FLINS

The morning of FRIDAY May 7
Last night at 3:30 a half-track broke down the doors of the RENAULT-FLINS factory. 5,000 CRS overran the factory and threw the picket line outside. During TUESDAY the management maneuvered to force the workers to return to work without having obtained the

satisfaction of their demands. After distorting the election by making the non-striking executives vote, they called the cops. CATEGORICAL REFUSAL AND POLICE REPRESSION: THESE ARE THE SOLE RESPONSES OF POWER TO THE WORKERS' DEMANDS. The workers of RENAULT call on the population to come en masse to their support at FLINS at 4:30 in the morning on June 7 in front of the factory. STUDENTS, TEACHERS, WORKERS, let's form a large popular union behind the workers of FLINS. Contact the Action Committee for your district. At the Sorbonne and Beaux-Arts, departures will be organized and coordinated to ensure safety. Telephone LIT 50 01. We need cars, vans, and automobiles. Put them at everyone's disposal.

— Coordination Committee of CAR
Movement of March 22
Movement of Support for the Struggles of the People.
JUNE 6 1968

occupying the factory. The CRS won't get production moving. To do that, we need to want it. And yet this is not the case. At Billancourt, at Cléon, at Mans, in all of Renault's factories, the workers are on strike, with the same determination as on the first day. The workers of Renault struggle all together, in all countries. Having set out all together, they will only resume work all together, when their demands have been satisfied. On this matter, the cops will change nothing. If we know how to stay all together, we are and will remain the strongest, because not a single car will leave the assembly lines as long as we don't want them to. WE WILL NOT WORK UNDER THE THREAT OF THE COPS. COMRADES, ALL TOGETHER IN THE STRUGGLE UNTIL THE END!

*Supplement to No. 30 of* THE WORKERS' VOICE
*29 rue de Château-Landon, Paris, 10th Arrondissement*
*Permanently manned office: every day of the Siege from 8 a.m. to 8 p.m..*

# 17

*This single-page mimeographed supplement to the Workers' Voice is an urgent call for support at Renault-Flins. The section describing an army of armed police enforcing the "freedom to work" illustrates well the ironic application of power the striking workers faced.*

### WORKERS' VOICE: June 7, 1968
RNUR (Régie Nationale des Usines Renault) Flins Special Issue

### THE STRUGGLE CONTINUES
Last night, more than a thousand CRS and mobile guards came to "retake" the Flins factory. The Management prepared this coup well. It was at three in the morning that their cops came in, when there were only two or three hundred workers to guard the factory. And, not confident enough of themselves, they judged that an imposing display of force was necessary, sending in four or five times as many police armed to the teeth who, to show well their aggressive intentions, entered into the factory by breaking down the gates. Ever since the day when it "stuffed" the ballot boxes with "yes" ballots, the Management has attempted a maneuver on the Flins factory. They know that, of all of Renault's factories, Flins constitutes a weak point, isolated deep in the countryside with workers living sometimes 60 or 70 kilometers away. So what? Now, this deployment of mercenaries camps in the park, with belts buckled and epaulettes fastened. The purpose, it seems, is to assure "freedom to work!" A fine image of "liberty," these clowns in uniform! What does the Management hope to do with their help? The strike won't end just because they're

# 18

*As the strike began to wane in early June, radical workers and students were under pressure to keep its momentum up. The Renault factory in Flins became a focus of attention—one Atelier Populaire poster describes it as "le pilier du grève," "the pillar of the strike." This tract describes a clash between workers and police that took place on June 7, after the factory's workers rejected the Grenelle agreements, and after a convoy of workers and students had traveled some 40 km from Paris to show their support for the strikers.*

### JUNE 8, 1968
RENAULT-FLINS: Victorious Resumption of the Strike

— Capital believed it was attacking the weak link of the metal-working industry (an isolated factory, no union tradition, a number of immigrant workers, a fascist organization in the factories).
— It sent 5,000 CRS, mobile guards, a half-track, etc.... to protect the scabs' "freedom to work."
— But the workers of Flins continue the combat. Friday, at 5:00 a.m., they amassed with a number of students in front of the thousands of cops protecting the factory. Workers and students overtake the CRS along the route where the cars arrive, carrying the workers who were tricked into thinking they were resuming work. They get into each car to explain the situation, and quickly all of the cars are empty and the 9,000 workers are united in a meeting to continue the strike.
— It is then (10 in the morning) that the mobile guards attack the gatherings of workers in Elizabethville. Not only do the workers have no access to their factory, but the neighboring villages are also prohibited.

— All day the workers, at first surprised and unarmed, respond and hold on before the mobile guards. Power is forced to add 50 cars of CRS during Friday night.

*L'Humanité* says this morning: it is the student provocateurs that are at the origin of the violence. This is a lie. It was the workers of Flins (there were 8,000 of them) who sent for the students. It was the CRS, by their scandalous presence in the factory and the surrounding area, who provoked the workers of Flins. The students who wish to retake the Sorbonne understand the workers of Flins who wish to retake their factory: that's why they were yesterday and are still at the side of the workers in the face of the repression of the bosses and the police.

The reality: it's the anger of the workers.

**The reality: it's the fraternization of the workers and the students.**

Today the strike movement turns its eyes to RENAULT-FLINS. Entire sectors take up the struggle again: the postal sorting offices, Berliet, etc... go back on strike, seeing in the fighting spirit of the workers of Flins the sign of an ongoing struggle for the abolition of the bosses. The workers of Flins have opened a new stage of the struggle. LET'S MOBILIZE: all of the businesses, all of the workers, all of the students. LET'S REINFORCE THE STRIKE MOVEMENT. SUNDAY AND MONDAY will be two decisive days for the workers' struggle.

*— Coordination of the Action Committees of the Parisian Region*
*Movement of Support for the Struggles of the People*
*Movement of March 22*

# 19

*These two articles from the newspaper* Action *describe the education front of the Events. The first discusses plans for the "Université d'été," the Summer University that students hoped would prolong communication about the struggle and keep the spirit of rebellion high for renewed action in the fall. The second describes the occupation of Lycée Henri IV, a high school in the Latin Quarter.*

## ACTION: No. 14—Thursday, June 20
## PROPOSALS FOR THE SUMMER UNIVERSITIES

The question of direct democracy will also need to be tackled at the Summer University: from this problem of syndical and political control of the rank and file over the management, the business committees of several factories have spontaneously come to debate with representatives of the SNE-Sup (Syndicat National de l'Enseignement Supérieur). Thus, the Summer Universities will come about starting from the fundamental demands of the workers—and

not a priori, in the abstract. We have seen how the question of a model of civilization has been tackled, linked to a strategy of struggle for the overthrow of the bourgeoisie.

### Short-term objective

The Summer Universities will and must come into being very quickly, for the following reasons:

— The workers are coming back to work, but they are still very strongly mobilized on all of these problems, and it is possible to make them partners in the summer universities very quickly.

— Furthermore, the Summer Universities are, in their hands, a political weapon to respond to the government's attempts at setting the reactionary university to rights. All of the structures, all of the new methods that were tested, will be the best response to the endeavors of the government.

— Finally, it is the best way to show that the Movement endures and is capable of realizing what it says. This is the method of mobilization, the only way to impede the "investment" of the forces of "order" in the colleges, the only possibility of giving political objectives to the militants who realize that physical confrontation is impossible, that, for the moment at least, the Sorbonne cannot be retaken.

### Where will they be?

The Summer Universities cannot be everywhere: it will be necessary to choose. To choose other colleges: if it is true that the Sorbonne is a symbol, symbols don't matter at all. To choose sites: Paris empties in August and there is no reason to want to keep the workers in Paris. Summer Universities can also be set up at Montpellier or Aix.

### With whom to work?

The Summer Universities must be largely interdisciplinary: they will need the participation of people from the law, from the economic sciences, from the exact sciences, from medicine, from sociology, etc. All must work together on the themes that we have mentioned. As for the organization of the Summer Universities, that is the immediate task of the student-worker action committees. This is a problem that must be taken up by the unions that have contacts with the elected strike committees, such as the SNE-Sup. On a local level, the political battle will be a battle of protest to obtain the necessary material means for the Summer University: housing (it could be found in the university dormitories), food (maintaining subsidies to university dining halls open to all). The budget must be taken from the universities' operating budgets. Moreover, it is logical that the work that comes from these encounters be published. This poses the question of a self-run academic and popular publication using State funds. To institute a permanent Summer University is to pose in living terms the question of a model of civilization that opposes bourgeois

civilization and struggles to overthrow it; it is to restore the true face of the movement, which is well beyond the barricades.

## THE COMMUNE OF LYCÉE HENRI IV

Since Monday evening, the students of Henri IV High School have carried out an important battle: the battle for the real power of students, political freedom in secondary establishments and the permanent establishment of a "critical high school." During the entire duration of the general strike, the high school students have occupied their school 24/7. 10 days ago, they abandoned the occupation at night. The taking of the Sorbonne by the police forces, the delaying stance of the teaching unions, and the refusal of the ministry to take their demands into consideration[1] have made them understand that the successes that they have actually obtained in the action could be called back into question just the same as the demands they have not obtained. They decided, by a great majority, to reoccupy their high school day and night and to push the administration's backs to the wall.

### Self-management: political control

For them, the self-management of education that they tested for a month with some of their teachers required the participation of student delegates at staff meetings to serve as referees. This demand made by the CAL met with the approval of numerous teachers as well as Parisian principals, whereas it was officially rejected by the Paris board of education several days ago. Notification was given that the staff meeting could, in certain cases, receive a student delegate (at the same time as a representative of the students' parents!) to hear their wishes, but nothing more. On Tuesday, the day on which the senior class meeting was held, the principal decided to apply the directives of the board of education to the letter, and this fact set off the students' anger. The delegates were asked to leave the meeting, but they refused; then, before the departure of the delegates accompanied by the teachers, the principal locked himself and several colleagues in. At the announcement of these facts, 200 students immediately occupied the staircases and hallways leading to the principal's office and demanded that a delegation be received. Then an attack on his office was planned. The suspension of the class meeting (already radically restricted) made this project known. The students remained together in meetings while the prep school students at the Saint-Cyr military academy, the "Cyrards," began to gather and decided to be done with "all of its history of occupation." On Wednesday morning, while the students talked, the leaders of

1   The High School Students' Action Committees (CAL) demands consist of four principle points: 1. Student representation at staff meetings without the presence of the administration. 2. Recognition of the CAL by the administration. 3. Political liberties within high schools (tracts, posters, debates). 4. Student participation in the life of the high school: representation on the Internal Council, etc.

the pedagogical work groups tried to prepare a preliminary report on the work produced during the occupation. In the afternoon, beginning at 3 p.m., a general assembly of the students was held in the cafeteria. The assembly was stormy. The dominant impression is that it was necessary to resolve the crisis: the principal and administration needed to be made to yield not only on the class meetings, but also on the other demands of the CAL. It was decided to occupy the administrative offices right up to the door of the principal's office. This last item forced the discussion of…

### The principal's mercenaries

But meanwhile the "Cyrards" had transformed themselves into the principal's mercenaries. Armed with clubs, they occupied the first floor of the wing containing the administrative offices. The students secured themselves against any attack, occupying the visitors' room and the telephone switchboard. A test of strength began, and some students from Louis-le-Grand and Turgot high schools came to support their comrades. Everyone knew, however, that if a fight broke out, the police forces would intervene happily at the principal's request. But he was forced to take a step: at 6 p.m., through the intermediary of a teacher, it was announced that the principal would receive a student delegation in one hour. The wait continued. In the visiting room there were card games and discussions of the situation. In the courtyard, small debates opened between students and teachers. The teachers who were present were by and large in favor of the students' demands. At 7 p.m., the delegation was received. A half hour later, the delegates returned to the courtyard and related the results of the meeting to 300 of their comrades: a "nyet" from the principal. Excluding the concession of one classroom for the students (which they had already de facto obtained during the occupation), the administration met all of the students' demands with a refusal. The principal entrenched himself behind the ministry's position: he could not accept representation on the Internal Council without a decree from the board of education. The same went for class meetings. The delegate then presented two possibilities: either confront the principal's mercenaries physically, or give up everything by continuing the occupation of the school. After discussion and a vote, the first solution was finally rejected: combat would not achieve much, except perhaps a sensational "paving stone" for Lazareff. To let the "Cyrards" protect the management is to reveal their true function. The assembly then discussed the practical details of the night occupation and of establishing liaisons with other high schools, particularly those that continued or had returned to the strike. At Lycée Henri IV, the commune of students is not ready to give in.

# 20

![bar]

*This newsletter was published by students at the College d'Enseignement Technique of Chatillon, a technical junior high school. Its title seems to be a sardonic reference to L'Anti-Mythe, the internal newsletter of the Action Committee for the 14th arrondissement, and as that title suggests it is replete with derisive, back-biting, and nasty comments about the internal workings of the movement: the first page attacks an individual member of the Action Committee and declares many more of its members "lazy, unpleasant imbeciles." This is followed by a lengthy piece commenting on events at the CET, but with frustratingly few details. The text of the fourth page cuts off abruptly, and it is not clear if there was an additional leaf to this newsletter or if the text simply extended further than the mimeograph machine's reach.*

**THE MYTH**: No. 1—Thursday, July 4, 1968
Internal Bulletin of the Action Committee
for the 14th arrondissement and Montrouge

Let's actively prepare the October Revolution.

### The contagious disease of the committee: Ignorance

On July 2, a contagious disease was rife in the Action Committee of the 14th: ignorance. Its most characteristic symptoms consist of beginning interruptions in meetings with: "I DON'T KNOW, BUT..." If the comrades don't know, it would be better if they don't believe themselves forced to speak. This disease will be difficult to cure, but the comrade who began speaking at the July 2 meeting and contaminated others (all but one have been contaminated)—this comrade is also the biggest loudmouth on the committee. For those comrades who have not understood, he's the one who said "RED CAP OF MY HEART."

Riddle: WHAT IS THE SMALL H.?
IT IS FORBIDDEN TO FORBID...

### Sociological study of Action Committee 14

The elements of the (hastily) appointed group appear to be split up thus:
1st subgroup: Lazy, unpleasant imbeciles
Strongly represented
2nd subgroup: Lazy, pleasant imbeciles
Is in fact the same as the first, because laziness and stupidity make pleasantness difficult
3rd subgroup: Lazy, [un]pleasant, intelligent people
Does not exist because intelligence makes one pleasant.

4th subgroup: Lazy, pleasant, intelligent people
Exists, but is of no use.
5th subgroup: Active, unpleasant imbeciles
Is much more formidable than the first.
6th subgroup: Active, pleasant imbeciles
Is even more formidable, but you can't hold it against them.
7th subgroup: Active, unpleasant, intelligent people
Will not like this article, and wants the author to sign it.
8th subgroup: Active, pleasant, intelligent people
The 8th subgroup is an empty group. (THE BEAUTIFUL BODY)

L...L...L...

The CET (College d'Enseignement Technique) of Chatillon is, like the CET of metalworking apprentices, in the low level of selection (tests). That is what makes most of the students who are there feel that their stage of apprenticeship is an education in rejection (no one there wants to be a metalworker, milling machine operator, or a worker in a factory). But the CET is nothing less than a privileged place for them, at least for those who have gathered to occupy it. It is because of the place rather than anything else that the boys of an occupation committee have gotten together; we find that Casius, as much as the son of the president and the parents of students, was the big goof-off. While the CET was without "purpose," for example Monday after the party, practically all of the boys of the occupation committee came there, left and came back. I don't understand at all what connection there is between the work of the CET (reflection upon reform) and the ideas created by the principal and the professors of Nicolety's style. When the (transport) strikes ended, the students of the CET were found with the occupation group, the latter wanted to expose what he had done. He couldn't make a speech, making himself deal with a "mistake" (ass-kisser) by the students. During the few days in which courses were theoretically resumed, and before the official closing of the CET, the occupation committee found itself in a privileged status of liberty vis-à-vis the classes and the CET. At the moment that we began to work there, Nicolety, Balanger, etc. tried to make the students receptive to the work of the occupation committee. For Nicolety, because I assisted in his class, he took care of himself well, pedagogically. This posed the pb. [problem] of the power of the group's political freedom. (As I type this text I propose that, in *The Myth*, we use abbreviations... yokel) One of the first problems of our failure is not having seized this situation; the contacts that we had with one of the boys of the CET were relationships of representatives to representatives. We came to see the CET and we did not see the few—Casius, Tanguy, Jean-Marc —who had this function in Nico's first class, where I had assisted, and also these latter who represented the occupation committee; Nico demanded that they come into his class. There is a demand that we have not exploited—it is that if the types on the occupation

committee welcome us, it is that we were "outside." This link with the outside has not been realized by the Anti-Myth: it is enough to see the sort of article that they have communicated to us. I think that if we took this demand (contrary to that of the management, who wait for us to help the mass of students in the CET recover), and the status of the occupation group, into consideration at the time, we would have quite a job compared to that which has been made. The fact that we have passed these two things by poses the problem of the Action Committee's work, because in the end we asserted it to ourselves: these ideas which drained themselves into the Action Committee on cultural animation, spectacles, cafeteria etc. The face-smashing of the spectacle committee was to analyze with the work that we had not done at the CET. In fact, the only "trick" that we have done at the CET was that the party was possible and that the party had a character (this shows in its repercussions + in its style) that it had not traditionally had. The role of the management in this party was very interesting because if anxiety overcame the students (to relieve the drooling impossibility of their doing something) it was even worse for the management. In effect, the ideal for the management was that the students themselves threw their party because the management's ideas of self-discipline and "self-bullshitting" stopped them where the students laid the table and withdrew; this one who, though a keen teacher of "modern pedagogy," is all the same a little weak. The students that organized themselves there with us made a real shift of power and were not bullshitting themselves, and there the management was incapable of creating something to equal the organization: the principal, when one takes him to be there but not present. But he didn't feel like a "principal pitching in," at least at that moment. The crude attempt at taking back in hand to stop the ball was on view in this setting. It's interesting that the principal, after what happened on Sunday, wasn't able to dismiss us. The only evasion that he could find is: you will come only as individuals and not as the Action Committee. But he found a means of breaking what had happened in emptying the CET, and the lack of work there (which really wasn't), the party allowed it to happen, because last Monday many boys passed CET, and if the Action Committee permitted the occupation committee to find a purpose and a place in which to find it, the manipulation of the principal had little chance to pass. Tuesday, the principal remembered the fullness of his function. He is funny enough, while we discuss with the boys who were there, that the principal was taken to sweep the courtyard. "And the principal swept all alone!" Discussion was impossible. The problem is now to find specific interventions into the group of those who are staying in Paris and of those who are in the provinces or who work during the summer. Daniel, the "Men Pen," was critical of our action in the party; pretty much the only one that exists, refusing him a political character. Such a criticism poses all of the problems of the action that was or might be at the CET, that is to say to consider the group with which we had contact as a place that

necessitates actions that permit boys to find their political shapes. No, our role is to shape ourselves into teachers of political theory or to permit them to find it in their day-to-day lives.

— PRESIDENT MITHO

PS. Jean-Pierre's sweet talk about the difference between manual labor and work reserved for intellectuals is not true. This theme of decoration was chosen as a group, admittedly not by the entire Committee but by a large enough number. So Bertha only started the necessary outlines on the walls, if only to give at least the compass and ruler technique, but the students continued sometimes in a different style: look at the wall to the left of the entrance, which is not English posters. There was an in-depth analysis to make this remark of Jean-Pierre's, because he wasn't there at the time of its decoration…

**PASS IT ON (gathered by President MITHO)**

The janitor doesn't like it when we throw lit cigarettes out the window; we don't aim them at anything in particular. The housekeeper complains: the rolling pin gets dirty too quickly and the lavatory is dirty. Those comrades who forget "we are not alone," there are also very good people in the fourth! Forward for the long march of the youth toward the people! Since the beginning of the month of May, the intellectual youth in revolt has understood that it is only one part of the army of the revolution, that its role is not only in the faculties but that it also needed to join with the working classes to help them to break out of the isolation in which the bosses try to keep them. In making friends with the workers, the intellectual youth strengthen their class positions, becoming effectively revolutionary. It was necessary to help the organization of workers, to popularize their struggles in the petty-bourgeois sectors of the districts. For the development of the struggles of the working class, the resolved struggles (occupations of factories, self-defense) must become as widely-known as possible, and the sabotages of the capitulators must be denounced. In this first stage of the long march, the youth puts itself at the service of the struggling workers. The Gaullist bourgeoisie and the reformist management of the CGT and the revisionist PCF have multiplied the obstacles to this unity in the struggle. They have succeeded in removing one part of the provincial working class, the bulk of the poor farmers, and the agricultural workers from the combat, despite the solidarity of many of them with the mass strike movement. The PCF has done nothing to exalt the workers' struggles in the countryside; it has attempted to maintain the separation between young intellectuals and workers. Also, for the struggle of the French people against the exploiters, against the reactionary government, against their reformist allies and capitulators, it's necessary to strengthen the unity of the masses under the direction of the most advanced elements. That is the goal of the second stage of the long march of the youth. This movement

of support for the struggles of the people wants to: UNITE THE YOUTH in proposing to them a clear course: to help all of the people (that is to say the workers of the cities and the countryside, the poor farmers, the petty bourgeoisie, the intellectual youth) to organize under proletarian direction, that is to say under the direction of the most advanced elements of the working class; to lead the youth on the only revolutionary path: the path of class struggle, in breaking its division into sects and cliques. UNITE THE PEOPLE by developing a propaganda campaign on the events of MAY while organizing numerous exchanges of experience between the youth of the countryside and the farm workers: the progressive youth will learn from the exploited farmers and workers how they struggle; they will develop the theme of solidarity with the workers' and farmers' struggle. UNITE THE PEOPLE by defeating the politics of the bourgeoisie and its social-democratic allies: divide and conquer. The youth will contribute to realizing the united front of all revolutionary struggles. WHAT IS OUR JOB NOW? The long march of the youth must continue. In Paris, at the heart of the work undertaken during May, propagandise towards:

Businesses; Young workers and the unemployed; Certain sectors of the districts (old workers); In the provinces, set up where groups of young workers and students meet. For example, in the north, the main task is to help the organization of workers and the unification of active and unemployed workers (female textile workers, miners). The struggles in the north, by and large, have been slow compared to those in the rest of France. It is necessary... [text cuts off].

# 21

**This brief set of guidelines gives a glimpse of how the Action Committees organized themselves and made decisions. The line at the beginning indicates that this was a proposal, and was not necessarily accepted or put into action.**

## ORGANIZATION OF ACTION COMMITTEES

Proposal of the Action Committees
of the 3$^{rd}$, 4$^{th}$, 5$^{th}$, and 11$^{th}$ arrondissements

### 1. Liaisons

Each member of an AC is a regular liaison with a neighboring AC or CB. In addition, this is a better tactic against the disruption of the movement by those in power.

### 2. Groups from 5-10 A.C.

— Periodic meetings of 2 delegates per AC (twice a month)
— Delegates replaced by rotation

— Role of the delegation:

a. No power of decision, except in the case of urgent events

b. Tour of duty to decide on an immediate action for the region; the members of the tour of duty convene or call the other groups in urgent cases.

External: clearance of an objective among those proposed by the AC and practical organization of this action.

Internal: Centralization and transmission of information, Clarification of political options, Facilitation of liaisons, Preparation of inter-group meetings (for example—mid-September)

### 3. Coordination of practical order

Central documentation that gathers information, transmits them in a liaison bulletin (BLICA). It gives information and establishes the first contacts inside and outside the movement. Close contact with the guard group. Stimulation of liaisons.

### IF THE PRINCIPLE OF THE GROUPS IS ACCEPTED:

Immediate execution. Division of present ACs by groups from 6 to 8.

# 22

**This radical newspaper opens with a detailed description of the students' tactics on the barricades. It suggests that, with better organization—and possibly less squeamishness about violence—the students might have been able to overcome the police and turn their revolt into a true revolution. The anonymous writers describe some students' experiments with gasoline bombs that "had a considerable detonation effect, followed by fires." They add —with a tinge of regret?—"They were not used." A brief entry on right-wing rhetoric quotes Fouchet's reference to the demonstrators as "la pègre"—"the underworld" or "scum." A lengthy article reprints tracts and position statements from a variety of groups, and a brief piece on the final page gives the history of the movement from March 22 to the beginning of May, written by the March 22 Movement. The creators of this document were interested in disseminating information to support the movement, but they also show a clear dedication to documenting history as it happened.**

**THE PAVING STONE: Tract No. 1—May '68**

## BARRICADES

In France, over the course of about 20 days, students and workers have descended into the streets four times already. One method of protest is developing: combat in the street and on the barricade. At first, these combatants who participated in direct action clearly had

no experience. They learned by practice during the days of open and violent crisis that has slowly spread across France and beyond its borders.

The first barricades—those of Boulevard Saint-Michel on Monday, May 3—were rudimentary. They acted as simple obstacles designed to slow the advance of the CRS, mobile guards and special brigades. Two points are to be emphasized:

— Considering the numerical size of the demonstrators, the number of wounded was relatively small and the barricade proved an effective means of self-defense;

— Despite the impact of grenade-launchers and the asphyxiating effect of the gas, the throwing of paving stones and other projectiles enabled the forces of repression to be held momentarily in check.

During the course of the Red Night of May 10-11, the combatants' technique was already improved:

— The first barricade on Rue Gay-Lussac, for instance, was made up of piled paving stones, chains, and concrete. These materials restricted the advance of the CRS or hindered their retreat, keeping them in great numbers in a relatively reduced space. From roofs, windows, and balconies, militants and some inhabitants of the district bombarded the CRS unceasingly, thus allowing the withdrawal of the besieged. Changing their tactic, the forces of repression fired tear gas grenades or toxic gas against the shutters and through the windowpanes of the apartments, thus wounding many individuals and causing fires.

— In the implementation of this systematic operation of successive barricades, one could have noticed several errors: forgetting to create a provisional passage allowing the front-line combatants to withdraw; too great a concentration of demonstrations, thus restricting movement between the barricades. On the other hand, the transportation of projectiles toward the front was never interrupted.

— The potential for protection was increased tenfold over the course of the same night by the very nature of the barricades and obstacles (not only paving stones, planks, railings, but also overturned cars positioned on alternate sides), which transformed into a screen of flames when grenades hit them.

At the beginning of the night of May 22 to 23, the demonstrators contented themselves with lighting smaller fires with the debris from fences and the filth strewn over the sidewalks. Essentially, these served as spectacular acts rather than attempts at occupying terrain or defense. Incidentally, the police responded by bringing fire engines and trucks into play.

However, we point out:

— The distribution of demonstrators in small groups—never larger than about a hundred, and therefore very mobile—provoked a division of the police forces, keeping them breathless all night on the Left Bank;

— To compensate for the danger of using incendiary bottles, to limited effect, some demonstrators had recommended 10 or 20 liter jerrycans filled with burning clothes, intended to be thrown from the tops of buildings. It appears that this material had a considerable detonation effect, followed by fires. They were not used.

From a political and tactical point of view, several facts stand out from the events of the night of May 24 to 25:

— The participation of the workers in the riot was greater than on the preceding days.

— For the first time, confrontations were created beyond the Left Bank and barricades were put up in new districts, thus provoking the dispersion of the forces of repression across several parts of Paris (Gare de Lyon, Bastille, Nation, République, Place de la Bourse— sacred flame of the "Temple of Capitalism"—grand boulevards, Opéra, Les Halles, etc.).

— Also for the first time, the insurrection broke out simultaneously in the provinces (Lyon, Nantes, Strasbourg, Bordeaux).

— The police utilized a new technique: attack by fast-moving medium-sized units, supported by fire engines and especially bulldozers. After an intensive preparation with the assistance of gas and offensive grenades, the charge was led in a hurry, the CRS hoping to thereby sweep up the demonstrators. All methods of anti-riot conflict were employed systematically, the forces of order striving at every moment to break the concentrations of demonstrators up into small groups to then cut down the pockets of resistance with great brutality (pogroms, bludgeoning of first aid officers, etc.).

— This time, the barricades were definitely more elaborate. All of the fences available were used. It appears that the slaughter of some trees and the overturning and destruction of hundreds of private cars to consolidate the barricades may have offended some of the defenders of order and private property—the same people were not shocked, on the contrary, by the bloodthirsty brutality of the CRS. Fires often diverted the attention of the police forces. The installation of barricades increased accordingly. The ones that were built across main streets or on bridges enabled the immobilization of the CRS. During these times the small streets, easier to defend, were methodically obstructed. This time the workers and students opened genuine fronts, sometimes going so far as to practically encircle the CRS, forcing them to transport considerable reinforcements to free themselves. The effectiveness of scattering the barricades and their operation was demonstrated, and the fires often placed the police forces in a difficult position. It must be noted, however, that the rules of urban guerilla combat were not applied: the demonstrators' tactics always had a character of improvisation and defense, lacking in coordination. In fact, they ignored the position of different barricades, and no specific team was in charge of a group of combatants. There were no contact groups; there was no one specific in charge. The police could have practised classic offensive methods: dispersing tear gas, assaults, occupation of territory. The vehicles charged with the supply of munitions took up a position at the rear of the police forces, strong but poorly protected, and were never attacked, thus allowing

the CRS to refill their sacks of grenades without interruption. In summary, the responsibility for the "escalation" of the demonstrators' self-defense tactics was only made in response to the accumulation of repressive measures carried out by the police state.

## THERMIDORIANS AND VERSAILLERS

In a tract calling for a demonstration at l'Etoile on May 18, some anonymous nationalists expressed themselves in terms that define the level of their "criteria":

*ENOUGH*

1. of red flags by the thousands
— on public monuments
— in marches and demonstrations
— in the amphitheaters.
2. of the "Internationale"
— sung by demonstrators with raised fists
3. of the French flag
— desecrated, torn up, burned in public places
— turned into foul rags
— the Tomb of the Unknown Soldier defiled.
4. of anarchy which sets in
— the university turned into a cesspit
— the CNRS in cultural revolution
— the Odéon turned into a dump
— the frescoes of the Sorbonne covered in paint.

*MORE LAWS*
*MORE AUTHORITY*
The communist revolution prepares and scores points every day.

Fouchet, Minister of the Interior, comically confirms his boss's call against the shitty mess. As for him, he rails not only against the "anarchists who are certainly very well organized for street combat and guerilla warfare," but also "the scum, more numerous each day." It's really something: "I demand that Paris vomit up this scum who dishonor it," and adds: "The students must come out of their vertigo."

## POSITIONS

*The explosion and dissent of ideologies and organizations brings us to cite a certain number of tracts and public statements of position in order to specify the orientation of the spontaneous revolutionary movement that the young workers and students are leading today.*

*From a call of the March 22 Movement demanding the formation of Committees of Revolutionary Action:*
The new type of political expression and struggle sparked by the March 22 Movement has proved that power is found in the streets. Following the route traced by the workers of Caen, Mulhouse, Le

Mans, Redon, from Rhodia to Paris, the students, high schoolers, and workers who demonstrated against the police state's repression during the night of Friday, May 10, 1968 have struggled in the street for several hours against 10,000 cops. The bourgeoisie sought to quash a form of dissent and demand that directly accuses its own power. To the bourgeoisie's violence, the demonstrators, clearly supported by the population, opposed their political will: the bourgeoisie's mercenaries knew the delights of Molotov cocktails and tasted the affections of paving stones in front of the barricades. Several hundred among them were left high and dry. Students and workers learned to fight. In the future they will show that they have not forgotten this lesson.

*On May 22, the COUNCIL FOR MAINTAINING THE OCCUPATIONS took a stand for POWER TO THE WORKERS' COUNCILS:*
In ten days, not only were hundreds of factories occupied by the workers, and the activity of the country almost totally interrupted by a spontaneous general strike, but also many buildings belonging to the State were occupied by de facto committees that have seized the management. In the presence of such a situation, which cannot go on in any case, but which faces the alternatives of either expanding or disappearing (repression or liquidating negotiation), all of the old ideas are brushed aside, all of the radical hypotheses on the return of the revolutionary proletarian movement are confirmed. The fact that the entire movement has truly been sparked off, these past five months, by a half dozen revolutionaries of the group of "Enragés" reveals all the more the extent to which objective conditions were already present. Already the French example has rung out beyond the borders and made internationalism reappear, inseparable from the revolutions of our century. The fundamental struggle today is between the masses of workers on the one hand— who cannot speak directly—and, on the other hand, the political and union bureaucracies of the Left that control—even if it's only from the 14% of union members that make up the active population—the doors of the factories and the right to negotiate in the name of their occupants. In the past, these bureaucracies have not been degraded into traitorous workers' organizations, but have been a mechanism of integration into capitalist society. In the present crisis, they are the principal protection of a shaken capitalism. Gaullism can negotiate, mainly with the PC-CGT (albeit indirectly), regarding the demobilization of workers, in exchange for economic advantages: thus the radical currents are suppressed. Power can pass "to the Left," which will play the same politics, although coming from a weaker position. Repression by force can also be attempted. Ultimately, the workers can take the upper hand by speaking for themselves and becoming aware of the demands that are at the same level of radicalism as the forms of struggle that they have already put into practice. Such a process may lead to the formation of Workers' Councils, deciding democratically at the foundation, united

by delegates dismissible at any instant, and becoming the sole deliberative and executive power over the entire country. How does the prolongation of the present situation affect such a perspective? In several days perhaps, the obligation to return certain sectors of the economy to work, under the workers' control, could form the basis of this new power, which takes everything beyond the unions and existing parties. It will be necessary to put the railroads and print shops back to work, for the needs of the workers' struggle. It will be necessary for the new de facto authorities to requisition and distribute food. It may be necessary that failing currency be replaced by goods staking the future of these new authorities. It is through such a practical process that the profound will of the proletariat can make its presence felt, class awareness takes over history and realizes for all workers the domination of all aspects of their own lives.

*To the central unions' attempts at reformist appropriation, the MAY 10 GROUP declared that "EVERYTHING IS POSSIBLE FOR THE WORKING CLASS IN ACTION":*

The government could make two apparently important concessions today: nationalization of large industries and joint management of businesses, that is to say all the way up to agreeing that some workers supervise the exploitation of the entire proletariat, and so much the better if they are "democratically" elected like the deputies of Parliament are. NO TO THIS JOINT MANAGEMENT OF BUSINESSES. WHAT IS REQUIRED IS THE EXCLUSIVE MANAGEMENT OF WORKERS OVER THE ENTIRE ECONOMY AND OVER POLITICAL POWER. NO TO THE NATIONALIZATIONS THAT POWER MIGHT BE PREPARED TO CONCEDE UNDER THE GUISE OF SOCIALISM. In addition to the fact that this establishes a State capitalism, in no way does this improve the lot of the workers (look at Renault, etc.). To thwart Power's divisionary maneuvers, like certain groups of the Left, numerous WORKER-STUDENT ACTION COMMITEES have been created. One of them declares:

*WORKERS*

The students have taken the university and are managing it. The goal of the universities was, until now, to create leaders at the service of the bosses. From now on, we refuse to become the guard dogs of the bourgeoisie. To be a slave of the bosses is horrible: to be a CRS cop on top of that is unbearable. Our problems are the same as yours. In fighting on the barricades and in occupying our workplaces, we have called into question the conditions of work that have been imposed upon us. At Nantes, the workers have set up barricades and have been clubbed like us, and on the same night (May 10) the army intervened. At Redon, at Laval, the workers are in revolt. To bring down this system that oppresses us all, we must STRUGGLE together. Worker-Student action committees have been created to this end. Together we struggle, together we will win.

*On its side, the REVOLUTIONARY COMMUNIST YOUTH spoke to workers and students in its terms on May 21:*

WE MUST GO ALL THE WAY! WE ARE OCCUPYING:
— THE COLLEGES
— THE ADMINISTRATIONS
— THE FACTORIES…
… WE'RE STAYING THERE!
— We won't let the bourgeois politicians or social-democrats, the Mitterrands and the Guy Mollets, negotiate the return to order in exchange for a ministerial armchair!
— We won't let the union leaders negotiate a return to work in exchange for benefits that, though perhaps appreciable, will be quickly trimmed by inflation and the intensification of production rates. The power that we want is not a government of the Left following the government of the Right. The power that we want has nothing to do with parliamentary combinations of bourgeois and reformist politicians! The power that we want must institute the direct democracy of socialism, based on the authority of grassroots committees in businesses and districts. The power that we want must come from the workers' and students' Strike Committees and Action Committees. STUDENTS, WORKERS, A UNIQUE CHANCE PRESENTS ITSELF TO US: LET'S NOT LET IT GET AWAY!

*However, as events evolve, the specific problem of the university becomes blurred before global protest, before the irreversible will to destroy the capitalist system to promote a new society. This will has been clearly expressed by the MARCH 22 MOVEMENT in its call for the unification of struggles and its calling of four meetings on Friday, May 24:*

We are occupying the colleges, you are occupying the factories. Are we fighting for the self-same thing? 10% of the children of workers are in higher education. Is this what we are struggling for, that there might be more of them, for a democratic reform of the university? This might be better, but it's not the most important thing. These children of workers will become students like any other. That the son of a worker could become a manager—that is not our plan. We want to abolish the separation between workers and managers. There are students who, upon graduating university, don't find jobs. Are we fighting so that they might find work? For a good policy on the employment of graduates? This might be better, but it is not essential. These graduates of psychology or sociology will become selectors, psycho-technicians, orientators who will try to adjust your working conditions; the graduates of mathematics will become engineers who develop more machines that are more productive and more unbearable for you. Why do we, students who come from the bourgeoisie, critique capitalist society? For the son of a worker, to become a student is to leave his class. For the son of the bourgeoisie, this might be the occasion to understand the true nature of his class, to wonder about the social function to which he is

destined, about the organization of society, about the place that you occupy. We refuse to be scholars cut off from social reality. We refuse to be used for the profit of the ruling class. We want to abolish the separation between the work of action and the work of thought and organization. We want to construct a classless society; the meaning of your struggle is the same. You demand a minimum salary of 1000 F in the Parisian region, retirement at 60 years, 48 hours' pay for a 40-hour week. These are old and fair demands. And yet they appear unconnected with our objectives. But in fact you occupy the factories, you take the bosses hostage, you go on strike without notice. These methods of struggle have been made possible by lengthy actions led with perseverance in workplaces and also thanks to the students' recent combat. These struggles are more radical than your legitimate demands because they do not simply seek the improvement of the lot of workers in the capitalist system; they involve the destruction of this system. They are political in the true sense of the word: you do not struggle so that the Prime Minister can be changed, but so that the boss will no longer have power in either business or in society. The form of your struggle offers to us, we students, the model of truly socialist activity: the appropriation of the means of production and of the power of decision by the workers. Your struggle and our struggle are convergent. It is necessary to destroy all that isolates one from the other (habits, newspapers, etc.). It is necessary to create a link between the occupied businesses and colleges. LONG LIVE THE UNIFICATION OF OUR STRUGGLES!

*To the revolutionary action of the workers and students, certain parasites have only been able to cling on with the congenital counter-revolutionary opportunism that is their own. Here, for example, is a declaration of a composite group of writers, signed by a "provisory bureau" which has its headquarters at the Society of People of Letters, from May 21:*

A certain number of writers, feeling that the present circumstances permit the constitution of a truly significant professional association for the defense of their interests, are in session this morning at 11 a.m. in the Hôtel de Massa. All of the existing associations of writers agree to support them in their action and they proclaim their solidarity with the students' and workers' movements. The defense of their interests being the unique preoccupation of these intellectuals, jealous of their privileges, who dare to pretend agreement with the revolutionary students, we can only denounce them as we denounce the cultural industry and the bourgeois University of which they are the servants. A tract of the CAR (Revolutionary Action Committee) affirms that, to the contrary, "today more than ever, faced with the Gestapo of Power, the revolution is in the streets. The State (its socio-police, politico-cultural structures) will collapse beneath the pressure of the revolutionary workers: THE REVOLUTION MUST BE MADE BY ALL AND NOT BY ONE. Wreck industrial culture; long live permanent, collective creation." This radical statement of position is

not left without echo. Several days later, the ACTION COMMITTEE OF THE PLASTIC ARTS, which has its headquarters at the School of Beaux-Arts, in the Marbot workshop, called for the boycott of cultural institutions and events, symbols of current political power; questioned the socio-economic structures of the distribution of art; proposed to the galleries either to close their doors to indicate solidarity with the students, or to transform themselves into centers of opposition in connection with the current struggle of the workers and students. On the other hand, the ACTION COMMITTEE OF THE PLASTIC ARTS desires the creation of a unique union, the expansion of "painting in the street," the organization of exhibitions in businesses, the sabotage of auction revenues at the Galliera museum, and, for the future, the suppression of Salons.

*We remember that certain artists and writers have scaled the barricades, to the side of the students and the revolutionary workers, and their socio-professional problems. Further, the ex-Theater of France was taken over by a REVOLUTIONARY ACTION COMMITTEE that immediately submitted the following motion to the convened assembly in the great hall on May 16, at 6 a.m:*

The Revolutionary Action Committee, the workers, the students and the artists occupying the Odéon resolve that the ex-Theater of France cease to be a theater for an unlimited duration.
Starting May 16, it becomes:
— a meeting place between workers, students, and artists.
— a permanently-manned revolutionary creative office.
— a place for uninterrupted political meetings.
On May 17, the CAR made known the following declaration in a tract:
The Revolutionary Action Committee who, in connection with the militants of the revolutionary student movement, have taken over the ex-Theater of France and transformed it into a meeting place permanently open to all, announces that, during the night of May 16-17, it has transferred the responsibility for the unlimited occupation of the premises to an Occupation Committee made up of actors, students, and workers, whose political position is in line with its own. Of course, the goals of the occupation remain the same, that is to say:
— The sabotage of all that is "cultural": theater, art, literature, etc (from the Right or the Left, governmental or avant-garde) and keeping political struggle at the highest priority above all others.
— The systematic sabotage of the cultural industry and in particular the industry of the spectacle, so as to give way to a truly collective creation.
— The concentration of all energies on political objects, such as the expansion of the revolutionary movement, the struggle in the streets against Power, the reinforcement of the union between revolutionary workers, students, and revolutionary artists.
— The extension of direct action, for instance through occupying as many places of work, broadcasting, or decision as possible.
The CAR considers that it met its goal in occupying the ex-Theater of

France as soon as the political objective was clear and public. Today this irreversible movement must expand and grow stronger. As to theaters, the slightest corporate activity, the smallest show organized within their walls, the slightest slackening of revolutionary agitation would betray the spirit that was revealed on the barricades and which must not diminish at any cost, but must increase in strength. In addition, not a single ticket must be sold at the ex-Theater of France, whose status as a wasteland must be maintained. The theatrical act of occupation was, in this case, a political act.

— It took over one of the bastions of Gaullist power.

— It revealed the collusion between a certain counter-revolutionary unionism and the bosses allied with the club-wielding brutes. The CAR decides to move on to other things in other places. The CAR warns the Odéon Occupation Committee ("CAR-Odéon") against the risk of an authoritarian, bureaucratic overgrowth that might re-establish obsolete hierarchies and which would take away from this organization its revolutionary dynamism. It is necessary to drive back every attempt at recovery of the premises by Power, any re-conversion of the premises into a theater. The only theater is guerilla theater. Revolutionary art happens in the street.

**THE MOVEMENT**

Bourgeois and capitalist society creates for itself a multitude of "guard dogs": news, culture, credit, etc. Each of these is a means of alienating the mass of workers. Two of these dogs are particularly essential to the survival of the monopolies, namely:

— the forces of repression (the police, the army);

— the "executives" who, in order to preserve their jobs, are obliged to help capitalism to increase its power of oppression.

On March 22, 150 students from Nanterre overran the college's administrative building. This action had three goals: to make it known that they would not tolerate that their comrades from the Vietnam National Committees, arrested without grounds the day before, remained in prison; to show that they did not intend, after their studies, to be forced to play the role of executive-servants; to establish de facto freedom of political expression within the college. Following this event the college is closed. After Easter vacation, the students of Nanterre continue, through political propaganda in the faculty, to question all forms of the present capitalist society. The college is closed once again following the anti-imperialist day organized by the May 2 Movement, and seven of our comrades are brought before a disciplinary council. To protest against these repressive measures, the students hold a meeting at the Sorbonne the following day. By order of Rector Roche, the cops invade the Sorbonne… they drag off the students, and… it all begins. The same evening, a popular and spontaneous movement is created in sympathy with the students and against police repression: blood flows in the Latin Quarter. Throughout the day an ever-larger number of workers and students understand that the struggles against the bosses, against police repression,

against the bourgeois university, are simply one and the same struggle. Capital's response is severe: our wounded are counted by the thousands. But the movement increases today and ten thousand workers go on strike, often against the orders of those who pose as their representatives; this is the beginning of an awakening of revolutionary consciousness among the rank-and-file. It is not necessary to go back over the events in the Latin Quarter, but we can respond to two grievances that we have heard frequently. We are now reproached for spitting on the tricolor flag, but for us this flag is the false symbol in whose name the gun merchants have called thousands of French to butchery. It was natural, in 1789, to adopt the tricolor flag, and it might seem surprising that in this era anyone would miss the fleur-de-lis banner. It is also natural, today, to adopt the red and black flag of proletarian internationalism. We are reproached for damaging materials beyond repair: let it be well known that when capitalists make war, they aren't content to destroy a few cars, but rather entire towns, provinces, human lives… while the workers and students participating in the current uprising are only acting to defend themselves. Moreover, very often the owners of the cars are at our sides on the barricades (Geismar's car has been burned). The struggle has just begun. The bigwigs of the workers' and students' unions have agreed to talk with the government. What is the result? 1936: 40 hours, 1968: 52 hours. Who are they kidding? The mass of the workers refuses such swindles; trade-unionism being nothing more than the construction of the society of exploitation. We refuse dialogue with the capitalist State; we are there to destroy it. The traditional political organizations (parties, unions, small groups) are completely outdated instruments of class struggle; they have no reason to outlive the society into which they are integrated. Speech no longer belongs to the bureaucrats; power is in the street. For the time being, our task is to prepare for the coming revolution by means of:

— an information campaign to propagate our ideas in depth

— a constant collaboration with the workers and the establishment of self-management of businesses by workers' councils

— the sabotage of the villainous referendum which they want to impose on us

— the continuation of the systematic obstruction that we are putting up against the "normal" functioning of such institutions as bourgeois education and the cultural industry.

Or, more generally, by every subversive act that is likely to counter Gaullist power and impede its replacement by a disguised neo-capitalism. We have been forced into violence; we will go on until the end. We do not claim to have worked out in advance what will replace the old world. We have no pre-established model from which to copy; all together we will set up a socialist society on radically new foundations, where all who were simply consumers will participate in management, where all those who never had speech will be able to express themselves.

*— The Militants of the March 22 Movement*

# 23

This newspaper, published by radical members of the CGT, offers several reports from inside the occupied factories. There's an apparent tension in how the workers think of their union: on the one hand, angry over the betrayals of the Grenelle agreement, on the other, hopeful that the union leaders will start taking their radical demands seriously. A quote from an "old CGT militant" sums it up well: "In the factory everything that is there belongs to me, because I'm the one who produced everything there." These stories of conflict — both internally, with union delegates and vacillating workers, and externally, with the police and government —are often packed with action and offer a fascinating glimpse at the front lines of the strike. A brief article on the newspaper's last page offers a glimpse into the workings of the Atelier Populaire.

## THE PEOPLE'S CAUSE
### Journal of the popular front: No. 11, June 6-7 1968

RATP: Betrayed, but not vanquished

After the massive vote of the RATP workers on June 3 for the continuation of the strike, the union leaders have accelerated their treason: in order for the elections to take place "orderly and peacefully," it is vital that the buses and trains roll, whether or not the demands are satisfied. Example: at the Lebrun bus depot, the workers voted against the "proposals" of the Ministry of Transportation. The CGT delegate imposed a new vote, the first being, according to him, "illegal". Result: the majority this time for the strike again! Example: at the Lagny depot, the delegates ask the workers: "Do you consider the Ministry's proposals favorable?" The workers hesitate: sure, there are already advantageous concessions, but some, a minority, don't think it's enough. They vote "no." The "yes" voters lose their temper. Conclusion of the delegates: "You have voted yes to the resumption of work." Example: At the Levallois depot, like elsewhere, the delegates make the young people vote. Classic sabotage: it is announced that the "general tendency" is for resumption. The vote (by secret ballot, of course) is favorable to resumption. But the workers are nauseated. Whether they voted yes or no, they are nauseated: deprived of all perspective, many tear up their CGT cards. Example: at the Montrouge depot, it's even worse. June 3: 80% for the strike. The following day: the strike committee locks itself in to prevent all of the workers from entering. The delegate's speech: "Let's not destroy our unity; trust the delegates after the resumption of work, the delegates will continue the struggle." (!) Not one word on the votes that had already taken place and that had said no to the resumption: it was to guarantee the "objectivity," in case the

workers of Montrouge, hearing that their friends wanted to continue the struggle, did the same. In the vote: 80% FOR THE CONTINUATION OF THE STRIKE. The delegate here is Bouchez. He says: "A new vote is necessary, the first was a 'snafu.'" But the workers REFUSE. The following day, Bouchez announces that the accords were signed and that work must be resumed. That's what Bouchez wants, that's what he gets, so he is content. The workers tear up their cards. But Thursday, at Nation Terminal, at the stations at Ichy, Garenne, Lebrun, the workers refuse to resume work. The Lebrun station is surrounded by cops and mobile guards. Under their noses, the workers fly the red flag (hitherto forbidden by the Strike Committee). To destroy the movement, the union leaders pull out all the stops: four full-timers are sent in, who are booed by the workers when they propose a vote by secret ballot. "Those who are partisans of the secret ballot, there, beneath the pendulum." There are some who go there, beneath the pendulum, but nearly all of the workers stay put. Friday, work is resumed at Lebrun as well. But the workers of the RATP are in solidarity with their class brothers still on strike and attacked by the cops.

## BENDIX (DRANCY)

BENDIX, 3,000 workers, the lowest salaries in DRANCY. The strike and occupation of the premises continues. After three weeks on strike, for the workers it's not even a question of voting on the matter of resuming work. On what must it be declared? On nothing! The bosses are tough; they refuse to give more than the pathetic formalities of the national agreement. In these conditions, there is no question of negotiation. As a young CGT delegate said, "You believe that we're on strike for peanuts?" She added: "For the bosses, we are really meat from the butcher shop, nothing more than cattle to be exploited." The occupation of the factory is massive. Every morning a General Assembly of striking workers is held to evaluate the situation and discuss. An old CGT militant told us: "In the factory everything that is there belongs to me, because I'm the one who produced everything there." The occupation of the factory is not done as a matter of form; it has its full political meaning: the true masters of the factory are the workers. Self-defense is now being considered seriously. It is in response to the Gaullist and fascist provocations that have already wounded four workers. UNITED FOR THE SATISFACTION OF ALL DEMANDS, THE WORKERS OF BENDIX WILL STRUGGLE UNTIL VICTORY!

## "IF CITROEN SENDS IN THE COPS, THEIR TEETH WILL BE KICKED IN" THEIR TEETH WILL BE KICKED IN!

Many workers outside Citroën-Michelet in Levallois on Wednesday morning. Bercot must already be thinking about the profits that he's once again going to be able to extort. Outside the office, the workers of the CGT, which brings together the majority of the unions, distributed tracts calling for the continuation of the struggle.

The demobilizing propaganda of the bourgeoisie and the union leaders has not borne its fruits. The workers have not come to return to work, quite the contrary. A vote by show of hands made it unanimous for the continuation of the strike and the strengthening of the occupation. Failure, Mr. Bercot! But Citroën, the fascist, has a deep understanding that has led it to be well-versed in the means of breaking a strike. The masters showed up, explaining quite loudly that everyone has a right to an "extension…" but for this it's necessary to return to work. PROVOCATION, FAILURE… The workers aren't giving in to this blackmail; less than a french fry on Bercot's plate doesn't equal a steak on the workers' plate. This is not an "extension" that will make capitalist misery disappear. We will not capitulate! The agents of the masters are grabbed and led to the edge of the water by kicks to the ass, all to cries of: "To the Seine, to the Seine." But if they don't take a bath, it's because we don't want to give a pretext after which the CRS could be brought in. Spontaneously a procession is formed, French and immigrant workers united under the banner of the CGT. "Citroën can pay," "Citroën must pay," "We will go on until the end," are chanted with force. "Bercot on the assembly line" is transformed into "Bercot into the Seine." A young worker remarks that if he were thrown into the water someone else would take his place. The workers will never have freedom and better living conditions until the capitalist class is swept aside. The workers of the city's other occupied offices (there are many) make ovations on the passage of the demonstration and once again take up the chant: "We will go on until the end!" Citroën's pitiful provocation will only serve to reaffirm everyone's will to struggle, to strengthen class hatred and to tighten unity. Citroën wants to fool us, but "Citroën will pay!" NEW PROVOCATION, NEW FAILURE. At Citroën-Rothschild, near Michelet, the local agents and the masters have attempted to force the picket line with truncheon in hand. And what they received was blows from a fire hose. The workers are not afraid of the violence of the scabs and cops. Dripping, entrenched behind a car, some of them attempt to force open the door. But inside, the workers open up a little and they get a new blast from the hose that repulses the raid. Meanwhile, Michelet's guys arrived, formed a chain and chanted orders while clearing the street of this vermin sent in by the bosses. The firmness and resolution of the workers, led by the CGT, destroyed the bosses' latest provocation. Mr. Citroën, you can't expect to be able to use your servants' fascist violence against the workers without them responding. The response will be equal to your attacks. "WE WILL GO ON UNTIL THE END!"

### RESISTANCE AND VIGILANCE AT CITROËN-JAVEL

Once again the local police and masters are lurking around the occupied factory. Once again the workers have thoroughly denounced the exploitation that they suffer every day. And all of these maneuvers have had only one result: to join the workers together in common struggle, preparing and strengthening self-defense. Today, a new maneuver from Bercot has failed: a meeting of workers at the Sports Palace and a vote by closed ballot; the workers' determination has not been weakened. But as they redouble their vigilance with regard to the bosses' provocations, no less firmly do they denounce the capitulators in the workers' movement, those who, at the moment the CRS drove away the workers of Flins, proclaimed a victorious return to work.

### RENAULT-FLINS

Before the occupation of Renault-Flins by the CRS, the workers were opposed to a secret vote. In surveying the factories they were able to establish that the factories were packed with "yes." Thus they will be turned into bonfires for the proletarian resistance. After the helping hand from the CRS, the union organizations have reacted to each one in a different way. The workers were able to assess demagogy from some and open treason from others. FO (Workers' Force) found outraged accents for the occasion that fool no one. The CFDT, always ready to make declarations, denounces the action of the CRS and… proposes a demonstration at l'Etoile (!). But the majority of the workers stay at the walls; their comrades of Nord-Aviation and other striking factories rejoining them. The official representatives of the CGT take the floor. Scoffing at the traditions of the workers' great central union, shamelessly ignoring the workers' demands, they dare to affirm: "the occupation of the factory by the CRS impedes the resumption of work." The satisfaction of all of the demands, firm guarantees, in brief: all of that for which the workers of Flins have led the struggle for three weeks, is no longer the issue! For all practical measures, our bureaucrats propose a delegation to the prefecture to "protest" against the occupation of the factory by the CRS! The outcry that greets this proposition indicates well what the workers are thinking. No one believes in the effectiveness of such proposals. Those who make them also know very well what they will bring, but they really must do something to try to channel, to curb the mounting anger. This is the true meaning of these proposals of the bureaucrats. As for the great CGT, the workers of Flins waited until it placed itself at the head of the movement: thanks to the ugly job of the capitulators who are still pretending to be in charge of it, the bosses are attempting to reestablish their law. Against the bosses' law, the capitulators of the CGT call for a vote for the Union of the Left at the next elections. BUT THE WORKERS OF RENAULT-FLINS KNOW NOW WHO THEIR FRIENDS AND ENEMIES ARE, and they will not soon forget.

### LANG PRINTING WORKS (Paris, 19th arrondissement)

At the general meeting yesterday, June 7, the workers of Lang decided to continue the struggle. For this, they are reinforcing the occupation of the factory and organizing themselves to hold out. With the help of the Action Committees of the 19th arrondissement and of

the Committee of Support for the Struggles of the People of the 20th, they have decided to resolve the material problems posed by the continuation of the struggle (supplies, organization of child care, etc…). As elsewhere, the magnificent struggle that the 2,700 workers of Lang have led for 19 days has been completely unmentioned by the bourgeois press at large; they are going to strengthen the propaganda toward other labor offices and the population of the districts. Their unity and their resolve works wonders: THEY WILL WIN!

**Article written for Freedom—the newsletter of department store workers—by a group of striking workers from INNO-NATION:**

## TO THE ASSAULT ON HEAVEN

This morning at 10 a.m., the employees of *Nation* were invited to speak for the resumption of work by a secret ballot vote. Our movement has obtained 141 votes against 92 for the boss. In these conditions we are continuing our righteous struggle so that all of our demands may find a democratic solution. Inno-Nation has shown the way of this struggle against the employers' ogre. To all of the workers, we say: rejoin our ranks so that the enslavement of the worker may finally cease. It was necessary to see the senior management and their servants get together with crestfallen expressions on the Boulevard de Charonne. Despite an improvised dais from a public bank, the orator, by his grand gestures and swaying hips, had better present himself to Médrano for the amusement of children, but not to spur on hesitant servants. We have obtained one victory, but it is not complete. Also, to each and everyone we say that the brotherly union of all workers puts on the bosses and the government the obligation to abdicate. Imagine the contrast between the inside and the outside: Some in joy. The others in rage.

— *INNO-NATION*

### The theory of the capitulators…

If the negotiations have still not succeeded, the blame lies with the government and the bosses… The CGT forcefully denounces slogans calling for self-defense in the factories. Such slogans can only play the game of power and give them a pretext to intervene.

— *Local CGT Union*
*Plessis-Clamart*

### …and the reality of class war

Wednesday June 5

— In a Beauvais factory after three weeks on strike, the local management organizes a secret vote, "at the request of the employees" (!)
— The resumption of work is voted by 1,300 in favor versus 450 against.
— Two hours later, the delegates organize a blockade inside the factory
— 80 workers choose to continue the picket line.
Occupation of the entire premises, doors blocked by containers of

parts. Molotov cocktails are prepared inside. Very good morale among the strikers, who are ready and waiting for the arrival of the cops. At 4:30 a.m. the factory siren blares: that's the alarm! Already five cars are at the doors. The mobile guards force open one door, surge into the factory throwing bombs of tear gas and sulfur. The workers set the machines in motion. Then the delegates ask them to leave peacefully. But once in the yard the strikers refuse to go any further. Faced with this resolve, the mobile guards charge with their rifle butts out. Three of them club a pregnant woman. The strikers then try to set fire to the flasks of alcohol and acetone stocked by the door. They bombard the mobile guards with paving stones, with pieces of steel… and try hard to break through the barricade. Two CRS are hit: one of them collapses, hit in the head by a paving stone. Then a commissioner is badly hit by a brick. Final massive charge—general dispersal of the strikers, who regroup 400 meters further away, where they welcome the workers arriving to work at 7 a.m. *Nauseated by the brutal attacks of the CRS, they rejoin in a movement of solidarity with their striking comrades.* The clowns of the press lie: no resumption of work. The strike continues.

## ATELIER POPULAIRE

Since the occupation of the Ecole des Beaux Arts, progressive students and artists, in complete anonymity, have put their abilities at the service of the struggles led every day by the workers. This is not a laboratory job: workers come to give slogans, to discuss with the artists and students, to critique the posters produced or to distribute them outside. At the entrance of the workshop can be read: "To work in the peoples' workshop is to concretely support the great movement of the striking workers who occupy their factories, against the anti-populist Gaullist government. In putting all of his abilities at the service of the workers' struggle, everyone in this workshop works also for himself, because by doing so he opens up to the educational power of the popular masses." And now everyone, worker and student, foreign and French, enthusiastically comes to participate in the production of posters. Thus the bourgeois style of work that was in practice has completely disappeared: poster projects done communally, after a political analysis of the day's events or after discussions at the gates of the factories, are proposed democratically at the end of the day in a General Assembly. Here is how they are considered:

— Is the political idea correct?
— Does the poster communicate this idea well?

Then the accepted projects are realized in serigraphy and lithography, by groups that take turns from each other day and night. Dozens of groups of poster-hangers are formed and meet up in cells from the district Action Committees and the strike committees of the occupied factories, each one relating its experiences and its discussions with the population. Since, then, the production groups of popular posters have been set up in different Action Committees for Paris and for the

suburbs; others have been set up in the provinces in order to make closer links between students, workers, and working farmers.

### The struggle continues

More and more, different levels of the population spread the righteous ideas of the workers through these posters. And the progressive students and artists, while concretely placing themselves at the service of the people's struggle, set themselves up at their school and revise their point of view while binding themselves to the masses. AT THE PEOPLE'S WORKSHOP EVERYONE IS DETERMINED TO CONTINUE COMMITTED ACTION. LONG LIVE THE MILITANT STRUGGLE OF ARTISTS AT THE SERVICE OF WORKING PEOPLE!

### PROGRESSIVE LAWYERS AT THE SERVICE OF THE WORKERS

The bosses, in order to break the strike movement, attempt to isolate the most determined workers: layoffs, suspensions, transfers, trips to court following police provocations, etc... The strikers struggle against the bosses on all fronts. Notably, they counter-attack collectively, before tribunals, to enforce their rights and to uncover the class character of justice at the service of the bourgeoisie. In this struggle, they can count on the firm support of a group of lawyers who, in greater and greater numbers, wish to support them. This is why they have decided to form a collective of lawyers who put themselves resolutely under the leadership of the struggling workers' righteous ideas. Beginning today, all workers victimized by police and bosses' repression can call on this collective of militant lawyers who will provide their defense. (The distributors of *The People's Cause* will convey their requests to all of the comrades.)

# 24

*Beginning in early June, the Atelier Populaire produced five "Wall Newspapers"—large-format posters carrying news updates on strikes, protests, and government repression. Like many of the informative fliers and handbills, these served as a corrective to disinformation spread by the government and official media. The news in the Wall Newspapers was gathered directly from the workers through their strike committees, and from the various Action Committees.*

### WALL NEWSPAPER #3
### The Struggle Continues

### RENAULT-FLINS

**June 10:** 4,000 workers, despite the counterorder of the CGT leadership, entered the factory.

**June 11:** The factory is reoccupied by the workers. The CGT militants call all of the workers to organize a massive occupation of the factory immediately. But the union leadership, after having expressed its support of the occupation, asks the workers to stay home until the following day. At 8 p.m., there are only 40 workers in the factory; the management takes advantage of this for an attempt at breaking the strike: it orders a lock-out.

........ the factory is closed

........ the union leaders pursue negotiations.

**June 15:** Against the advice of the central unions, a meeting is held at Mureaux; it is decided to send a delegation to the burial of Gilles Tautin, the high school student drowned during the police repression of June 10. 150 workers from Flins, members of the Strike Committee, join with the 15,000 student workers and high school students who follow the coffin.

**June 17:** 8,000 workers (of the 10,000 in the factory) vote by secret ballot in an election called for by the management.

The CGT leadership calls strongly for the resumption of work, which is voted by a feeble majority (58% of the votes). The strikers of Flins have held out for close to five weeks. Their determination is not declining; they are continuing the struggle.

### BOATMEN

The boatmen were among the first to go on strike. For three weeks, they have set up dams in the Seine and the canals of the north and east. The bosses have been carrying out a progressive increase of work hours, in particular night shifts.

— A worker's base salary: 480 F, 16 hours of work per day.

— Retirement at 65 years (360 F per month for a pair of old workers).

### FASCISM

June 15:

— The government releases the most important leaders of the OAS (Organisation de l'armée secrète):

Salan (life imprisonment)

Lacheroy (condemned to death in absentia)

Curutchet (life imprisonment)

Argoud (life imprisonment)

45 other members of the OAS.

— The government brought workers in for questioning, arrested 17 students in their homes, brought others to court, carried out searches, and expelled 153 foreign workers and intellectuals.

### DOCKWORKERS

**June 17:** The dockworkers of Marseille unanimously decide to continue the strike. It is the twenty-ninth day of the strike. In solidarity, the dockworkers of all French ports, except Dunkirk, decide to cease work for 24 hours.

## REPRESSION

**Night of June 10-11:**

— At Place Ed. Rostand (Paris 5), a Peugeot van from the College of Medicine, belonging to Properties, license plate 82653 D, known to the police department as an ambulance, bearing red crosses, is attacked and wrecked by the forces of order without any identity check.

— Some of the material is looted: a stretcher, a surgery light, some medicines, the battery, the generator, etc…

— The four occupants are violently beaten: the driver (two broken ribs), the nurse (multiple injuries), the intern (head trauma), the extern (wounded, three stitches). Two of them are hospitalized at Cochin.

— Note that twice this ambulance came to treat those wounded by the police forces at the central police station of the 5th arrondissement. One example of many.

# 25

*WALL NEWSPAPER #4*
**The Struggle Continues**

## RENAULT-FLINS

REMINDER OF THE CONDITIONS OF THE JUNE 17 VOTE
During the meeting before the vote:

— The CGT urges the "victorious resumption of work."

— The CFDT and FO appeal to individual's consciences.

A vote by secret ballot is organized. At the meeting, "no" means the refusal to resume work. But on the ballot, one must look carefully to see that "no" means the refusal to continue the strike. Many workers are tricked by this, particularly foreigners (there are 3,000 foreign workers at Flins) who don't always know how to read French. They therefore voted "no" to the continuation of the strike, thinking they were voting "no" to the resumption of work.

**June 19, 3:30 p.m.:** The workers learn that the management has taken measures of repression:

— The denunciation of temporary work contracts, which leads to the layoff of 40 workers and the re-hiring of new ones.

— Increase of production rates: the hourly production of each assembly line must be brought up from 60 to 67 cars.

— Reduction by a third of break times in the painting workshops (10 minutes instead of 15 every two hours).

At 3:40 p.m. the workers begin a work stoppage, thereby proving that their will to struggle has not been undermined. Soon the great majority of the workers stop work and hold a meeting. The CGT and CFDT leadership get back in touch with the management for the satisfaction of the above points. Before this refusal, the proletarian union members of the CGT propose the immediate reoccupation of the factory. Then the CFDT delegates support this while the CGT directors oppose it, limiting themselves to calling a meeting for the following morning at 8 a.m. 150 workers then form a picket line, despite the demobilizing maneuvers of the PCF militants.

**June 20, 5 a.m.:** The CGT distributes a tract denouncing the militants of the picket line. This tract calls them "small anarchist groups that trick the workers while dishonestly taking up for themselves the title of the CGT." The picket line is forced to leave the factory by an inflammatory maneuver from the management. Instead of organizing the meeting set for 8 a.m., the CGT calls for the resumption of work: "Today, the CGT does not want to call the workers to the adventure of an unlimited strike that does not unify the workers. On the contrary, we (CGT) call them to continue their ongoing pressure under different forms, notably by short work stoppages wherever the union permits it." (CGT Flins) In making such calls, which aim for nothing other than pressure on the management through negotiations, the CGT does not strengthen the workers' unity of struggle, but weakens it. Work resumes… THE STRUGGLE CONTINUES.

## METALWORKERS

**June 20:** After a general meeting, the foundry workers and designers from more than 20 small and medium-sized businesses in the Paris region reaffirm their will to continue the strike until the satisfaction of their demands: monthly payment, reduction of hours without reduction of salary, 13th-month pay, and a salary increase (12%)—recognition of union rights.

## VIETNAM

**June 15:** After the Tet Offensive, intended to show the inefficiency of the American defence, the second offensive was allowed to pierce the "Defence Band" surrounding Saigon. Mr. Nguyen Van Tien, representative of the Viet Cong in Hanoi, emphasized that from now on "in Saigon our forces will increase in number and quality. This is possible with the support of the people, who actively participate in combat, and students, who play the role of catalysts in the movement." The Viet Cong representative added that there exist revolutionary committees at the local level of which the population made themselves leaders, and that a committee for the entirety of the town was created on the basis of these local committees.

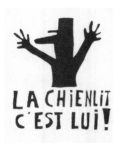

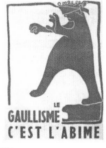
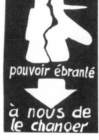
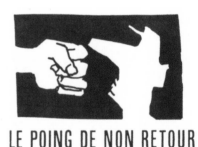

1 He's the shitty mess!—*May 19*   2 Scum—*ca. May 25*   3 Like father, like scum—*ca. May 25*   4 Help!   5 I am the exterminating angel   6-7 Freedom
8 Give me ten more years, I will take back your raises!   9 It's too much   10 Ten years is too much—*third week of May*   11 The general's two trump cards: His prestige and his TV   12 The Gaullist regime is a slimming diet   13 The general will against the will of the General   15 Fascism, the ultimate face of Gaullism
16 Gaullism is the abyss   17 Power is weak—it's up to us to change it   18 The fist of no return—*third week of May*

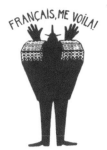
19

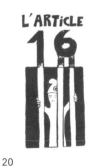
20

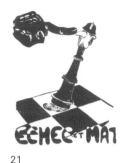
21

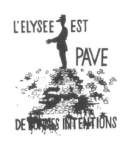
22

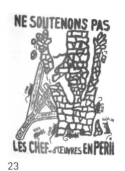
23

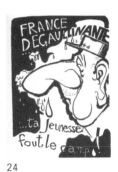
24

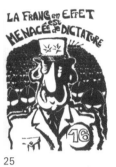
25

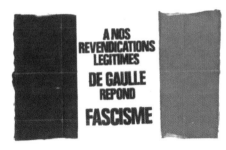
26

27

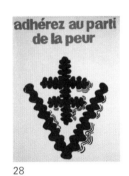
28

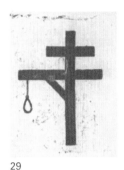
29

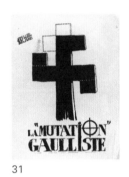
30

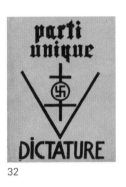
31

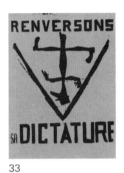
32

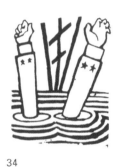
33

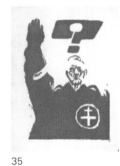
34

35

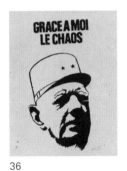
36

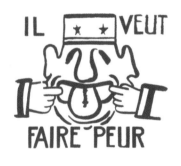
37

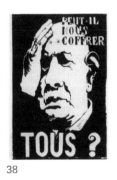
38

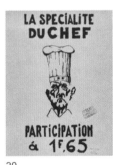
39

40

41

42

43

44

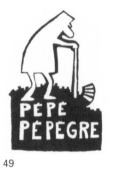

45

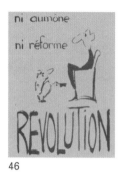

46

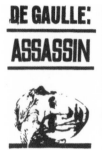

47

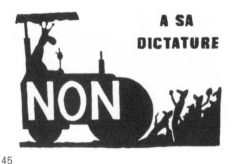

48

49

50

51

52

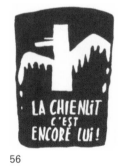

53

54

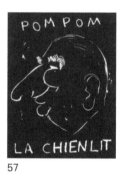

55

56

57

**41** I'm a revolutionary too!  **42** I am not ashamed to be a revolutionary  **43** Me, Machiavellian?  **45** Me  **45** No to his dictatorship  **46** Neither charity nor reform—Revolution!  **47** De Gaulle: Murderer  **48** Doctors can make prescriptions, not Gaullists!  **49** Grandpa scum—*ca. May 25*  **50** Operation survival  **51** Wanted dead or alive (preferably dead): Big Charly. This cowboy has organized a gang of outlaws on May 13, 1958. He has devastated the whole western country for 10 years. He heads an armed gang of CRS. Very dangerous! He is armed and followed by Kid Massu and Boss Salan, killers.  **52** Marriage of the year—what will they give birth to?  **53** De Gaulle's solutions = The bourgeoisie's solutions. To save the possibility of profit for capitalism (miscellaneous subsidies—tax exemptions). Austerity for the workers: wage freezes; rising prices and public fees; tax increases; reduction of social funds; increasing productivity through accelerating production rates. To assure his policies: "ORDER in the cities, the countryside, the colleges." The police state prepares to break every legitimate demonstration of popular discontent by force. The right to strike is threatened. IN THE FACE OF GAULLISM'S THREATS, representing the interests of the bourgeoisie, let's reinforce the mass movement. NO, the working class will not pay for the reinforcement of French capitalism. The workers' interests and the bourgeoisie's interests are absolutely irreconcilable. More than ever the defense of the workers entails the destruction of capitalism. Worker-student debates every night at the Sorbonne—Action Committees.  **54** All united against Gaullist provocation  **55** Let's continue the struggle; Capital is killing itself  **56** He's still the shitty mess!  **57** Pom Pom [Pompidou]—The shitty mess

242    ADDITIONAL POSTERS

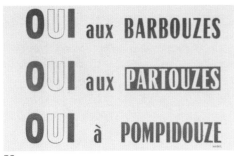

58

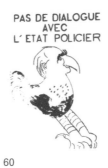

59

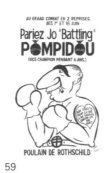

60

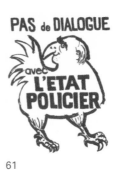

61

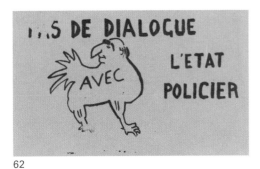

62

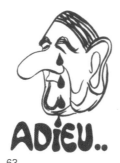

63

64

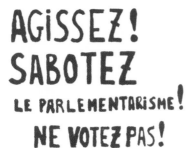

65

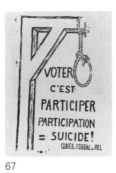

66

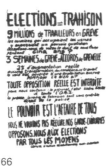

67

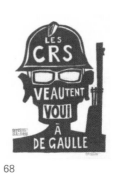

68

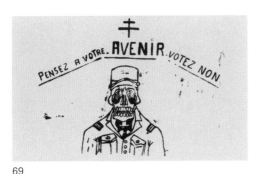

69

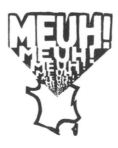

70

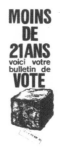

71

72

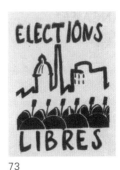

73

58 Yes to secret agents, orgies, Pompidous   59 At the big bout on two occasions, June 1 and 15—Bet on "Battling Joe" Pompidou, vice-champion for six years, the protege of Rothschild—"To the trusts for life, to de Gaulle when it suits me!"   60-62 No dialogue with the police state   64 Faure is the wheel, Hasard is the rest, Brouet sits down inside, the mandarins push it   65 Act! Sabotage parliamentarism! Do not vote!   66 Elections = betrayal! 9 million workers on strike! The workers who occupied the factories exerted an everyday power. Will we accept a vote on the right to cheat us for five years? 3 weeks of strikes = the Grenelle agreements. 2% effective raise, no transformation of working conditions—the way is clear for increasing exploitation. Pompidou said it well: ALL REAL OPPOSITION IS FORBIDDEN. We are to support: the bosses, the free state, and all of the CRS. The press, radio, and television are under the direct control of the police. POWER IS EVERYONE'S CONCERN. We do not want to reelect our prison guards! We will oppose the elections by all means!   67 To vote is to participate. Participation = suicide!   68 The CRS cattle vote yes to de Gaulle   69 Think about your future—Vote no   70 Vote [cattle]—Civic poison center   71 Moo!   72 Under 21 years old? Here is your ballot   73 Free elections

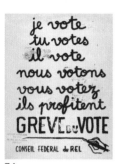

74

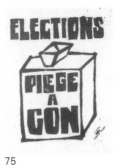

75

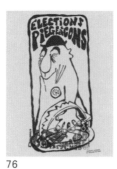

76

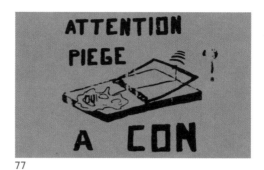

77

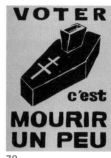

78

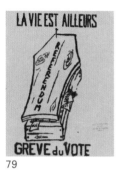

79

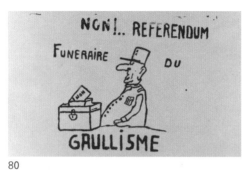

80

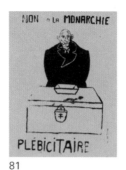

81

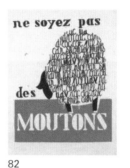

82

83

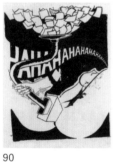

84

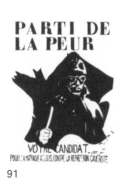

85

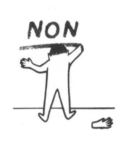

86

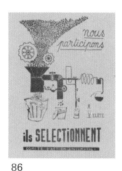

87

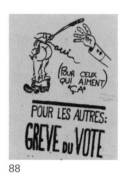

88

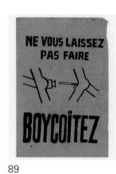

89

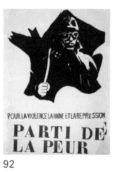

90

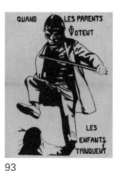

91

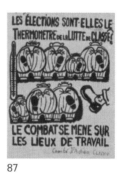

92

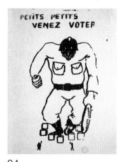

93

94

95

---

**74** I, you, he, we, you vote, they profit—Vote strike   **75-76** Elections—an idiot trap   **77** Warning, idiot trap   **78** To vote is to die a little   **79** Life is elsewhere— Vote strike   **80** No! Referendum—Funeral of Gaullism   **81** No elected monarchy   **82** Don't be sheep   **83** Yes… to revolution   **86** We participate, they choose **87** Are elections the thermometer of the class struggle? The battle is carried out in the workplace   **088** Yes for those who like "that"; For the others: vote strike **89** Don't let it happen—Boycott   **91** Party of fear—Your candidate… for a spiked club against leftist repression   **92** For violence, hate, and repression—Party of fear   **93** When the parents vote, the children suffer   **94** Come and vote, little ones   **95** Yes

96

97

98

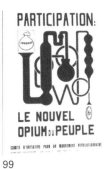

99

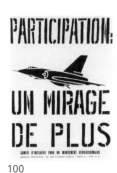

100

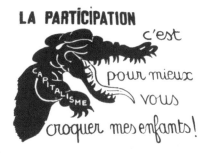

101

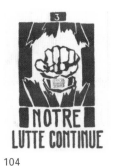

102

103

104

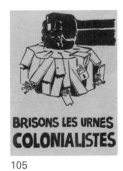

105

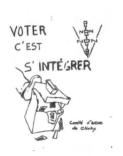

106

107

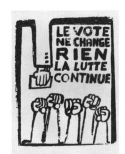

110

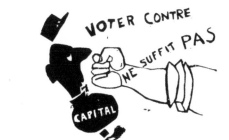

111

112

113

114

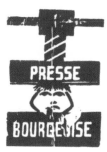

115

96   Referendum-dum—No to Drancy   97 Vote freely   98 Stop the merry-go-round   99 Participation—the new opiate of the masses   100 Participation—one more mirage   101 Participation—all the better to eat you with, my children!   102 Participation takes its first steps. At Nanterre on January 31, a hunt for Leftist militants: 20 wounded, 29 arrested. For its own survival, the bourgeoisie must put participation in place. It thereby denies the opposition of its interests with those of the proletariat. Participation is an illusion. One does not participate in one's own exploitation and oppression. Power chooses the university as its testing ground. It isolates this sector and seeks to eliminate it. Opposition by all means! Press: …the Enragés begin again… Diplomacy: …the students can get along together... Intimidation: blacklists, blackmail, arrests. Repression: Sorbonne, Vincennes, Nanterre. This is what participation in the Universities is with the CRS, CDR, snitches, house police… Tomorrow we will set ourselves up in our factories. NO TO COLLABORATION with our common enemy! Workers and students —the same combat. Power to the workers! Long live socialism!—*May 27*   103 Reformendum   104 Our struggle continues   105 We will break the colonialist ballot boxes   106 To vote is to integrate   107 The cake of the senile   108 Vote, old man, vote—5th republic   109 Revolution—Power is in the workplace, not in a rigged referendum 110 The vote changes nothing—the struggle continues—*June 25*   111 To vote against is not enough   113 Do you know what you're getting yourselves into?   114 The regime compresses—The press is an accomplice   115 Bourgeois press

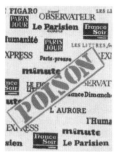
116

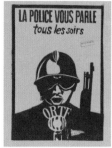
117

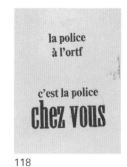
118

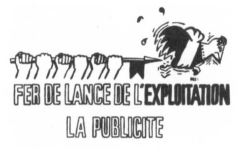
119

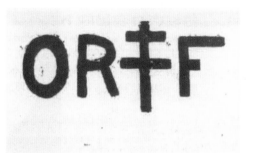
120

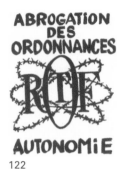
121

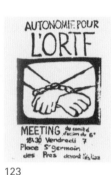
122

123

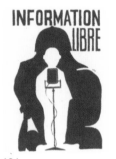
124

125

126

127

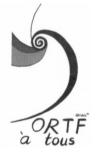
128    129    130

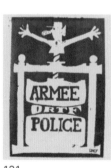
131

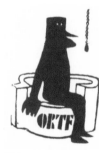
132

---

116 [Newspaper logos]: Poison    117 The police speak to you every night    118 Police at the ORTF are police in your home    119 Respond and struggle against the rising tide of capitalist psychological imprisonment organizations while sabotaging the advertising apparatus of collective alienation    121 Advertising—the spearhead of exploitation    122 Repeal the orders—Autonomy for the ORTF    123 Autonomy for the ORTF    124 Free information    125 Enough poison!    126 Let's liberate the ORTF—*May 27*    127 Truth SOS—Free ORTF    129 Free ORTF    130 ORTF for everyone    131 Army—ORTF—Police    132 ORTF

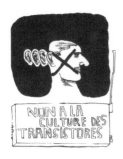

133

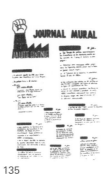

134

135

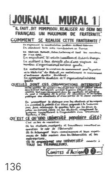

136

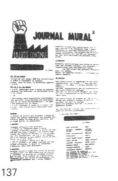

137

138

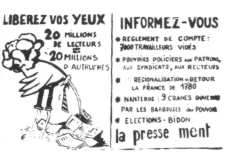

139

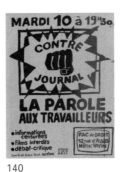

140

141

142

143

144

145

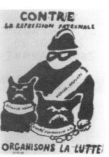

146

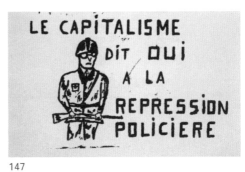

147

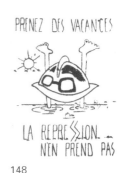

148

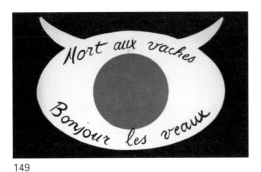

149

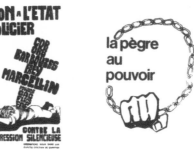

150

151

152

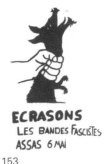

153

**133** No to transistor culture   **135-137** Wall Newspapers   **138** Strike Committee journal   **139** Free your eyes—20 million readers = 20 million ostriches—Inform yourselves—Settling of scores: 7,000 workers thrown out—Police powers for bosses, unions, rectors—Regionalization = A return to the France of 1780— Nanterre—9 skulls cracked open by Power's secret agents—Bogus elections—The press lies   **140** Tuesday the tenth at 7:30 p.m.—Against the newspaper— Speech to the workers—News censored, films banned, critical debate—College of law …—*ca. Sept. 10*   **141** Literature of revolution—Duras, Malraux, de Beauvoir....   **142** If you want to do nothing… read *Action*—daily! On sale at all newsstands, every evening   **143** If you want to act... read *Action*! **144** Advertising—Information—Ad agency action committee   **146** So... shall we participate?   **147** Capitalism says yes to police repression   **148** You take vacations—Repression doesn't   **149** Death to cows—Hello to calves   **150** Let's organize the struggle against repression   **151** No to the police state—CDR, CRS, Secret agents, Frey, Marcellin, Poujade, CAC, Cops, FAF—Against silencing repression   **152** Scum in power   **153** Let's crush fascist gangs—Assas May 6

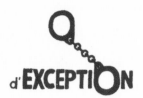

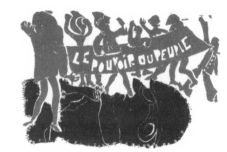

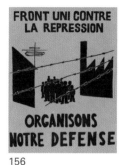

154

155

156

157

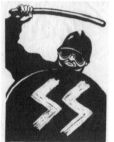

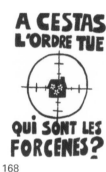

158

159

160

161

162

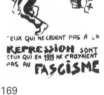

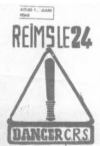

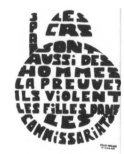

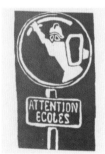

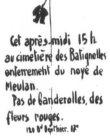

163

164

165

166

167

168

169

170

171

172

173

---

**154** Franco-ist state—emergency vacations  **155** State of emergency  **156** United front against repression—Let's organize our defense  **157** United front against repression  **158** Fascisms look alike and follow one another  **159** Down with secret juries  **160** *See translation on p. 216*  **161** Don't let yourselves be tickled by demagogues  **162** The people's power  **163** [*From a design by Jacques Carelman—"SS" was added later by another artist*]  **164** You can't beat imagination  **165** Nothing to see here, move along  **167** Under this sign you will give beatings  **168** At Cestas, order kills—Who are the maniacs?  **169** Those who don't believe in repression are those who didn't believe in Fascism in 1939  **170** Reims the 24th—Danger CRS  **171** Warning—Schools  **172** The CRS are men too—The proof? They rape girls in the police stations  **173** This afternoon at 3 p.m. in Batignolles cemetery, the burial of the Meulan drowning victim—No bandages, red flowers

174

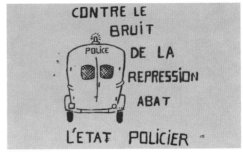

176

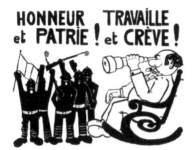

177

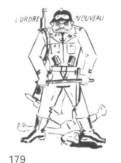

178

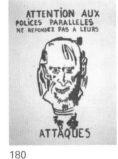

179

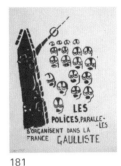

180

181

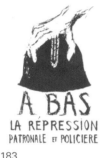

182

183

184

185

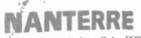

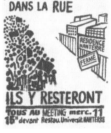

174 On June 10, our comrade Gilles Tautin, a 17-year-old high school student, was murdered by the Gaullist police. He had gone to Flins, the outpost of proletarian resistance, to put himself in the service of the righteous struggle of the Renault workers for the satisfaction of all their demands and for the liberation of their factory. Gilles died to serve the people, for the union of the youth movement and the workers' movement. From now on, his name will be inseparable from the popular revolution, the spring, and our people. We will accompany Gilles for the last time in militant discipline. The gathering for the departure of the procession will be Saturday at 3 p.m. outside his parents' home, 120 Blvd. Berthiere (17th arrondissement). [Signed,] his comrades.—ca. June 11  175 Too much violence—Enough CRS!  176 Against the noise of repression, tear down the police state  177 Honor and country! Work and wither!  178 He's ready… are we?  179 The new order  180 Beware of secret police—Do not respond to their attacks  181 Secret police gathering in Gaullist France  182 Psychiatry against the police. It is time to make it known that 50% of those hospitalized for mental illness at the Hospital of the Seine were put there by the police, and have a record on file at police headquarters. The police can therefore interfere with the hospitalization system, and could even stand in the way of the medical decision for release. Every absence without police permission is declared "escape." Because of these facts, psychiatrists, regardless of what we say, want, or do, have lived through an illness: the cop, who manipulates the basis for the most basic therapeutic relationship. The psychiatrists must no longer be the defenders of the present society! They want to be allowed to finally deal with illness, and not with those who are judged disruptive to social order. [Signed] the Un-deranging Psychiatrists of the Seine  183 Down with the repression of the bosses and police  184 Nanterre, the only university residence closed by the fear of the government, is open to all! In the same manner all of the unoccupied buildings in the Parisian region must be opened to workers suffering from the housing crisis. All to the residence meeting, Thursday at 3 p.m. outside Restau U  185 If you throw the students into the street, they will stay there—Everyone to the meeting, Wednesday the 11th

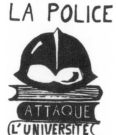

186

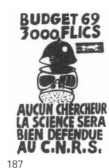

187

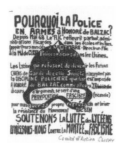

188

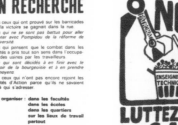

189

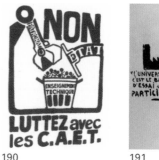

190

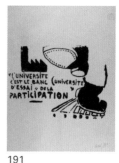

191

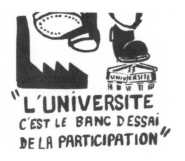

192

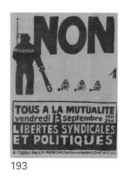

193

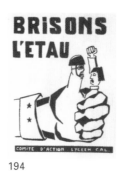

194

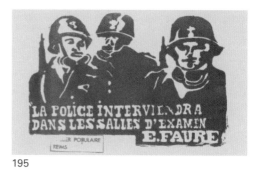

195

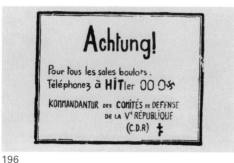

196

197

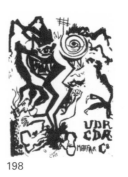

198

---

**186** The police attack the university   **187** 1969 budget—3,000 cops, not one researcher—Science will be well-defended at CNRS (National Center for Scientific Research)   **188** Why are there armed police at Honoré de Balzac High School? Since May '68, the cops have again flourished everywhere, cop administrations in the schools and colleges. School police strengthened at Nanterre—Cop director at M.J. de Clichy—House police in the factories. The high schools who refuse to become the future guard dogs of this society do not accept the police discipline which has been imposed on them at Honoré de Balzac and elsewhere. The administration, having run out of arguments, makes use of a fascist provocation (a fire) to hide its own repression and to break the resistance of the student movement. We support the struggle of the high school students! Let's unite against the rise of fascism.   **189** WANTED: All those who demonstrated on the barricades that victory will be won in the street. Those who did not fight to go to debate university reform with Pompidou. Those who think that the battle in the colleges takes its full meaning in the workers' occupation of their factories. Those who have decided to be done with the power of the bourgeoisie, and have taken up the means to do so. All those who have not already joined the Action Committees because they don't know who to contact. ...to organize action committees: in the colleges, in the schools, in the dorms, in the workplace, everywhere.   **190** Struggle with the CAET (Technical School Action Committee)   **191-192** The university is the testing ground of participation   **193** All to the Mutualité, Friday Sept. 13, 7 p.m. to midnight—Union and political freedoms—No to campus police   **194** Let's break the stranglehold—High School Action Committee (CAL)   **195** "The police will intervene in the classroom"—E. Faure   **196** Attention! For all your dirty work, call HITler 00-0[swastika], Kommandant of the Committees for the Defense of the 5th Republic (CDR)   **197** CDR   **198** UDR [Gaullist political party] CDR Mafia & Co.

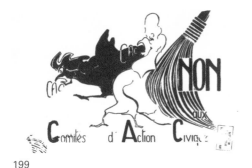

199

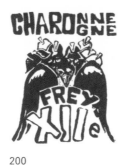

200

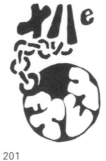

201

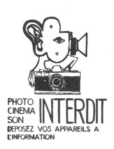

202

203

204

205

206

207

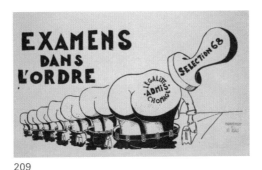

208     209

210     211     212

213     214     215     216

---

**199** No to Civic Action Committees   **200** Charonne/carcass   **202** Photographs, film, sound recording forbidden—Leave your information apparatus   **203** ACES (Corporatist Association of Students in the Sciences)—The Corporation in the movement   **204** Good civic action   **205** For a system of education at the service of the people   **206** Tests—Extraordinary general assembly—Thursday September 5 beginning at 2 p.m.—New college of medicine   **207** Pre-med tests—CPEM (Certificat Preparatoire aux Etudes Medicales)   **208** Total unlimited strike—School of Pharmacy   **209** Tests on the agenda—Selection '68—Legality and unemployment admitted   **210** Student representative elections—College of Sciences—Student representatives—*late June*   **211** Students in the schools of law and economic sciences—come to elect your representatives to the joint assembly for the reform of studies and to prepare for the resumption this fall—*Mid-June*   **213** UNEF: This summer's People's Universities. Debate introduced by Jacques Sauvageot (Vice President of the UNEF), Maurice Chalaye (Member of the national board of SNESup), Guy Retore (Director of Théâtre de l'Est Parisien), Marc Heurgon (Member of the national board of PSU), Alfred Krumnow (CFDT militant), Jean Louis Weisberg (Member of the national board of the CAL   **214-215** A youth too often worried about the future   **216** Student workers—Meeting every evening

nous voulons
une université
populaire

217

A TAUPE DU SAVOIR
218

UNIVERSITE D'ETE
68
UNIVERSITE
POPULAIRE
219

UNIVERSITE
POPULAIRE
D'ETE
MEETING
ancienne fac de médecine
MERCREDI 10 JUIL 21h
220

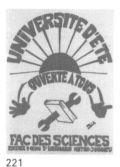
221

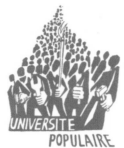
Université
Populaire
5
au
18
août
Montpellier
222

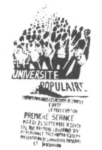
UNIVERSITE
POPULAIRE
223

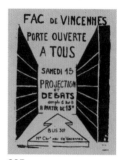
224

FAC DE VINCENNES
PORTE OUVERTE
A TOUS
SAMEDI 15
PROJECTION
ET
DEBATS
amphi d hid
A PARTIR DE 15h
BUS 301
225

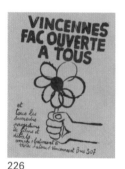
226

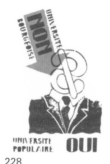
227

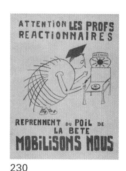
228

UNIVERSITE
BOURGEOISE
NON
UNIVERSITE
POPULAIRE
OUI
229

ATTENTION LES PROFS
REACTIONNAIRES
REPRENNENT DU POIL DE
LA BETE
MOBILISONS NOUS
230

NOTRE LUTTE EST ENTREE
DANS UNE PHASE PROLONGEE
EN AVANT POUR
LA LONGUE MARCHE
DE LA JEUNESSE
231

UNIVERSITE
POUR
TOUS
232

RENAULT
NOS REVENDICATIONS
AU DEPART
1 40 HEURES DANS L'IMMEDIAT
SANS REDUCTION DE SALAIRE
2 1.000 F. DE SALAIRE MINIMUM
3 LA RETRAITE A 60 ANS
A 55 ANS POUR LES FEMMES
4 LA 5ème SEMAINE DE CONGES PAYES
POUR LES JEUNES TRAVAILLEURS
5 L'ABROGATION des ORDONNANCES
6 LIBERTES SYNDICALES
233

FLICS A FLINS
FLICS CHEZ VOUS
234

---

**217** We want a people's university  **218** The mole of knowledge  **219** Summer University '68—People's University  **220** People's Summer University—Meeting at the old College of Medicine—*early July*  **221** Summer university, open to all—College of Sciences  **222** People's University—August 15-18, Montpellier  **223** People's University  **224** People's University—Possible topics: The Grenelle agreements, the ORTF, participation. First session, Tuesday Sept. 24… Introduction of the people's university and discussion—*September*  **225** Vincennes college—doors open to all—Films, debates  **226** Vincennes college open to all—Films and debates every Saturday  **227** People's University—Rive Gauche suburb SLD—Second session, Friday Oct. 4  **228-229** Bourgeois university no, People's University yes  **230** Warning: Reactionary teachers are regaining their courage—Let's mobilize  **231** Our struggle has entered a prolonged phase—The youth must continue to link with the workers and the population of the cities and countryside to unite the people—The population of the cities and countryside must come to the workers' cause to unite the people—Onward for the youth's long march!  **232** University for all  **233** Renault: Our immediate demands. 1. A 40-hour week immediately, without a reduction in wages. 2. 1,000 F. minimum wage. 3. Retirement at 60; 55 for women. 4. A fifth week of paid vacation for young workers. 5. Repeal of the social security edicts. 6. Union freedoms—*Late May; reissued June 15*  **234** Cops at Flins—cops in your homes

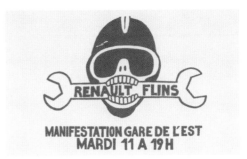

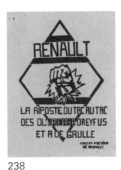

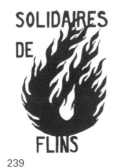

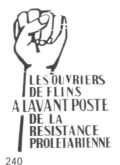

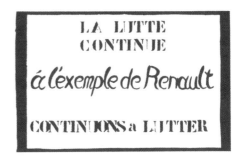

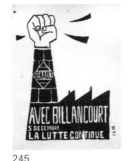

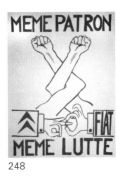

235 Workers of Renault-Flins—Victory is ours   236 The CRS attack Flins—We won't let them break the strike   237 Renault Flins—Demonstration, Gare de l'Est —Tuesday the 11th at 7 p.m.—*ca. June 11*   238 Renault—The workers' immediate riposte to Dreyfus and de Gaulle   239 Solidarity with Flins   240 The workers of Flins are the vanguard of proletarian resistance   241 Power responds to the workers' demands with a categorical refusal and police repression—5,000 CRS invade the factory—Down with the repression of the bosses and police! Popular support for Renault-Flins!   242 The struggle continues—Let's follow in Renault's footsteps and continue the struggle   243 Long live the exemplary struggle of the workers of Renault-Flins! Today the entire working class looks to Renault-Flins: the workers of Flins are the vanguard of proletarian resistance. Against the bosses and their cops, against the capitulators, THE STRUGGLE CONTINUES. In large factories and small businesses alike, in the metalworking industry, in the chemical industry, in printing, etc., THE STRIKE INTENSIFIES and SELF-DEFENSE GROWS STRONGER. In large businesses (IMPF, TrisPostaux, etc...) the workers have already gone back on strike. After the example of the workers of Flins, let's ORGANIZE RESISTANCE against repression everywhere. For the continued occupation of factories, UNTIL VICTORY!   244 Flins—June '68-June '69—Let's continue the combat—*ca. June 1969*   245 The struggle continues with Billancourt, December 5   246 Citroën—fascist bosses   247 Citroën, June 6: The management organizes a vote by secret ballot, not controlled by the workers. The ballots are in two colors, which permits the imposition of the choice of the vote on immigrant workers. This maneuver by the management is denounced by the strikers, who do not participate in the vote. The executives and the managers—and the cowards—vote to resume work. June 7: During a meeting at Place Ballard, it is decided to continue the strike. This is followed by a demonstration of more than 10,000 strikers who fill the streets of the 15th arrondissement, supported by the populace. Long live the struggle of the workers of Citroën!   248 Same boss, same struggle

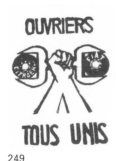

**OUVRIERS TOUS UNIS**

249

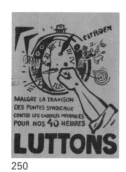

**LUTTONS**

250

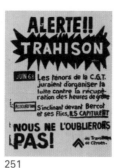

**ALERTE!! TRAHISON**

251

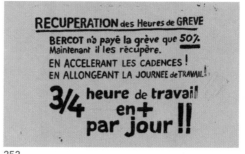

**RECUPERATION des Heures de GREVE** — Bercot n'a payé la grève que 50%. Maintenant il les récupère. EN ACCELERANT LES CADENCES! EN ALLONGEANT LA JOURNEE de TRAVAIL. **3/4 heure de travail en+ par jour!!**

252

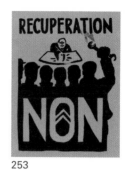

**RECUPERATION NON**

253

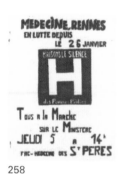

**le cinéma s'insurge** — états généraux du cinéma

254

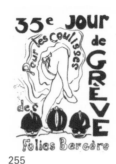

**35e JOUR de GRÈVE** — Pour les coulisses des Folies Bergère

255

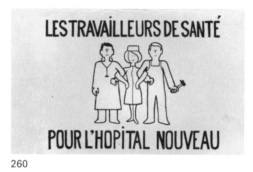

**LES COMÉDIENS SOLIDAIRES DES TRAVAILLEURS POUR UN THÉATRE LIBÉRÉ**

256

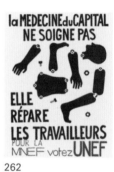

**EN MÉDECINE COMME PARTOUT, PLUS DE GRAND PATRON**

257

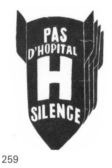

**MEDECINE RENNES**

258

**PAS D'HOPITAL H SILENCE**

259

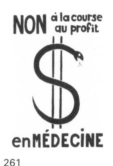

**LES TRAVAILLEURS DE SANTÉ POUR L'HOPITAL NOUVEAU**

260

**NON à la course au profit $ en MÉDECINE**

261

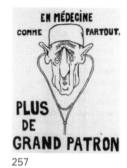

**la MEDECINE du CAPITAL NE SOIGNE PAS — ELLE RÉPARE LES TRAVAILLEURS POUR LA MNEF votez UNEF**

262

**TRAVAILLEURS DE LA RATP** — L'ETAT PATRON VOUS A TROMPE — VOS BUREAUCRATIES SYNDICALES VOUS ONT DECUE — **CONTINUEZ LA LUTTE** — COMITE D'ACTION RATP

263

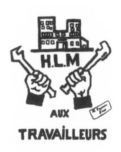

**SOUTENEZ LES CHEMINOTS EN GRÈVE** — VEC ET POUR LES TRAVAILLEURS

264

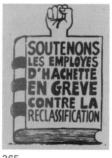

**SOUTENONS LES EMPLOYES D'HACHETTE EN GREVE CONTRE LA RECLASSIFICATION**

265

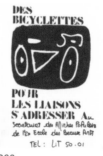

**DES BICYCLETTES POUR LES LIAISONS S'ADRESSER Au** Secretariat des Affiches Populaires de l'ex Ecole des Beaux Arts TEL: LIT 50.01

266

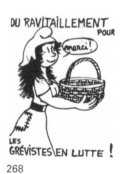

**H.L.M. AUX TRAVAILLEURS**

267

**DU RAVITAILLEMENT POUR merci! LES GRÉVISTES EN LUTTE!**

268

---

**249** All workers united   **250** Despite the betrayal of the union big shots, against diabolical production rates, for our 40 hours, we struggle!   **251** Warning, betrayal! June '68: The big shots of the CGT swear to organize the struggle against the paying back of strike hours money. Today: Bowing before Bercot and his cops, THEY SURRENDER. We will not forget!   **252** Reclamation of strike hours—Bercot only paid strike days at 50%, and now he is taking it back. While increasing production rates! While extending the work day by 45 minutes a day!   **253** No reclamation   **254** The film industry rises up—Estates-General of cinema **255** 35th day of the strike backstage at the Folies Bergères   **256** Comedians in solidarity with the workers for a free theater   **257** In the school of medicine like everywhere else, no more big boss   **258** Rennes Médecine on strike since January 26—Let's break the silence of public power—All to the march on the Ministry **259** No hospital, silence   **260** Health care workers for a new hospital   **261** No to the race for profit in medicine   **262** The medicine of capital does not treat workers, it fixes them—For the MNEF vote UNEF   **263** Workers of the RATP—the patrician state has tricked you—your union bureaucracies have deceived you—continue the struggle—*after May 26*   **264** Support the striking railway workers, with and for the workers   **265** We support the employees of Hachette in the struggle against reclassification   **266** Bicycles for meetings to contact the secretariat of popular posters of the ex-Ecole des Beaux Arts   **267** H.L.M. (Habitation à Loyer Modéré / rent-controlled housing) for the workers   **268** Supplies for the struggling strikers!

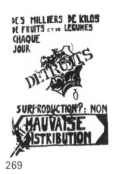

269

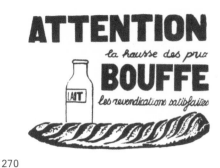

270

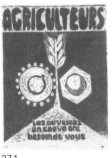

271

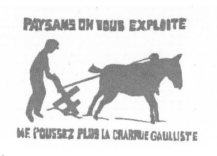

272

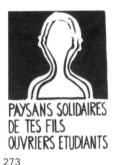

273

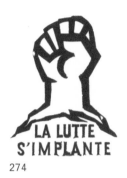

274

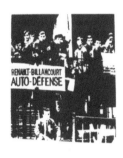

275

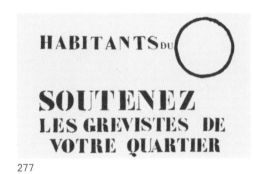

276 277

278

279

280

281 282

283

284

285 286 287

269 Thousands of pounds of fruits and vegetables are destroyed each day—Overproduction? No, poor distribution   270 Warning—Increased prices eat up the satisfied demands   271 Farmers, the striking workers need you   272 Farmers, you are being exploited—Stop pushing the Gaullist plow   273 Farmers in solidarity with your children, the workers and students   274 The struggle establishes itself   275 Renault-Billancourt—self-defense—*ca. June 4*   276 The struggle continues—Sochaux   277 Residents of ___—support your local strikers—*ca. May 25* [*Blank circle to be filled in according to where the poster was displayed*]   278 1936: 40-hour work week—1968: 48-hour work week—2000: 56-hour work week…   279 We will not be dupes! After June 1936, the workers' achievements were taken back by the bourgeoisie in less than two years. After the miners' general strike in 1963, the bosses won back what they had given in less than two months. How? Through increasing prices and inflation. Through growing unemployment. Through the violation of union freedoms. Under pain of suicide! The capitalist economic system is keen to take back what it has lost. Full satisfaction of all demands. Only with the workers in power can it be guaranteed!   280 Active strike—All united—Release of our comrades—Renewed suspension of sentences—Repeal of the Decree of December 13—Publication of campus police files—Regulation of markets   281 Down with diabolical production rates   282 End repression   284 Close ranks against repression   285 The worker will not pay   286 No, we will not let them string us along   287 Will the mercenaries of power run the factories?

288

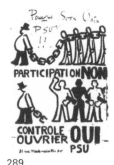

289

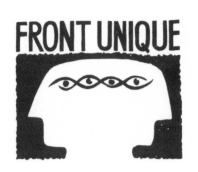

290

FRONT UNIQUE

291

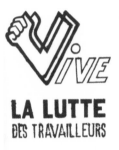

292

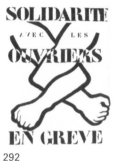

293

294

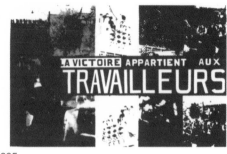

295

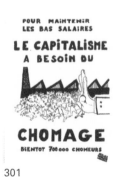

296

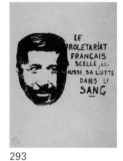

297

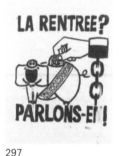

298

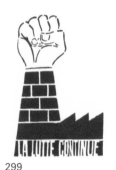

299

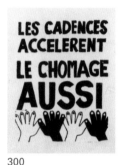

300

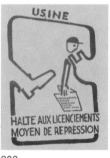

301

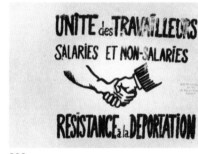

302

303

304

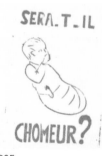

305

---

288 Long live the occupation of the factories   289 Participation no, workers' control yes   290 For the freedom to work: I, the non-striking worker… Promise to renounce the social and economic advantages that my comrades have obtained. I declare that I am fully satisfied with: my miserable salary, impossible hours and diabolical production rates, the insecurity of my job, the lack of union freedom in my industry, government edicts on social security, and my current social advantages. I declare that I will entrust my interests to the bosses and their various governmental representatives. I freely call for the resumption of work under "the protection of the forces of order."   291 Unified front   292 Solidarity with the striking workers   293 The French proletariat, too, seals its struggle with blood   294 Long live the unity of workers in action and at the grassroots   295 Victory belongs to the workers   296 Long live the workers' struggle   297 Back to work? Let's talk about it!   298 Struggle!   299 The struggle continues   300 Production rates increase—so does unemployment   301 To keep wages low, capitalism needs unemployment—700,000 unemployed soon   302 Factory—Stop layoffs—Means of Repression   303 Unity of employed and unemployed workers—Resistance to deportation   304 Against layoffs—unemployed workers, form and rejoin your Action Committees   305 Will he be unemployed?

**HALTE AU CHOMAGE**
**1.000.000 DE SANS TRAVAIL**

306

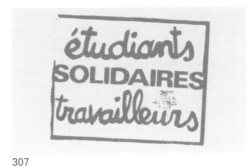

*étudiants* SOLIDAIRES *travailleurs*

307

DANS LES FACULTES ET
LES LYCEES
DES COMITES D'ACTION
DANS LES USINES
DES COMITES DE GREVE
**LE POUVOIR
AUX TRAVAILLEURS**

308

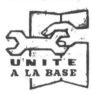

OUVRIERS
PAYSANS
ETUDIANTS
UNITE
A LA BASE

309

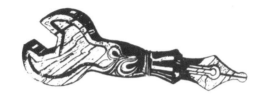

310

CAMARADES LE COMBAT
CONTINUE dans les U'NES
ET NON dans les UPNES
CA PIT AL
C.A
TRAVAILLEURS... ETUDIANTS

311

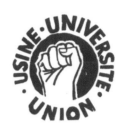

USINE·UNIVERSITE·UNION

312

USINE
UNIVERSITE

313

TRAVAILLEURS
PAYSANS
ETUDIANTS
SOLIDAIRES

314

pouvoir ouvrier
pouvoir paysan
pouvoir étudiant
pouvoir au peuple PSU

315

ETUDIANTS
TRAVAILLEURS
LUTTENT
ENSEMBLE

316

CONTRE
L'EXPLOITATION
CAPITALISTE
NOTRE LUTTE CONTINUE
COMITE D'ACTION ETUDIANTS-TRAVAILLEURS

317

ACHETEZ PLUS
ILS PROFITENT MIEUX
REPUBLIQUE FRANÇAISE
L'EXPANSION
C'EST POUR EUX

318

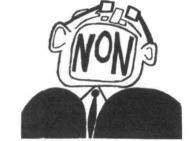

achetez plus
pour que nous
vendions mieux!
PATRONAT FRANÇAIS
L'exploitation
...c'est nous!

319

CONTRE
LE
VEDETTARIAT

320

NON

321

---

**306** End unemployment—1 million out of work  **307** Students and workers in solidarity  **308** In the colleges and high schools, action committees—in the factories, strike committees—Power to the workers  **309** Workers, farmers, students—unity in the grassroots  **311** Comrades, the struggle continues in the factories, not in the ballot boxes  **312** Factory, university, union  **313** Factory, university  **314** Farmers, workers, students in solidarity  **315** Farmer power, student power, power to the people—PSU  **316** Students and workers struggle together  **317** Against capitalist exploitation, our struggle continues—Student/Worker Action Committee  **318** When you buy more, they profit more… Expansion is for them  **319** Buy more so we can sell better… We are Exploitation!  **320** Against stardom  **321** No

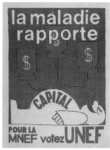

322

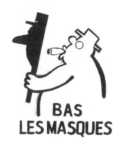

323

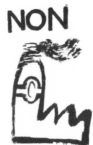

324

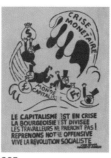

325

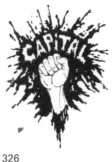

326

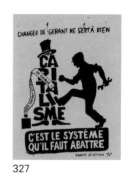

327

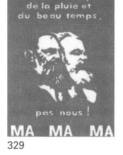

328

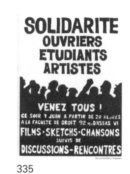

329

LIBERTE
democratique
EGALITE
sociale
FRATERNITE
des peuples

330

331

332

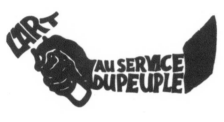

333

GALERIES
EPICERIES D'ART

CHOMEURS
LICENCIES EN ARTS PLASTIQUES

334

335

336

337

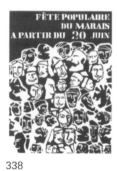

338

339

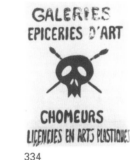

340

341

SAMEDI 28 et DIMANCHE 29 JUIN
JOURNEES
POPULAIRES
AU
THEATRE de L'EPEE de BOIS
15 rue de l'Epée
SPECTACLES CHANSONS IMPROVISATIONS
EXPRESSION LIBRE
ENTREE LIBRE
Comité de l'Epée du bois

342

FEDERATION NATIONALE
DU SPECTACLE·CGT
SOUTIEN
AUX GREVISTES

343

---

322 The disease pays well… For the MNEF vote UNEF   323 Down with masks   325 Capitalism is in crisis—The bourgeoisie is divided—The workers will not pay! Let's go back on the offensive—Long live the socialist revolution!   327 Changing the manager will do nothing—It is the system that we must tear down 328 Which person is most important?   329 Everyone talks about the weather… we don't.   330 Democratic liberty—Social equality—Brotherhood of the people 331 We support Krivine's revolutionary campaign—Communist League, Red Committee   332 No—they will not leave   333 Art at the service of the people   334 Galleries—Art's grocery stores—Unemployed, layoffs in the visual arts   335 Worker-student-artist solidarity—Everybody come! This evening, June 7, starting at 8 p.m. at the college of law—Films, sketches, songs, followed by discussion and meetings   336 Culture revolution week—International city—Debates, films, exhibitions 337 People's festival of Marais—Friday the 21st, festival of the sun   338 People's festival of Marais beginning June 20   339 People's festival of Marais —Exhibition of Lasry Bachet's sound structures—all afternoon   340 Theatrical happening of May 10 1968—Monday June 24, 11 p.m.—Theatre de la Rue Artsa 341 Open doors at the School of Medicine, June 29-30—Films, food, news, debates   342 Saturday June 28 to Sunday June 29—People's days at the Theatre of L'Epée de Bois … Shows, songs, improvisations, free expression—Free admission   343 National Federation of the Spectacle/CGT—Support to the strikers

344

345

346

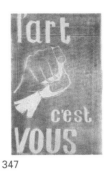

347

348

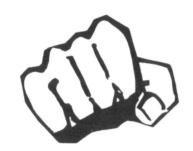

349

350

351

352

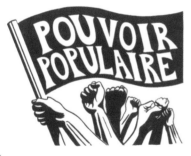

353

354

355

356

357     358     359     360

**344** Pacra Bastille—People's music-hall—film, discussions—free every day     **345** Pacra—Free people's music-hall—Counterintelligence with the striking journalists from press and TV—films, theater, shows     **346** Pacra—this evening, Sunday the 30th, 9 p.m.—Theater—films, events, etc.—songs—People's Puppets of the Ex-ENSBA—Information on the taking of l'Ecole des Beaux Arts by the forces of order—Debate—Free admission—Fundraiser for the ex-Ecole des Beaux Arts     **347** You are art     **348** Cultural revolution against a society of robots     **350** New nursery schools in the neighborhood     **351** College nursery schools —Trust us with your kids     **352** The nursery school cannot continue without your help—Bring material support—Cots, food, etc…     **354** Action committees— the struggle will live     **355** In the 3rd and 4th arrondissements, the battle continues—Initiative Committee for a Revolutionary Movement     **356** People's power **358** Essential revolution     **359** Don't think, go     **360** Let's be done with the chain of the 5th republic

361

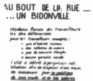

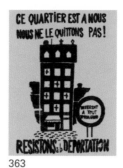

362

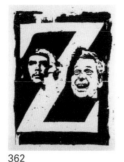

363

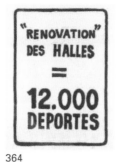

364

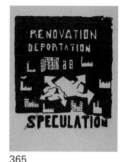

365

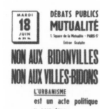

366 367 368 369 370

QUE FAIS-TU CONTRE
LA FAIM?
JE LUTTE CONTRE
L'IMPERIALISME!!

371

2 JUIN A 20 H 30
MEETING
A LA SORBONNE
COMITES
D'OCCUPATION
DES PAYS COLONISES

372

LES
FRONTIERES
ON S'EN FOUT!

373

**361** 5th Republic   **363** This neighborhood is ours—We're not leaving! We resist deportation—no entry to speculators   **364** "Renovation" of Les Halles [food market] = 12,000 deported   **365** Renovation, deportation, speculation   **366** At the end of the street... a shantytown. Forced residence for the least favored workers. For immigrant workers: no fixed address, poverty wages, no job security, no social security. The state has an interest in perpetuating this situation in order to have a large supply of unskilled workers available for its policy of underemployment and poor wages. Against organized unemployment! Against poverty wages! The only possible defense is the struggleand the solidarity of French and immigrant workers against the common enemy: the bosses!   **367** Public debates at Mutualité, Tuesday June 18—No to shantytowns—Urbanism is a political act, it must be at the service of the people   **368** No to shantytowns, no to phony villages—Urbanism is a political act at the service of the people…   **369** Paris belongs to us! ... What is the government looking for? ... Let's foil the cops' plans... The combat will take place throughout Paris... The regime is teetering; let's pull it down! ... Workers, students, let's combine our efforts and organize our strength. The Parisian people must rule Paris.   **370** The people will defeat imperialisms and repression   **371** What are you doing against hunger? I'm struggling against imperialism!   **372** June 2 at 8:30 p.m.—Meeting at the Sorbonne—Occupation Committees of Colonized Countries   **373** Borders—we don't give a damn

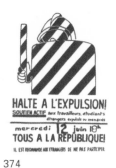

374

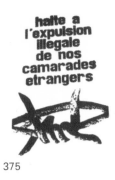

375

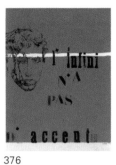

376

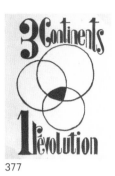

377

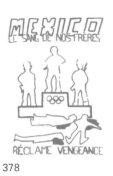

378

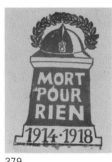

379

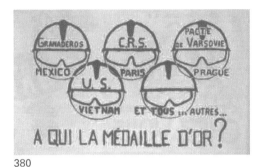

380

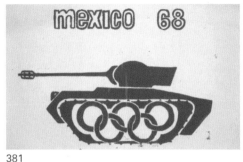

381

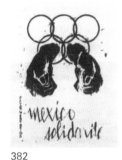

382

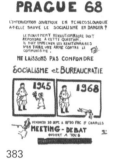

383

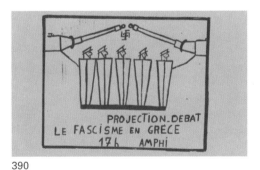

384

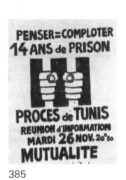

385

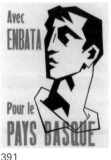

386

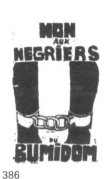

387

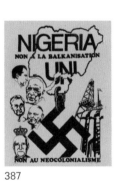

388

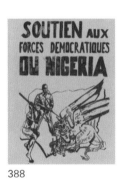

389

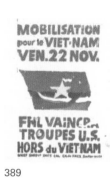

390

391

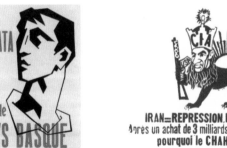

392

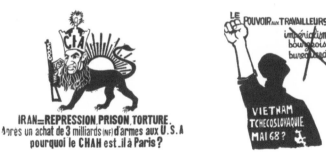

393

**374** End deportation! Active support to foreign students and workers who have been expelled or threatened—Wednesday June 12 at 6 p.m.—All to the Republic! It is recommended that foreigners do not participate  **375** End the deportation of our foreign comrades  **376** Infinity has no accent  **377** Three continents, one revolution  **378** Mexico—the blood of our brothers calls for vengeance  **379** Died for nothing—1914-1918  **380** Granaderos in Mexico, CRS in Paris, the Warsaw Pact in Prague, the US in Vietnam, and all the others—Who gets the gold medal?  **381** Mexico '68  **382** Mexico solidarity  **383** Prague '68: Has Soviet intervention in Czechoslovakia saved socialism from danger? The revolutionary movement must respond to this question. It must stop reactionaries from becoming a weapon against communism. Let's not confuse socialism and bureaucracy!  **384** Prague cries out  **385** To think = to plot—14 years of imprisonment—Trial of Tunis—Informative meeting, Tuesday Nov. 26  **386** No to the slave-drivers of BUMIDOM (the Bureau for the Development of Migrations in Overseas Departments)  **387** Nigeria united—No to balkanization and neocolonialism  **388** Support for the democratic forces of Nigeria  **389** Mobilization for Vietnam—Friday Nov. 22—The Viet Cong will win—US troops out of Vietnam  **390** Screening and debate: Fascism in Greece  **391** With Enbata for the Basque nation  **392** Iran = Repression, prison, torture — After a 3-million franc purchase of arms from the USA, why is the Shah in Paris?  **393** Power to the workers—no to imperialism, bourgeoisie, bureaucracy — Vietnam, Czechoslovakia, May '68?

394

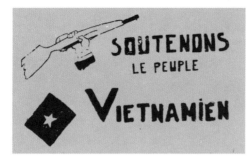

395

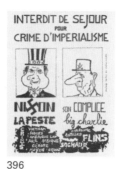

396

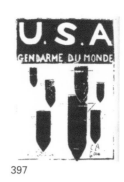

397

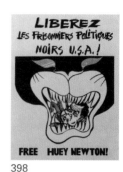

398

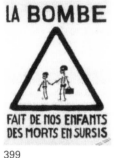

399

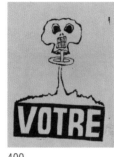

400

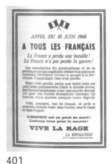

401

402

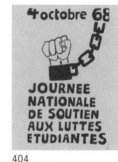

403

404

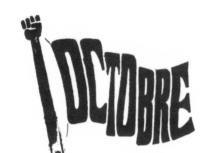

405

406

407

408

409

410

411

**394** US—RDV [North Vietnam] FNL [Viet Cong]   **395** We support the Vietnamese people   **396** Residence forbidden for the crime of imperialism—Nixon the Plague—Crimes, Vietnam, Blacks, Latin America, Asia, Africa, Europe, Middle East—His accomplice, Big Charlie—Charonne, Antilles, Flins, Sochaux   **397** USA, World police   **398** Free black political prisoners in the USA!   **399** The bomb makes our children corpses in waiting   **400** Yours   **401** June 18, 1968: A call to all of France. France has lost a battle! It has not lost the war! The political and union big shots have surrendered, giving in to panic, forgetting honor, sending the people into servitude. But, nothing has been lost. Nothing has been lost because our struggle is a permanent struggle. Throughout the world, immense forces have still not given up. One day these forces will crush the enemy. On that day, we will win back our dignity. That is why all Frenchmen, wherever they may be, must unite in action, in risk and in hope. The spirit is in danger of dying! Let's struggle to save it! LONG LIVE RAGE! [*Parody of the poster of de Gaulle's June 18, 1940 address to the French people*]   **402** Back to school—Police state—Warning, school zone—The struggle continues   **404** October 4 '68: National day of support for student struggles   **406** Thursday December 12, 9 p.m. Meeting/debate: The lessons of May '68—The student movement, The general strike, The Action Committees   **407** All accomplices of Andrée Destouet in the struggle against capital   **408** Winter is tough at Nanterre, Jan-Feb '69—The hunting of militants increases — Don't let yourself get shot … No to participation; arrests and expulsions continue, our battle does too: Let's organize our defense   **409** Winter will be harsh   **410** May '68-69—Only the struggle pays off; Let's continue the battle **411** The lessons will not be forgotten in '69

**CA** *Comité d'Action.* Action Committee. The basic unit of collective action in the May Events.

**CAC** *Comité d'Action Civique.* Civic Action Committee. Gaullist groups opposed to the strike and student revolt.

**CAET** *Comité d'Action de l'Enseignement Technique.* Technical Education Action Committee.

**CAL** *Comité(s) d'Action Lycéen(s).* High School Action Committee(s).

**CAR** *Comité d'Action Révolutionnaire* Revolutionary Action Committee. Among other things, this group established the occupation of the Odéon.

**CDR** *Comité(s) de Défense de la République.* Committees for the Defense of the Republic. Gaullist counter-revolutionary group.

**CET** *Collège d'enseignement technique.* Technical college.

**CFDT** *Confédération Française Démocratique du Travail.* French Democratic Confederation of Labor. Major trade union federation with a social-democratic slant.

**CFTC** *Confédération Française des Travailleurs Chrétiens.* French Confederation of Christian Workers. Christian trade union affiliated with CGT.

**CGT** *Confédération Générale du Travail.* General Confederation of Labor. Major trade union federation with ties to the Communist Party.

**Charonne** Metro station in the 11th Arrondissement in Paris. In 1962, it was the site of a police massacre of 9 people, mostly young Communists, who were protesting in support of Algerian independence.

**CLER** *Comité de Liaison des Etudiants Révolutionnaires.* Revolutionary Students' Liaison Committee. Trotskyite student organization.

**CNRS** *Centre National de la Recherche Scientifique.* National Center for Scientific Research.

**Cohn-Bendit, Daniel** German-born radical student. The most prominent of the Enragés, he was also known as "Dany le Rouge" (Danny the Red), thanks to his politics and his hair color alike. He enrolled at Nanterre in 1966, studying sociology. After several confrontations with authority figures throughout 1967 and early 1968, he helped found the March 22 Movement.

**CRS** *Compagnies Républicaines de Sécurité.* Republican Security Companies. Riot police.

**Douane** *Direction générale des douanes et droits indirects.* Directorate-General of Customs and Indirect Taxes. French law enforcement agency responsible for overseeing borders and preventing smuggling.

**EDF** *Electricité de France.* French Electricity. Public utilities company.

**ENSBA** *Ecole Normale Supérieure des Beaux-Arts.* School of Fine Arts. Documents from the Atelier Populaire, in anticipation of the revolutionary restructuring of arts education, referred to the school as "Ex-ENSBA"

**Faure, Edgar** French Prime Minister in 1952 and 1955, Faure became the Minister of National Education after May 1968.

**FER** *Fédération des Etudiants Révolutionnaires.* Federation of Revolutionary Students. Trotskyite student organization.

**Flins** 40 km outside Paris, the location of a major Renault factory.

**FGDS** *Fédération de la Gauche Démocrate et Socialiste.* Federation of the Democratic and Socialist Left. A coalition of Mitterrand's Convention of Republican Institutions (CIR), the French Section of the Workers' International, and the center-left Radical Party.

**Fouchet, Chretien** French politician who served as Minister of Education from 1962 to 1967 and Minister of the Interior from 1967 to May 1968. In 1967, he introduced a series of rigid education reforms that depersonalized the French higher education system and produced discontent among students.

**Frey, Roger** French Minister of the Interior from 1961 to 1967. His tenure saw the brutal repression of Algerian separatists and their supporters, including the 1962 Charonne massacre, and made extensive use of informers and secret police organizations like the Civic Action Committees.

**Front Algérie Française** French Algerian Front. Radical right-wing group that opposed Algerian sovereignty in the early 1960s. Though not active in 1968, de Gaulle's pardoning of right-wing anti-separatists in July 1968 brought to mind memories of the F.A.F. and similar groups.

**Grenelle Accords or Grenelle Agreements** Settlement reached between the government, corporations, and trade unions on May 25-26, 1968. The striking workers initially rejected the limited concessions offered to their union delegates.

**IFOP** *Institut Français d'opinion publique.* French Institute of Public Opinion.

**JCR** *Jeunesse Communiste Révolutionnaire.* Revolutionary Communist Youth. Trotskyite student organization.

**MNEF** *Mutuelle Nationale des Etudiants de France.* National Friendly Society of French Students. An organization managed by UNEF delegates.

**Mouvement du 22 Mars** March 22 Movement. Radical student organization founded in March 1968 following the occupation of an administrative building at Nanterre.

**OAS** *Organisation de l'armée secrète.* Right-wing organization which aimed to prevent Algerian independence.

**Occident** Right-wing organization responsible for numerous attacks on radical demonstrations in 1967-68.

**OCI** *Organisation Communiste Internationaliste.* Internationalist Communist Organization. Trotskyite student organization.

**ORTF** *Office de Radiodiffusion et Télévision Française.* French Radio and Television Broadcasting Office. France's public broadcasting agency.

**Pacra** Music-hall near Place de la Bastille.

**PCF** *Parti Communiste Française.* French Communist Party.

**PCI** *Parti Communiste Internationaliste.* Internationalist Communist Party. Trotskyite organization, the French section of the 4th International.

**PCMLF** *Parti Communiste Marxiste-Leniniste de France.* French Marxist-Leninist Communist Party. Maoist organization.

**PDM** *(Centre) Progrès et Démocratie Moderne.* Center for Progress and Modern Democracy. Right-wing Catholic party.

**PSU** *Parti Socialiste Unifié.* Unified Socialist Party.

**PTT** *Postes, Télégraphes et Téléphones.* Mail, Telegraph and Telephone. National agency governing mail and telecommunications.

**RATP** *Régie Autonome des Transports Parisien.* Independent Parisian Transport Authority.

**RNUR** *Régie Nationale des Usines Renault.* National Corporation of Renault Factories.

**RTL** *Radio Télévision Luxembourg.* Luxembourg-based media conglomerate.

**SAVIEM** *Société Anonyme de Véhicules Industriels et d'Equipement Mécanique.* Public Limited Company of Industrial Vehicles and Mechanical Equipment. Truck manufacturer, part of the Renault group.

**SMIG** *Salarie minimum interprofessional garanti.* Mandatory minimum wage for industrial workers.

**SNCF** *Société Nationale des Chemins de fer Français.* French National Rail Company.

**SNE-Sup.** *Syndicat Nationale de l'Enseignement Supérieur.* National Higher Education Union. Union representing university lecturers.

**UDR** *Union pour la Défense de la République.* Union for the Defense of the Republic. The name adopted by de Gaulle's party during the May Events; it had previously been known as the Union des Démocrates pour la Cinquième République (Union of Democrats for the Fifth Republic), or UD5.

**UJCML** or **UJC(ml)** *Union de la Jeunesse Communist (Marixst-Léniniste).* Union of Communist Youth (Marxist-Leninist). Maoist student organization.

**UNEF** *Union Nationale des Etudiants de France.* French National Student Union.

**Ve Plan or 5th Plan** Broad-ranging economic plan enacted in January 1966.

## BIBLIOGRAPHY

*Items marked with a ‡ are translated in full in the text section on p. 204-239.*
*Items marked with a † are translated in part.*

*Action.* †No.3, May 21, 1968; no.7, June 11, 1968; †no.10, June 14, 1968; no.14, June 20, 1968; no.15, June 21, 1968; no.16, June 24, 1968; no.17, June 25, 1968. Paris: Action, 1968

Adamson, Greg. *25 Years of Secondary Student Revolt.* Sydney: Resistance, 1993

"Algerian War of Independence 1954-1962." Armed Conflict Events Database. Nov. 27, 2003. ACED. www.onwar.com/aced/chrono/c1900s/yr50/falgeria1954.htm

Artcurial. *Mai 68 en mouvements: Lettrismes, Cobra, Situationnistes, Happening, Fluxus* (Vente no. 01491). Paris: Artcurial, 2008

Atack, Margaret. *May 68 in French Fiction and Film: Rethinking Society, Rethinking Representation.* Oxford: Oxford University Press, 1999

Atelier Populaire. *Atelier populaire présenté par lui-même: 87 affiches de mai-juin 1968.* Paris: Usines Université Union, 1968

Atelier Populaire. *Posters from the revolution, Paris, May 1968: Début d'une lutte prolongée.* London: Dobson Books Ltd., 1969

BBC Radio 4. "1968: Myth or reality?" Sept. 2008. BBC. www.bbc.co.uk/radio4/1968/

Black, Conrad. "Conrad Black on Charles de Gaulle, the man who saved France from anarchy." June 6, 2008. *National Post:* Full Comment. http://network.nationalpost.com/np/blogs/fullcomment/archive/2008/06/06/conrad-black-on-charles-de-gaulle-the-man-who-ended-france-s-slide-into-anarchy.aspx

*Black Dwarf*, vol. 13, no. 1, June 1, 1968. London: The Black Dwarf, 1968

Bourg, Julian. *From Revolution to Ethics: May 1968 and Contemporary French Thought.* Montreal: McGill-Queen's University Press, 2007

Camard & Associés. *Il y a 40 ans... Mai 68.* Paris: Camard & Associés, 2008

Caute, David. *Year of the Barricades: A Journey Through 1968.* New York: Harper and Row, 1968

*Combat: De la résistance à la révolution.* ‡No. 7421, May 25-26, 1968; No. 7423, May 28, 1968. Paris: Combat, 1968

Corkran, Christine M., "Defining Political Action: Posters and Graffiti from Paris 1968." History Honors Thesis, Franklin and Marshall College, 2005. http://dspace.nitle.org/handle/10090/741

Create Situations. *The Beginning Of An Epoch.* New York: Create Situations, 1971

Cutler, David. "Timeline: Some key dates in Franco-Algerian relations." Nov. 29, 2007. Reuters. http://uk.reuters.com/article/idUKL28581320071129

Daum, Nicolas. *Mai 68 raconté par des anonymes.* Paris: Éditions Amsterdam, 2008

Dejay, E., and P. Johnsson. *Paris Mai-Juin 1968: 94 Documents.* Paris: S.E.R.G., 1968

Dreyfus-Armand, Geneviève, and Laurent Gervereau, eds. *Mai 68: les mouvements étudiants en France et dans le monde.* Nanterre: B.D.I.C., 1988.

Erickson, Ric, ed. "A chronology of 'May '68.'" May 4, 1998. *Ric's Metropole Paris.* www.metropoleparis.com/1998/318/chron318.html

Evans, Les, ed. *Revolt in France, May-June 1968: A Contemporary Record.* New York: Les Evans, 1968.

Feenberg, A. and J. Freedman, eds. *When Poetry Ruled the Streets: The French May Events of 1968.* Albany: State University of New York Press, 2001

Gasquet, Vasco. *500 affiches de Mai 68.* Paris: Balland, 1978. Reprinted: Bruxelles: Editions Aden, 2007

Gates-Vickrey, Carly Marie. "Occupying the Minds of Students: A Revolt in France, 1968." BA thesis, University of Wisconsin—Eau Claire, 2007. http://minds.wisconsin.edu/handle/1793/18448

Gregoire, R., and F. Perlman. *Worker-Student Action Committees: France, May 68.* Detroit: Black & Red, 1969, reprinted 1991

Hoyles, Andre. "General Strike: France 1968: A factory by factory account." *Prole.info.* www.prole.info/texts/generalstrike1968.html

*L'Humanité.* May 25, 1968; Edition special, May 25, 1968; no. 1031, May 26, 1968; May 27, 1968; Edition special, May 27, 1968; Suppl. 104. Paris: L'Humanité, 1968

*L'Humanité nouvelle*: Organe central du Parti communiste marxiste-léniniste de France. May 23, 1968; May 24, 1968; no. 1031, May 26, 1968; Paris: Parti Communiste Marxiste-Léniniste de France, 1968

Johnson, Douglas. "Obituary: Raymond Marcellin." Sept. 15, 2004. *The Guardian.* www.guardian.co.uk/news/2004/sep/15/guardianobituaries.france

Kahn, Gilbert. *Paris a brulé.* Paris: Del Duca, 1968

Kennedy, John F. "Inaugural address of President John F. Kennedy." Jan. 20, 1961. John F. Kennedy Presidential Library & Museum. www.jfklibrary.org/Historical+Resources/Archives/Reference+Desk/Speeches/JFK/003POF03Inaugural01201961.htm

Kerbouc'h, Jean-Claude. *Le piéton de mai.* Paris: Julliard, 1968

Lewino, Walter. *L'imagination au pouvoir.* Paris: Le Terrain Vague, 1968

Mandel, Ernest. *The Lessons of May 1968 and The Commune Lives!* [France], IMG Publications, 1971

Marwick, Arthur. *The Sixties: Cultural Revolution in Britain, France, Italy, and the United States.* Oxford: Oxford University Press, 1998

*The Maydays in France.* Second issue of *Anarchy: a Journal of Anarchist Ideas*, no. 89, July 1968. London: Freedom Press, 1968

*Paris: Alternative Society Now.* Special issue of International Times, no. 32. London: International Times, 1962

*Paris: May 1968.* Solidarity Pamphlet no. 30. London: Solidarity Publications, 1968. Reprinted: London: Dark Star and Rebel Press, 1986

PBS. "Vietnam Online: Timeline." Mar. 29, 2005. PBS: American Experience. www.pbs.org/wgbh/amex/vietnam/timeline/index.html

Petrescu, Dragos. "Continuity, Legitimacy and Identity: Understanding the Romanian August of 1968." *Cuadernos de Historia Contemporanea*, vol. 31, 2009, p. 67-86

Pudal, P., et. al. *Mai-Juin 68.* Paris: Editions de l'Atelier, 2008

Reader, Keith A. *The May 1968 Events in France: Reproductions and Interpretations.* New York: St. Martin's Press, 1993

*Révoltes: Pour la construction de l'organisation revolutionnaire de la jeunesse.* No. special, May 20-22, 1968. Paris: Révoltes, 1968

Rohan, Marc. *Paris '68: Graffiti, Posters, Newspapers and Poems of the May 1968 Events.* London: Impact Books, 1988

Schulz-Forberg, Hagen. "Claiming Democracy: The Paris 1968 May Revolts in the Mass Media and Their European Dimensions." *Cuadernos de Historia Contemporanea*, vol. 31, 2009, p. 27-53

Schwarz, Peter. "1968: The general strike and student revolution in France.

Part 4: How Alain Krivine's JCR covered for the betrayals of Stalinism (2)." Jul. 7, 2008. *World Socialist Web Site.* www.wsws.org/articles/2008/jul2008/fra4-j07.shtml

*Servir le Peuple.* No. 22, May 21, 1968. Paris: Groupes de Travail Communistes, Union des Jeunesses Communistes (Marxiste-Léniniste), 1968

Situationist International. "The beginning of an era." *Internationale Situationniste*, no. 12, Sept. 1969. *Situationist International Online.* Trans. Ken Knabb. www.cddc.vt.edu/sionline/si/beginning.html

Stansill, P. and D. Z. Mairowitz, eds. *BAMN (By Any Means Necessary): Outlaw Manifestos and Ephemera 1965-1970.* Harmondsworth: Penguin Books Ltd., 1971

*Student Revolten.* Special issue of *Ord & Bild*, vol. 77, May 1968. Stockholm: Ord & Bild, 1968

Tchou Éditeur. *Mai 68 affiches.* Paris: Tchou Éditeur, 1968.

Thomas, Nick. *Protest Movements in 1960s West Germany: A Social History of Dissent and Democracy.* Oxford: Berg Publishers, 2003

Viénet, René. *Enragés and Situationists in the Occupation Movement: Paris, May, 1968.* Paris: Gallimard, 1968. Reprinted: New York: Autonomedia, 1992

*Voix Ouvrière.* No. 26, May 20, 1968; no. 27, May 24, 1968; May 25, 1968. Paris: Voix Ouvrière, 1968.

## ARCHIVAL BIBLIOGRAPHY

*The following materials represent an archive of May '68 ephemera and periodicals assembled by Phillippe Vermès. These texts form the basis of the selected ephemera section on pages 204-239.*

### Handbills, fliers, and Pamphlets

Ca. March 28, 1968. Comité de soutien à la lutte des travailleurs des bidonvilles de Massy. "Quand les travailleurs des bidonvilles s'organisent on est oblige de les écouter." Massy. 2pp.

‡Ca. May 13, 1968. Coordination des Comités d'Action. "Appel." Paris. 2pp.

‡May 15, 1968. Atelier Populaire. "Pourquoi prolongeons nous la lutte?" Paris, Ecole des Beaux Arts. 2pp. Two copies, plus two pages of a draft version with extensive manuscript notes.

Ca. May 18, 1968. Parti Communiste Français. "Déclaration à 'France-Inter' de Waldeck Rochet, Secrétaire general du Parti Communiste Français." Paris. 1p.

May 20, 1968. Étudiants, Enseignants et Architectes Communistes. "Vive l'union des travailleurs et des étudiants en lutte." Paris. 1p.

May 20, 1968. Union Nationale des Syndicats C.G.T. du Personnel des Cabinets d'Architectes, des Bureaux d'Etudes d'Architecture et d'Urbanisme, and Syndicat National du Personnel des Professions Animatrices de la Construction. "[Statement issued following a meeting on May 20, 1968.]" [Paris]. 2p.

May 21, 1968. "Proposition de Motion d'orientation, présentée le 21 Mai 1968." 1p. of a longer text.

‡Ca. May 21, 1968. Atelier Populaire. "Essai de developpement de: Atelier populaire: oui, Atelier bourgeois: non." Paris. 7pp., with manuscript notes on the last leaf.

‡May 22, 1968. Commission Critique de l'université de classe. "Commission Critique de l'université de classe." 2pp.

May 22, 1968. Conseil pour le maintien des occupations. "Pour le pouvoir des conseils ouvrières." Paris. 1p.

‡Ca. May 22, 1968. Comités d'action. "De Gaulle à la porte!" [Paris]. 2pp.

‡May 23, 1968. Comité central de l'organisation communiste internationaliste. "Travailleurs, militants, jeunes." Paris. 2pp.

Ca. May 23, 1968. Union Nationale des Étudiants de France. "UNEF." Paris. 1p.

May 27, 1968. École et Familles. "Communiqué de presse." Paris. 1p.

‡May 29, 1968. Grimaud, Maurice. "Lettre de M. Grimaud aux agents de la police parisienne." Paris. 2pp.

Ca. May 1968. Comité d'action "Nous sommes en marche." Paris. 56pp.

Ca. May 1968. Comité d'action pour l'étude d'un enseignement libre dans des écoles autonomes d'architecture. "Après une période de manifestations violentes, la grève illimitée a été decidée dans l'ensemble de l'Université." Paris. 1p.

Ca. May 1968. Mouvement de soutien aux luttes du people and Comité de defense contre la repression. "Vive l'unité des ouvriers et des étudiants à leur service." Paris. 1p.

‡Ca. late May, 1968. Syndicalistes prolétariens CGT. "Non à la trahison! Gouvernement populaire!" 1p. With manuscript notes.

Ca. late May, 1968. Union des étudiants communistes de France. "Vive la lutte des syndicats ouvrièrs." Paris. 2pp.

June 3, 1968. Rocton, Yves. "Déclaration du camarade Yves Rocton, member du Comité de Grève de Sud-Aviation (Nantes)." 1p.

‡June 3, 1968. Comité de coordination des comités d'action, Mouvement de soutien aux luttes du puuple, and Mouvement du 22 Mars. "La borgeoisie [sic] a peur!" Paris. 1p. Three copies in two different states.

Ca. June 3, 1968. Intersyndicale de l'O.R.T.F. "L'O.R.T.F. est en grève. Pourquoi?" Paris. 1 p.

June 4, 1968. Comité d'action "Bidonvilles." "Comité d'action 'Bidonvilles.'" 1p. Three copies.

‡June 4, 1968. Comités d'action, Mouvement de soutien aux luttes du peuple, and Mouvement du 22 Mars. "Feuille informative contre l'intoxication." 2pp.

†June 4, 1968. Commission témoinage et assistance juridique. "Les témoignages sur la repression." Paris. 15pp.

June 4, 1968. Employees of Peugeot la Garenne. "Tract distribué le 4 juin 1968 au matin." La Garenne-Colombes. 1p. Three copies.

June 4 ,1968. Mouvement des comités d'action de la région parisienne. "La bourgeoisie a peur." Paris. 2pp.

‡June 5, 1968. Mouvement du 22 mars. "Chez Renault, à Flins." Paris. 1p.

‡June 6, 1968. Comité de coordination des comités d'action de la région parisienne, Mouvement du 22 Mars, and Mouvement de soutien aux luttes du peuple. "Tous à Flins." Paris. 1p.

June 6, 1968. Travailleurs grévistes de Renault-Flins. "Appel à la population." Flins. 1p.

June 6, 1968. [Travailleurs grévistes de Renault-Flins?] "Travailleurs de Renault-Flins, ne reprenez pas le travail, défendez vos revendications." Flins. 2pp.

Ca. June 6, 1968. [Intersyndicale de l'O.R.T.F.?] "Des chercheurs en sciences sociales dénoncent l'utilisation frauduleuse des sondages d'opinion." 2pp.

June 7, 1968. Mouvement international révolutionnaire des arts. "Manifeste." Paris. 3pp.

Ca. June 7, 1968. Mouvement international révolutionnaire des arts. " Programme d'action du 'Marché Parallèle." Paris. 2pp.

‡June 8, 1968. Comité de coordination des comités d'action de la région Parisienne, Mouvement de soutien aux luttes du peuple., and Mouvement du 22 Mars. "Renault-Flins: Reprise victorieuse de la grève." Paris. 1p.

June 8, 1968. Étudiants et enseignants de l'ex-ENSBA en grève. "Motion." Paris. 1p.

June 14, 1968. Enseignants et étudiants en grève de l'ex-ENSBA, Arts Déco, et ESA. "Proposition de motion au sujet du communiqué de presse de Monsieur Malraux." Paris. 1p.

Ca. June 17, 1968. "Non aux bidonvilles, non aux villes-bidons." Paris. 1p.

June 18, 1968. Commission Université d'été. "Problèmes de l'université d'été." Paris. 2pp.

Ca. June 18, 1968. Front Populaire. "Poings levés! Demain la France populaire: Projet de programme de Front Populaire." Excerpt from La Cause du Peuple no. 18, June 18-19, Paris. 4pp. Two copies.

Ca. June 26, 1968. Mouvement de soutien aux luttes du peuple. "Longue marche de la jeunesse." Paris. 2pp.

June 1968. Institute Autogéré d'Urbanisme. "Cogestion ou autogestion?" Paris. 1p.

Ca. June 1968. Berg, Charles. "Alliance des jeunes pour le socialisme." Paris. 2pp.

Ca. June 1968. [Étudiants et enseignants de l'ex-ENSBA en grève?] "Texte d'orientation pour la corpo UNEF: Peinture, gravure, sculpture." Paris. 2pp.

Ca. May-June 1968. Comité d'action, 27ème section, 10ème division. "Pourquoi cette feuille d'information". 2pp.

Ca. May-June 1968. Comité d'action d'arts plastiques. "Comité d'action arts plastiques met en garde contre la multiplication d'initiatives qui resteraient disperses en tous sens…" Paris. 1p.

Ca. May-June 1968. Comité d'action des ouvriers en grève. "Ouvriers du Chantier Maine-Montparnasse." Paris. 1p.

‡Ca. May-June 1968. Comités d'action des 3e, 4e, 5e, et 11e arrondissements. "Organisation des comités d'action." Paris. 1p.

Ca. May-June 1968. Union des étudiants communistes, secteur Beaux-Arts. "Comment la lutte des étudiants rejoint celle des travailleurs." Paris. 1p.

Ca. July 24, 1968. [Étudiants de l'école maternelle Paul Dubois.] "Les enfants de mai: dessins, peintures, slogans par les enfants de l'école maternelle libérée de la rue Paul Dubois, par les enfants du square du Temple, par les enfants du Marais." Paris. 2pp. Four copies, one with manuscript notes.

July 26, 1968. Comité d'action du quartier Buci. "Bulletin no. 13: Pour un gouvernement populaire d'union democratique." Paris. 1p. With manuscript notes.

Ca. July 1968. "Experience d'un militant communiste au C.E.T." Paris. 2pp.

Ca. August 23, 1968. Occident. "Le communisme apatride à l'oeuvre." Paris. 1p.

Ca. August 26, 1968. Mouvement du 17 mai. "Pour le socialisme, contre l'agression." Paris. 1p. Two copies.

August 29, 1968. Parti communiste révolutionnaire (trotskiste). "Chasser les tendances pro-capitalistes dans les etats ouvriers!" Paris. 2pp.

Ca. Fall 1968. Section peinture sculpture gravure. "Propositions pour l'Élaboration d'un cahier de revendications." 1p.

Ca. Fall 1968. [Atelier Populaire?] "Information." Paris. 2pp. With manuscript notes.

Ca. November 26, 1968. [Atelier Populaire?] "Contre la selection des peintures, graveurs, sculpteurs: ne participent pas." Paris. 4pp.

Ca. November 1968. [Atelier Populaire?] "Pourquoi 'Non à la participation, oui à la satisfaction de nos revendications." Paris. 4pp.

Ca. November 1968. UNEF Écoles D'Art. "Adherez a L'Amicale UNEF Des Écoles D'Art: Commission D'Étude De La Loi Edgar Faure." Paris. 1p.

Ca. 1968. Centre international de recherches sur l'anarchisme. "Documents et recherches sur l'anarchisme: Le centre international de Lausanne (I)." 3pp.

Ca. 1968. "Comment reussir à convaincre un 'prospect' raisonneur et sceptique.". 1 leaf removed from a longer publication, with manuscript notes.

Ca. 1968. "D'orientations politiques de discussion: platforme d'hypotheses d'enseignement, Mai-Juin 1968." Cover leaf only from a longer publication.

Ca. 1968. "Non à la selection de classe bourgeoise! Oui à la selection de classe proletarienne!" 3pp.

Ca. November 1970. Association des comités de défense des locataires de 5O. "Bonne ou mauvaise année?" Paris. 6pp.

Ca. November 1970. Association des comités de défense des locataires. "RÉSISTANCE à l'expulsion." Paris. 1p.

## Newspapers and newsletters

*L'Anti-Mythe: Bulletin d'information sur les luttes sociales pour les travailleurs et les habitants du 14ème arrondissement et de Montrouge.* No. 17, July 1, 1968 (5pp.); no. 19, July 3, 1968 (2pp.); no. 20, July 4, 1968 (2pp.); no. 21, July 5, 1968 (1p.)

*La Base: Bulletin d'information du comité d'action des grands magasins.* No. 2, July 30, 1968. 6pp.

*La Cause du Peuple: Journal de Front Populaire.* †No. 11, June 6-7, 1968 (4pp.); no. 12, June 8, 1968 (2pp.); no. 17, June 16-17, 1968 (4pp.); no. 20, June 25, 1968 (4pp.)

*Lutte ètudiante: Organe de la fraction ètudiante du Parti Communiste Revolutionnaire Trotskiste.* No. 6, Aug. 1968. 14pp.

†*Le Mythe: Bulletin interieur du comité d'action du 14ème arrondissement et de Montrouge.* No. 1, July 4, 1968. 4pp.

†*Le Pavé.* Tract no. 1, May 1968. 4pp.

*Servir le Peuple: Journal des Groupes de Travail Communistes et de l'Union des Jeunesses Communistes (Marxiste-Léniniste).* No. Spécial 22, May 22, 1968. 8pp.

*Le Tribunal du Peuple: Journal des Avocats au service du Peuple.* No. 1, July 1968. 4pp.

†*Voix Ouvrière: R.N.U.R. Flins.* No. Spécial (Suppl. to no. 30), June 7, 1968. 1p.

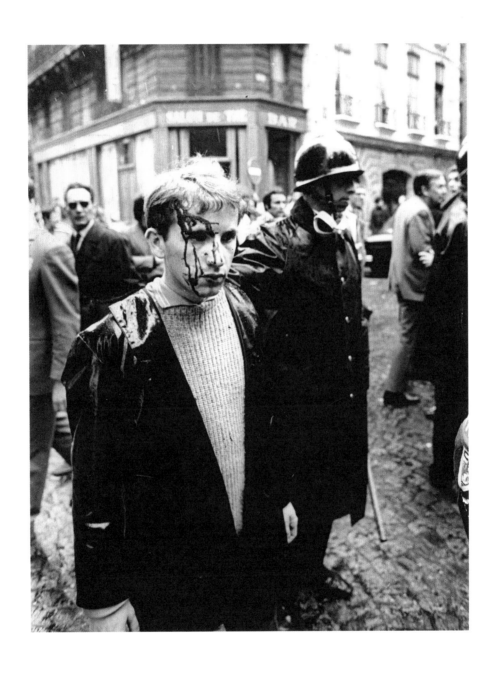

BOURGEOIS
VOUS
N'AVEZ
RIEN COMPRIS

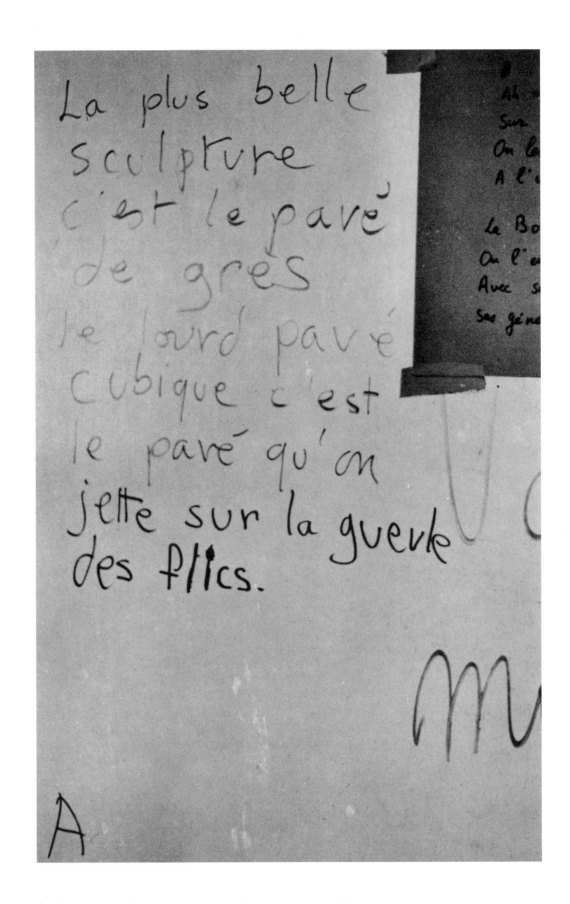

↑ The most beautiful sculpture is the sandstone paving stone, the heavy,
cube-shaped paving stone is the one that we throw in the face of the cops
*Monday, May 13. Sorbonne.*
*Photograph by Jo Schnapp.*

## POSTSCRIPT

The Atelier Populaire does not claim to be establishing a historical record of their action nor to be putting forward a solution, but simply to show the methods of struggle discovered day by day in action. The existence of an Atelier Populaire depends on the determination and need for giving the widest possible publicity to each particular struggle.

The fight is neither over nor brought to a stop; the circumstances of struggle change; new methods of continuing it will be found in action in our support of the workers.

Let us form in our cultural and political action the rearguard of the workers' struggle against the repressive system of bourgeois culture.

Let us redouble our attempts to find both in action and through our contact with the masses the methods of struggle best suited to each situation.

Let us increase the number of Ateliers Populaires so as to provide the conditions necessary for the emergence of a people's culture and an information network at the service of the workers.

Let us not work in isolation: we should spread as widely as possible the lessons we have learnt at every stage of practical action.

ATELIER POPULAIRE
August 1968
UUU (Usines-Universités-Union)
64 rue de Richelieu, Paris 9e.

*Text reproduced from the 1969 Atelier Populaire book* Posters From The Revolution.

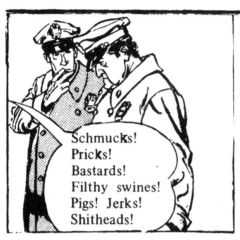
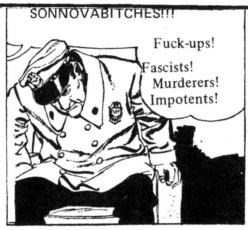